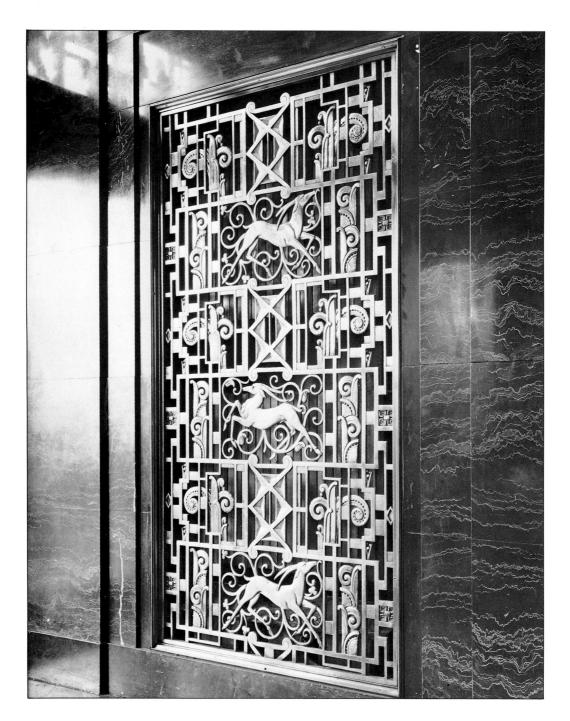

Above Rubush and Hunter: bronze grill, Circle Tower Building, 1929-30.

Opposite Demêtre Chiparus: "The Girls", a gilt and cold-painted bronze group of a chorus line.

THE ENCYCLOPEDIA OF ART·DECO

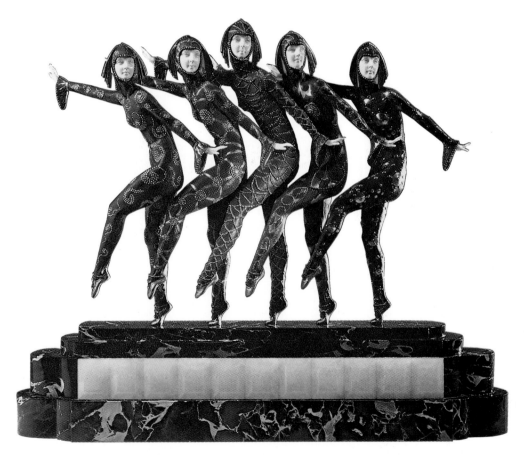

Edited by ALASTAIR DUNCAN

E.P. DUTTON

New York

CONTRIBUTORS

ALASTAIR DUNCAN is the consultant for the 19th- and 20th-century decorative arts at Christie's, New York. He has been with the auction house since the firm opened its galleries at 502 Park Avenue, New York, in 1977, and during that time has organized and catalogued scores of sales devoted to Art Nouveau, Art Deco and Victorian decorative arts. He is the author of several previous books (see back jacket), the most recent being *American Art Deco* (1986). He is a member of the British Society of Master Glass Painters, the Decorative Arts Society of the Royal Pavilion in Brighton, the Advisory Council of the New York Art Deco Society, the newly formed National Art Deco Trust & Foundation in Washington, D.C., the Decorative Arts Council at the Fashion Institute of Technology (FIT) in New York, and the Appraisers Association of America, Inc.

AUDREY FRIEDMAN, who graduated from Queens College with a BA in sociology, was a practicing social worker for five years, while simultaneously pursuing her interest in Art Nouveau and Art Deco. She is the owner of the Primavera Gallery, New York, which was opened in 1971. She has lectured for the Cooper-Hewitt, the New School and the Art Deco Society, and is a member of the Society of Jewelry Historians.

MICHAEL MEEK attended Georgetown Preparatory School, and is a graduate of the American College in Paris. He is a former associate of Sotheby Parke Bernet, New York (1980-84), and is currently the specialist in 19th- and 20th-century decorative arts for William Doyle Galleries, auctioneers of New York.

JENNIFER TOHER specializes in 19th- and 20th-century design and decorative arts. As an associate with the curatorial firm David A. Hanks & Associates, Inc., she has co-authored the recent publication *Donald Deskey: Decorative Designs and Interiors* and essays for two museum exhibition catalogs: *In Pursuit of Beauty: Americans and the Aesthetic Movement* and *High Styles: Twentieth Century American Design*. In addition, she was the editor of and a contributor to the 1983 exhibition catalog for New Jersey State Museum, *Beyond the Plane: American Constructions, 1930-1965*.

JODY WILKIE attended the Chapin School and received her BA in Art History from Vassar College. She is an assistant vice president and senior assistant in the Sculpture and Works of Art Department of Christie's, New York, and has been with the auction house for ten years. She has been interested in the decorative arts since childhood, and her personal preference is for French decorative arts and American bronzes of the 1920s and 1930s.

JANET ZAPATA received a master's degree in art history from Rutgers University. She completed internship programs in the American Decorative Arts Department of the Metropolitan Museum of Art and the Education Department of the Whitney Museum of Art, and also worked with David A. Hanks & Associates, Inc. In 1985 she was commissioned to organize the archives for Tiffany & Co. in preparation for the firm's 150th anniversary, and she has played a key role in several major projects for this event. She is an active lecturer on the decorative arts, and has become a recognized authority on Tiffany's history and products.

Copyright © 1988 by Quarto Publishing plc

All rights reserved. Printed in Hong Kong

Published in the United States by E.P. DUTTON, a division of NAL Penguin Inc., 2 Park Avenue, New York, N.Y. 10016.

ISBN: 0-525-24613-4

1 3 5 7 9 10 8 6 4 2

First American Edition

This book was designed and produced by
Quarto Publishing plc
The Old Brewery
6 Blundell Street
London N7 9BH

PROJECT EDITOR **HAZEL HARRISON**
EDITORS **MIKE DARTON AND PATRICIA BAYER**

DESIGN STYLIST **VINCENT MURPHY**
DESIGNER **BOB GORDON**

ART DIRECTOR **MOIRA CLINCH**
EDITORIAL DIRECTOR **CAROLYN KING**

Typeset by Keyboard Graphics Ltd & QV Typesetting Ltd
Manufactured in Hong Kong by Regent Publishing Services Ltd
Printed by Leefung-Asco Printers Ltd, Hong Kong

CONTENTS

INTRODUCTION

Art Deco survives today as the last truly sumptuous style, a highly fertile chapter in the history of the applied arts. There is continuing debate, however, on the exact definition of the term "Art Deco" and the limits of the movement it encompasses. When the Art Deco revival first began about 20 years ago, it was viewed as the very antithesis of Art Nouveau – indeed, the theory was that the new style was spawned in 1920 to eradicate its predecessor, which history had already judged a grave but mercifully brief transgression against good taste. Today this theory has been proved incorrect: Art Deco is not the opposite of Art Nouveau; it is in many aspects an extension of it, particularly in its preoccupation with lavish ornamentation, fine materials and superlative craftsmanship. Nor did it, as previously believed, take root abruptly in 1920 and flower for a brief ten years until eclipsed by the economic collapse of the 1930s.

Although World War 1 has generally been taken as the dividing line between the Art Nouveau and the Art Deco epochs, in fact the latter was conceived in the transitional pre-war years, and like its predecessors, it was an evolving style that neither began nor ended at any precise moment. Many items now accepted as pure Art Deco – such as furniture and *objets d'art* by Emile-Jacques Ruhlmann, Paul Iribe, Clément Rousseau and Paul Follot – were designed either before or during the outbreak of hostilities, and thus the movement cannot be rigidly defined within the decade 1920–1930. Had it not been for the four-year hiatus created by World War 1, in fact, the Art Deco style would probably have run its full and natural course by 1920.

THE ART DECO STYLE

It is not always easy to define the main characteristics of Art Deco, because the style drew on such a host of diverse and often conflicting influences. Many of these came from the avant-garde painting styles of the early years of the century, so that elements from Cubism, Russian Constructivism and Italian Futurism – abstraction, distortion and simplification – are all evident in the Art Deco decorative arts vernacular. But this was not all: examination of the style's standard repertoire of motifs – such as stylized flower clusters, young maidens, geometry and the ubiquitous *biche* (doe) – reveals influences from the world of high fashion, from Egyptology,

the Orient, African tribalism and Diaghilev's Ballets Russes. From 1925 the growing impact of the machine can be discerned in repeating or overlapping images, or later, in the 1930s, by streamlined forms derived from the principles of aerodynamics. All this resulted in a highly complex amalgam of artistic influences, defying description by one single phrase, though the term "Art Deco," derived from the Exposition des Arts Décoratifs et Industriels Modernes, held in Paris in 1925, remains the most appropriate one.

The style evolved in France, notably in Paris, where it manifested itself emotionally, with exuberance, color and playfulness. Elsewhere in Europe, and later in the US, it was given a more intellectual interpretation based on theories of functionalism and economy, and this element of design is known today as Modernism, to distinguish it from the high-style French variant, which is sometimes referred to as high Art Deco. Both, however, are aspects of a twentieth-century preoccupation with contemporary sources and inspiration, unlike the pre-war styles which were largely the product of period revivalism.

THE MACHINE AGE

Just as the Art Deco style had replaced Art Nouveau in France, so did Art Deco in turn yield to Modernism in the mid-1920s, its demise beginning at its very moment of triumph, the International Exposition. The movement's first tenet, that form must follow function, remained unchallenged by any later schools of design, but its second, relating to decoration and craftsmanship, proved its undoing. By 1926 the loosely knit band of French Modernists – Francis Jourdain, Pierre Chareau, Le Corbusier, Robert Mallet-Stevens and René Herbst – had become increasingly outspoken in their criticism of the Art Deco designers who catered to select clients by creating elaborately crafted *pièces uniques,* or limited editions. The Modernist argued that the new age required nothing less than excellent design for everyone, and that quality and mass-production were not mutually exclusive. The future of the decorative arts, they believed, did not rest with the wealthy few and should not be formed by their aesthetic preferences alone; an object's greatest beauty lay in its perfect adaptation to its usage. Each age must create a decorative style in its own image to meet its

specific needs, and in the late 1920s this aim was best realized by industry's newest means of production, the machine. Existing concepts of beauty, based on the artisan and his hand tools, thus needed to be redefined to meet the dictates of the new machine age.

Modernism made rapid progress in the late 1920s, although most designers took a stance somewhat short of the severe functionalism espoused by its most ardent adherents. As Paul Follot, a veteran designer, observed in 1928: "We know that the 'necessary' alone is not sufficient for man and that the superfluous is indispensable for him… or otherwise let us also suppress music, flowers, perfumes… and the smiles of ladies!" Follot's viewpoint was shared by most of his designer colleagues – even if logic called for the immediate elimination of all ornamentation, mankind was not psychologically prepared for such an abrupt dislocation in lifestyle. Most designers therefore opted for a middle ground, creating machine-made items that retained an element of decoration – which, ironically, had often to be hand-finished.

Outside France, functionalism had a longer history, having dominated decorative-arts ideology since the end of the Victorian era. In Munich, the formation of the Deutscher Werkbund in 1907 carried forward the logic and geometry at the heart of the Vienna Secession and Glasgow movements some years earlier. In contrast to both the French Art Nouveau repertoire of flowers and maidens and Germany's own lingering Jugendstil, the Werkbund placed emphasis on functional designs which could be mass-produced. A reconciliation between art and industry, updated to accommodate the technological advances of the new century, was implemented, with ornament given only secondary status. These ideals were realized more fully with the formation of the Bauhaus in Germany, which in turn inspired the Modernist strain that took root in American decorative arts in the late 1920s. After World War I many European and Scandinavian designers followed the German example by creating Bauhaus-inspired furnishings and objects. Indeed, examination of contemporary European art reviews shows that ornament was sparingly applied outside France, and although a certain amount was tolerated, the high-style embellishments of Paris between 1910 and 1925 were viewed as a Gallic eccentricity which should not be permitted outside French borders. The high-style's only real success abroad was in American architecture, where it was adopted to enhance America's new buildings, particularly skyscrapers and movie palaces. The US lacked a modern style of its own in the early 1920s, so its architects looked to Paris for inspiration and leadership in art as they always had in the past.

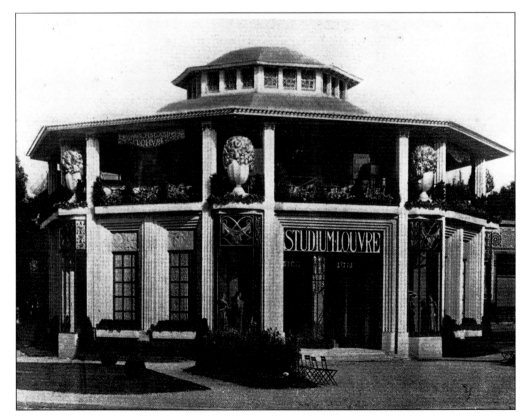

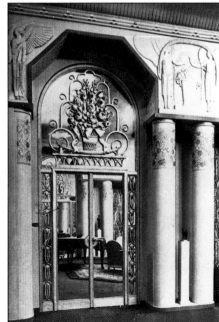

Left The Studium Louvre Pavilion, 1925 Paris Exposition; and **below** the doorway of the reception lounge, Ambassade Française.

ARCHITECTURE

Architecture is the single area in which the United States led Europe in 1920s Modernist decoration. In France, curiously, the Parisian Art Deco style, which dominated the annual decorative arts salons from the end of World War I until the 1925 International Exposition, was applied only infrequently to buildings.

Examination of contemporary reviews, such as *Art et Décoration* and *Art et Industrie,* shows a random selection of boutiques – typically perfumeries, bakeries and shoe stores – adorned with the new idiom. Interpretation varied between decorators and architects. Sue et Mare applied an opulent array of bas-relief baskets of fruit and swagged flower garlands to the façades of chic small shops, such as the Parfumerie D'Orsay, the Robert Linzeler jewelry shop and the Pinet shoe store **(1)**. Materials were characteristic of the firm's interiors: yellow marble ornamented with ormolu, blue stucco, wrought-iron and sculpted gilt-wood.

Elsewhere in the heart of Paris's most fashionable boulevards on the Right Bank, the decorating firms of Siegel and Martine generated a similar range of colorful Modernist shop façades, while the architects René Prou, Djo-Bourgeois and Jean Burkhalter designed a more restrained and angular form of store-front decoration.

THE 1925 INTERNATIONAL EXPOSITION

The most distinctive and cohesive examples of French Art Deco architecture were designed for an intended lifespan of six months only, at the 1925 International Exposition. The show's short duration, and the fact that the entire site would be razed by a demolition crew on its closure, invited experimentation with radical architectural forms and untried materials. Stone and brick yielded to laminates and plastics. The Exposition's charter, in fact, made radicalism a prerequisite: "Works admitted to the Exposition must show new inspiration and real originality. They must be executed and presented by artisans, artists, manufacturers, who have created the models, and by editors, whose work belongs to modern decorative and industrial art. Reproductions, imitations, and counterfeits of ancient styles will be strictly prohibited."

Illustrations of the Exposition show an exhilarating mix of avant-garde structures, primarily along the Esplanade des Invalides and, perched like a cramped medieval Italian town, along the Alexander III bridge **(2)**. The theatrical impact continued even beneath the bridge, where Paul Poiret's three flower-painted barges were moored. Banished to the Right Bank among the foreign exhibits, was Le Corbusier's stark Pavillon de l'Esprit Nouveau.

The four leading Parisian department stores set the mood in the designs for their pavilions: Pomone, of the Magasins au Bon Marché (L.-H. Boileau, architect); Primavera, of the Magasins du Printemps (Sauvage & Wybo, architects); La Maîtrise, of the Magasins des Galeries Lafayette (F. Chanut, chief architect, with J. Hiriat, G. Tribout, G. Beau and Maurice Dufrêne, decorator), and Studium Louvre, of Le Louvre (A. Laprade, architect).

Birth and death dates are given wherever possible, but due to the incomplete documentation of this relatively recent art movement some have of necessity been omitted.

Abbreviations used: SAD, Société des Artistes Décorateurs; SAF, Société des Artistes Français; UAM, Union des Artistes Modernes.

AALTO, *Hugo Hendrik Alvar*
1898-1976
Architect and designer
Born in Finland, studied architecture at the Helsinki Polytechnic. He began his professional practice two years later with Neo-classical designs. His style then moved towards Modernism and in 1930 he designed simple Modernist rooms for the Helsinki Museum 'Minimum Apartment' Exhibition. In 1933 he moved his office to Helsinki and his furniture was shown for the first time outside Finland, at Fortnum & Mason in London. Along with Maire Gullichsen and his wife, he formed a company named Artek to produce his furniture, as it still does today.

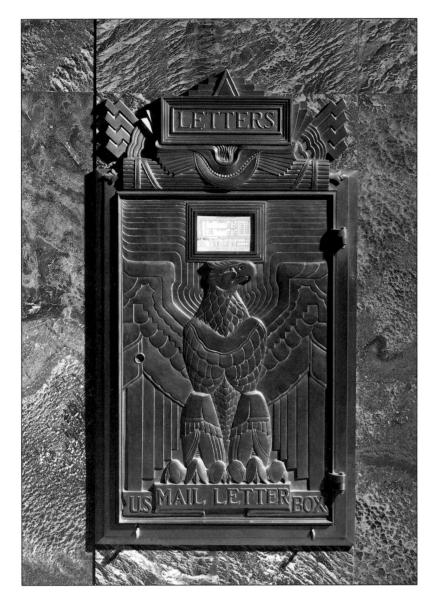

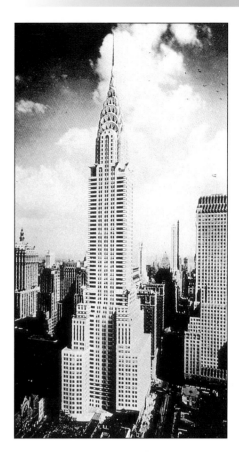

Left mail box in the lobby of the Chrysler Building, corner of Lexington Avenue and 42nd Street, New York, 1927-30; and (**right**) contemporary view of the building from the north, showing the Chanin Building on the right. The architect, William van Alen, is known today exclusively for the Chrysler Building, although he did design a handful of others also in the Modernist idiom, such as the entrance doors for Lookout Point in New York. His initial designs for the Chrysler Building incorporated an illuminated dome in place of the seven-story nickel and chromed steel by which it was replaced in the last stages of planning.

Other pavilions were equally eye-catching: the pavilion of Information and Tourism (R. Mallet-Stevens), the shops of the Place Clichy (C. Siclis), the National Manufactory of Sèvres (P. Patout & A. Ventre, in association with H. Rapin), and Ruhlmann's Hotel du Collectionneur (P. Patout) **(3)**. Each turn exposed the visitor to a bizarre mix of terraced structures, Cubism, overlapping arcs, and chevrons.

ADLER, *Rose*
1890-1959
Bookbinder, designer
Born in Paris, studied at the Ecole des Arts Décoratifs under André Legrand until 1925, then with the gilder and binder Noulhac. In 1923 Jacques Doucet purchased some of her bindings in a student exhibition, beginning a long association. Exhibited at the SAD from 1924, and at the Exposition du Livre and Exposition Internationale in 1925. Masterpiece bindings included *Calligrammes, Poèmes* and *Etudes pour Narcisse.*

Not everyone was convinced, however. One critic noted that the architecture at the Exposition represented a conglomeration of ill-proportioned rectangles and triangles traced, ironically, against the silhouettes of the Louvre, Tuilerie, and Invalides "which, like silent disapproving ghosts, stood in the distance."

Art Deco architectural ornamentation did not extend far beyond the French capital. Unlike the United States, which experienced a building boom in the 1920s, Europe was in a quiet period of retrenchment following the devastation of World War I. In addition, its rich architectural tradition leaned heavily toward renovation rather than demolition. Old buildings were restored rather than replaced. In England, the style took root, with modifications, in such period classics as the Strand Palace Hotel, the Ideal Boiler Building, and the Hoover factory, all in London. The isolated existence of such examples tended to stress the style's absence, however, rather than its pervasiveness.

THE TRIBUNE TOWER AND ITS SUCCESSORS

In the United States, conversely, the Parisian Art Deco style became the grammar of ornament adopted by a host of Modernist architects with which to dress their new buildings. The landmark 1923 Chicago Tribune competition, in which a first prize of $50,000 was offered for a modern office building "of great height", to symbolize the power and authority of the newspaper, drew 260 entrants from the US and abroad. The first prize was awarded to John M. Howells and Raymond M. Hood of New York, for a building which, paradoxically, evoked the past rather than the future in its selection of Gothic ornamentation. A cathedral tower, replete with flying buttresses and a pinnacle, crowned a structure which appears today as an anachronism in downtown Chicago.

The jury's choice seems extraordinary – especially as the second prize, a soaring set-back Modernist structure by Eliel Saarinen, quickly became the prototype for the numerous Modernist skyscrapers which sprang up across America in the next ten years.

The Tribune Tower became the rallying-point for the proponents of avant-garde architectural ornamentation. The competition helped the architectural community focus on a self-evident fact: for the country's architecture to come of age, it had first to divest itself of all traces of past foreign influence. The period revivalism of the Tribune Tower and Cass Gilbert's Woolworth Building were now out of place. Suddenly, all Neo-classical decorations were seen as *passé*, stylistic remnants of a bygone era. Architects began to search for a new form of decoration, one in symphony with twentieth-century building materials.

Ironically, because no Modernist style had yet evolved in America, the search had to be undertaken in Europe, at the 1925 International Exposition. As the critic Thomas Tallmadge noted in 1929, "We have almost always borrowed our ornament from Europe. The plan and construction of all our buildings, from houses to skyscrapers, is as distinctly American as their ornament is European. It has always been so, and the discouraging aspect of 'this modernism' is that we are continuing the same practice, for while we are evolving our own forms we are taking our ornament from the Exposition of Modern Decorative Arts in Paris or from European publications exploiting the modern movement. The study of original designs is not taught in our architectural schools, and we have no important schools of industrial design; in consequence, we have no great decorative artists…" In place of historicism, architects therefore chose the up-to-the-minute geometric and floral abstractions of the French capital.

ADNET, *Jacques*
b. 1900
Lighting designer, architect and decorator
Born in Chatillon-Coligny, trained at the Ecole des Arts Décoratifs in Paris. He worked first for Henri Rapin, then Tony Selmersheim, and after 1920 for Maurice Dufrêne, and exhibited his designs through La Maîtrise and Saddier et fils until 1928. He then took over direction of the Compagnie des Arts Français,

the firm previously founded by Louis Süe and André Mare.

As an interior designer he followed the philosophy of functionalism, and this simplicity is reflected in both his furniture and his lighting designs, which often make use of bare bulbs in understated metal settings. He frequently worked in collaboration with his twin brother, Jean, who was display director for Galeries Lafayette, and work done by the two

brothers was credited as J.J. Adnet.

J J Adnet: chandelier, late 1920s.

At this point it is important to stress that the term "Art Deco architecture" does not relate to a specific style of 1920s architecture, but to the distinctive type of Modernist decoration applied to new structures at the time. Skyscrapers such as the Chrysler and Chanin Buildings qualify as Art Deco not because they are tall and terraced, but because of the fanciful decoration with which they were embellished to emphasize that they were new. As in traditional architecture, Modernist decoration was used as a transitional device to alert the eye to changes in the building's contour. Stepped vertical decoration was found to accentuate a skyscraper's height; horizontal decorative bands that of the rhythmic ascent of its recesses. In addition to its exterior use in this manner, Art Deco ornamentation was concentrated principally on that part of a building seen and used most by its occupants – its entranceway – exterior grillwork, doors, lobby and bank of elevators. Often a sumptuous combination of stone, terracotta and metal transformed a bland commercial structure into one of great civic pride. On smaller buildings the same range of ornamentation was pared down for use as decorative accents.

With the marked exception of Ely Jacques Kahn, Ralph Walker, Stiles Clements and Frank Lloyd Wright, very few architects concerned themselves directly with the content of the ornament applied to their buildings. The initial selection of decorative trim was usually left to the firm's draftsmen, for later approval. There are countless commercial buildings, factories and stores across the United States with terracotta and bronze ornamental friezes, spandrels and entranceways that are practically identical. Contemporary architectural reviews and trade journals provide the answer to their authorship. Manufacturers advertised portfolios of Modernist designs from which the architect could select any number of stock items with which to adorn his building.

The motifs were decidedly Parisian, covering the entire vocabulary of French ornament: stylized fountains, cloud patterns, sunbursts, tightly packed fields of flowers, chevrons, etc. By shuffling available patterns, one could create one's own "unique" design. Precise detail did not matter, for it was the color rather than the specific decorative components which provided the definition to the passer-by far below.

For most of the 1920s, terracotta was the most popular material used to decorate the exteriors of America's new buildings, its molded surface often glazed with a muted palette of greens, golds, browns and reds. Sometimes, it clothed the entire structure – most dramatically in Los Angeles, on the Richfield Oil and Eastern-Columbia Buildings; in New York, the McGraw-Hill Building, and, in Detroit, the roof of Albert Kahn's Fisher Building. On occasions, cast stone and plaster, often unglazed, were used as alternatives to

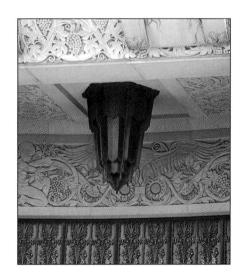

Mackenzie, Voorhees & Gmelin (architects): entrance detail, Barclay-Vesey building, corner of Barclay, Vesey, Washington and West Streets, New York, 1923-26. Considered ultra-modern by contemporary critics, the decoration on the terracotta frieze shown here looks distinctly Victorian in comparison to the angular ceiling fixture, which today appears far more advanced in concept.

ALBERS, *Anni Fleischmann*
b. 1899
Textile designer, graphic artist
Joined the Bauhaus weaving workshop in 1933 after an unsuccessful stint at the Hamburg School of Applied Art, where she designed wallpapers. She met Josef Albers, and the two were later invited to America by Philip Johnson. Her background at the Bauhaus provided the foundation for a career which blossomed after World War II, designing textiles, woodcuts and gouaches.

terracotta.

Toward 1930, however, architects began to comprehend that new building materials – specifically metal and glass – were more in harmony with new architecture than were traditional ones. Modern man's imagination was stirred now by the enormous tensile strength and brilliant sheen of steel, science's newest building aid. The age of metal began to phase out the terracotta and stone age in architecture, as it was doing in the decorative arts. As critic Philip N. Youtz noted in *The American Magazine of Art* in 1931, "The Empire State Building is a structure built of steel and designed in steel. The forms are a product of a twentieth-century imagination – not a memory from some previous century."

From the mid-1920s, Modernist architectural ornament gradually worked its way into every corner of the United States. New York's skyscrapers (and their decoration) were recreated in numerous small urban communities, to the chagrin of many, including Frank Lloyd Wright, who railed against the senselessness of large structures in sparsely populated areas. Regionalism played a surprisingly small part in the movement's growth; the same Parisian sunbursts and chevrons feature on factories in San Diego as on shops and banks in northern Michigan and Seattle. The KiMo Theater (Carl and Robert Boller, architects, 1926-27), in Albuquerque, New Mexico, provides a rare example of a direct regional influence, its colorful terracotta frieze fusing Pueblo and Navajo motifs on a Spanish Mission-style building **(4)**. Elsewhere, Frank Lloyd Wright incorporated abstract Mayan and Indian motifs into the designs of the concrete-block houses that he designed in the early 1920s in southern California **(5)**. Only in southern Florida – in particular, south Miami Beach – did an entire school of identifiable modern architecture emerge.

MODERNISM IN NEW YORK

In New York, the New York Telephone Company was the first to align itself with Modernist architectural decoration, retaining the firm of McKenzie, Voorhees & Gmelin (later Voorhees, Gmelin & Walker) in 1923 to design its corporate offices on West Street in lower Manhattan. Known now as the Barclay-Vesey, the building received considerable attention on its completion in 1926 for its massing and ornamentation, neither of which was thought to show any traces of historical influence **(6)**.

To achieve the desired effect, a beige cast stone was chosen to offset the building's darker brick façade. The decoration today is surprising, not only in its quantity, but because it was considered so modern and American at the time. A compact design of grape vines, fruit, plants, and game covers every cornice, arch, window sill, and lintel. The design now appears distinctly Renaissance, its profuse application Victorian. Not surprisingly, it did not become the wellspring of a subsequent American architectural Modernist movement.

McKenzie, Voorhees & Gmelin lost a great opportunity to introduce a modern design concept based on their clients' new field of telecommunications. The terrazzo mural panel in the lobby of the Telephone Company's later Newark Building portrays much more effectively, in the stylized bolts of electricity which radiate from Alfred E. Floegel's figure representing mankind's control of worldwide communications, the possibilities for a modern corporate style.

The brother of Rena Rosenthal (the pioneer Modernist gallery owner in New York) and the son of an Austrian-born importer of glass and mirrors, Ely Jacques Kahn established himself in the late 1920s as a brilliant architect and America's leading exponent of

ARGY-ROUSSEAU, *Gabriel*
1885-1953
Glassmaker, ceramist
Born in Paris as Joseph-Gabriel Rousseau, entered the National High School for Ceramics at Sèvres in 1902. Adopted his wife's family name after 1913 and became known as Argy-Rousseau. Best known for his work in *pâte-de-verre*, first exhibited in 1914; also developed the technique of *pâte-de-cristal*. Many examples of his work in

both techniques displayed at the salons in Paris in the 1920s, including the 1925 Exposition.

Argy-Rousseau: selection of *pâte-de-verre*, 1920s.

Modernist architectural design. Kahn attended Columbia University and the Ecole des Beaux-Arts, Paris, before joining a New York architectural firm, previously Buchman and Fox, in 1915. Within ten years Kahn, now Buchman's partner, was designing commercial buildings throughout the city. More than 30 were erected between 1925 and 1931. Kahn applied to these new structures a distinctly personal style of avant-garde decoration. The interplay of geometric motifs, which recur in his entranceways, elevator doors and mailboxes, is unmistakable. Each represents a fresh and vigorous interpretation of a common angular theme. Superior examples abound, among them being the Film Center, Squibb Building, Holland-Plaza Building, 2 Park Avenue, the Lefcourt Clothing Center, and 120 Wall Street embody only a few of his more spectacular entrances and lobbies **(7)**.

The most extravagant Art Deco façade in New York was that of the Stewart & Company Building on the east side of Fifth Avenue at 56th Street, now the site of the Trump Tower. The architects Warren & Wetmore conceived of a monumental entrance comprising six doors beneath a vast rectangular frieze flanked by two matching panels. The theme – to show that the building housed a series of women's specialty shops – had been common in Paris some years earlier: stylized draped nudes within lavish borders of tiered fountains, baskets of flowers and fruit, flights of birds, etc. A mixture of *repoussé* aluminum, polychromed faience and verdigris bronze brought the images sharply into relief, as revealed by the sun's rays or, at night, by a battery of lower, concealed lights.

For one brief and glorious moment in the early 1930s, the Chrysler Building soared above all others. Today it remains the period's most exhilarating structure and romantic symbol. Originally designed by William van Alen for William H. Reynolds, a

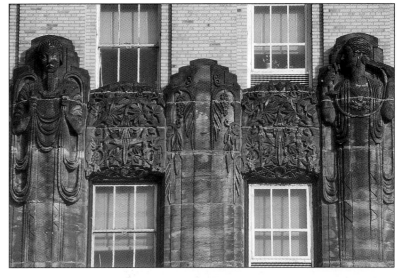

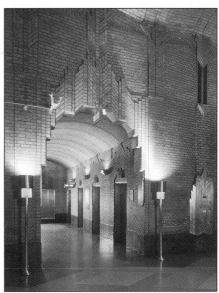

Above Voorhees, Gmelin & Walker (architects): terracotta frieze, New Jersey Bell Headquarters Building, 540 Broad Street, Newark, 1929; and (**right**) Ralph Walker (architects): lobby, Western Union Building, West Broadway between Thomas and Worth Streets, New York, 1928-30. Walker was responsible for the decorative detailing on the buildings constructed by Voorhees, Gmelin & Walker. These two illustrations, of designs completed by Walker at roughly the same time, suggest that for the New Jersey building he had to adhere to the style which his firm had introduced onto telephone buildings in 1923. His lobby for the Western Union Building is much more characteristic of his own preferred angular style.

ASPLUND, *Erik Gunnar*
1885-1940
Architect and furniture designer
Born in Stockholm, studied architecture at the Stockholm Academy of Art, and then went into partnership with Sigurd Lewerentz in 1913. From 1917 to 1920 he was editor of the journal *Arkitektur.* He showed a celebrated kitchen and living room at the 1917 exhibition of the Swedish Society of Arts and Crafts, and from 1924 he served on the Society's council. In 1921 he designed furniture and fittings for Stockholm City Hall, designed by Ragner Ostberg (1866-1945), and worked for the next eight years on the Stockholm City Library. He was the chief architect of the Stockholm 1930 Exhibition, which caused the widespread adoption of the modern functionalist style in Sweden.

ASPREY & CO
London firm of jewelers founded in 1781 by William Asprey. His son Charles worked with him, and in the 1830s opened a shop in New Bond Street. The firm, which won honors at the Great Exhibition in 1851 and gold medals in Paris in 1855 and 1862, still exists, manufacturing fine jewelry and silver.

ATELIER MARTINE see
POIRET, *Paul*

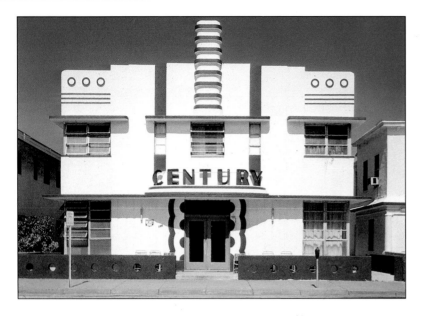

land developer, the initial plans were turned over to the new purchaser, Walter P. Chrysler, whose goal was nothing less than the world's greatest monument ... to himself, and, coincidentally, to capitalism. Just as Frank Woolworth had commissioned Cass Gilbert to design for him a building which would surpass both in height and architectural interest anything which had preceded it, so Chrysler's brief was for a building which would not merely scrape the sky, but pierce it. Its ornamentation was to be provocative, drawing discussion to the building, and, thereby, to Chrysler himself.

Stripped of its ornamentation, the building provides a characteristic example of late 1920s commercial architecture, one intended as a financial investment, with 77 floors of rentable space. Its massing, studied use of fenestration as an element of design, and surface treatment are similar to those of many buildings under

construction at the time. With its Modernist ornamentation, however, it became a classic. The excitement lies primarily in the seven floors that comprise the elongated dome, each of tiered arched form with triangular dormer windows enveloped in shimmering nickel chromed steel. Even today, surrounded by a host of taller midtown buildings, the dome still draws the eye unerringly. Below, the eagle gargoyles at the 59th floor recess and the winged radiator caps at the 30th level, enhance the novel effect, although neither amounts to more than a decorative fillip to the crown. The Chrysler Building generates an emotional response which allows the critic to forgive its excesses. Even those who found fault could not bring themselves quite to judge it as they would other buildings.

The Empire State Building rose on the west side of Fifth Avenue between 33rd and 34th streets, on the site previously occupied by the old Waldorf-Astoria Hotel. William F. Lamb, of the firm of Shreve, Lamb & Harmon, presented sixteen plans to the consortium of owners before consensus was reached in August 1929. Within 21 months, at a rate of roughly four-and-a-half stories per week, it was complete. The building achieves more than just height. It is an immensely skillful piece of massing, both dignified and serene, almost a natural wonder as much as a building, and one that passed quickly into folklore. It is not, though, as is commonly believed, a classic Art Deco structure. The building's Modernist ornamentation is restrained, even cautious, both in the lobby and its selection of cast aluminum spandrels on the exterior. The architects' brief was entrepreneurial: a profit-making building of which the size was carefully weighted against its optimum amount of rentable space. Ornamentation was not a priority, perhaps in part because it could not compete on a structure of such monumentality.

B

BACH, *Oscar*
1884-1957
Metalworker, furniture designer
Born in Germany, emigrated to the US in 1914 after being commissioned to design all the metalwork for the Berlin City Hall. He opened a studio in New York and received numerous private and commercial commissions, including many for liturgical work. He designed the chromed nickel and steel furniture for Raymond Hood's

office in the Daily News Building in New York, the interior metalware for the Chrysler and Empire State buildings, and executed four plaques by Hildreth Mayer for the exterior of Radio City Music Hall.

BACHELET, *Emile Just*
1892-?
Sculptor
First exhibited at the Salon des Artistes Français in 1920. Awarded a Gold Medal for his bas-reliefs designed for the Pavillon de Nancy at the 1925 Paris Exposition. Much of his sculpture was designed for manufacture in porcelain and terracotta.

The Chanin Building represented an even more self-congratulatory monument to individual success than the nearby Chrysler Building. Irwin S. Chanin, one of two sons of an immigrant from Poltava (in the Ukraine), had, like Chrysler in automobiles, built a substantial private fortune from scratch as an architect and land developer. Situated diagonally across from the Chrysler Building on Lexington Avenue and 42nd Street, the building "topped out" at 54 floors in just 205 days between January 3 and August 8, 1928. The exterior façade of the lower four floors and the interior, decorated by the Chanin design department headed by Jacques L. Delamarre in collaboration with the sculptor René Chambellan, was based on the theme of the "City of Opportunity".

There is no more impressive example of Modernist ornamentation than the bas-relief panels and radiator grills by Chambellan in the building's lobby. The Modernist theme continued throughout the building, in the store fronts on the ground floor, the entrance in the lobby to the Lexington Avenue subway, the Baltimore & Ohio Motor Coach Terminal on 42nd Street, the building's theater on the 50th floor, the general administrative offices and Mr Chanin's executive suite. The ornamentation throughout was French-inspired – except for the gates to the executive suite, for which the shameless capitalist theme was essentially Horatio Alger.

RAYMOND HOOD'S NEW YORK BUILDINGS

Following his Chicago Tribune triumph with John M. Howells, Raymond Hood turned his attention to a number of New York commissions, four of which bore distinct Modernist ornamentation. The first, the American Radiator Building at 40 West 40th Street, opposite Bryant Park, incorporated a bold black and gold brick

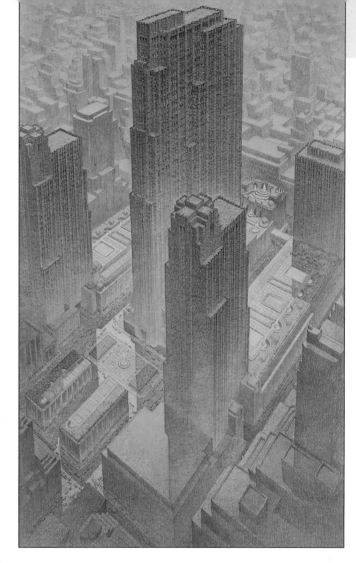

Opposite page Henry Hohauser (architect): Century Hotel, 140 Ocean Drive, Miami Beach. Most of the residential hotels on Miami Beach, such as this one, have recently been restored.

Above John Weinrich: perspective, the Rockefeller Center, 48-51st Streets between 5th & 6th Avenues, New York, New York. Pencil, pastel and gouache on board, c. 1931

BANG, Jacob E.
1899-1965
Glass designer, architect, sculptor
Began as an architect and sculptor after training at the Royal Academy of Fine Arts in Denmark. He became an important design influence while working with the firm of Holmegaards in Copenhagen, where his work was engraved primarily by the Swedish engraver, Elving Runemalm.

BARBIER, George
1882-1932
Graphic and poster artist, theater designer
Prolific and gifted artist, influenced by the Ballets Russes, developing a similar graphic style for fashion illustrations, theater set and costume design, posters, advertisements, magazine covers, etc., for which he often used the *pochoir* process. Illustrated many books on dance, e.g., *Dances de Nijinsky* (1913) and costumes for

the Folies Bergères and Casino de Paris. In the late 1920s he worked briefly in Hollywood. He died while at work on Louy's *Aphrodite*.

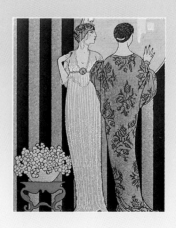

Barbier: *pochoir* for *Gazette du Bon Ton*, 1913.

color-scheme which emphasized the strong silhouette of the building's tower and craggy crown. Despite its lingering Gothicism, the building was hailed as a commercial breakthrough, in part because of the battery of floodlights which caused the crown to light up at night.

The Daily News Building on East 42nd Street shows a more mature Hood, well in touch with fashionable contemporary architecture. The commission called simply for a factory to house the Daily News' printing plant, but Hood saw the need to dress it in the modern idiom. The result was a simple, yet elegant, terraced skyscraper in which height was strongly emphasized by recessed vertical bands of windows and spandrels. The façade and lobby were ultra-modern, the latter paneled dramatically in black glass with a recessed central globe, a striking touch inspired by Hood's first visit to Napoleon's tomb in Paris.

For the McGraw-Hill Building, another factory-type structure to house the publishing company's offices, Hood, now in partnership with Andre Fouilhoux, switched gears again to create a horizontal emphasis achieved through the use of lateral windows, a technique which Walter Gropius had used in his Pagus factory 20 years earlier **(8)**. The McGraw-Hill Building brought Hood full circle from the historicism of the Chicago Tribune Tower and the American Radiator Building, through the Modernism of the Daily News Building, to a modified version of the International Style. No other contemporary architect showed such versatility, or bravery. Only his use of color (green terracotta shading to the paler azure blue of the sky at the top) and the publisher's name in bold capital lettering along the crown (reminding some of a monumental tombstone) set the slab-shaped building fully apart from the Internationalists.

Hood's fourth significant Modernist architectural project was Rockefeller Center, which he and Fouilhoux shared with two other architectural firms: Morris, Reinhard & Hofmeister, and Corbett, Harrison & MacMurray. Conceived in 1927 as the new home for the Metropolitan Opera Company, the project drew the participation of John D. Rockefeller, Jr, who helped to negotiate the lease of the land from its owners, Columbia University, and to develop the space around the proposed opera house for commercial use to subsidize the opera's operation. But the Depression, in addition to upheavals within the opera company's management, led to the latter's withdrawal from the project. Rockefeller was left with the three-block-long site (from Fifth to Sixth avenues between 48th and 51st streets) which he decided to develop as the nation's first large-scale, privately financed, mixed-use urban renewal project.

Rockefeller Center provides the Art Deco enthusiast with an infinitely rich array of 1930s Modernist ornamentation. The façades of the twin French and British buildings facing Fifth Avenue (the French Building was called La Maison Française and the British, Empire Building) are respectively enhanced with bronze sculptural friezes by Alfred Janniot and Paul Jennewein. Between these, both in the promenade leading to the plaza and in the plaza itself, there is bronze statuary by René Chambellan and Paul Manship, including the latter's *Prometheus*.

The RCA Building offers many further treasures, most particularly Lee Lawrie's polychromed triptych above the main entrance **(9)**, and Leo Friedlander's twin groups symbolizing Television which surmount the pylons flanking the building's south entrance **(10)**. A tour around the complex reveals other sculptural delights: for example, Hildreth Meiere's three plaques symbolizing the spirit of Song, Drama and Dance.

BARON, *Phyllis*
1890-1964
Textile designer
Began her studies at the Slade School of Art in London. Invited to join the Omega Workshop but chose to pursue the art of discharge printing in her own studio. Working after 1923 with her friend Dorothy Larcher, she formed a fruitful partnership which lasted until their deaths.

BASTARD, *Georges*
1881-1939
Dinandier
Born in Andeville, France. Georges Bastard came from a family of *tabletiers* (makers of chess- and checkers-tables), and began working in his father's *atelier* after studying at the Ecole des Arts Décoratifs. He worked in delicate materials — rare woods, mother-of-pearl, ivory, tortoiseshell, horn, rock crystal, and semi-precious stones —

producing small *objets d'art* such as fans, boxes and letter openers, often with carvings inspired by naturalistic forms. He collaborated with Ruhlmann and Montagnac on several pieces shown at the 1925 Paris Exposition, as well as showing his own pieces. In 1938 he was made director of the Sèvres porcelain factory.

BAUDISCH-WITTKE, *Gudrun*
1906-1982
Ceramist, textile designer, bookbinder
A member of the Wiener Werkstätte from 1926-30, and established her own ceramic workshop in 1930. She is noted for her textile designs and bookbindings as well as for her ceramic work.

Rockefeller Center's interior decoration is dominated by Radio City Music Hall, coordinated by Donald Deskey. As on the exterior, one is provided with works by the period's foremost avant-garde artists: Witold Gordon, Louis Bouché, William Zorach, Ruth Reeves, Stuart Davis, Yasuo Kuniyoshi, Edward Buk Ulreich, Henry Varnum Poor, Henry Billings, Ezra Winter and, most importantly, Donald Deskey himself.

Upstate New York boasts one major Art Deco monument, the Niagara Mohawk Building in Syracuse (Bley & Lyman, architects). Its exterior incorporates the entire Modernist vernacular: a symmetrical ziggurat form terminating in a stepped tower, a façade sheathed in sharply contrasting materials (brick ornamented with stainless steel and black glass), a strong sense of verticality throughout, all rounded off with an arresting sculptural figure which surmounts the entrance. A source of great civic pride on its inauguration in 1932, the building continues to provide a remarkable statement of the Modernist style. The interior decoration is limited largely to the lobby, which houses some streamlined chromium-plated and frosted-glass light fixtures, etched elevator doors, and a powerful set of machine-age Vitrolite panels by an unrecorded designer.

MIAMI BEACH AND THE MIDWEST

Nowhere in the United States did Art Deco architecture manifest itself with more uniformity than in Miami Beach. Incorporated in 1915 on an island bounded on the west by the intercoastal waterway and on the east by the Atlantic Ocean, Miami Beach emerged as an island paradise for those working-class people who could not meet the prices and exclusivity of its northern neighbor, Palm Beach. Following ruinous hurricanes and flooding in the late 1920s, a

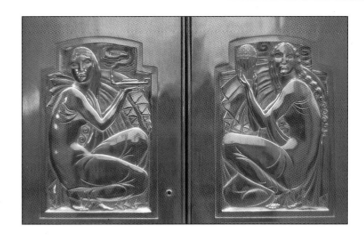

Above Cross & Cross (architects): detail of elevator doors, City Bank Farmers Trust Building, New York, 1929-31.

Below Attilio Piccirilli: "The Joy of Life", polychromed limestone panel, West 48th Street entrance, Rockefeller Center, New York, 1937.

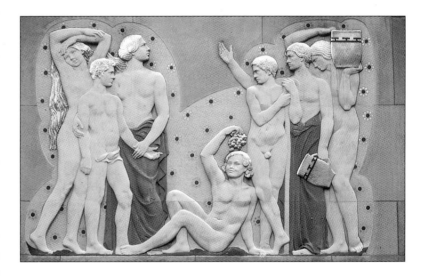

BAUMBERGER, *Otto*
1889-1961
Poster artist, lithographer
Born in Switzerland, educated in Munich, Paris and London, then established himself primarily in Zurich. Helped establish the Swiss School of Graphic Design before World War I. Worked as a lithographer for J.E. Wolfensberger, later becoming a partner in the firm. During World War II he designed theater posters, later stage sets.

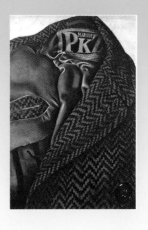

Baumberger: poster for PKZ, 1923.

new style of architecture appeared, one that joined the Modernist vision with the fanciful colors and idiosyncrasies of the subtropics. Confined roughly to a square mile in south Miami Beach between 5th and 23rd streets, a small city of holiday hotels and winter homes arose to lure a Depression-racked nation.

A distinctly regional architecture evolved (11). Not only were the buildings generally of the same height (none exceeds 12 or 13 stories), but basic elements recurred in various combinations from street to street. Most buildings show a crisply streamlined, horizontal line intersected in the center by a series of strong vertical lines culminating in a Buck Rogers-type finned tower or cupola (12). Diversity was provided by a marvelous range of subtropical pastels: white stucco alternating with pink, green, peach and lavender facades or trim. In recognition of their setting, windows were etched with flamingoes, herons, seashells, palms and, most significant of all, sunbursts. Neon lighting and flagstaffs completed the effect.

In the Midwest, following the Tribune Tower competition, Chicago played host to several Art Deco buildings at the end of the decade. The city's leading practitioners of the style were John A. Holabird and John Wellborn Root, Jr, the sons of two of the leading architects of the Chicago School. The pair teamed up after Holabird's partner, Martin Roche, died in 1927.

Breaking with Chicago's Beaux-Arts and Gothic classicism, Holabird and Root dressed several buildings between 1928 and 1930 in Modernist ornamentation, including the Palmolive Building,

Left Holabird & Root (architects): silvered-metal elevator doors, Daily News Building, 400 West Madison, Chicago, 1929. **Right** Albert Kahn (architect): General Motors Building, A Century of Progress Exposition, Chicago, 1933. **Opposite page** Wirt Rowland, in collaboration with Smith, Hinchman & Grylls, Associates, Inc. (architects): main lobby, Union Trust Company Building, corner of Congress and Griswold streets, Detroit, 1929. The lobby has a distinctly ecclesiastical flavor, in keeping with the building's sobriquet, "Cathedral of Finance."

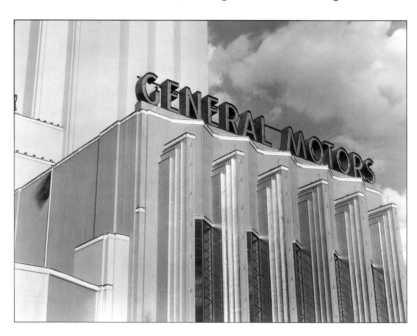

BEL GEDDES, *Norman*
1893-1958
Architect and industrial designer
Born in Michigan, attended the Cleveland School of Art and the Art Institute of Chicago before joining the Chicago advertising agency, Barnes-Crosby, as a draftsman. In 1918 he started a successful career in New York as a stage-set designer, and in 1927 he took up industrial design and opened his own firm. His early commissions (1929-32) were for domestic products such as furniture for the Simmons Co. (1929), counter scales for the Toledo Scale Co. (1929), and a range of gas stoves for the Standard Gas Equipment Corp. (1932). His prototype "House of Tomorrow" (1931) and his skyscraper cocktail shaker (1937) proved his adaptability to many design fields.

BELL, *Vanessa*
1879-1961
Painter, decorative arts designer
Sister of the writer Virginia Woolf and originally a painter, strongly influenced by the style of the French post-Impressionists. Through her association with the Omega Workshops (1913-19) she joined a group of artists in their attempt to bring a painterly style to the decoration of household furnishings. Her life after the Omega Workshops period was devoted to her residence, Charleston, which she shared with the painter Duncan Grant, and to work in a variety of media.

Bell: dinner service for Newport Pottery, 1934.

333 North Michigan, the Chicago Daily News Building, the Chicago Board of Trade Building and the Michigan Square Building. Of these, the Chicago Daily News Building (13) warrants mention not only because it has survived intact, but because it is enhanced with an unusually broad and spirited blend of Modernist art: in particular, the ceiling mural in the main concourse, entitled, "The Printing of the News," by John W. Norton. There is also sculpture – exterior fountain statuary and reliefs by Alvin W. Meyer – and striking Modernist elevator doors.

In the same year, the Michigan Square Building provided the architects with a forceful expression of Modernist design, especially in the building's central Diana Court, and its row of street-front stores. Directly across the Chicago River from the Daily News Building is the 44-story Chicago Civic Opera Building, completed by the firm of Graham, Anderson, Probst & White in 1929. The exterior is decorated at the recesses with rows of circular windows and balustrades. Elsewhere, the facade is decorated with charming pairs of stylized theatrical masks depicting Comedy and Tragedy.

The new Union Trust Building in Detroit stands unquestionably as America's premier Art Deco bank building, the theme and scale of its Modernist decoration justifying the sobriquet acquired when it opened in 1929, "Cathedral of Finance". The Union Trust Company had originally commissioned Smith, Hinchman & Grylls, Associates, to build their new offices, but the $12 million project was turned over to Wirt Rowland, who had dressed his most recent architectural commission, the City National Bank Building (the Penobscot) in Detroit, with Modernist ornamentation. The Union Trust Company, a new banking group anxious to project a concerned and public-spirited image, gave Rowland broad latitude to develop a decorative theme which would impart this message.

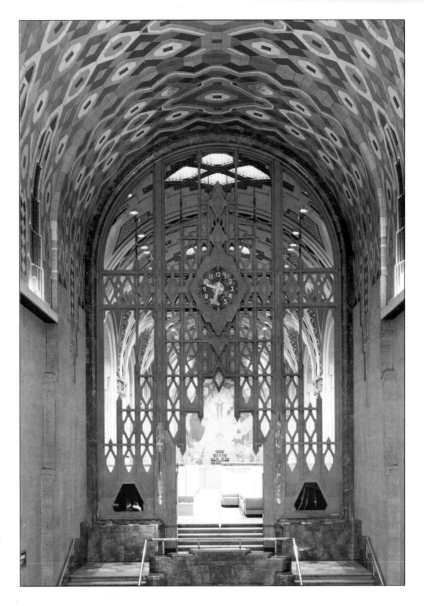

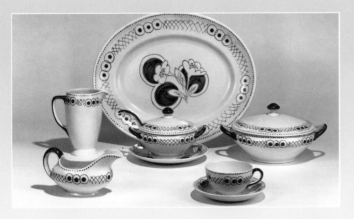

BELPERRON, *Suzanne*
Jeweler
Collaborated with René Boivin for ten years. Her creations were displayed at his shop in Paris. She also opened a boutique in Paris in the rue Châteaudun, called Herz-Belperron.

Belperron: chalcedony and pearl ring, about 1930.

blank

c

d

Rowland began at the front door, decorating its upper half-dome with a central figure symbolizing progress, flanked by three medallions representing Agriculture, Transport and Industry. On each side of the entrance were sculpted stone figures, one holding a sword to represent the banking institution's power, and the other a key to signify its security (the latter an ill omen, as quickly became evident). The arch above the side entrance on Congress Street continued the theme with a tiled beehive (to symbolize Thrift and Industry), an eagle (representing Money), and a caduceus (representing Authority and Commerce).

Within the building, the main lobby's vast vaulted ceiling repeated the beehive theme in bright Rookwood ceramic tiles. Imported Travertine marble columns, Mankato stone, Belgian black marble, and red Numidian marble walls compounded a kaleidoscopic effect further set off by the glistening Monel metal elevator doors, cashier desks, and trim, and a vast Monel ornamental grill centering a star-shaped clock **(14)**.

Within six months of the building's completion, the Union Trust Company failed in the wake of the stock market crash. The Company reorganized in March 1930, under the name of the Union Guardian Trust Company. In 1949, following a second bankruptcy, the building was sold at public auction to the Guardian Building Company of the Michigan Corporation.

Kansas City has, until very recently, been America's unheralded Art Deco center. Unlike St Louis – which is fundamentally a nineteenth-century city – Kansas City underwent a building boom in the 1920s and 1930s. The result has provided a bonanza for Art Deco devotees: a wide range of well-preserved architectural elements on parking garages, apartment houses, and commercial and municipal buildings. The prize is the Kansas City Power and Light Co. Building, which has retained its spectacular illuminated tower and almost all the metalware in its lobby. Kansas City's real Art Deco charm, however, lies in the scores of glazed terracotta friezes which adorn its commercial buildings. It is extraordinary, considering the attrition rate of similar factories and shops across the country, how many have survived.

Two further Midwestern Art Deco masterpieces, erected at the same time in Cincinnati, have had a far less certain road to survival. The Union Terminal, designed by Fellheimer & Wagner, is today a makeshift shopping mall, the vast sweep of its rotunda playing host to similar projects since the station closed in 1972. Built to consolidate Cincinnati's railway system under one roof (the city had been serviced by five separate stations until that time), the terminal's exterior has an ascetic grandeur that touches on the International Style. A host of decorative elements awaits the traveler on the inside, however – a tea room paneled in ceramic tiles from the local Rookwood Pottery, a mosaic mural by Winold Reiss, terrazzo floors, and a women's lounge adorned with tooled leather walls by Jean Bourdelle. Machine Age chromed furnishings and accessories rounded off the sparkling 'moderne' look **(15)**.

The other Cincinnati Art Deco landmark achieves an entirely different effect. Part of the Carew Tower, designed by Walter Ahlschlager of Chicago, and Delano & Aldrich, associate architects from New York, as one of America's first multi-purpose commercial buildings, the Starrett Netherland Plaza Hotel shared its block-long quarters with two large department stores, a garage, a restaurant, and business offices. The hotel's interior, recently restored, reflects a jumble of styles **(16)**. Art Deco predominates among an eclectic mix of Beaux-Arts Rococo and Egyptian Revival themes. The Art Deco decoration was plucked unashamedly from

BENEDICTUS, *Edouard*
1878-1930
Tapestry and rug designer
Trained as a painter, later undertook decoration and finally turned to tapestry. He executed designs for Tassinari, Chatel, Brunet, Meunier & Co. and others, as well as various rug designs.

BERNARD, *Joseph-Antoine*
1866-1928
Sculptor
One of France's foremost sculptors of the early twentieth century, exhibited steadily at the Paris salons. His first entry, a plaster model entitled "Hope Conquered," was included at the salon of 1893. He was recognized for his ability to infuse his dancing figures with a vibrancy and life, and his work was so highly regarded in the

1920s that he was asked to design one of the reliefs of dancers for the Pavillon des Collectionneurs at the 1925 Paris Exposition, as well as being given his own exhibition area.

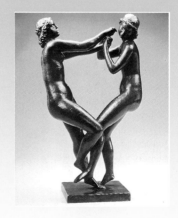

Bernard: bronze group of two dancers, early 1920s.

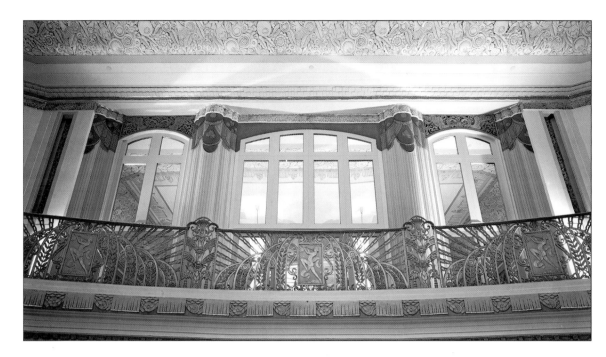

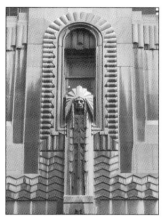

Left Walter W. Ahlschlager, probably in collaboration with decorator George Unger: Carew Tower balcony, Cincinnati, 1921. **Below** Wirt Rowland: stone relief, Penobscot Building, Detroit, about 1929.

1925 Paris; designs by Edgar Brandt, in particular, are repeated in balustrades, chandeliers, and the molded borders on the Rococo-style ceiling murals. The Continental Room, the Hall of Mirrors, and the Palm Court are replete with replicas of high-style French *art moderne*.

Another surviving Midwest gem is the Circle Tower in Indianapolis, its stepped-pyramid shape conforming to the city's 1922 zoning law. The limestone entrance frieze is sumptuously ornamented with a profusion of carved botanical motifs, including bellflowers, vines and sunflowers, encompassing a pierced-bronze overdoor cast with a stylized Egyptian scene of pharaohs, courtiers and beasts. The elaboration continues inside the lobby. Cast-bronze elevator doors, plaques, screens, and reliefs, all Art Deco, contrast with alternating gold-veined black marble and plain black marble walls and a floor adorned with gray-green, cream and black terrazzo chevrons.

Like Kansas City to its north, Tulsa, Oklahoma, boasted numerous Art-Deco-inspired buildings. The seven-story Halliburton-Abbott department store building of 1929 (Frank C. Walter, architect) incorporated along its cornice a brightly colored band of scrolled foliate panels in terracotta **(17)**; the plaster moldings on the building's interior repeated the stylized Parisian theme. Known also as the Skaggs Building, the Halliburton-Abbott was recently torn down.

BERNHARD, *Lucien*
1883-1972
Poster and graphic artist, architect, designer
Born in Austria, studied at the Munich Academy, establishing himself as a versatile artist-architect. Designed furniture, rugs, textiles, packaging, light fixtures and buildings. His first posters are c1903 and he pioneered advertising concepts in poster design. He emigrated to the US in 1923, where he worked as an interior designer while retaining his Berlin studio, Bernhard-Rosen. He was co-founder of Contempora, a group of European Modernist designers working in New York.

BESNARD, *Jean*
1889-1958
Ceramist
Studied folk pottery and produced folk-inspired wares with highly idiosyncratic glazes, most noted for his development of the "lace" glaze on pottery.

Besnard: white-glazed pottery vase, about 1925.

THE WEST COAST

On the West Coast, Los Angeles's grandest Art Deco building, both by day and under floodlights at night, was the Richfield Oil Building (known now as the Atlantic Richfield Building) at 6th and Flower Streets **(18)**. Begun in 1928 by Morgan, Walls & Clements, the 13-story structure was surmounted by a double recessed tower, itself topped by a 130-ft beacon tower. The building's novel aesthetic impact lay in the architect's decision to sheathe it in glazed black terracotta intersected by vertical terracotta gold ribbing. A band of gold winged figures along the parapet, symbolizing motive power, by the sculptor Haig Patigian, and a matching stepped frieze above the entrance rounded off the highly contrasting and opulent effect. The lobby provided a further splurge of color: a bank of decorated bronze elevators alternated with Belgian black marble walls trimmed in Cardiff green beneath an additional colorful composition on the ceiling. Tragically, the building was demolished in the late 1960s.

Most of Los Angeles's other Art Deco masterpieces have survived, though some only barely. Two broad categories – the "zigzag moderne" of the 1920s, and the "streamline moderne" of the 1930s – are today used to describe the range of stylistic variations which evolved. The former describes the modern, largely vertical, building with recesses, which originated on the East Coast; the latter a horizontal structure with rounded corners and curved projecting wings and parapets, to which glass bricks and portholes were often added to provide an increased sense of movement and aerodynamics.

Notable zigzag-moderne structures include the Los Angeles City Hall, the Central Library, the Selig Retail Store, the Eastern-Columbia Building **(19)**, the Pantages and Wiltern theaters, the Guaranty and Loan Association Buildings, the Oviatt Building, and the Bullocks Wilshire department store. The last two merit special mention as they both took their inspiration directly from Paris.

James Oviatt, the President of the Alexander & Oviatt clothing store, spent six months of each year in Europe purchasing new fashion lines. While there in 1925, he visited the Exposition Internationale. Greatly impressed by what he saw, he summoned his store designer, Joseph Feil of Feil & Paradise, to Paris, where together they spent two months planning the decorative elements of the building which was erected three years later at 617 South Olive. They retained René Lalique and the decorating firm of Saddier et fils to assist in the decoration. Lalique responded to his only recorded California commission with designs for the entrance lobby – grillwork, elevator doors, mailbox, and an illuminated glass ceiling similar to his ceiling for the Sèvres Pavillon at the Paris Exposition **(20)**. Saddier et fils furnished the store's interior (and Mr Oviatt's penthouse on the top of the 13-story building). Unsurprisingly, a distinct French flavor prevails, not least in the penthouse bar, which includes a duplicate set of the bar-room stools which Saddier had introduced at the 1927 Salon of the Société des Artistes Décorateurs in Paris.

The co-founder of the Bullocks Wilshire department store, P. G. Winnett, also visited the Paris Exposition in 1925, returning to Los Angeles with a determination to model his intended new store in the Modernist idiom. Contemporary artists were commissioned to decorate it. The building has survived in its original condition, providing for today's historian a rare encyclopedic record of 1920s avant-garde art.

Examples of the 1930s streamline moderne in Los Angeles include the Pan-Pacific Auditorium, the Coca-Cola Bottling

BINDER, *Joseph*
1898-1972
Poster and graphic artist, painter
Born in Austria, studied at the School of Arts & Crafts, Vienna. Established his own studio in 1924, designing posters and packaging for a tea and coffee importer. He moved to the US in the early 1930s, where he taught graphic design. In 1935 he became a freelance artist and graphic designer in New York, while continuing to teach. He is known especially for his poster for the 1939 New York World's Fair.

Binder: poster for the New York World's Fair, 1939.

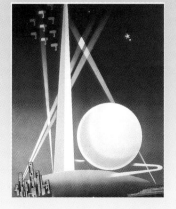

BLACK, STARR & FROST
Firm of goldsmiths and jewelers founded as Marquand & Paulding in Savannah, Georgia, in 1801, becoming established in New York City under its present name in 1876. Its several business partnerships included a merger with the Gorham Corporation in 1929. Over the years the firm has maintained a stock of imported jewelry and precious objects.

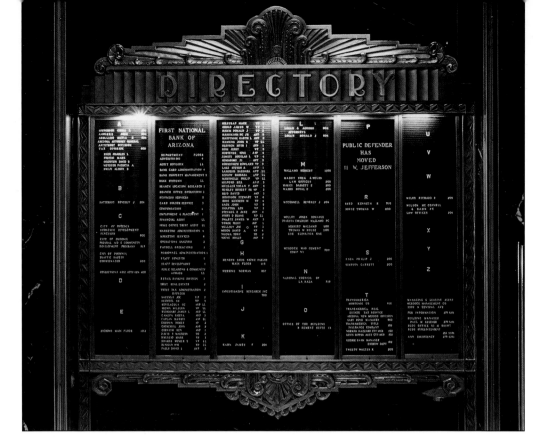

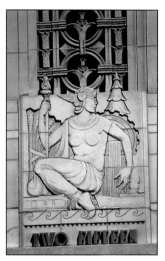

Left Lescher & Mahoney (architects): directory, Title & Trust Building, corner West Adams & 1st Avenue, Phoenix, Arizona, 1931; and (**below**) architect unidentified: terracotta relief, 215 West 7th Street, Los Angeles, about 1929.

Company plant, the California Petroleum Service Station (on Wilshire Boulevard) and a host of now forgotten roadside diners. The Union Railroad Terminal provides an unusual blend of streamlined modernism with Spanish Colonialism.

In San Francisco, the movement found a most gifted disciple in Timothy L. Pflueger, of the architectural firm of J. R. Miller & T. L. Pflueger. Pflueger designed several important commissions in the new idiom, in particular the Medical and Dental Building at 450 Sutter Street (**21**). The architect's choice of a stylized Mayan theme to decorate a medical center seems highly inappropriate today, yet contemporary critics did not question this. What was found newsworthy was the use of broad bands in incised hieroglyphics to span the building between its rows of windows, providing the effect, from a distance, of a giant woven tapestry. The entrance and lobby repeated the theme in tones of golden brown (**22**).

The Luncheon Club in the San Francisco Stock Exchange was a further commission for Pflueger (**23**). This time the effect was strongly Parisian; the room's furniture and pilasters incorporated broad reeded supports and capitals terminating in scrolls in a manner suggesting certain pieces by Süe et Mare some years earlier.

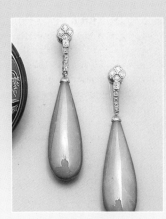

Black, Starr & Frost: diamond and coral earrings, about 1923.

BLONDAT, Max
1879-1926
Sculptor

One of the artists who successfully made the transition between the Art Nouveau and Art Deco styles. He exhibited at the salon of the SAF from 1911-14 and from 1920-25. He was responsible for many public projects such as fountains, memorials, tombs, portraits and allegorical representations. He was awarded the Légion d'Honneur in 1925. Aside from his public commissions, he also excelled in decorative design, and was represented at the 1925 Exposition by two lunette-shaped reliefs for the dining room of the Pavillon de l'Ambassade.

MOVIE THEATER ART DECO

Pflueger's most celebrated architectural achievement was the movie theater he designed for Paramount-Publix, a giant studio-theater chain, across San Francisco Bay in Oakland. Ground-breaking began in December 1930. The Oakland Paramount matched, in its massive scale and splendor, any movie palace built. The theater's management claimed innumerable additional records for the Paramount's interior, but in reality it was no larger or more spectacular than the other movie-palace giants.

The local movie theater provided most of the American population with its only first-hand exposure to the modern style. It was not by accident that in the 1920s such theaters were termed "movie palaces". Aware that most of the working class eked out a drab livelihood far beneath the American dream, owners erected glittering theaters across the nation as a palliative to life's daily grind. Here one could retreat for an hour into a fantasy world portrayed on the silver screen, propeled along the way by the most lavish and exotic surroundings conceivable.

Extravagance became the keynote to 1920s theater design. To this end the entire building – its façade, marquee, entrance vestibule, lobby and auditorium – was transformed into a palatial fairyland. Designers switched from one national style to another

Right and opposite page S. Charles Lee (architect): auditorium and entrance with ticket booth, Wiltern Theater, 8440 Wilshire Boulevard, Los Angeles, 1929. Like almost all of the giant movie palaces built in the late 1920s, the Wiltern gradually slipped into disrepair until it had to be vacated. Following the example of the Pantages Theater, in nearby Hollywood, the Wiltern has recently been fully restored to its original splendor, and is under consideration as the new home for the Los Angeles Philharmonic orchestra.

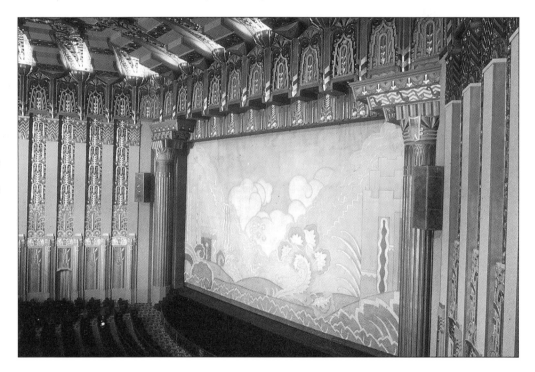

BONET, *Paul*
b. 1889
Bookbinder
Born in Paris, studied at Ecole Robert-Estienne under Desmules and Giraldon, with extra instruction from gilder Jeanne. First exhibited at Exposition du Livre (1925), then Salon d'Automne and Société des Artistes Décorateurs. Collector Carlos R. Scherrer, of Buenos Aires, became his most important patron, also Doucet.

He developed new photograhic and sculptural binding techniques in the 1930s, and pioneered the use of new materials such as duralumin. Major works included *La Belle Enfant* and *Calligrammes*.

BONFILS, *Robert*
1886-1971
Designer, poster and graphic artist, bookbinder
Born in Paris, emerged as one of the most versatile French Art Deco designers, producing a wide range of works on canvas and paper and designs for textiles and ceramics. One of three artists commissioned to design the official posters for the 1925 Paris Exposition.

with equal facility. The actual theme of the decor did not matter, only the degree to which it was romantically applied. Movie theaters were designed as the Alhambra, Granada, Tivoli and Coliseum. Others, such as the Avalon, Palace, Paradise and Ritz, offered an equally grand, but less specific, flight into fantasy.

To the theater manager, the arrival of the Modernist idiom, based on the prevailing French Art Deco style, simply meant that there was another choice in his decorative vernacular. That it was modern mattered considerably less than that it was lavish. Architects and impresarios such as Marcus B. Priteca and S. L. ("Roxy") Rothafel oversaw the decoration of theaters in which every available inch was crammed with Modernist Parisian motifs – chevrons, tiered fountains, bouquets of summer flowers, sunbursts, and so on.

Foremost among these were the Pantages and Wiltern, both in

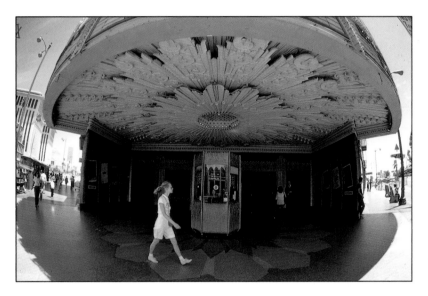

Los Angeles, and the Paramount in Oakland, all recently restored to their former splendor. Others equally exuberant were the Uptown Theater, Philadelphia (24), and the Fox Detroit Theater, Detroit. Less gaudy examples included the State Theater, Philadelphia; the Pickwick Theater, Park Ridge, Illinois (25); the Paramount in Aurora, Illinois; the Fox in Brooklyn; the Avalon, Catalina Island, California, and the St George Playhouse, Brooklyn (26).

It was the advent of the sound motion picture, or "talkie," that paved the way for Modernism, rather than any disenchantment by the public with period interiors. The attempt to re-create historic settings had led earlier to the "atmospheric interior," in which buildings – palaces, temples, etc. – were reproduced in plaster around the circumference of the auditorium. The entire façade of a Florentine palace, replete with balustraded balconies and niches enclosing statuary, gave the audience the impression of sitting down in the heart of Tuscany. The protruding walls of the make-believe palace tended to create acoustic problems, however, and "atmospheric interiors" were suddenly regarded as encumbrances: trappings of the silent motion picture era which was itself facing extinction.

Streamline moderne movie-theater design emerged gradually in the 1930s. Some of the designers who had earlier created the elaborate historical interiors, such as John Eberson and the Rambusch Decorating Company, switched readily to the new idiom. Decoration became more restrained. Emphasis was placed increasingly on curvilinear forms, as exemplified by the stepped contours of the auditorium in Radio City Music Hall and, ultimately, the bold sweep of Eberson's Colony Theater in Cleveland. Black glass, mirror and chromium-plated sheet-metal paneling provided the new mood.

BOUCHERON, *Frédéric*
Jeweler
Opened his first jewelry store at the Palais Royale in 1858, and soon acquired fame as a fine technician and a creator of beautiful designs. In 1893, he was the first jeweler to set up shop at the Place Vendôme, where he continued to serve the social élite, and where the firm still operates successfully today. Over the years, the Maison Boucheron opened branches worldwide, and

the London store, established in 1907, is still flourishing.

Boucheron: brooch in jade, diamonds and onyx set in platinum, about 1925.

SCULPTURE

Within the discipline of 1920s and 1930s sculpture, the category of chryselephantine (bronze and ivory) statuary, has become synonymous with the term "Art Deco." Active throughout Europe, chryselephantine sculptors worked primarily in Paris and Berlin, where two very distinct styles evolved.

Ivory had been readily available in Europe as an inexpensive material for carving since the late nineteenth century, when the Belgian Congo was opened up and the colonial government pushed to develop it as an income-producing export. The 1897 Colonial section of the Brussels Exhibition in Tervueren, near Brussels, is credited with the first official public display of modern chryselephantine sculpture. The term had previously referred to the gold and ivory statues, often embellished with precious and semi-precious stones, produced by the ancient Greeks. The sculpture produced in Paris and Berlin during the 1910s, 1920s and 1930s imitated the classical models **(1).**

BRONZE AND IVORY SCULPTURE

Demêtre Chiparus is considered the French master of bronze and ivory sculpture, choosing as his subjects the gods of contemporary society rather than the gods of Olympus. Ida Rubenstein and Vaslav Nijinsky of the Ballets Russes became the models for his "Russian Dancers;" two cabaret performers popular in Paris at the time inspired "The Dolly Sisters," and a chorus line of cabaret girls in catsuits was transformed into his five-figure group, "The Girls."

Many similar examples by Chiparus reflect the interest in the French capital at the time in the Orient – Bakst's costumes, Poiret's dress designs, and the night clubs and dance crazes of the new Jazz Age.

Chiparus designed on a fairly large scale. His forte lay less in the quality of his carving than in the jewel-like surface treatment applied to the bronze costumes of his figures. He was careful in his choice of ivory for limbs and faces, however, to insure that its grain followed the natural line of their features in order to increase the realistic effect which he sought. Figures were mounted on interesting bases, the shapes of which became a vital part of the entire sculptural composition. Some of these were inset with bronze plaquettes cast with figures that echoed the pose of the sculpture above.

Very few – if any – of these figures were unique, although editions of the larger, more elaborate, models were probably limited. Chiparus's pieces were produced by foundries and manufacturing houses who likewise marketed ('edited') the work of his contemporaries. The Parisian firm of Etling is thought to have edited his early works, and the LN & JL foundry his later works. As with "Dancer of Kapurthala," models were produced in two or more sizes, or in a variety of materials, to accommodate a range of expenditures. In contrast to today's values, ivory in the 1920s was less expensive than bronze, so the more it was included in a model, the less expensive the finished piece was likely to be.

BOURAINE, *Marcel*
Sculptor
Mainly self-taught, and one of the most prolific artists of the period. He modeled a variety of mythological female figures, and a selection of his stylized animals designed as bookends and small paperweights was marketed through Alfred Dunhill in New York.

Bouraine: white marble figure of a nymph, about 1925.

BOUY, *Jules*
1872-1937
Furniture and lighting designer
Born in France, and went to the US in 1913. During the 1920s he produced furniture for Alavoine and Co., and was the manager of Ferrobrandt, Edgar Brandt's New York office. He is best known for metal lamps and furniture with skyscraper motifs.

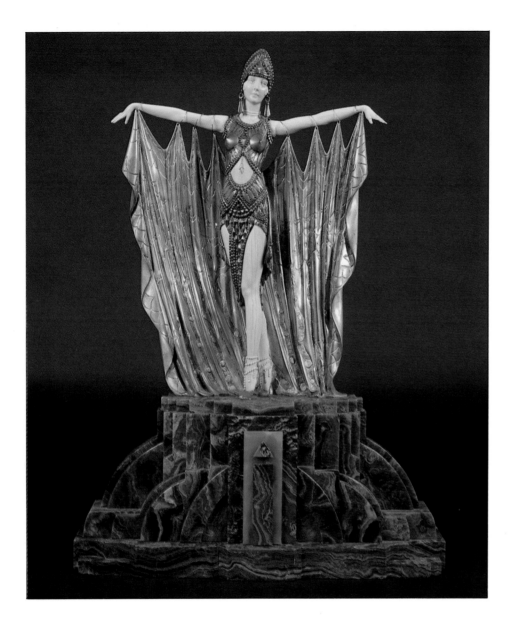

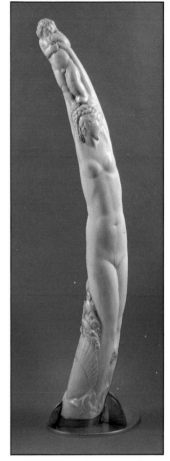

Left Demêtre Chiparus: "Semiramis," a rare silvered gilt and cold-painted bronze and ivory figure of an Assyrian Queen. Height 26½in, including onyx base signed "Chiparus." **Above** Emile Just Bachelet: "Venus et L'Amour," a carved ivory tusk, height 48½in.

BRADEN, *Norah*
b. 1901
Ceramist
Studied at the Royal College of Art, London and worked with Bernard Leach in 1925 before assisting Katharine Pleydell Bouverie in her production of wood-ash-glazed pots.

BRANDT, *Edgar*
1880-1960
Wrought-iron worker
Born in Paris. He studied technical and scientific subjects, and designed and made jewelry and wrought-iron work before opening his *atelier* in 1919. He produced his own designs, but primarily executed the work of other designers. Brandt was a major contributor to the 1925 Paris Exposition, with his own stand. In 1926 he was commissioned to do the ironwork for the Cheney building in New York City, and shortly after opened Ferrobrandt, his New York branch. Among his other important commissions were the ramp for the Mollien staircase at the Louvre, the gate for the new French Embassy in Brussels and the Eternal Flame for the Tomb of the Unknown Soldier in Paris.

Edgar Brandt with Daum frères: wall sconces, wrought iron and glass. 1920s.

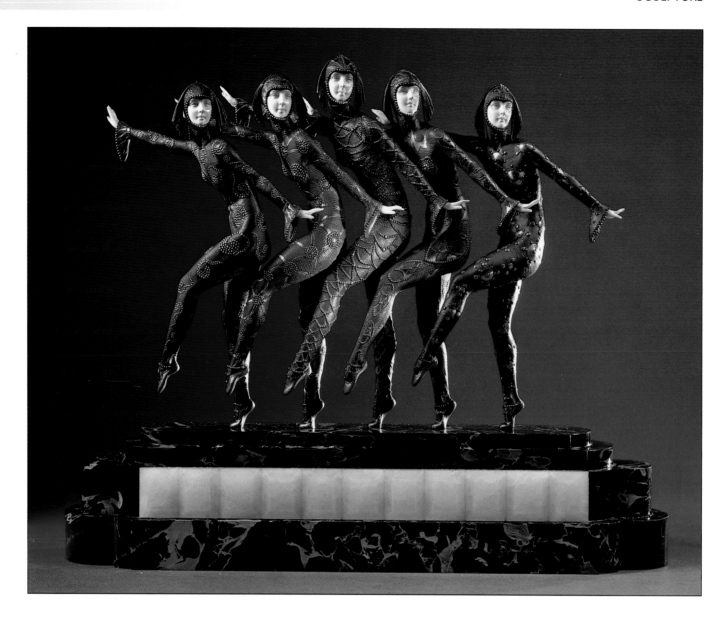

BRANDT, *Marianne*
1893-1983
Metalworker
Born in Germany, studied at the Bauhaus from 1923-28. In 1924 she worked with Moholy-Nagy in a metal workshop, designing prototypes of everyday objects for industrial production. In 1928-29 she worked with Gropius on the Dammerstock housing project, and from 1929-32 she designed metal objects for Ruppleberg in Gotha. After the war she taught at the High School of Applied Arts in Dresden, and from 1951-54 in Berlin at the Institute of Applied Arts.

BRANDT, *Paul-Emile*
Jeweler
Swiss born, moved to Paris, where he studied under Chaplain and Allard, and designed and made significant pieces of jewelry and *objets d'art* in the Art Nouveau style at the turn of the century. After World War I, he turned to the geometric motifs and chromatic contrasts that characterize the Art Deco style.

Paul Brandt: clips in diamond, onyx, platinum and white gold, about 1925.

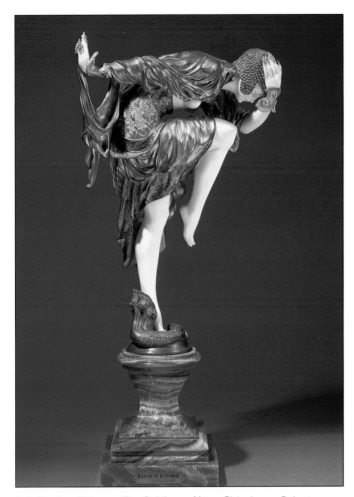

Left Demêtre Chiparus: "The Girls," a gilt and cold-painted bronze group of a chorus line, height 24½in including base, signed "DH. Chiparus" and inscribed "ETLING.PARIS".

Above Claire Jeanne Roberte Colinet: "Ankara Dancer," a gilt and cold-painted bronze and ivory figure of a snake charmer, early 1920s, height 24in. Inscribed "C.J.R. Colinet" and stamped "42."

As the foremost sculptor working with bronze and ivory, Chiparus produced few works in inferior materials. The same applied to Claire Jeanne Roberte Colinet, a Belgian sculptress active in Paris, whose styling and choice of subject matter were similar to those of Chiparus, but whose costumes and drapery were rendered in a far more fluid style. Her pieces depicted exotic figures and dancers associated with countries such as Egypt, Mexico and Russia, rather than those associated directly with the theater and cabaret popular in Paris at the time.

Alexandre Kéléty is another sculptor whose quality of design was impeccable. He modeled smaller-scale works, specializing less in the use of bronze and ivory than in exotic techniques for treating the bronze, such as damascening, a method much used in the Middle East (the name is derived from Damascus). This involves inlaying a precious metal into the surface of a base one in a decorative pattern – for example, flowers into the hem of a gown. Maurice Guiraud-Rivière and Marcel Bouraine also worked both with bronze and ivory, and with metal alone. The house of Etling, which edited most of the better models created by these artists, appears to have cornered the top end of the market for decorative sculpture.

The sculptor Max Le Verrier also edited a wide selection of *objets d'art*, employing noted sculptors and designers to produce inexpensive decorative items such as ashtrays, bookends and perfume burners made of inexpensive materials or alloys. These were then marketed through his shop at 100 Rue du Théâtre. Sculptors working for the house of Le Verrier included Fayral, Janle, Laurent, Derenne, Bouraine, Le Faguays, Charles and Guerbe. Several, such as Bouraine, provided models for both the Le Verrier and Etling foundries **(2)**.

BRANGWYN, *Sir Frank*
1867-1956
Painter, ceramic and textile designer
Englishman who worked for William Morris and is best known for his large decorative schemes. He began designing tablewares for Royal Doulton in 1928. His 1926 murals for the House of Lords were rejected, but he continued to design ceramics, as well as carpets by James Templeton & Co. and Alexander Morton & Co.

Examples of his works can be seen in London at Skinners' Hall, the Royal Exchange and Lloyd's Register, and in New York at Rockefeller Center. He was knighted in 1941.

Brangwyn for Wilkinson Pottery: pottery charger, painted by Clarice Cliff, about 1933.

In Berlin, Ferdinand Preiss and his company Preiss-Kassler controlled the production of bronze and ivory sculpture. The workshop opened in 1906 as a partnership between Preiss and Arthur Kassler. In 1910, the firm added Robert Kionsek of the Gladenbeck foundry in Berlin, and two ivory carvers from Erbach, Ludwig Walther and Louis Kuchler. In 1929, the company expanded further in its acquisition of Rosenthal und Maeder, a rival firm that monopolized the talents of certain designers.

Preiss himself designed most of the models produced by his firm. Early works, small in scale, were of classical figures. The firm closed during World War I, to reopen in 1919, when its style began to shift away from the classical toward the depiction of contemporary children, acrobats, dancers and athletes, for which it is now best known. As with their French counterparts, these figures often represented well-known personalities. For example, Preiss's dancer holding aloft a blown-glass beach ball is Ada May, a member of C. B. Cochran's revue *"Lighter Than Air."* Likewise, many of the athletes were modeled after Olympic stars, such as the ice skater Sonja Henie.

Among the artists who provided models for the Preiss-Kassler firm were Paul Philippe, "Professor" Otto Poertzel, R. W. Lange, Harders and, surprisingly, the avant-garde artist Rudolf Belling. The styling of each of these artists' work was in such harmony with the existing PK style that it is often virtually indistinguishable. This applies particularly to Poertzel. "The Aristocrats" and "Butterfly Dancers" models, for example, have been known to carry both his and Preiss's signatures. Whereas there are slight differences between the two versions, these are so minor that it was widely assumed until recently that Preiss and Poertzel were one and the same man **(3)**.

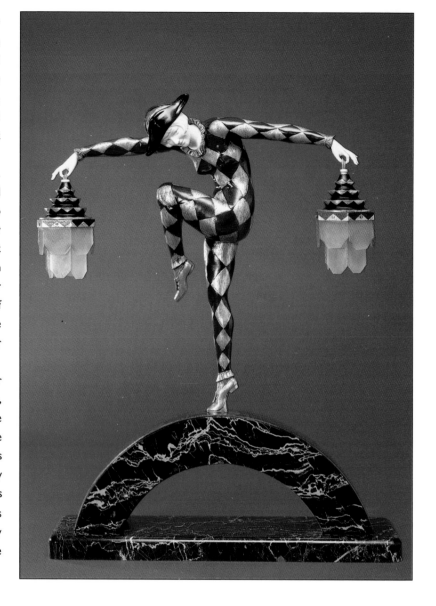

BREUER, *Marcel*
1902-81
Architect and furniture designer
Born in Hungary, spent a brief period in Vienna before moving to the Bauhaus in Weimar in 1920, where he specialized in furniture. From 1925-28 he taught at the Bauhaus in Dessau as head of the furniture workshop. He designed his famous Wassily chair in 1924 and a modular system of storage furniture the following year. In 1928 he set up private practice in Berlin. In 1928 he designed the Cesa chair, his own enormously successful version of the cantilevered chairs pioneered by Stam and Mies van der Rohe. He went to America in 1927 and worked as an architect in partnership with Walter Gropius until 1941. He was a professor of architecture at Harvard from 1937 to 1947.

BUQUET, *Edouard Wilfred*
Lighting designer
Although his name was unknown until fairly recently, his "Anglepoise" lamp, for which he received a patent in 1927, was ubiquitous, being used by Breuer, Sognot, Le Corbusier, Ruhlmann, Joubert et Petit, Coard and numerous other designers and decorators. The design, which was practical and adaptive, was done in wall, table and floor models of various proportions, each handmade except for the base.

Buquet: floor lamp, chromed metal.

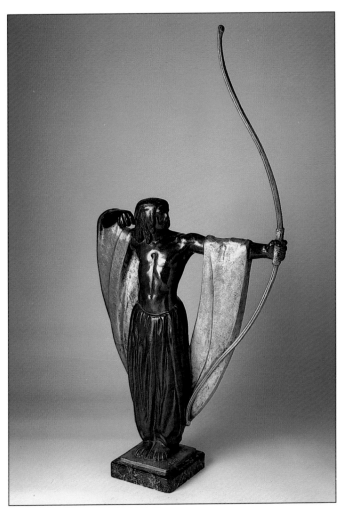

Whereas Chiparus concentrated mainly on the posture and intricate finishing of the bronze-work on his figures, the Berlin makers were concerned more with the quality of the ivory carving. An adaptation of Achille Collas's pantograph enabled the carved ivory detailing on these figures to be duplicated almost exactly, even down to the expression on a figure's face and the angle of its fingers. Figures were assembled like puzzles along a central core pin. As in the French technique, the surface of the bronze was chased and then cold-painted. The costumes on Preiss's figures required far less chasing, however; emphasis was provided instead by soft cold-painted metallic lacquers, often shaded to provide depth. The ivory faces of the models were also painted naturalistically, and the hair stained.

The most popular period for these bronze and ivory statuettes was 1931–36 **(4).** They were marketed in Great Britain through the Phillips & MacConnal Gallery, which included a selection in an Ideal Homes Exhibition held at that time in London's Olympia Exhibition center. It is interesting to note that the firm's brochure listed Preiss's birthplace as Vienna and his first name as Frederick, a marketing ploy geared to circumvent the anti-German sentiment in Great Britain following World War I **(5).**

Austria, specifically Vienna, developed its own style of bronze and ivory statuettes and small decorative bronzes. These represented a marriage of the French and German styles – a combination of the more theatrical poses of the French and the softer surface treatment and scale of the Germans. Viennese artists such as Lorenzl Gerdago, and Schmidtcassel provided representative examples.

Bruno Zach was another Austrian sculptor active at the time, one whose work was more overtly erotic than that of his peers.

Left Marcel Bouraine: "Harlequin," a silvered, enameled and cold-painted bronze, ivory and glass table lamp, late 1920s, height 21½in.

Above Alexandre Kélèty: "The Archer," a parcel gilt-bronze figure, late 1920s, height 44in including base. Inscribed "A Kelty" (sic).

BUSH-BROWN, *Lydia*
b. 1887
Batik designer
Born to American parents in Florence, Italy, studied at the Pratt Institute in New York. Her batiks are influenced by her travels in the Middle East in both technique and decorative motifs. She employed the traditional Javanese technique of building up colors on silk, incorporating precise detailing.

BUTHAUD, *René*
1886-1986
Ceramist
Originally trained as a painter in the French town of Bordeaux, and was later awarded both the Prix Chenavard and the Prix Roux. He applied his Neo-classical style to pottery after 1928, and was exhibited at the Rouard Gallery in Paris from the late 1920s to the end of his artistic career.

Buthaud: pottery vase, about 1931.

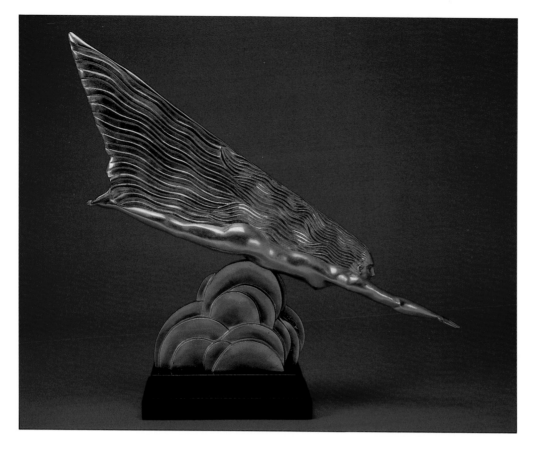

Zach modeled cabaret girls and dancers from the *demi-monde*, "rough trade" made smoother by the tongue-in-cheek sense of humor and sophistication of his stylization. His cigarette-smoking girls in leather suits have enormous girlish bows in their hair. Other young ladies, clad in teddies and garters and carrying whips, have no threatening airs. By way of contrast, Zach also modeled ice skaters, skiers and ballerinas.

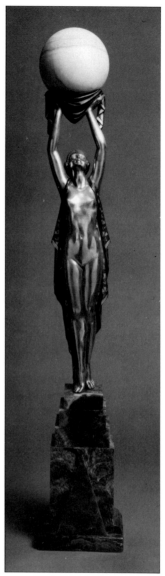

Above Maurice Guiraud-Rivière: "The Comet," a gilt and cold-painted bronze allegorical female figure, height 27⅞in including stepped black marble base. Inscribed "GUIRAUD-RIVIERE" and "ETLING PARIS."

CALLENDER, Bessie Stough 1889-1951
Sculptor

Born in the American Midwest, studied drawing at the Art Students' League under George Bridgeman and sculpture at the Cooper Union. Lived in Paris from 1926-30 and in London from 1930-40, continuing to study. In Paris she spent many hours at the Jardin des Plantes studying animals, her primary subject matter. She was much influenced by the firm, static outlines of Egyptian sculpture. During the later years of her career, she modeled her preliminary sketches in clay, then carved the forms directly into stone.

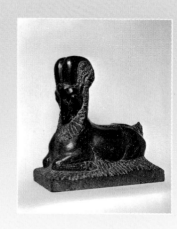

Callender: granite figure of a ram, about 1930.

Right C. Mirval: a silvered, gilt and cold-painted bronze figure of a stylized Mexican dancer, late 1920s, height 24½in, including elaborate green onyx and veined black marble base. The figure is inscribed "C. Mirval."

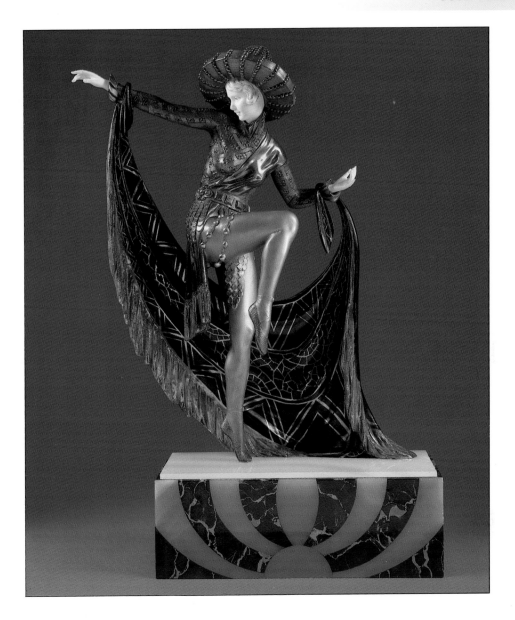

Left Aurore Onu: a cold-painted and silvered bronze and alabaster figure of a scarf dancer, formed as a *luminaire*, about 1925, height 36in, including the elaborate stepped onyx base, inscribed "Made in France."

CAPON, *Eugene and G.L.*
Metalworkers and lighting designers
The Capon brothers worked in various metals, among them brass, steel and patinated bronze, and were best known for lighting. They executed work for both Léon Jallot and Gallerey at the 1923 SAD salon, and also exhibited lighting at the 1925 Paris Exposition.

CAPPELLIN, *Giacomo*
1887-?
Glass designer
Italian designer best known for his copies of sixteenth-century Venetian glass, some produced in collaboration with Paolo Venini who joined him in 1921. In this year their firm, Vetri Soffiati Muranesi Cappellin-Venini & C. was started, but soon afterwards their main patron, Andrea Rioda, died. They exhibited at the Paris Exposition in 1925.

CAPPIELLO, *Leonetto*
1875-1942
Painter, poster artist and caricaturist
Born in Italy, settled in Paris in 1898, where he designed posters and cartoons for *Le Rire*, *L'Assiette au Beurre*, etc. His graphic style was transitional, inspired by the Art Nouveau artist Jules Chéret, but with elements of Art Deco elongation.

CARDEILHAC
French firm of jewelers founded in 1802 at 8 Rue Royale by Vital Cardeilhac. His son Edward took over in 1850. They exhibited at the world expositions at the turn of the century, showing refined Art Nouveau designs. A number of their works are in the Musée des Arts Décoratifs, Paris. In 1951 the business merged with Christofle.

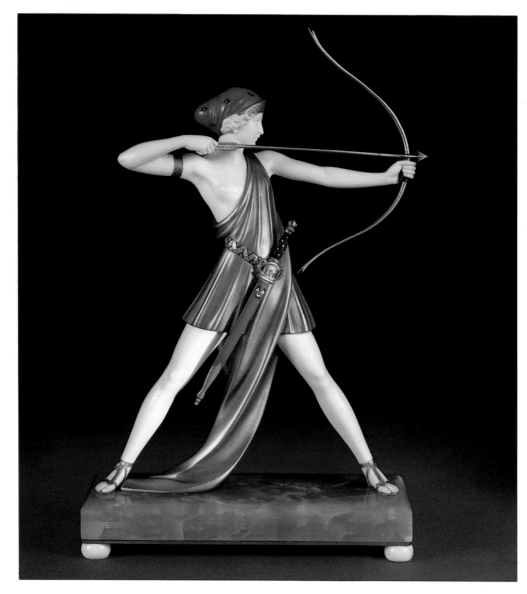

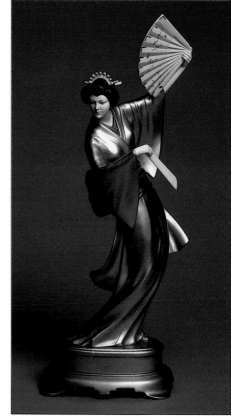

Left and right Two figures by
Ferdinand Preiss: "The Archer,"
bronze and ivory, about 1930, height
9⅛in including base, and "Flame
Leaper" (right), bronze, ivory and
amber, about 1930, height 14½in
including base. Above Harders: a
figure of a Japanese fan dancer from
the Preiss-Kassler workshop, about
1929, height 16⅞in.

CARDER, *Frederick*
1863-1963
*Glass designer, founder Steuben
Glass Works*
Born in Staffordshire, England,
worked for various local
potteries and glass factories
before becoming a designer for
Stevens & Williams of Brierley
Hill. Left England in 1903 to
found the Steuben Glass Works
at Corning, New York. Here he
acted as designer and developed
intarsia, iridescent, bubbled and
metallic glasses which competed
with Tiffany's products. When
the factory was taken over by
Corning Glass in 1918, Carder
continued in the post. Held the
position of art director from
1932 and retired in 1959.

CARDEW, *Michael*
b. 1901
Ceramist
Leading English studio potter. He
met Shoji Hamada and Bernard
Leach in 1923 and joined the St
Ives Pottery, leaving in 1926 to
establish his own. He traveled to
Africa in 1942 to become a
pottery instructor in a Gold
Coast local development
scheme. The remainder of his life
was spent in Africa and England,
with a number of lecture/

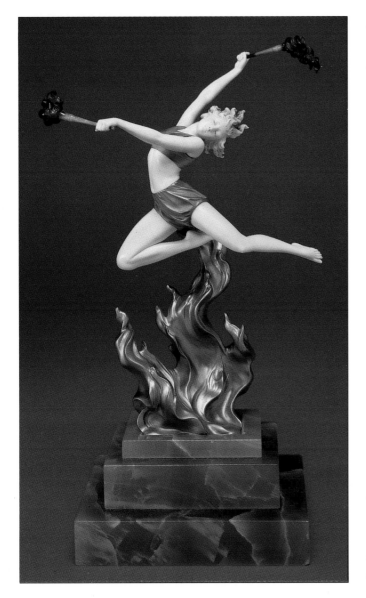

The manufacturers

Many of the decorative bronzes produced in Austria were made by the Argentor and Bergman foundries in Vienna. The most important Austrian manufacturer of the period, however, was Friedrich Goldscheider, whose firm produced cast plaster and ceramic versions of the bronze and ivory dancers designed by sculptors such as Zach and Lorenzl. The latter, in particular, created many models for Goldscheider.

Goldscheider established a branch in Paris in 1892 to "commission, manufacture and sell bronze, plaster and terracotta sculpture." The bronzes were made at an in-house foundry which was organized as a separate French company. When the Austrian-based parent company was forced to close after World War I, the Parisian foundry survived and, under the guidance of Arthur Goldscheider, developed into an *éditeur d'art* of considerable merit.

Arthur Goldscheider merited his own pavilion at the 1925 Paris Exposition. The firm's roster of contributing artists reads like a Who's Who of Art Deco design. Participants were divided into two groups. Sculpture was listed under the heading *La Stèle*, in which objects were identified with a small rectangular seal inscribed in stylized block letters. Other works of art, including glass and decorative objects, were listed as *L' Evolution.* Among the sculptors who exhibited under the *La Stèle* umbrella were Max Blondat, A. Bouraine, Fernand David, Pierre Le Faguays, Raoul Lamourdedieu, Pierre Lenoir, Charles Malfray, Pierre Traverse and the Martel brothers. Artists such as Jean Verschneider exhibited in both groups.

One of Goldscheider's most highly stylized, and probably most successful, sculptures was Pierre Le Faguays's group of a lecherous satyr in pursuit of a voluptuous nymph. The zigzag tresses of the

demonstration tours in America, New Zealand and Australia promoting the revival of slip decoration.

Cardew: pottery jug, 1930s.

CARTIER FAMILY
Jewelers

The firm of Cartier was established by Louis François, who had become established as a jeweler for the Paris élite in the mid-nineteenth century. Louis, his grandson (1875-1942), who moved the Paris branch to the Rue de la Paix in 1898, was largely responsible for bringing an oriental influence to the firm's Art Deco designs. Pierre (1878-1965) established the New York City branch in 1909 and Jacques (1884-1942) took charge of the London branch, which opened in 1902.

Cartier: clip in red enamel, onyx, white gold and diamonds, about 1925.

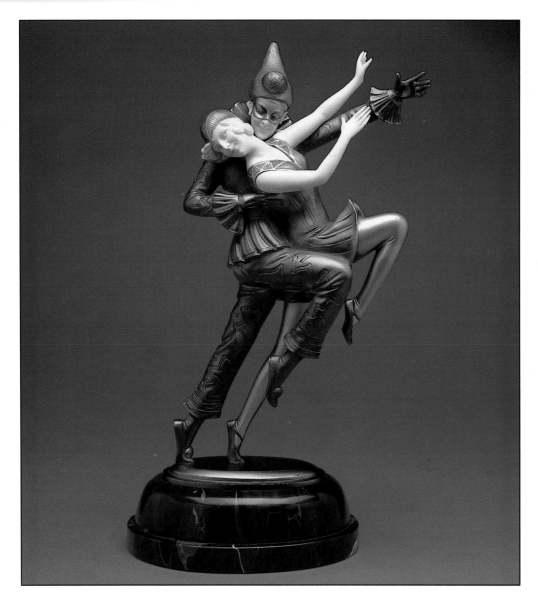

Left "Professor" Otto Poertzel: "Columbine and Pierrot," a cold-painted bronze and ivory group of characters from the Commedia del'Arte, about 1930, inscribed "Prof. Poertzel," height 13¾ in. including domed black marble base inscribed with the Preiss-Kassler seal. **Right** Pierre le Faguays: "Faun and Nymph," bronze with a dark patina, inscribed "Le Faguays" and impressed with the Goldscheider "La Stèle" foundry seal. 1925, height 20⅞ in including the green marble base. As indicated by the foundry stamps, the present model was exhibited at the Paris 1925 Exposition at the Goldscheider Pavilion. The "La Stèle" stamp refers to this exhibition, in which objects shown by the foundry were divided into two categories: "La Stèle" and "L'Evolution."

CARLU, *Jean*
1900-83
Graphic and poster artist
Studied architecture but switched to poster design after World War I. Designed in various other media, including magazine covers for *Vanity Fair*. Adopted a variety of avant-garde techniques, including Symbolism, abstraction and photomontage. Well-known posters include "Pépé Bonafé" and "Théâtre Pigalle."

CASSANDRE (MOURON, *André*)
1901-1968
Poster artist, painter, theater designer, typographer
Born in the Ukraine. Studied at the Académie Julien, Paris. First poster done in 1923, and until 1928 he designed for Hachard. He carried out masterpieces for the French National Railways and ocean liners, and also designed typefaces. In 1930 he formed *Alliance Graphique* with Maurice

Moyrand. He exhibited in the US in the 1930s, including covers for *Harper's Bazaar*. He committed suicide in 1968.

Cassandre: gouache maquette for a poster, 1930.

maiden's hair, trailing at right angles from her head, and the highly stylized two-dimensional poses of the two figures, which are almost Egyptian, have become trademarks of the Art Deco style.

Art Deco's vocabulary of geometrical motifs and stylized floral patterns, repeated in all disciplines of the decorative arts, took their cue from the pervading themes of the era. Interest in the Middle East, specifically classical Greece and Egypt, had grown stronger after World War I, culminating in the discovery in 1922 of the treasures of Tutankhamen's tomb. Increasingly, Egyptian motifs and horizontal patterning crept into European styling. The two-dimensional flatness in Middle Eastern reliefs, in which the silhouettes of figures were portrayed in profile with heads facing frontward, found its way into European design. The development of animal sculpture at this time easily traces these influences.

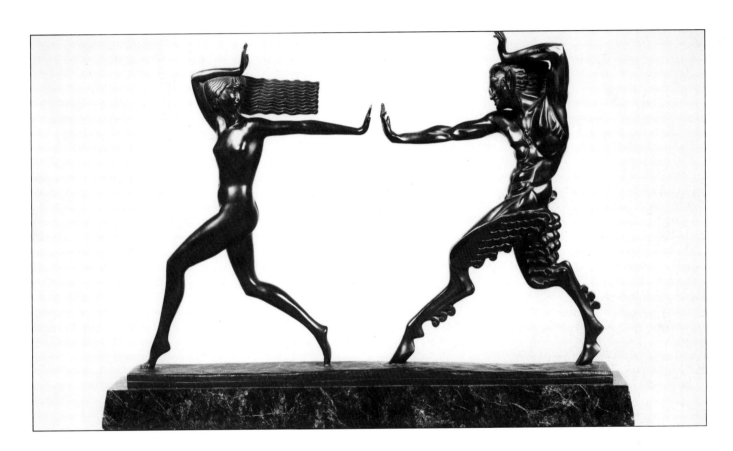

CHAMBELLAN, *René Paul*
1893-1955
Architectural sculptor
Born in Hoboken, New Jersey, studied at New York University from 1912-14 and later at the Académie Julien in Paris. After World War I he established himself as one of America's foremost architectural sculptors. His work was sought for important public commissions, and his most important private ones include the façades for the American Radiator Building and the Daily News Building (both in conjunction with the architect Raymond Hood), the Stewart and Co. Building, the New York Life Insurance Building, the Cromwell-Collier Building, the foyer of the Chanin Building and the ceiling of the RKO Center Theater in Rockefeller Center.

CHANEL, *Gabrielle "Coco"*
1883-1971
Couturier and jewelry designer
Developed an early liking for the simple, unadorned clothes and accessories which led to her success as a fashion designer. She applied similar design principles to the creation of inexpensive costume jewelry, which combined the artistic values of Art Deco with her practical approach.

Chanel: necklace in sterling silver, glass, imitation pearls and rhinestones, 1923.

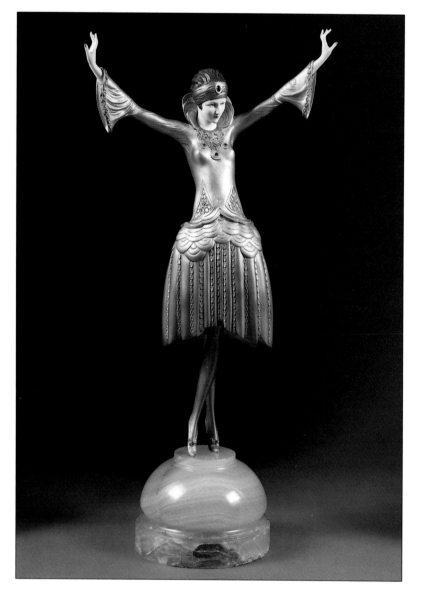

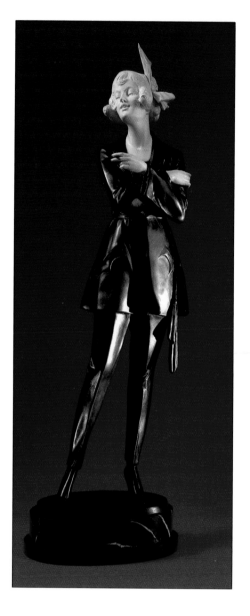

Left Paul Philippe: "Dancer with Turban," a jeweled bronze and ivory figure, inscribed "P. Philippe" and stamped "GERMANY." About 1929, height 26⅛in including domed green onyx base. Other examples of this model are known which are stamped "R.u.M." thus dating this example, as 1929 was the year in which the Rosenthal & Maeder company was bought out by Preiss-Kassler. **Right** Bruno Zach: "The Black Leather Suit," a bronze and ivory figure, inscribed "Bruno Zach" and "Made in Austria." About 1930, height 28⅛in including the black marble base.

CHANIN, *Irwin S.*
b. 1900
Architect
Son of immigrants from Poltava, Russia, built a substantial private fortune as an architect and real-estate developer. He worked for his father on building jobs and later for a subway contractor. His major career break came when he developed cost-efficient housing in Brooklyn. He went into partnership with his brother, Henry, forming the Chanin Construction Company in the early 1920s. Several major commissions followed shortly after, including the Fur Center Building, the Forty-sixth Street Theater and the Majestic and Century apartment complexes. The Chanin Building in New York was an edifice to his individual success.

CHAPIN, *Cornelia Van Auken*
1893-1972
Animalier sculptor
Born in Connecticut, studied sculpture with Gail Sherman Corbett. Her preferred subjects had always been animals, and in 1934 she moved to Paris to study under Spanish animal sculptor Mateo Hernandez. She worked by direct carving, into stone or marble, taking her materials to the Vincennes Zoo. In the Salon d'Automne of 1936 she exhibited a tortoise which led to her election as a member of the group, the only foreigner and the only woman so honored.

The Animalier Sculptors

In the nineteenth century, animal sculptors such as Antoine-Louis
Barye, Pierre-Jules Mêne and Isidore Bonheur, had concentrated on
the realistic depiction of beasts wild and domestic. In the early
twentieth century, however, sculptors such as the Italian
Rembrandt Bugatti and the Belgian Alberic Collin, led the
movement away from a strictly realistic interpretation of animals
toward a more impressionistic portrayal, despite the fact that both
artists modeled from life at zoos. It was the French, however, who
developed the stylized hard-line form and pose which have come to
be associated with Art Deco *animalier* sculpture. François Pompon
– whose walking polar bear created a stir both at the 1922 Salon
d'Automne and in the foyer of the Ambassade Francaise pavilion of
the Société des Artistes Décorateurs at the 1925 Exposition – is
perhaps the best known Modernist *animalier* sculptor.

Above Georges Hilbert: a polished
granite figure of a bulldog, signed
"Hilbert 1926", height 16⅛in. **Left**
Georges Lavroff: a silvered bronze
figure of a crouching tiger, inscribed
"G. Lavroff" and stamped "8591."
Length 24in including shaped
Belgian marble base.

CHAREAU, *Pierre*
1883-1950
Architect and furniture designer
Born in Bordeaux, made his
debut in 1919 at the Salon
d'Automne, displaying a bedroom
and office for Dr Jean Dalsace,
for whom he later undertook his
most celebrated architectural
commission, the Maison de
Verre. At the Paris 1925
Exposition he participated as
both architect and decorator. In
1930 he became a member of

the UAM, designing stylishly
modern furniture, lights and
textiles. In the same year he
produced tubular steel chairs
designed by Jean Burkhalter and
in 1938 he designed interiors at
the Collège de France. He
moved to the United States in
1940.

Chareau: bookcase/table, French
walnut and chromed metal, about
1930.

Edouard Marcel Sandoz, Simone Marye, Georges Hilbert, Sirio Tofanari, L. Schulz, Paul Jouve, Maurice Prost, Louis Albert Carvin, and the Spanish artist Mateo Hernandez all also exhibited *animalier* sculpture in Paris between the wars. These sculptors used a variety of materials, including bronze, ceramic, stone and marble, to produce large garden statuary and smaller, more intimate, table-top figures. As with figural bronzes, a single model could be reproduced in different sizes or converted into utilitarian decorative objects such as bookends and dinner bells.

Many of these sculptors specialized in direct carving, employing the Assyrian technique of leaving the stone between the legs of the animal rough (uncarved), which reinforced the strength both of the beast and of the sculpture itself. Sandoz imparted a whimsy which was unequaled among his contemporaries. In his series of dancing frogs each of the creatures has an individual character.

Above Christa Winsloe Hatvany: a bronze figure of a fawn, height 15in, early 1920s. **Far left** Edouard Marcel Sandoz: a bronze group of fennec foxes with a rich brown patina, inscribed "Ed. M. Sandoz 1930" and stamped with the E. Robecchi foundry seal. Height 15½in.**Left** Paul Howard Manship: "King Penguin," gilt-bronze, 31in high including base. This is one of the aminals on the Paul J. Rainey Memorial Gateway to the New York Zoo, commissioned in 1923.

CHASE BRASS AND COPPER COMPANY
Founded in Waterbury, Connecticut, in 1876, manufacturing industrial items such as wire and tubing, they entered into domestic design in the late 1920s and by the 1930s were producing an extensive range of kitchen utensils, cocktail and smoking accessories and other items in chromium and bakelite.

CHAUMET, *Joseph*
1854-?
Jeweler
Became director of one of the most prestigious jewellery houses in Paris, founded in 1780 by Nitot, whose most illustrious customer was Napoleon Bonaparte. Chaumet was one of the 30 participants selected to exhibit in the jewelry section of the 1925 Paris Exposition.

CHERMAYEFF, *Serge*
b. 1900
Architect and furniture designer
A Russian emigré educated at Harrow in England. He worked as a journalist before 1924, and then became chief designer for the decorating firm E. Williams Ltd. In 1928 he was appointed director of the Modern Art Studio set up by the London furniture manufacturers Waring & Gillow. His designs for furniture, carpets and decoration

were strongly influenced by the 1925 Paris Exposition. He used black glass, silver cellulose, Macassar ebony and abstract patterns. From 1931-33 he was in private practice as an architect and designed modern interiors for the BBC. From 1933-36 he was in partnership with Eric Mendelsohn, their best-known collaboration being the De La Warr Pavilion at Bexhill, and in 1936 he designed unit furniture for Plant Ltd. In 1939 he

Interaction Between Art Forms

Although the term "Art Deco" should by definition be applied only to the decorative arts, a group of sculptors active in the early twentieth century straddled the all-too-arbitrary division between the "fine" and "decorative" arts. For the most part they included painter-sculptors associated with the School of Paris – friends of painters and sculptors such as Chaim Soutine, Marc Chagall, Constantin Brancusi, Fernand Léger, Henri Laurens and Archipenko. Two of these "chameleon" sculptors – Josef Csaky and Gustave Miklos – had studios in the same building as their associates. Nicknamed "la Ruche," or "The Beehive," the building had been designed by Gustave Eiffel as the Pavillon des Vins for the 1900 Exposition Universelle. In 1902, the grandson of the eighteenth-century painter François Boucher arranged for it to be moved to 2 Passage Danzig in Montparnasse, where it became a true beehive of creative energy for these impoverished modern artists **(8)**.

One of the most interesting developments in French decorative arts was this interaction between supposed "fine" and "decorative" artists – between artists who worked in a variety of disciplines. The most important sculptors within this category were Gustave Miklos, Josef Csaky, Jean Chauvin and Jean Lambert-Rucki.

The work of these four sculptors bears no aesthetic resemblance to the decorative works of the other artists mentioned above. Miklos modeled in a severely geometrical style. His towers are an exercise in architectural form. His animal figures are far less abstract, although still formed with intersecting planes that are not in the least realistically conceived. Csaky's work is also Cubist in inspiration. Many of his pieces from the 1920s resemble three-dimensional interpretations of paintings by Léger. Chauvin is

Jean Lambert-Rucki: "Tête Cubiste (Visage)," oak and glass mosaic, signed and dated. Height 26½ in. Lambert-Rucki worked in a variety of media, including painted plaster, and he frequently mixed wood with other materials, such as glass (as here) or metal.

emigrated to the United States and taught design and architecture.

CHEURET, *Albert*
Sculptor, designer

Studied with Perrin and Lemaire, made a member of the SAF in 1907, after having exhibited regularly. His work was strongly influenced by ancient Egyptian forms, and he often used naturalistic motifs, especially birds, in his designs. He produced some furniture and several extraordinary clocks, but most of his designs were for

lighting. He exhibited a complete shop design, as well as lighting and small bronzes and clocks, at the 1925 Paris Exposition.

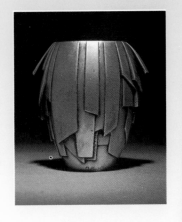

Cheuret: vase, silvered bronze, 1920s.

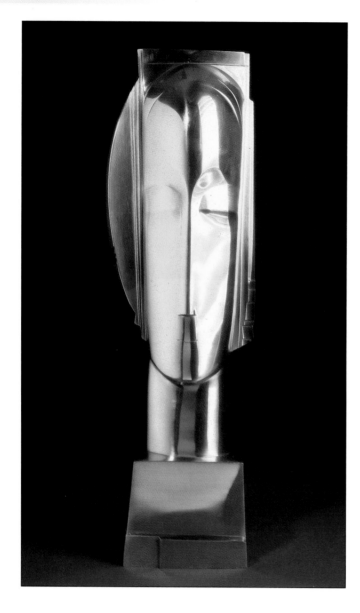

the most abstract of this group, and the most cerebral, whereas Lambert-Rucki's work is perhaps the most varied. He worked in a variety of media, mixing wood, glass and metal. Many of his pieces are in painted plaster assembled with bits of wood and wire. In this respect it must be remembered that these artists were extremely poor, and that the cost of bronze casting was often therefore prohibitive. For this reason, many original models were cast in bronze only posthumously.

It must be remembered, also, that in the years preceding World War I the avant-garde movement in modern art was unpopular; it was accepted and adopted by an elite few. Private patronage, rather than public commissions, sustained the artistic leaders. One such patron was the noted Parisian couturier and inveterate collector Jacques Doucet.

In 1912, Doucet sold his extraordinary collection of eighteenth-century French furniture and decorative arts at auction, and decided to furnish his new apartment at 46 Avenue du Bois with contemporary works. He commissioned Paul Iribe and his assistant Pierre Legrain to design the interior, which he filled with the work of avant-garde artists. His collection included major examples by contemporary painters and sculptors; for example, *Les Demoiselles d'Avignon* by Picasso, *Mlle Pogany* by Brancusi, and works by Modigliani, De Chirico, Braque, Derain and others. By 1925 this seminal collection of modern art, peppered with a few African masks and carvings, was no longer in harmony with its surroundings, so Doucet bought a studio in Neuilly in which to house it. The architect Paul Ruau was retained to design the new space, and Legrain to design its furnishings.

As previously, Legrain orchestrated a collaborative effort between the most progressive cabinet-makers, sculptors and

CHIPARUS, Demêtre
Sculptor
Born in Rumania but worked in Paris, first exhibiting at the salon of the SAF in 1914 where he was awarded an Honorable Mention. Best known for his figures in bronze and ivory which are carved from fine-quality African ivory, using the grain of the material as part of the design of the figure. His early work, groups of small-scale figures of children at play, developed into larger and more sophisticated models of dancers, personalities and exotic creatures.

CHRISTOFLE, Charles
1805-63
Silversmith
Founded the firm of Christofle in 1839, investing in it an entire personal fortune. The firm was famous for its superbly crafted silverplate, and won many awards. It is still active today.

CLARK, Allan
1896-1950
Sculptor
Born in Montana, studied at the Art Institute of Chicago and the National Academy of Design in New York, also in the Far East with Chinese and Japanese masters from 1924-27. Was a member of the Fogg Museum expedition to the cave chapels of Tun Huang and Wan Fo Hsia, and traveled extensively throughout South-east Asia. Eastern culture

interior designers working in Paris. The objects produced were individually extraordinary. However, it was the harmony of vision and the collaborative effort which was truly remarkable, and for this credit must be given in no small part to Doucet himself, a man of impeccable taste, style and instincts. Photographs of the Doucet interior show rugs designed by Miklos and Marcoussis, a stair banister by Csaky, and a settee by Marcel Coard. Miklos also showed his versatility in designs for objects such as flatware, doorknobs, drawer handles, lamps and andirons.

The pavilion of the Société des Artistes Décorateurs at the 1925 Exposition included screens lacquered by Jean Dunand with drawings of wonderful African-inspired beasts by Lambert-Rucki. The animal sculptor Paul Jouve provided Dunand with additional designs for panels and screens. He also worked with the noted bookbinder, F. L. Schmied, on the illustrations for Kipling's *Jungle Book*. Miklos in turn provided Schmied with interior graphics and decorative motifs for book projects, such as *Creation* (1925), *La Vérité Parole* (1929) and *Paradis Musulman* (1930). Perhaps the most versatile of these sculptor-designers, Miklos also created figural pins executed in gold by Raymond Templier. Although considered sculptors, these artists were therefore gifted and inspired designers who could each turn their hands with equal facility to any project.

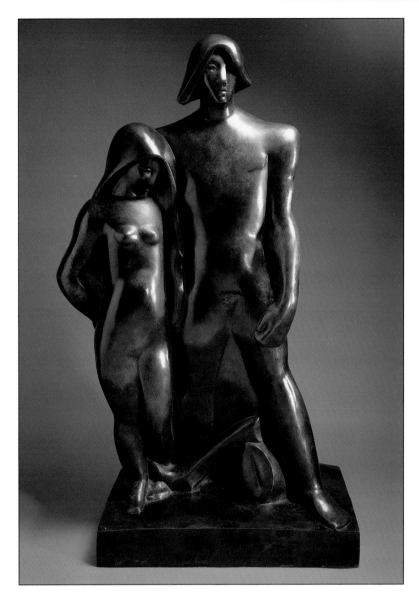

Opposite page Gustave Miklos: "Divinité Solaire," a polished bronze inscribed "G Miklos 4/4," height 25⅞in. After Miklos' death, in 1971, his widow authorized an edition of four polished bronze casts to be made, of which the last casting is considered to be the finest.

Right Josef Csaky: "Adam and Eve," bronze, signed and inscribed with the name of the foundry (Blanchet). The group was conceived in 1933. The present bronze is an estate cast.

and techniques greatly influenced his style, both in his oriental and occidental subjects such as animal figures. He made both bronzes and direct wood carvings.

CLIFF, *Clarice*
1899-1972
Ceramist
Born in Staffordshire, England, and apprenticed as an enameler at Lingard Webster & Co. at the age of 13. At 17 she was hired as an engraver at A.J. Wilkinson Ltd., and here, from 1918-25, she acquired a talent for pottery techniques. Her first "Bizarre" wares were produced about 1929, and although she continued to design pottery in

more conservative styles after the World War II, she is best remembered for her more lighthearted, even frivolous, wares.

THE UNITED STATES

In America the move toward the development of an Art Deco style in sculpture evolved slowly. The Beaux-Arts traditions of the late nineteenth century, exemplified by the work of Augustus Saint-Gaudens and Frederick William MacMonnies, remained very popular in the early years of the new century. Because the conservative National Sculpture Society still controlled the public commissions, scholarships and appointments that were the lifeblood of a sculptor's career, few were willing to venture into the realm of the abstract or to turn away from the realistic figural style which insured them the approval of the panel of judges who presided at the important exhibitions.

Garden Sculpture

The end of the nineteenth century saw the development of garden statuary in bronze as a new outlet for sculptors' talents. Wealthy US families such as the Whitneys, Fricks, Warburgs and Vanderbilts were building large country estates. Modeled on Italian villas, most of these incorporated large gardens which demanded formal planning and landscaping. Because American foundries were now capable of casting large pieces, many of these families (or the architects who planned the estates) considered placing the commissioned work of an American sculptor in the garden rather than importing Renaissance-style stone figures from Europe. The architect most influential in promoting the work of native-born sculptors was Stanford White, of McKim, Mead & White, who designed most of the estates along the Eastern Seaboard **(10).**

This new demand helped to develop a cohesive group of sculptors, many of them women, who modeled large-scale garden sculpture in a style moving away from the traditional academic

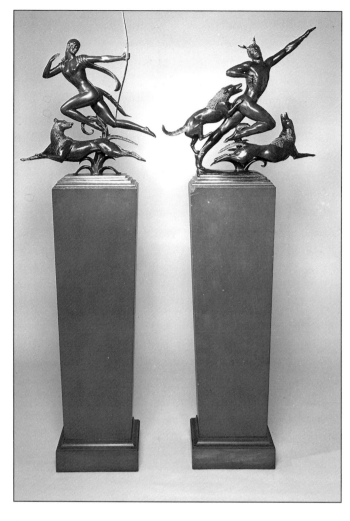

Paul Howard Manship: A pair of mythological groups, "Diana" and "Acteon." Bronze, with a rich dark green patina, height 38⅞in. Both are inscribed with the sculptor's name and that of the foundry (C. Valsuani), and they are dated 1921 and 1925.

COARD, *Marcel*
1889-1975
Furniture designer
Born in Paris, studied architecture at the Ecole des Beaux-Arts until the outbreak of World War I, after which he established himself as a decorator. For his own designs his preferred woods were oak, Macassar ebony and palisander; it was his selection of veneers and encrusted materials that gave his pieces their stamp of individualism. He was rigidly independent, avoiding the annual salons and the small groups which exhibited in Paris, and his work was reserved for a few private patrons including Jacques Doucet, for whom he designed and made furniture using rare and unusual materials such as shagreen, mirrored glass and mother-of-pearl.

COATES, *Wells*
1895-1958
Industrial designer
A leading figure of the British avant-garde. Born in Japan, son of a Canadian missionary, he studied engineering in Vancouver from 1913. He began to work as a designer after 1927 and in 1931 won a competition to design a stand for the Venesta Plywood Company at the Manchester British Empire Trade Exhibition. In the same year he and Pritchard formed the Isokon Company. In 1931 he designed the sound studios for the BBC in Portland Place, London, and in 1933 he helped form the MARS group as an English chapter of the Congrès Internationaux d'Architecture Moderne. His later designs included the Thermovent Ekco fire (1937) and Ekco television with a lift-up top (1946), the Radio Time combined wireless and alarm clock (1946) and aircraft

strictures. Their works were more fun-loving and decorative. Although emphasis was still placed on the realistically modeled human figure, it was now less academic. Active during the 1910s, 1920s and early 1930s, these young US sculptors gradually introduced Modernist elements into their sculpture. They came to represent the mainstream of taste in America, one which formed a bridge between the traditions of Beaux-Arts sculpture and the geometrical abstractions of the later Modernist movement. Not always daring in outlook, they did in many instances nevertheless incorporate imagery employed by their counterparts in Europe: the use of repeated pattern, streamlined form, and mythological subjects reinterpreted in a contemporary manner.

Harriet Whitney Frishmuth, Edith Baretto Parson, Janet Scudder, Edward McCartan, Wheeler Williams and John Gregory were among those who became synonymous with this hybrid style of sculpture. Nymphs, babies and mythology were the subjects usually chosen for their models. Animals such as storks, herons and ant-eaters became a natural theme for garden statuary. These pieces were often given an Art Deco interpretation, with angular silhouettes and features. Artists such as Eugènie Shonnard, Albert Laessle, and Cornelia Chapin modeled some of the most appealing of these. Others, such as Bruce Moore, who had been exposed to Modernism as a student in Europe, developed a highly personal and forceful Art Deco form of stylization.

Many of the models conceived by these artists for oversized garden sculptures, often piped as fountains, were cast in bronze either by the Gorham Foundry in Providence, Rhode Island, or by the Roman Bronze Works Foundry, which is still active in Corona, New York. Very few, if any, of these casts were unique. Examples were generally made and placed on demand. Reductions of the models were cast on a commercial basis and marketed either directly through the foundry or through galleries such as the Grand Central Art Gallery or the Milch Gallery, in New York, which represented contemporary artists. In addition, the Gorham Foundry had its own retail store on fifth Avenue, New York. Theodore B. Starr and Tiffany & Co. were two other retail outlets for sculpture at this time. The National Sculpture Society's annual exhibitions, held in various cities around the country, also served as a marketing vehicle for its members.

The foundries

Of all the US foundries active during the early twentieth century, Gorham and the Roman Bronze Works were unquestionably the two most important. Gorham turned out finely detailed casts with superb patinas. The greenish brown found on many of its pieces has became known as "Gorham Green." By the same token, the Roman Bronze Works became known and respected for its rich reddish dark browns and superior piping for fountain figures.

The foundry markings used by these two houses were very distinct. Gorham impressed its works with the words GORHAM CO FOUNDERS, followed by the letter Q and a series of three or four numbers that identified the model. Sometimes an inscribed # , followed by a serial number, was also included to identify the number in the edition of the particular example. In early casts, the name of the foundry might be inscribed in a larger script. Some bronzes are additionally stamped with the firm's cipher – a series of three linked squares enclosing a G, a wolf and a C.

The Roman Bronze Works foundry changed its inscription whenever the company changed ownership or was re-incorporated. Early pieces were generally inscribed in small block

interiors for De Havilland and BOAC (1946-47).

COLIN, *Paul*
1892-1985
Graphic artist, stage and costume designer
Arrived in Paris 1913. He achieved fame with his 1925 poster announcing Josephine Baker's La Revue Nègre in Paris, and did numerous music-hall posters, paintings and book illustrations, including Baker and her jazz musicians. He also designed stage sets. In 1926 he opened the Ecole Paul Colin, a school for graphic arts where he taught for nearly 40 years. A notable portfolio of c 1930 is entitled *Le Tumulte Noir*, in an edition of 500, all hand-colored by himself in the *pochoir* process.

Colin: lithographic poster, 1937.

letters <u>ROMAN BRONZE WORKS N– Y–</u>. (Sometimes the dashes were replaced by periods.) In other instances, the words are spelled out in a larger script followed by the words <u>Cire Perdue</u> ("lost wax"). Casts of small models were inscribed R.B.W. Mid-century casts were inscribed <u>ROMAN BRONZE WORKS INC</u>. For years it was thought that the abbreviation for "incorporated" was not used until 1946. Foundry records are scanty, but it is now believed that this revised form may have been used as early as the 1930s. In 1976 the foundry reverted to its original marking. Roman Bronze Works casts, if numbered, are usually inscribed with the number on the underside of the bronze.

Other, smaller, foundries in operation at the time included the Kunst Foundry, the American Art Foundry, The Jonathan Williams Foundry, and the Cellini Bronze Works, all in New York; and the Griffoul Foundry, in Newark. As the Depression approached, many of these smaller houses were brought under the protective umbrella of the Roman Bronze Works and were eventually completely assimilated by the larger company. For this reason, bronzes inscribed *AMER ART FDRY N.Y.* can be assumed to have been cast prior to 1928, the year in which the foundry was absorbed by the Roman Bronze Works.

Architectural sculptors

Architecture and the skyscraper became the final catalysts for bona-fide Art Deco style which developed in the United States. The modern shape of these tall buildings demanded a corresponding Modernist decorative vocabulary, which sculptors such as Paul Manship, Paul Jennewein, and Lee Lawrie were ready to provide. Many of the decorative elements applied to buildings in the inter-war years were commercially produced by firms such as the Roman Bronze Works and the Atlantic Terra Cotta Tile Company. In many instances, unfortunately, the name of the designer is unrecorded.

Manship and Jennewein represented what can be defined as the early style of Art Deco. Both were awarded the Prix de Rome, spending several years studying in the Italian capital from where they traveled around the Mediterranean. Both were deeply impressed by archaic and Greco-Roman sculpture, from which they drew the techniques of repeated pattern, flat controlled drapery and strict iconography. Manship developed this influence into a personal style in which his vocabulary of form and pattern have become synonymous with American Art Deco. Jennewein adopted a similar, but less imaginative, vocabulary. Both sculptors were able to support themselves for the better part of their careers with public architectural and memorial commissions executed in their preferred styles. Both also modeled smaller-scale figures in the round which represent some of their most successful endeavors.

For many disciplines, the Rockefeller Center project represented the apex of Art Deco design. The sculptors involved both in the interior and exterior decoration of the project's buildings and public spaces produced some of their finest works, many of which have become indelibly engraved in the lexicon of the American decorative arts of this century. Manship's gilt-bronze figure of Prometheus, which dominates the skating rink at Rockefeller Center, and Lee Lawrie's figure of Atlas at the entrance to 630 Fifth Avenue, have become two of Manhattan's best-known pieces of sculpture.

If the United States did not produce a decorative-arts style which directly paralleled that of European Art Deco, it did develop its own variation, one more accurately defined as Modernist. Based on the start geometry of Cubism rather than on the human forms of

COLINET, *Claire-Jeanne-Roberte*
Sculptor
Born in Belgium and studied under Jef Lambeaux before moving to Paris. She exhibited at the salon of the SAF from 1913 on and at the Salon des Indépendants from 1937-40, but is best remembered for her earlier work. She worked primarily with bronze and ivory, modeling exotic female figures with flowing drapery and body movements. Her work is closest in style to that of Chiparus, but her surface modeling is freer and her poses far more exuberant.

COOPER, *Susie* (**VERA**, *Susan*)
b. 1902
Ceramist
Born in Staffordshire, England, and attended classes at the Burslem school of art in 1919. In 1922 she began work for the A.E. Gray Co. Pottery. Her work was exhibited in the 1925 Paris Exposition. She subsequently showed remarkable marketing as well as design talent in her tablewares, which enjoyed considerable success in Britain in the 1930s. She also executed subdued designs in the post-war period, and her firm was eventually bought out by Wedgwood.

archaic design, it peaked in the 1930s and 1940s, too late to be truly considered Art Deco.

There was, however, a group of avant-garde artists in America who embodied the abstract principles of Cubism and modern European art shown to the US public at the 1913 Armory Show. Some, such as the Chicagoan John Storrs, were native-born; others, such as Robert Laurent and Gaston Lachaise, were French immigrants who brought with them the inspiration of their homeland. Boris Lovet-Lorski, classically trained as a painter and architect in Imperial Russia, developed in the 1920s and 1930s a rigorous sculptural style which mixed his classical training and figurative modeling with Cubism and three-dimensionality through intersecting planes. His marble figures and groups incorporate elegance, sleek surfaces and dynamic design in a striking interpretation of both European and American Modernist sculpture.

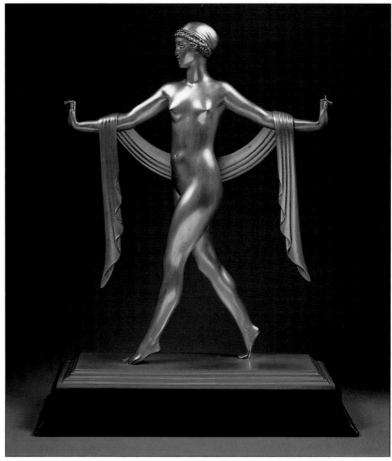

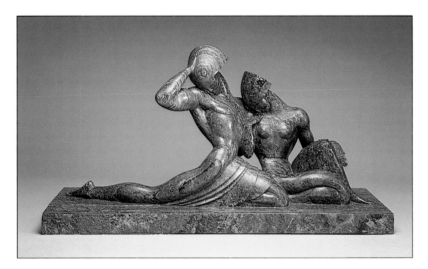

Left Boris Lovet-Lorski: "Rhythm," Swedish marble, signed "Boris Lovet-Lorksi," and carved about 1936. Height 15in.

Above Carl Paul Jennewein: "Greek Dance," a gilt-bronze figure of a goddess, about 1926, height 20½in including ebonized wood base. The work is inscribed "C.P. JENNEWEIN" and stamped P.P.B.U.C° MUNCHEN MADE IN GERMANY.

COPIER, *Andries Dirk*
b. 1901
Glassmaker
Born in Holland, studied in Utrecht and Rotterdam from 1917-25. Joined Leerdam Glass as an apprentice in 1917 and started to produce glass with new forms and techniques. Was awarded a silver medal at the Paris Exposition of 1925. Held first exhibition of "Unica" pieces at Stuttgart in 1927. Leerdam Glass gained great recognition in Europe under his artistic direction.

CORMIER, *Joseph Descombes*
b. 1869
Sculptor
Studied under Hiollin, and first exhibited at the salon of the SAF. He specialized in Neo-classical figures designed for commercial production in both low-grade bronze and white metal. His female nude "Femme au Lotus" was used in the vestibule of "l'Ambassade," the SAF pavilion for the 1925 Paris Exposition.

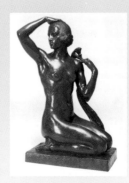

Cormier: bronze figure of a nymph, 1925.

FURNITURE AND **I**NTERIOR **D**ECORATION

The period from 1905 to 1910 was a transitional one, during which the style now known as Art Deco began to evolve in Paris. Its major proponents seem to have had two primary objectives concerning design. The first was the desire to remove all traces of foreign influence in order to return to a purely French mode. As André Véra wrote: "Thus for furniture, we will take the advice neither of the English nor of the Dutch, but will continue the French tradition, insuring that the new style will be a continuation of the last international style we have, that is the Louis-Philippe style."

Right Dominique: *semanier*, Brazilian pilissander and ivory, about 1928; and (**below**) Pierre Chareau: desk, Brazilian pilissander, ivory and chromed steel, about 1928. Pilissander, used in both of these pieces and known also as jacaranda, became one of the most popular exotic veneers used by French cabinetmakers in the 1920s due to its rich and distinctive grain.

COWAN, *Reginald Guy*
1884-1957
Ceramist, founder Cowan Pottery
Born in Ohio to a family of potters and received practical and formal training. He provided the forum for many of America's most gifted ceramists through his Cowan Pottery, which was for ten years (1921 until late 1930) at the forefront of modern American ceramic design. In the early 1920s the Cowan Pottery Studio began commercial production and distribution of *compotes*, figurines, vases and bookends with roughly 1,200 national outlets. Commercial success came from early adoption of the Modernist style. In 1929 financial difficulties developed, and quality fell as the Depression began to affect the volume of sales.

CRETTE, *Georges*
1893-?
Bookbinder
Born in Créteil, attended the Ecole Robert-Estienne before joining the *atelier* of Marius Michel, the last great traditional French binder. Mobilized in World War I, then returned to Michel, where he assumed managership on Michel's death in 1925. He was a member of the SAD from 1924-29, and won the grand prize in binding at the 1925 Paris Exposition. He often collaborated with Schmied and Dunand. Masterpiece bindings include *Le Cantique des Cantiques* and *Le Livre de la Jungle*.

Consequently, French taste in furniture was expressed by a return to eighteenth- and early nineteenth-century styles – Louis XV, Louis XVI, Consulate, Empire and Directoire – adapted to contemporary taste.

The second of the objectives in forming a new style was to abolish the obsession with the curve, which had been used as a primary mode of expression in Art Nouveau furniture at the turn of the century. Disciplined, stylized bouquets replaced the whiplash stems of Art Nouveau. The two most important arbiters of the Art Nouveau movement died in these transitional years: S. Bing, who had established the Parisian shop L'Art Nouveau, died in 1905, and Emile Gallé, the man who had established it in glass and other media, in 1904.

Bing's rival, Julius Meier-Graefe, founded La Maison Moderne in Paris in 1899 under the direction of Léon Jallot, later – in 1903 – to found his own decorating studio, renowned for furniture with simple lines and rich surface textures. The gallery included the work of several young designers who later were in the vanguard of the 1920s furniture movement. Included were Paul Follot, who designed furniture with rich surface ornament applied to simple and elegant forms; Maurice Dufrêne, who favored rustic simplicity and the application of industrial techniques to furniture production, and Clement Mère, who studied painting with Gérôme before joining La Maison Moderne.

FRANCE: THE TRANSITIONAL YEARS

New organizations were established in the first decade of the twentieth century that enabled designers of decorative objects to exhibit their work at regular intervals. The most important of these was the Société des Artistes Décorateurs, formed in 1901. Until this time, the designers had been forced to exhibit at two annual salons in which their participation was subordinate to paintings, which were considered "fine art," and therefore superior. The founding members of the Société des Artistes Décorateurs included prominent designers and architects from the Art Nouveau era, including Eugène Grasset, Hector Guimard and Eugène Gaillard, in addition to individuals who emerged as leaders of the Art Deco movement: Emile Decoeur, Francis Jourdain, Maurice Dufrêne, Paul Follot and Pierre Chareau.

Other major designers during these transitional years were Léon Jallot, Paul Iribe (who was to spend a considerable period in the United States), Louis Majorelle, Mathieu Gallerey, Pierre and Tony Selmersheim, Charles Plumet, Théodore Lambert and Henri Bellery-Desfontaines. Their furniture can be considered as a somewhat modified and simplified version of Art Nouveau, in which increased angular compositions were lightly adorned with carved motifs. A bookcase exhibited by Jallot (1) at the 1908 salon provides a typical example, its simple form incorporating a curvilinear apron. Further ornamentation was provided by an upper row of panels naturalistically carved in a restrained Belle Epoque manner. However, the veneers were rich and varied, in anticipation of the coming 1920s style (2).

In 1912 Follot presented a suite of dining room furniture at the Salon d' Automne in which the chairs and commode were enhanced with pierced baskets of flowers (3) that appear today as high Art Deco – that is, from the mid-1920s rather than the pre-war years. Ruhlmann incorporated the same stylized motif, with modifications, in his celebrated *encoignure* of 1916, indicating that the Art Deco style in furniture would have reached maturity by 1920 if not for the hiatus caused by World War I (4).

CREUZEVAULT, *Lucien*
1893-1958
Bookbinder
Succeeded the binder Dodé in 1904. Exhibited at the Musée Galliéra in 1927 and 1928, receiving first prize, and at the 1929 salon of the SAD. He designed numerous bindings in a geometric Art Deco style, including *La Bataille, Le Pot au Noir,* and *La Rose de Bakawali.* In the 1920s he was joined by his son, Henri, also an accomplished binder.

CROS, *Henri*
1840-1907
Glassmaker, painter, sculptor
Born in France. A sculptor and painter, he tried to combine both arts by sculpting in colored waxes. In his search to find a material which could be used for polychrome sculpture, turned to encaustic decoration and made painted terracottas. After much research he succeeded in making small medallions in "plastic glass," now known as *pâte-de-verre*.

CSAKY, *Josef*
1888-1971
Sculptor
Born in Hungary, arrived in Paris in the years preceding World War I. He was one of the first to adopt the principles of Cubism being developed by Picasso and Braque, and by 1920 he had started modeling reliefs of geometric forms, painting and incising the negative space. In the same period he also modeled a series of animals.

Csaky: white marble head of a young girl, 1928.

Other readily identifiable Modernist images, such as the sunburst, zigzag and chevron, likewise made their entry into the new grammar of decorative ornament before and during World War I in the work of André Mare and Louis Süe, two Parisian interior designers who formed a partnership in 1919. The period was characterized by experimentation, as artists and furniture designers searched for a means to distance themselves from the *fin de siècle* and to create a bona-fide twentieth-century style. In this, Neo-classicism became a unifying force.

Two important events occurred in these pre-war years to influence the evolution of the Art Deco style in furniture. In 1909 the Ballets Russes, directed by Diaghilev, opened in Paris. The sets, designed by Léon Bakst, were brilliantly colored with bold patterns. These sets, coupled with the savage colors of the Fauves, who exhibited at the 1905 Salon d'Automne, helped interior designers move away from the restrained palette of the previous era, and to incorporate an unprecedented brilliance in their schemes. Radiant reds and greens were used for cushions, and bold abstract and figural patterns for upholstery, draperies and wallpapers.

The 1910 Salon d'Automne was also extremely important to the development of the coming Modernist style in France. It was at this exhibition that an invitation was extended by the exhibition's jury to the Munich Deutscher Werkbund in the hope that German participation would shake French designers and manufacturers out of the lethargy apparent in their recent work. The Munich exhibit – represented by the work of Thedor Veil, Adalbert Niemeyer, Paul Wenz, Richard Riemerschmid, Otto Baur, Karl Bertsch and Richard Berndl, among others – was intended to inspire their French counterparts to develop a new and distinctive national style.

Although French cabinetmakers and designers had by 1910 rejected the organic protrusions on Art Nouveau furniture in favor of a more restrained and functional style, they were not prepared to forego the Belle epoque's preoccupation with lavish materials. Exotic woods, such as Macassar ebony, rosewood and amboyna, became fashionable, often veneered in patterns that accentuated their contrasting textures. Distinctive grains, such as those found in burl maple and calamander, added to the aura of opulence sought. For large surface areas, sharkskin (also known as shagreen and *galuchat*), parchment, snakeskin or lacquer were applied to provide color and interest. Ivory, and to a lesser extent, ormolu, were used as a decorative accent for key escutcheons, *sabots* (mounts at the bottom of furniture legs), and bands of trim which traced the contours of the piece of furniture.

Two artisans emerged as masters of Modernist materials. The first was Clément Rousseau, who designed and executed finely detailed furniture and precious objects in rare woods, tooled and stained leather, carved ivory, and enamel. The other was Adolphe Chanaux, a virtuoso craftsman who executed furniture designs for André Groult, Emile-Jacques Ruhlmann, and Jean-Michel Frank, as well as for his own creations. Chanaux's importance lay in his mastery of all the period's most exotic and fashionable furniture materials – sharkskin, parchment, vellum, ivory, straw marquetry and hand-sewn leather – to which he applied his talents with equal facility.

NEW CONCEPTS IN INTERIOR DECORATION

In 1911 the term *ensemblier* appeared, and with it the suggestion that a new concept in interior decoration had emerged. In opposition to the Art Nouveau credo, following which furniture designers and architects had attempted to design every element of

DAMMOUSE, *Albert-Louis*
1848-1926
Glassmaker, ceramist, sculptor
Born in Paris, trained as a sculptor and later worked as a ceramist. His work in glass, dating from 1898, is difficult to define, as it was early described as a soft porcelain with enamel set between minute castings of harder enamel. Examples of his work are very rare.

DAMON
Lighting designer and manufacturer
In addition to his own designs, he commissioned other artists to work for him, most importantly Boris Lacroix, who provided his most strikingly original designs. Damon experimented with various techniques for producing frosted glass that would diffuse light and eliminate the glare of the bulbs. His designs were functional, elegant and original.

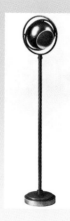

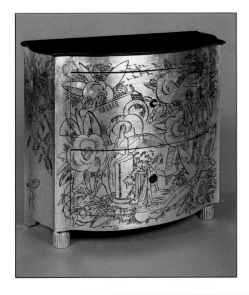

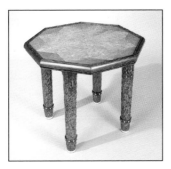

Left Atelier Martine: commode, silvered wood with incised decoration, 1923. **Above** Clément Rousseau: occasional table in exotic woods, shagreen, ivory and mother-of-pearl, about 1921. **Below** Jean Dunand: four-paneled screen in lacquered wood, 1920s.

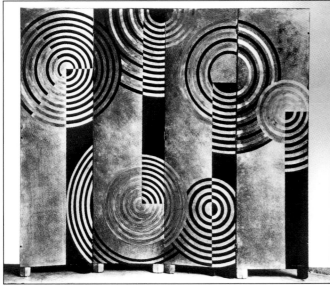

an interior to insure that it was entirely *en suite*, a tendency emerged for decorators to collaborate on certain commissions. Evidence of this collaboration, which was apparent at the 1913 salons, reached fruition after the war in the interiors of the French embassies in Warsaw and Washington, the Parfumerie D'Orsay, Jean Patou's residence, and luxury ocean liners such as the *Paris* **(5)** and the *Ile-de-France*. All of these were designed with an unprecedented spirit of cooperation. The Ambassade Française pavilion at the 1925 Exposition drew the combined participation of all of the members of the Société des Artistes Décorateurs.

The first patron of the new Modernist style was the couturier Jacques Doucet, who in 1912 commissioned Paul Iribe to design and furnish his new apartment on the Avenue du Bois, Paris. Doucet sold his collection of eighteenth-century furniture and *objets d'art* at auction, replacing it entirely with contemporary paintings and furnishings. In the same year, Paul Poiret, also well known as a fashion designer, established his Atelier Martine. Another celebrated couturière and art patron, Jeanne Lanvin, retained Armand-Albert Rateau to decorate her house and boutique, and Madeleine Vionnet commissioned Jean Dunand similarly to furnish her house with his lacquered furniture.

In 1924, Doucet again sought Modernist designers to decorate the studio which he had commissioned the architect Paul Ruau to design for him in Neuilly to house his collections of Oceanic and African art. Pierre Legrain, who had worked for Paul Iribe during Doucet's earlier commission, was joined in Neuilly by a cross-section of Paris's most avant-garde artist-designers: Eileen Gray, Marcel Coard, André Groult, Rose Adler, Constantin Brancusi, Paul Mergier and Louis Marcoussis.

Damon: *torchère* in nickeled metal, late 1920s.

DA SILVA BRUHNS, *Ivan*
Rug designer
Began as a painter and interior decorator, and received his first rug commission from cabinetmaker Louis Majorelle. The da Silva Bruhns workshop was located in Aisne, and his rugs were often part of major decorative arts exhibitions in the 1920s and 1930s, such as the Exposition Coloniale of 1931.

DAUM FRERES
Jean-Louis-Auguste and Jean-Antonin Daum came from Lorraine and established their first glass factory in Nancy in 1875. They initially made gold-ornamented glass partly based on Arabian designs and fine cameo glass (about 1890). While under Gallé's influence and later under Maurice Marinot's, the Daum factory had an active role in developing high standards of craftsmanship, and the family

won numerous prizes. Until 1920 the Daums were designing exclusively in the Art Nouveau style, but when Paul Daum entered the firm simpler forms began to appear. These were exhibited at the 1925 Paris Exposition. The firm was later directed by Michael Daum, who introduced a sculptural quality to the glass.

In the United States, there appears to have been only one major Modernist collector at the time, Templeton Crocker. A member of a prosperous California railway and banking family, Crocker commissioned Jean-Michel Frank in 1927 to decorate his San Francisco duplex penthouse apartment (6).

In the inter-war years, Paris homeowners could select their furniture from four major department stores – Au Printemps, Le Louvre, Au Bon Marché and Les Galeries Lafayette. A fifth, Trois Quartiers, was established in 1929. The function of these stores was that of arbiter of taste, especially in the promotion of up-to-date household commodities. To serve their clients better, the stores established their own art studios in which to design and manufacture what they believed the customers wanted, rather than what they had previously been forced to accept through lack of choice. The studio for Au Printemps was Primavera, that of Le Louvre, Studium Louvre; that of Au Bon Marché, Pomone, and that of Les Galeries Lafayette, la Maîtrise. The cream of France's young designers – Louis Sognot, René Prou, Robert Block and Etienne Kohlmann – were brought in to direct these studios and their

modern furniture production. The public was easily persuaded that it was, at long last, getting what it wanted. Competition between the department stores spread to smaller firms, such as René Joubert and Philippe Petit's Décoration Intérieure Moderne (DIM), André Domin and Marcel Genevrière's Dominique, Michel Dufet's Meubles Artistiques Modernes (MAM), and Louis Süe and André Mare's La Compagnie des Arts Français. Furniture benefitted by the competition, as designs and materials were modernized. At the 1925 Exposition, both the stores and firms were well placed to present a wide range of ultra-modern household goods to the public.

Styles in furniture and decor
An almost limitless number of French designers applied themselves to the Modernist style. For simplification, the furniture designers of the period can be grouped loosely into three categories: traditionalists, Modernists, and individualists.

The traditionalists took as their point of departure France's eighteenth- and early nineteenth-century cabinet making heritage.

Left Süe et Mare: commode, ebo mother-of-pearl and brass, about 1925; and (**right**) mantel clock, gilt-bronze, about 1925. Both pieces evoke the splendor and sumptuousness of the Louis XV and Louis-Philippe epochs, brought up-to-date by the firm's characteristic stylizations.

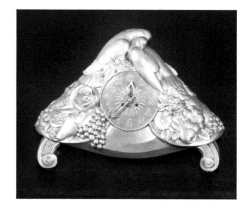

DAURAT, *Maurice*
Metalworker
Daurat, who worked in pewter and elevated it to the status of a precious metal, was attracted to metalwork when he was quite young. He began his career chasing jewelry and working in bronze, and established his own *atelier* to show his work, but he soon made pewter his chosen field.

DECOUER, *Emile*
1876-?
Ceramist
Apprenticed for ten years to Edmond Lachenal before establishing his own studio; exhibited stoneware-porcelain hybrid vessels in the oriental manner throughout the 1920s and was named an artistic consultant from 1942-48.

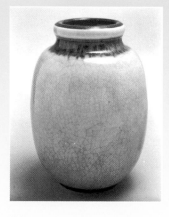
Decouer: pottery vase, about 1924.

DECORATION INTERIOR MODERNE (DIM)
Founded in 1918 by René Joubert and Georges Mouveau with the idea of designing and realizing furniture and interiors. They were joined in 1924 by Philippe Petit, and began successfully manufacturing mass-produced furniture as well as fine and luxurious pieces. Modernist in their design orientation, they sought a pared-down look, and produced light fixtures to

This unimpeachable legacy provided the inspiration for a host of 1920s designers, most importantly, Emile-Jacques Ruhlmann, Paul Follot, André Groult, Jules Leleu, Louis Süe and André Mare, Armand-Albert Rateau, Jean-Michel Frank, Henri Rapin, Maurice Dufrêne, Léon and Maurice Jallot, Eric Bagge, Georges de Bardyère, Gabriel Englinger, Fernand Nathan, Jean Pascaud, René Gabriel, Marcel Guillemard, Suzanne Guiguichon, Blanche-J. Klotz, Lucie Renaudot, Charlotte Chaucet-Guilleré, Georges Renouvin, Pierre Lahalle and Georges Levard, Auguste-Victor Fabre, Pierre-Paul Montagnac, Alfred Porteneuve and the ageing 1900 *maître*, Louis Majorelle. In addition, most of the cabinet makers in Paris's furniture-making quarter, the Faubourg Saint-Antoine, generated a range of proven, rather traditional, models. Mercier frères and Saddier et fils, produced some good-quality furniture in the modern idiom, as did André Frechet at the Ecole Boulle.

The Modernists rebelled against the tightness of the Neo-classical harness, bringing their own blends of individualism – defiant or understated – to the projects at hand. For these, metal was *de rigueur*. The most notable modernists were Jacques Adnet, Edouard-Joseph Djo-Bourgeois, André-Leon Arbus, Robert Block, Pierre Petit, René Prou, Louis Sognot, Charlotte Alix, Michel Dufet Maurice Barret, Léon Bouchet, Georges Champion, Renée Kinsbourg, Maurice Matet, and Paul Dupré-Lafon. These were joined towards 1930 by architects, who moved increasingly into the field of furniture design. René Herbst, Robert Mallet-Stevens, Jean Burkhalter, Pierre Chareau, André Lurçat, Le Corbusier, Charlotte Perriand and Jean-Charles Moreux – to name only the most prominent – extended their architectural designs to the building's interior space and furnishings, giving prestige and authority to the Modernist philosophy.

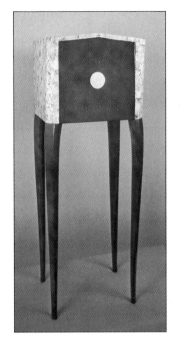

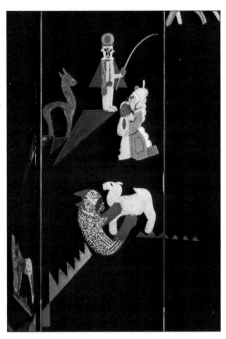

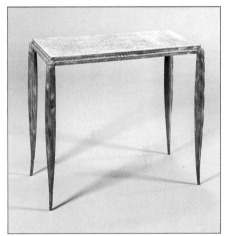

Above DIM: jewelry cabinet, Chinese red lacquer and *coquille d'oeuf*, 1926. **Above right** Jean Dunand: detail of the four-panel screen, "Le Cirque,", showing Jean Lambert-Rucki's design in lacquer and *coquille d'oeuf*. **Right** Jean Dunand: table in lacquered wood and *coquille d'oeuf*, about 1925. In this technique of eggshell inlay, textural patterns were obtained by the careful juxtaposition of the pieces: the outside of the shell has a slightly different texture and hue from the inside, giving subtle variations of tone.

complement their interiors before eliminating them completely in favor of recessed lighting. Among the artists who designed for them were Le Chevallier, Guévrékian, Prouvé and the firm of Venini in Murano. René Joubert died in 1931, and Philippe Petit left soon after. The firm remained in business, however, through the 1940s.

DECORCHEMONT, *François-Emile*
1880-1971
Glassmaker
Born in Conches, France. First works were done in a fine opaque glass paste known as *pâte-d'émail*. About 1907 he succeeded in creating a true *pâte-de-verre* using powdered glass purchased from the Cristalleries de Saint-Denis. Eventually he made his own glass and introduced metallic oxides

for different color effects. Around 1920 he found a formula for a hard translucent substance composed of crystal, and combined the oxide colors with silica. Pieces made in this way were shown at the 1925 Paris Exposition. From 1933 to the outbreak of World War II he worked on *pâte-de-verre* leaded glass windows for churches.

Decorchement: *pâte de verre* bowls, 1920s.

The third group, that of the individualist, relates to those furniture designers whose brilliance and range of influences defy ready categorization. Only four qualify: Pierre Legrain, with his bizarre blend of tribal African and Modernist influences; Irish-born Eileen Gray, with her lacquered Orientalism, whimsy, theatricality and Modernism; Eugène Printz, whose distinctly personal and kinetic designs were constructed in the traditional manner; and Marcel Coard, whose innovative spirit was allowed only infrequent escape from the bulk of his traditional decorating commissions.

Emile-Jacques Ruhlmann was without peer as a cabinet maker. Had France of the 1920s been a monarchy, he would certainly have held the position of *ébéniste du roi*. A strict traditionalist, his forms were elegant, refined and, above all, simple. Nothing comparable had been seen in France for 125 years. It is interesting to note that many of his Art Deco masterpieces were designed before 1920 and not, as one might presume, in the mid-1920s. The 1925 Exposition catapulted Ruhlmann to the forefront of the modern French decorative arts movement. Until then, he had been known only to an exclusive and wealthy clientele. His pavilion at the Exposition, L'Hôtel du Collectionneur, changed that, however. Hundreds of thousands of visitors flocked through its monumental doors to gaze in awe at the majestic interior. Ruhlmann reacted with remarkable equanimity to the post-1925 advent of metal into furniture design, in view of the fact that his reputation rested largely on the use of sumptuous veneers. He adjusted bravely to metal's advances, incorporating it into his designs **(7)** until his death in 1933.

Many of Ruhlmann's contemporaries generated superior furniture. Among the finest were Süe et Mare, whom Jean Badovici described as "an admirable association of two dissimilar minds which combined the best of their qualities to put them at the

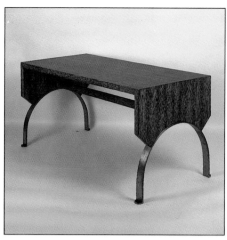

Right Eugène Printz: two-desk-table, palm wood and metal, about 1930; and (**below**) Léon Jallot: two-panel screen, lacquered wood, 1928. Within two years, this type of high stylization had disappeared from Jallot's furniture designs, replaced by an emphasis on metal mounts and the absence of surface ornamentation.

DE FEURE, *Georges*
1868-1928
Furniture designer and book illustrator
Born Georges Joseph van Sluitjers, the son of a Dutch architect. He started work as a craftsman in Holland, and in 1891, after working in a bookbindery in The Hague, he moved to Paris where he produced illustrations for *Le Courrier Français* and *Boulevard*. He changed his last name to Van Furen and then to

De Feure. He founded the Atelier De Feure to produce furniture, with the architect Theodor Cossman as his partner, and he later designed for the London theater. He was also active as a book illustrator. In the 1920s he designed interiors for the *modiste* Madeleine Vionnet. At the Paris 1925 Exposition he designed two of the pavilions.

DELAUNAY, *Sonia*
1885-1979
Textile and fashion designer
Studied in Paris and married painter Robert Delaunay in 1910, adopting his Fauvist style in her textiles. A 1922 design for abstract dresses led to an invitation to work for a Lyons textile firm, and her design program for clothing and accessories, "La Boutique Simultanée," was acclaimed at the 1925 Paris Exposition.

DELORME, *Raphael*
1885-1962
Painter
Born in Bordeaux, attended the city's Ecole des Beaux-Arts. Studied under Gustave Lauriol and Pierre-Gustave Artus. A cousin, Mme Metalier, offered him her castle in Valesnes, where he painted in a style which mixed Art Deco and Neo-classical images, including *trompe l'oeil* and perspective effects. Claimed to have sold only one painting.

service of Beauty. One provides a sure and precise knowledge and a rigorous sense of geometry; the other a refined and delicate sensibility." The result was a highly distinctive and lavish range of furnishings inspired by the Louis XIV, Louis XV, Restauration and Louis-Philippe periods.

Other important furniture designers in Paris included Jean Dunand, who mixed traditional lacquerwork with ultra-modern angular forms. Lacquer exponents tended to concentrate their production on screens and *panneaux décoratifs;* for example, Gaston Suisse, Gaston Priou, and Katsu Hamanaka. In glass, René Lalique extended the traditional uses of the medium in his designs for a series of tables and consoles. Wrought iron was another material used in furniture manufacture in the 1920s. The work of its leading proponents – Edgar Brandt, Raymond Subes, Michel and Jules Nics,

Paul Kiss, Adelbert Szabo and Richard Desvallières – is discussed in the chapter on Metalwork.

Just as there had been a transitional period between the Art Nouveau and Art Deco periods, so there was a gradual progression from high-style Art Deco to Modernism in the late 1920s. Simplicity became increasingly more fashionable. Furniture designers working in the high Art Deco style had to combine their traditional forms with industrial methods and materials. In 1927 an early article about the benefits and beauty of metal appeared in *Art et Décoration.* Furniture by Ruhlmann and Chareau was illustrated in which functional metal components were combined with richly veneered surfaces. By the end of the decade, however, wood had practically disappeared from the furniture shown at the annual salons. The glorious age of France's *ébénistes* had passed.

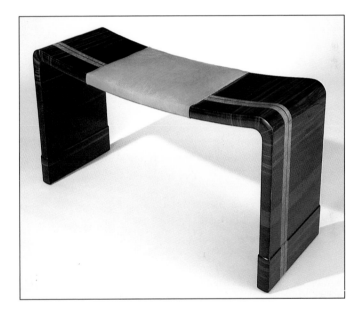

Left Pierre Legrain: fall-front secretaire, sycamore and chromed metal, exhibited at the 1930 Salon des Artistes Décorateurs. **Right** Eileen Gray: bench, Macassar ebony, burr maple, purpleheart and leather, about 1923. Gray produced this model, which takes its influence both from African tribal and Greek precedents, in various woods with lacquered trim.

Delorme: *Architecture,* oil on canvas, 1920s.

DESKEY, *Donald*
b. 1894
Designer, all fields of applied arts
Began his career in advertising, and started to work as a designer in the late 1920s. He became well known in 1932 as the designer of furniture and interiors for Radio City Music Hall in New York. His furniture of the early 1930s set the precedent for the modern style; using aluminum, bakelite and other industrial materials he

pioneered a style based on a mixture of influences from France and Germany. By the end of the 1930s he had turned his attention to industrial and packaging design, and by 1950 his firm Donald Deskey Associates was one of the leading American industrial design firms. He also invented a high-pressure laminate called Weldtex.

Deskey: adjustable table, aluminum and bakelite, about 1930.

Left and below right Bruno Paul: table in veneered wood, 1935, and commode in blue-lacquered wood, 1914. Below left Gunnar Asplund: armchair in mahogany, leather and ivory, manufactured by David Blomberg, Stockholm, 1925. The north European rejection of the French high style is clearly evident in these examples of German and Scandinavian design, in which functionalism takes priority over ornament.

OTHER EUROPEAN COUNTRIES

Although most critics view German design of the 1920s in the context of Modernism embodied by the Bauhaus, many German designers now considered to be Modernists actually created furniture in the contemporary French style. For example, Bruno Paul, of the Munich Vereinigte Werkstätten and Director of the Berlin Kunstgewerbeschule, invariably incorporated an element of richness in his furniture designs. Well into the 1920s, he continued to design pieces in luxurious materials and thick, glossy veneers for the Deutscher Werkbund, a group known for its emphasis on the union of artists and industry. The furniture designed by Paul for the 1927 Cologne exhibition was more in keeping with the Modernist high style in Paris than the machine ethics of the Bauhaus (8).

DESNY

The firm of Maison Desny in Paris, located at 132 Ave. des Champs-Elysées, existed only from 1927 to 1933. It consisted of two men, one of whom was René Nauny. Both had originally been connected with the circus, where they had worked as set designers. During its brief existence the firm produced entire interiors for a select clientele, designing furniture, murals, rugs, lighting and decorative objects, all in a refined and starkly original Modernist style. They worked closely with Robert Mallet-Stevens, Djo Bourgeois, Jean-Michel Frank, Alberto and Diego Giacometti and André Masson.

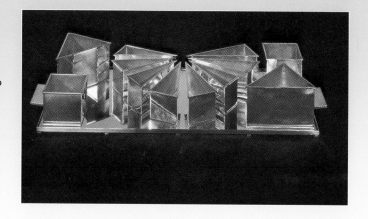

Desny: surtout-de-table, silver-plated metal and mirrored glass, about 1925.

According to a contemporary critic, ". . . [For the traditionalist] the home is not merely an expression of purpose, a "living machine", but a pleasant place to be. Such an artist will also add to pure utility something to beautify it. He will give grace to the form . . . and not be adverse to adding a little carving. The head and footboards of beds he will turn into beautiful silhouettes."

German designers thus made expensive custom-made furniture in limited quantities. According to the same critic, "Special attention is paid here to the wood used and to the finish. The simpler and more severe the piece the more attention is paid to the materials. Especially handsome inlaid pieces are preferred because it is possible by clever assembling of veneers to achieve beautiful patterns . . . "

That observation drew an obvious comparison with the well-crafted and sumptuous cabinetry of France's foremost furniture designers, such as Ruhlmann and Leleu, who catered to a similar elite clientele.

French-inspired furniture was also produced in Scandinavia. From the early 1920s, individual designers and companies in the industrial arts gathered forces in preparation of the 1925 Exposition. Denmark and Sweden each had its own pavilion, in addition to stands in the Grand Palais; Finland exhibited only in the joint facility. Erik Gunnar Asplund was perhaps the premier Scandinavian designer to work in the Modernist style. He designed an armchair made of mahogany, leather and ivory in about 1925, produced by David Blomberg of Stockholm, in a style which evoked the Paris fashion. The chair was part of a suite of furniture favorably reviewed by the critics at the 1925 Exposition (9).

In Britain, the design aesthetic throughout the first half of this century, including the inter-war years, was primarily conservative and traditional. Sir Gordon Russell and Sir Ambrose Heal designed a variety of furniture, mostly of simple post and panel construction, which showed how English furniture at the time was still steeped in the Arts and Crafts tradition initiated by William Morris (10). Yet, again, some furniture created by Russell and Heal at the time of the 1925 Exposition was more evocative of the contemporary style in France. Russell designed a boot cupboard in 1925 in Honduras mahogany in a style very similar to French models introduced a few years earlier (11). And in 1929 Heal produced a desk and chair in weathered oak on which the perpendicular detailing again betrayed the influence of contemporary Continental models (12).

The general absence of furniture in England in the Modernist style was punctuated by a handful of spirited avant-garde models. Sir Edward Maufe, an architect known principally for the Guildford Cathedral, designed a range of furniture that appears to have been inspired by Paris. A typical example is provided by a desk manufactured by W. Rowcliffe in around 1924, and exhibited at the 1925 Exposition (13). Made of mahogany, camphor and ebony gessoed and gilded with white gold, the desk had all the sumptuousness and ostentation characteristic of prominent French models. This was perhaps partly due to the influence of Maufe's wife, who worked for Sir Ambrose Heal.

Betty Joel, née Lockhart, was born in China in 1896. At the end of World War I she and her husband established their decorating firm in South Hayling, near Portsmouth, with a showroom on Sloane Street, London. Early designs revealed the fact that she was self-taught. By the end of the 1920s, however, she had developed a distinctive furniture style in which curved contours (described by her as silhouettes of the female form) predominated. Superfluous moldings and projections were eliminated; ornamentation was

DESPRES, *Jean*
1889-1980
Jeweler
Born in Souvigny, and worked as a laborer in the aviation industry during World War I. His experience with industrial design and metalwork led to his interest in precious metals and jewelry design. Much of his jewelry was painted and engraved by Etienne Cournault.

Despres: silver necklace, about 1925.

DESPRET, *Georges*
1862-1952
Glassmaker
Born in France. At the Paris Exposition of 1900 exhibited some bowls in the *pâte-de-verre* techique popularized by Cros. Had begun experiments previously (in 1899), working with a dense opaque-colored paste which produced jewel-like results.

achieved through a range of luxurious, contrasting veneers. Joel's firm won many commissions to decorate libraries, boardrooms, shops and hotels. Joel is remembered today primarily for an inexpensive line of furniture aimed at the working woman. Many of her designs were popularized by English manufacturers of modestly priced furnishings. She retired in 1937.

THE TRIUMPH OF MODERNISM

No unified furniture aesthetic emerged at the Paris Exposition. Rather, there was an uneasy coexistence of contradictory images and styles. Varnished rosewood appeared alongside tubular nickeled steel; the Cubist rose competed with Constructivist geometry; and the brilliant colors derived from the Ballets Russes and the Fauves clashed with the subdued tints used by Modernists who embraced Le Corbusier's preference for achromatism.

Even before 1925 there had been signs of a reaction against the excessive ornamentation of Paris's high-style furnishings and *objets d'art*, opposition which gathered force increasingly after the Exposition closed. Amedée Ozenfant and Le Corbusier's *L' Aprés le Cubisme*, written in 1913, advocated a universal style stripped of ornament and, even, individuality, which owed its inspiration to the machine. The tenets of Russian Constructivism, upheld by Nikolaus Pevsner, espoused similar concepts. The architecture of the avant-garde Russian Constructivists, such as Konstantin Melnikov's USSR pavilion at the Exposition, contrasted sharply with the prevailing Beaux-Arts architectural style in France, seen in such gaudy structures at the Exposition as A. Laprade's pavilion for Studium Louvre and A. C. Boileau's pavilion for Au Bon Marché. Observers were reminded that progressive foreign design advocated a sharp reduction in ornamentation. In Paris, the deluxe *ébénistes* were put

on notice that unique or limited editions of largely hand-crafted, sumptuous furniture were no longer feasible, for either commercial or aesthetic reasons. The style had lost favor with its former patrons, who now preferred the simplicity and functionalism of a more contemporary, machine-related style.

In 1930, a new organization was formed to give identity to the group of designers who took Modernism as their doctrine: this was the Union des Artistes Modernes (UAM). Members included René Herbst, Francis Jourdain, Hélène Henri, Robert Mallet-Stevens, Pierre Chareau, Raymond Templier, Edouard-Joseph Djo-Bourgeois, Eileen Gray, Le Corbusier and Charlotte Perriand. These architects and designers rejected the excessive ornamentation characteristic of the Paris salons of the early 1920s, and gave priority to function over form. They designed furniture in materials such as steel, chrome and painted-metal tubes, in which individual elements were designed for mass production.

Tradition and innovation

Certain designers, such as Pierre Legrain, Jean Dunand, and Marcel Coard, adopted a middle ground in which they incorporated only the angular forms of the newly emerging Modernist style while continuing to work almost exclusively in rare and precious materials. Their clientele was limited increasingly after 1925 to patrons such as the influential couturiers Jacques Doucet and Madeleine Vionnet.

Modern interiors and tubular-metal furniture began to be featured in *Art et Décoration* and *Mobilier et Décoration* soon after the 1925 Exposition. By 1927 furniture by such Modernists as Adolf Rading, Hans Ludwig Hilderseimer, Le Corbusier, Pierre Jeanneret, Mart Stam and Marcel Breuer was being featured in arts reviews,

DESVALLIERES, *Richard*
b. 1893
Metalworker
Born in Paris, the son of the painter Georges Desvallières. He learned traditional methods of ironwork, and refused to incorporate modern techniques into his work. He did a body of work for Süe et Mare's Compagnie des Arts Français as well as grills, firescreens and various items of furniture, some quite massive, for his own *atelier*.

In 1933, he executed the interior ironwork for the Eglise Sainte-Agnès de Maisons Alfort.

Desvallières: wrought-iron center table, 1920s.

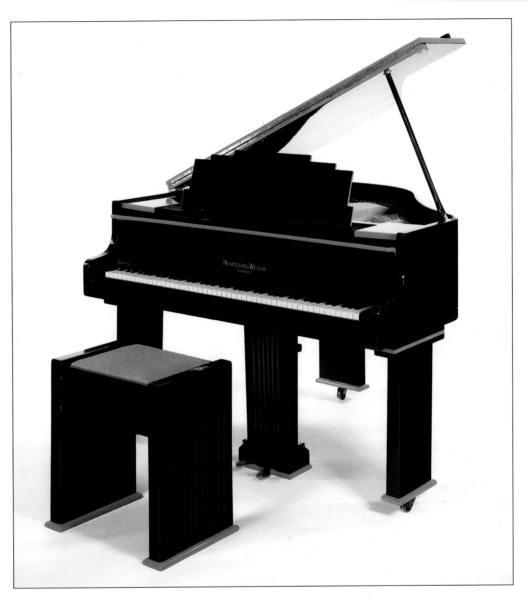

Above Sir Edward Maufe: desk in mahogany, camphor and ebony, gessoed and gilded with white gold, manufactured by W. Rowcliffe, England, 1924-5. The application of a bright gold finish to the piece was uncharacteristic of English furniture design in the 1920s, and was probably inspired by similar gilt- and silver-leaf models created at this time in Paris by Paul Poiret's Atelier Martine. The application of tasseled pulls further suggests Poiret's theatrical influence. **Right** Monington & Weston: baby grand piano and stool, lacquered wood, about 1930. As the fashion for inner-city living grew, the scale of most pieces of furniture, such as this piano, was reduced to accommodate them in small flats or townhouses.

DIEDERICH, *Wilhelm Hunt*
1884-1953
Wrought-iron, ceramic and fabric designer
Born in Hungary, emigrated to the United States at the age of 15. He lived in Boston with his uncle, the artist William Morris Hunt, before beginning his studies at the Pennsylvania Academy of the Fine Arts. He worked in ceramics and fabric design, but is best known for his work in wrought-iron.

DJO-BOURGEOIS, *Edouard-Joseph*
1898-1937
Furniture designer
Born in Bezons, France. Studied at the Ecole Speciale d'Architecture, and in 1923 joined Le Studium Louvre and made his début at the salons. At the 1925 Paris Exposition he exhibited two ensembles in the Studium Louvre pavilion: a smoking room and office/library. After 1926 he established his own business and developed a group of avant-garde clients. He used modern furniture materials in his designs, replacing his earlier preference for combinations of wood and glass with tubular metal, aluminum, iron and concrete. Frequent collaborators through the years were Paul Brandt and Louis Tétard.

providing an increased awareness of the internationalism of the new Modernism.

And by the end of the 1920s, tubular-steel furniture was being created both by architects and furniture designers. The public was asked to reconsider the aesthetic merits of utilitarian, even humble materials such as steel and metal alloys for furniture production, in place of the proud and royal traditions of France's eighteenth-century cabinet-makers. Metal entered the home through the kitchen door – in the traditional manufacture of metal household utensils – after which it gradually worked its way into the other rooms of the house. Final, and complete, acceptance came in the selection of metal rather than wood for salon and dining-room furniture, to be seen and used by guests.

The infiltration of Modernist furniture into the home and office was not restricted to France. It had, in fact, developed more quickly in more progressive countries. Germany is often considered the pioneer nation in the development of the modern movement. The Belgian designer Henry van der Velde founded the Weimar School of Applied Arts in 1906, which was absorbed in 1919 by Walter Gropius who, in turn, founded the Bauhaus. This was an attempt to unify all disciplines within the decorative arts under the general direction of architecture.

The Bauhaus instructors and their students advocated rational and functional design, and an increased dependence on the machine for mass-production. One of the most important Bauhaus furniture designers was Marcel Breuer who, with Mart Stam and Ludwig Mies van der Rohe, was the first to develop the cantilevered tubular metal chair. Later, in England, Breuer explored further the use of industrial materials in his design of a laminated-plywood lounge chair, manufactured by the Isokon Furniture Company, London.

New developments in Eastern Europe at the time reflected a similar adherence to the new Modernist philosophy. In Prague the Prazske Umelecke Dilny (Prague Art Shop) had been founded in 1912. Leaders of this school included Pavel Janak, Josef Chocol, Vlatislav Hofman, and Josef Gocar, who designed furniture inspired by the Cubism of Braque and Picasso, and some of whom believed that only a designer's artistic concepts were important, that technical and functional aspects of design were secondary. Examples of the school's furniture were exhibited at the 1914 Deutscher Werkbund exhibition in Cologne. The outbreak of World War I put an end to the endeavor.

Functionalism

The De Stijl group was formed in 1917. Theo van Doesburg, Gerrit Rietveld and Félix Del Marle designed furniture intended to fill the utopian interior spaces conceived by the leaders of the movement, Piet Mondrian and van Doesburg. Their furniture was angular and skeletal, of simple construction, employing planar, wooden boards painted either black or in the primary colors used by the De Stijl artists.

By the late 1920s, the functionalism championed by the Bauhaus had begun to assert itself in Scandinavia. This influence was felt most strongly in Sweden, which was more receptive to avant-garde German ideology than its neighbors. Some of the Bauhaus's most fruitful and artistic ideas were evident in furniture shown at the landmark 1930 Stockholm exhibition, held at Nordiska Kompaniet (NK) department store. The exhibition revealed a revolutionary attitude to domestic design, with special emphasis on residential architecture and furnishings. In keeping with modern concerns for practicality, flexibility and hygiene, dwellings at the exhibition had

DOMINIQUE
Decorating firm founded in 1922 by André Domin, a self-taught artist, and Marcel Genevrière, a trained architect. The company offered a wide range of carpets, fabrics, furniture and wrought-iron. Two important commissions were Jean Puiforcat's home and the Houbigant perfume factory at Neuilly. At the 1925 Paris Exposition they designed the salon in the Ambassade Française, and in the same year they were awarded first prize for their entry in a chair competition organized by the Union Centrale des Arts Décoratifs. In 1926, together with Pierre Chareau, Pierre Legrain, Jean Puiforcat and Raymond Templier, they exhibited at the Galérie Barbazanges as the Groupe des Cinq.

DORN, Marion
1899-1964
Rug and textile designer
Studied graphic art education at Stanford University. Moved to Paris in 1923 and began a lifelong relationship with the graphic designer Edward McKnight Kauffer, whom she married in 1950. She first made textile hangings in the 1920s and turned to collaboration on rugs in 1927.

DUFET, Michel
b. 1888
Interior designer
Born in Deville-les-Rouen, France. Studied architecture and painting at the Ecole Supérieure des Beaux-Arts, Paris. In 1913 he established the furniture retailing firm of MAM (Meubles Artistiques Modernes). The following year he made his début at the SAF, exhibiting again after the war, and entering into partnership with the painter

large windows, light walls and a minimum of furnishings. The furniture was geometrical in shape and extremely light, with restrained decoration.

The new furniture forms developed by the Bauhaus architects had a profound impact on international design by the 1930s. Noteworthy were Breuer's bent tubular-steel models, which were imitated, with modifications, throughout Europe. In Scandinavia, however, designers preferred to incorporate Breuer's functionalism with traditional materials, such as wood, in serial production.

Bruno Mathsson is probably the best-known Swedish designer of the period. One of his more notable furniture designs was the Eva chair of 1934, produced by the Firma Karl Mathsson in Varnamo. Made of bent beech upholstered in woven fabric, the model was sculpturally molded to fit the human body. Mathsson's experiments in bent and laminated wood, combined with his studies of function and maximum comfort, generated many popular designs

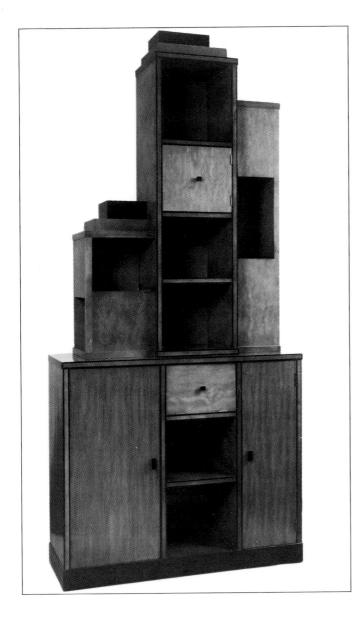

Left Paul T. Frankl: "Skyscraper" bookcase/cabinet, birch and lacquer, about 1928; and (**right**) "puzzle" desk, red lacquer with silver-leaf drawers and silvered handles, about 1927. The first designer in the US to embrace the skyscraper as a decorative motif, Frankl quickly denounced it as a "monument to greed" when the economy began to unravel following the Wall Street crash.

Louis Bureau until 1924. In 1922 he founded the art magazine *Les Feuilles d'Art*, and in 1923 he became director of a firm of interior decorators, Red Star, in Rio de Janeiro. The 1930s brought numerous commissions, and in 1932 he furnished a waiting room for the Commissariat General of the Colonial Exposition. Commissions for the liners *Normandie*, *Foch* and *Ile-de-France* followed.

DUFRENE, *Maurice*
1876-1955
Interior designer
Born in Paris, studied at the Ecole des Arts Décoratifs. In 1899 he started to work as a designer for Julius Meier-Graefe's La Maison Moderne. In 1904 he became a founding member of the SAD, through which he exhibited for 30 years. In 1921 he was appointed artistic director of La Maîtrise. He edited three volumes of

Ensembles Mobiliers, devoted to the interior design shown at the Paris 1925 Exposition, and also published an album of plates of interiors at the 1926 salon of the

SAD. He did a similar album for the Paris Exposition of 1937.

Dufrêne: bedroom furniture for La Maîtrise pavilion, 1925 Exposition.

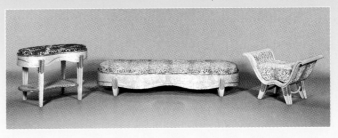

which have remained in continuous production since their conception **(14)**.

At the same time, designers in Denmark moved into new areas of experimentation. Kaare Klint made furniture which combined practicality with economy. His first independent commission was to design exhibition cases and seats for the Thorwaldsen Museum of Decorative Arts in Copenhagen. His Red Chair, designed in 1927 for the museum, was widely acclaimed.

Alvar Aalto began to design modern furniture in the 1920s. His "Scroll" or "Paimio" armchair, of around 1929, has become a classic

Right Kem Weber: armchair in Macassar ebony, probably for the Kaufmann department store, San Francisco, about 1928. **Below** Josef Urban: table and armchairs, ebonized wood and mother-of-pearl, about 1922. Displayed in the Wiener Werkstätte Gallery in New York, these pieces show both Urban's training as a theater set designer and his participation in the Vienna Secession movement at the turn of the century.

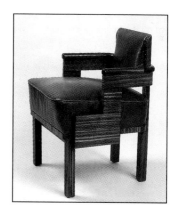

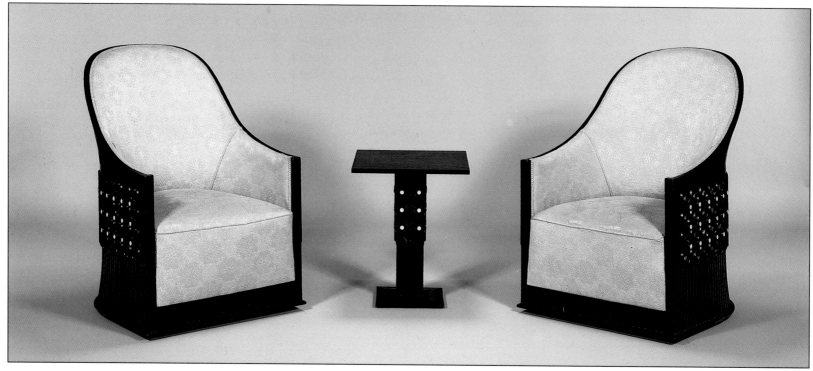

DUFY, *Raoul*
1877-1953
Painter, graphic artist, textile designer
Best known as a painter, but also noted for his illustrations to Guillaume Apollinaire's *Bestiaire* (1908). In 1911, he met and was employed by Paul Poiret to design fabrics for the Atelier Martine; the following year he moved to the firm of Bianchini-Feriér, where he designed clothing and furnishing fabrics

until 1930. For the next three years he designed printed silks for Onondaga of New York.

DUNAND, *Jean*
1887-1942
Dinandier and lacquerer
Born in Switzerland, went to Paris in 1896 after studying in Geneva. He intended to become a sculptor, but turned to *dinanderie* around 1902, working in copper, steel and pewter. His first works were Art Nouveau in feeling, but gradually his forms and decorations evolved to more simple, geometric stylizations, and he increased his repertoire

of objects. He began learning the technique of lacquer in 1912, and this became his most important means of artistic expression. He worked in close collaboration with Legrain, Printz, Ruhlmann and Goulden, and among his important works were lacquer panels for the ocean liners *Ile de France*, *l'Atlantique* and *Normandie*.

Dunand: metal and lacquer vase, 1920s.

of modern Finnish design. The frame and seat are made of laminated and painted bentwood. The model captures the qualities of functionalism and lightness sought in tubular-metal furniture, adding a pleasing note of grace in its use of natural wood and sinuous curves. Aalto's bent and laminated wood stacking stools of 1930–33, produced by Korhonen in Turku, were also very successful commercially due to their formal simplicity and inexpensiveness. The stools have remained entirely practical and adaptable to multiple requirements **(15)**.

Other Scandinavian designers also experimented with tubular steel. In 1929, Herman Munthe-Kaas of Norway designed an armchair produced by the Christiania Jernsengfabrikk, of Oslo. Although its form is based on Breuer's tubular-steel prototype, the model differs in its incorporation of an unusual metal-strap back and a series of simple string hooks that support the upholstered seat.

Serge Ivan Chermayeff, a Russian émigré who trained initially as an artist in Paris, has been credited with the introduction of the modern movement into Britain. After marrying into the Waring & Gillow family in 1928, Chermayeff persuaded his in-laws to allow him to stage an Exhibition of Modern French and English Decoration and Furniture at the family's Oxford Street department store, for generations the bastion of ultra-traditional period-revival furniture in England. The exhibition received great critical acclaim in January 1929, in the *Architectural Review*, then the mouthpiece for Britain's Modernist movement. Chermayeff was singled out for his red and black bathroom and "brilliant English suite," the latter furnished without any trace of the expense or hand-craftsmanship associated with the traditional decoration of an English country cottage. His chromium-plated metal tubular furniture and unit storage systems represented a dramatic departure from the sterile tradition-bound models of his adopted country.

The designer John C. Rogers was also instrumental in bringing the modern style to England. In an article in the *DIA Journal* (the publication of the Design and Industrial Association), Rogers had begun as early as 1914 to instill a new spirit of design into British industry. He pleaded for a national conversion to Modernism and for a final rejection of the Arts and Crafts philosophy. In 1931, Rogers visited the Bauhaus in Dessau with Jack Pritchard and Wells Coates, a trip which inspired the furniture he exhibited at Dorland Hall, London, two years later. In 1932, in collaboration with Raymond McGrath and Coates, Rogers redesigned the interior of the BBC; he later emigrated to the United States.

Wells Coates was another major proponent of the modern movement in England, falling under the influence of Marcel Breuer, who between 1935 and 1937 was a design consultant to the English firm of Isokon (the name is a contraction derived by Pritchard of "Isometric Unit Construction"). Coates designed modern furniture in the 1930s for PEL (Practical Equipment Ltd), including an ebonized wood and chromium-plated metal desk inspired by an earlier Breuer model manufactured by Thonet from 1929 **(16)**. In 1935 PEL manufactured the tubular-steel furniture Coates designed for his Embassy Court flats in Brighton.

Sir Gordon Russell was another English designer influenced directly by Bauhaus principles. His Murphy Radio cabinet of 1931 shows distinct similarities to models created earlier in Dessau. The work of Denham MacClaren, whose Modernist furniture designs included a glass, painted-wood and chromium-plated metal table in 1931, has remained relatively obscure, as has that of Gerald Summers, who designed a chair in laminated birch for the Makers of Simple Furniture in around 1934 **(17)**.

DUPAS, *Jean*
1882-1964
Painter and poster artist
Attended the Ecole des Beaux-Arts, Bordeaux, with advanced studies in Paris. He won the Prix de Rome in 1910. In the early 1920s he painted two important works, *Jugement de Paris* and *les Antilopes*. He carried out posters and catalogue covers for the SAD, and porcelain decoration for Sèvres, and a mural on the subject of history of navigation in the grand salon of the ocean-liner *Normandie*.

Dupas: *Woman in Furs with Doves*, oil on panel, 1920s.

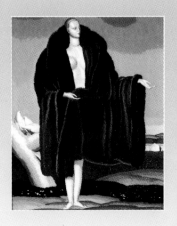

THE UNITED STATES

In the United States, the high Parisian style of the 1925 Exposition was rejected by the public, who viewed it as a Gallic eccentricity too exuberant for traditional local tastes. When Modernism established itself in America in the late 1920s, it was the northern European strain of machine-made, mass-production metal furniture which found acceptance.

Although Paris was across the Atlantic, it was not too far for its influence to be felt in the United States. American designers were well aware of the prevailing Modernist style in Paris through periodicals of the day, and through a succession of exhibitions that traveled across the country in the second half of the 1920s. A loan exhibition of items from the 1925 Exposition opened at the Museum of Fine Arts, Boston, in January 1926, from where it proceeded to The Metropolitan Museum of Art, New York, and six other US cities. More than 36 museum and department store exhibitions of avant-garde European furnishings and decorative arts followed in as many months across the United States.

Correspondingly, attempts were made on occasion to introduce a flamboyant European style of furniture, some noteworthy. The Company of Mastercraftsmen in New York, for example, produced shameless copies of contemporary French models, replete with marquetry panels and ivory trim. Joseph Urban, an Austrian

likewise designed somewhat theatrical furniture, such as a table and armchair, in around 1920, of classical proportions and adorned with mother-of-pearl inlays, manufactured by the Mallin Furniture Company (18). In Chicago, the designer Abel Faidy designed a similarly ornate suite of lounge furniture for the Charles and Ruth Singleton residence in 1927.

One of the finest Modernist furniture designers in the United States was Eliel Saarinen, a native of Finland. For his house at Michigan's Cranbrook Academy, Saarinen designed a dining-room ensemble which drew on the principles of French Modernist design. The chairs have classically fluted backs emphasized by the contrasting colors of the pale fir veneer and intersecting black-painted vertical stripes. The accompanying table is inlaid with an elegant geometrical pattern which recalls the restrained parquetry designs introduced by Dominique and DIM in Paris some years earlier.

The German Karl Emanuel Martin (Kem) Weber was trapped in California at the outbreak of World War I. Refused permission to return to his homeland, he settled finally in Los Angeles, where he joined the design studio at Barker Bros. as a draftsman. In 1927 he opened his own design studio in Hollywood, listing himself as an industrial designer. Not only was Weber virtually the only decorative-arts designer to embrace the Modernist creed on the West Coast, but his style was highly distinctive. For the John W. Bissinger residence in San Francisco, Weber created a striking suite of green-painted bedroom furniture enhanced with Hollywood-type decorative metal accents.

Eugene Schoen, a native of New York, also created furniture in a restrained Modernist style. After visiting the 1925 Exposition, he established his own interior decorating firm in Manhattan. Some of his more notable models, manufactured by Schmied, Hungate & Kotzian, betrayed a strong French influence in their Directoire-style sabre legs and fluted backs (19).

Paul T. Frankl is known primarily for his skyscraper furniture, inspired by the recesses on the tall buildings which soared above his New York gallery. He also created a man's cabinet and series of

EIFF, *Wilhelm von*
1890-1943
Glassmaker, jeweler
Born in Germany. Started as a painter but then spent four years as an apprentice in the Württemberger Metallwarenfabrik, after which he went to Paris to concentrate on glass and stonecutting. He completed his studies in Stuttgart where he settled in 1913. After World War I he was appointed Professor in the

workshops for glass and stonecutting at the Stuttgart School of Arts and Crafts, and worked there until his death. One of the techniques that he developed was glass etching using electrical tools.

"puzzle" desks that incorporated materials and finishes found on contemporary French models: red and black lacquer, gold- and silver-plated metal, and gold and silver leaf **(20)**. Curiously, the quality of the cabinetry in Frankl's furniture failed to match the novel architectural forms which he introduced.

Many other designers in the United States created Modernist wood furniture, much of it manufactured in the industry's principal center, Grand Rapids, Michigan, by firms such as Berkey & Gay, the Johnson-Handley-Johnson Company and the Imperial Furniture Company. Included were Herman Rosse, Ilonka Karasz, Jules Bouy, Herbert Lippmann, Ely Jacques Kahn, Robert Locher, Winold Reiss, and Norman Bel Geddes. Furniture manufacturers such as the Herman Miller Furniture Co., in Zeeland, Michigan, the Troy Sunshade Co., in Troy, Ohio, and the Ypsilanti Reed Furniture Co., in Ionia, Michigan, retained designers such as these to provide them with models for their lines of mass-produced furniture.

In metal furniture, Donald Deskey emerged as the country's premier designer, combining the luxury of French Modernism with the technology of the Bauhaus. One of the finest examples was his dining table for the Abby Rockefeller Milton apartment, in 1933–34. Although the piece included a Macassar ebony top, it was the inclusion of new materials – polished chrome and glass, and the siting of a bulb beneath the top to provide dramatic lighting effects – that drew the critics' praise. For his interiors for the Radio City Music Hall in 1932, Deskey set convention aside in a display of ostentation intended to buoy the Depression-wracked nation seeking refuge in movies and live entertainment. The private apartment above the Music Hall which Deskey designed for the Music Hall's impresario, Roxy Rothafel, was even more lavish **(21)**.

Several other designers in the United States created excellent

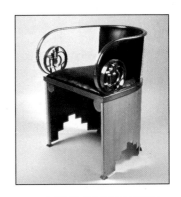

Right Walter von Nessen: armchair, aluminum and brass with red leather upholstery, about 1928. Like Frankl, von Nessen incorporated the skyscraper motif in his lighting and furniture designs, as shown here in the stepped cut-outs on the curved foot. **Below** Betty Joel: chaise longue, beechwood upholstered in cream silk, about 1930.

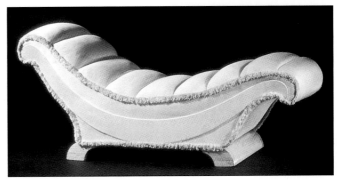

metal furniture in the late 1920s and 1930s, in particular Gilbert Rohde, Wolfgang and Pola Hoffmann, Warren McArthur, Walter Dorwin Teague, and the lighting specialist Walter von Nessen **(22)**. Walter Kantack, a New York metalware manufacturer, also produced inspired metal pieces of furniture, as did the architect William Lescaze, of Howe & Lescaze.

By the mid-1930s, it was evident that metal had won the battle with wood for the domestic US furniture market. Whereas wood continued to be preferred in some sectors of the household market, metal continued increasingly to win adherents.

ERTE
b. 1892
Graphic artist, fashion and theater designer
Born Romain de Tirtoff in Russia and studied at the Académie Ranson, Paris. Joined Poiret in 1913. He moved to Monte Carlo in 1914, designing magazine covers and fashion plates for *Harper's Bazaar* and he also designed stage sets and costumes for ballet, opera, films and night clubs, including the Folies

Bergères. He later worked in Hollywood, and he still designs lithographs.

Erté: cover for *Harper's Bazaar*, 1934.

LIGHTING

The invention of electricity and the development of the electric light were among the most revolutionary events in human history. To be able, at the touch of a switch, to command an unlimited supply of light which required no replenishing, gave off no smoke, produced little heat and, above all, posed virtually no risk of fire, was truly miraculous. Electric lighting is now so much a part of our lives that it is hard for us to appreciate how recent an invention it is, and how truly new it was in the 1920s; so new, in fact, that no one seemed to know quite what to do with it.

The interior designers were the first to realize that electric lighting was a novel element of decoration, something that could be adapted to any flight of fantasy. It is no wonder that some of the early results were a bit theatrical. Light bulbs were placed behind faceted glass pendants or imprisoned in globes of paper or silk. Floor lamps in painted wood with silk shades resembling mushrooms or umbrellas were draped with lace or embroidery so that only a filtered light could penetrate. Finally – and here one can detect the germ of a revolutionary idea – transparent or translucent objects were transformed into lamps. Cameo glass and porcelain vases were drilled for an electric cord. Some designers created fantastic animals: glowing owls, cats, fish and salamanders, not to mention creatures seen only in nightmares, graced table tops and boudoirs. While most of this was little more than an exercise in bad taste, it was a step forward in that the designs were meant expressly for electricity.

Right Süe et Mare: chandelier, gilt-bronze and alabaster, early 1920s. **Below** French wall sconce, designer unknown: wrought iron, glass, and enameled metal, early 1920s. The enameling was done by Camille Fauré. By 1925 the use of color, such as seen here, in light fixtures, had become unfashionable. Its place was taken by molded opalescent glass, usually white or lightly tinted, which controlled the passage of light rather than drawing attention to the fixture itself. **Far right** Table lamp by Daum frères, made in the 1930s is etched opalescent glass.

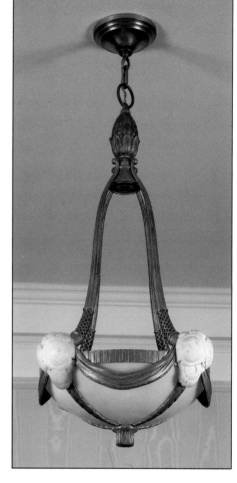

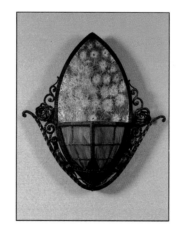

FOLLOT, Paul
1877-1941
Interior designer
Born in Paris, the son of a successful wallpaper manufacturer, studied design under Eugène Grasset. His furniture in the prewar years is today classified as "pure" Art Deco, and the Musée des Arts Décoratifs anticipated the importance of his work by purchasing several pieces directly from the 1912 Salon. In 1923 he accepted the directorship of the design studio Pomone, opened by Au Bon Marché. With assistance he designed all the rooms in the Pomone pavilion at the 1925 Exposition, and he remained with Pomone until 1928, when he joined Chermayeff at the newly established Paris branch of Waring & Gillow. When the firm disbanded its Paris office in 1931, he reverted to his role as an independent decorator.

Follot: dressing table, giltwood and marble, 1920.

A PARTNERSHIP OF GLASS AND METAL

It was in the field of wrought-iron (see Chapter 9), that designers first saw and understood the possibilities of electric lighting. The ironworkers were braver than the bronze manufacturers in creating designs meant expressly for electricity. They created sumptuous and unique pieces at the forge, their main difficulty being the problem of creating a successful union between robust metal and fragile glass – alabaster, which was much tougher and more substantial, was one solution, but it filtered out too much light. This

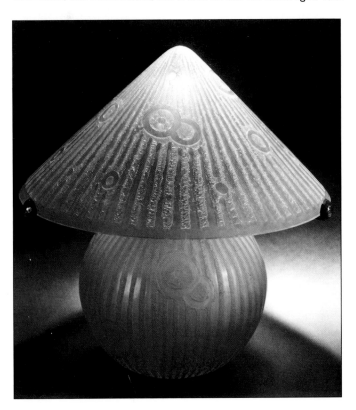

problem stimulated ironworkers and glassmakers to work together, and glass manufacturers such as Daum, Lalique, Muller and Sabino worked with wrought-iron designers to create glass coupes that were functional and added to the decorative qualities of the fixtures. The results were beautiful and served their purpose well, but they did little to advance the progress of a truly modern science of lighting design. They continued to exaggerate the importance of the armature, often relying on the multi-armed candelabrum form of earlier days for the basic design of hanging fixtures and sconces.

It was probably Maurice Dufrêne, a French furniture designer and interior decorator, who first had the idea of suspending basins of alabaster or glass from the ceiling by means of a simple cord. (This was an improvement over what was then being done in Austria and Germany, where designers had also adopted the use of cords, often criss-crossing them into a decorative network.) René Lalique used this simple idea of a suspended basin as the point of departure for his extraordinarily successful lighting. The quality of Lalique's glass and his varied, original, and always tasteful designs put him far ahead of others. His simplest designs consisted of shallow bowls in frosted or tinted glass; peach and yellow tones were favored because they blended well with most decors and were flattering. These simple shapes were molded in high relief with a variety of fruit and floral motifs, some quite true to nature, others stylized. As Lalique responded to more Modernist trends, he created strong, geometric forms for his hanging fixtures.

Lalique liked to play with the transmitted effects of light through glass, and experimented with ways in which it delineated forms which were either molded as figures, cast in high relief, or molded in intaglio. Strikingly effective, the concealed light source defined all the subtleties of the molding to create an object that seemed to

FONTAINE ET CIE
A firm which produced decorative hardware for over 100 years. They hired many prominent artist and designers, such as Süe et Mare, Maurice Dufrêne, René Prou, André Groult and Pierre-Paul Montagnac.

float in space. This was fully exploited in the *surtouts-de-table* that Lalique began to produce around 1925, comprising a thick slab of glass molded in intaglio. When illuminated from within their bronze bases, the effect was impressive, although not altogether practical, for they did not give off much light. They were, however, a logical extension of his glass *luminaires* and boudoir lamps, designed to resemble vases sprouting anything from sprays of flowers to pairs of lovebirds and cupids. Dramatic and original, they were the perfect pairing of romantic subject and soft, glowing light. For other glass artisans who sought to create lighting with their own personal stamp, the major difficulty was to avoid repeating what Lalique had already done.

There were additional technical problems still to be overcome. Glass can be temperamental and full of nasty surprises. Molded glass, however, is strong and resistant to breakage, and reflects and diffuses light in a very pleasing way. Molded glass elements held by the thinnest possible armatures resulted in lighting that was decorative, functional and modern for its time.

Ernest Sabino, who was one of Lalique's most successful competitors, favored motifs of flowers and branches in intaglio and relief, and sought to vary his designs and compositions to produce something original. His firm took several stands in the Grand Palais at the 1925 Exposition, where it displayed numerous hanging fixtures and sconces in colorless pressed glass. For the occasion, Sabino designed everything himself, and the glass was produced in his own workshops – a facility that gave him an edge over much of the competition because he did not have to rely on collaborators. Furthermore, his designs were meant for mass-production, which made the prices very attractive.

Simonet frères was one of the oldest bronze houses in the Archives quarter of Paris. Their strong, solid reputation, earned through years of doing fine restorations, did not keep them from being among the first drawn into the currents of new design. Indeed, Albert Simonet was one of the first to realize that electricity required new designs for lighting, and not simply a reworking of gas and candle fixtures. Even though his early work was strongly influenced by eighteenth-century designs, it was modern in its use of the decorative basin suspended by silk cords; his glass sconces were simple in form and flush to the wall. Consequently, his firm was one of the most prominent entrants in the competition when, concerned by the lack of new ideas in lighting, La Chambre Syndicale des Fabricants de Bronze, aided by L'Union des Syndicats d'Electricité and La Société pour l'Encouragement à l'Art et à l'Industrie promoted a Grand Concours du Luminaire Electrique, offering a 50,000-franc prize. Although Simonet did not actually win, their offering received excellent notices.

In 1925, Simonet frères completely overhauled their operations. Bronze became secondary, and they devoted their attention to the design of glass elements for lighting fixtures. They abandoned their earlier forms, and commissioned the sculptor Henri Dieupart to design sections of pressed glass, modern in concept, that would give off a flattering play of light from their surfaces. The firm's glass technicians had meanwhile devised a method of improving the quality of these pressed-glass sections and of eliminating many of the problems in casting glass.

Experiment and innovation

There were two major differences between the old and the new orders of lighting. The old style placed emphasis on the fixtures,

FOUQUET, *Georges*
1862-1957
Jeweler

Born in France, took charge of La Maison Fouquet in 1895 and redirected it towards new designs in collaboration with two independent designers, Desrosiers and Mucha. He was initially inspired by natural forms, but later moved towards modern designs, emphasizing geometric shapes and variety of color. He played a leading part in the 1925 Paris Exposition and later international expositions, contributing outstanding creations in collaboration with leading designers. La Maison Fouquet closed its doors in 1936, but Georges continued to work for his regular clients.

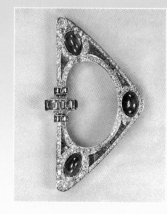

Fouquet: brooch in diamonds, emeralds and sapphires, set in platinum, 1922-3.

Left Jean Goulden: table lamp, silver, glass and enamel, late 1920s. Goulden had learned enameling from Dunaud, for whom he also designed, and he produced clocks and *objets d'art* as well as lights.
Below Simonet frères: "Monnaie du Pape" chandelier, silvered bronze and glass, about 1925. After 1925 this firm devoted all its attention to glass elements for lights, and eliminated many of the early problems in casting.

whereas the more modern design depended upon the light itself for decorative effect. Secondly, the traditional fixture was decorated with romantic elements such as leaves and floral motifs, often borrowed from earlier elements of French decoration or from antiquity. This was intended to divert attention from the fact that it was a light fixture. Modern lighting sought to accentuate the reality of the fixture and make it the decorative element. As with Modernist influences in other areas, the emphasis was placed on structure rather than on ornament.

Two systems were required to obtain an optimum light source free of strain and glare: direct and indirect. Lights could be incorporated into the walls and ceilings, making sconces and fixtures unnecessary. This concept complemented new trends in decorating that called for simplification of living spaces, and many decorators used it with excellent results.

Modern lighting capitalized on metal and glass, which science had demonstrated to be the most efficient transmitters and reflectors of light. Instead of hiding the glass bulb between layers of silk and brocade, modern designers succeeded in investing the bare materials themselves with artistic qualities. The resulting designs made use of simple lines, angles, juxtaposed squares, circles and triangles, and were completely in harmony with the new style of interior decoration. The design and manufacture of decorative equipment for interior lighting became a vast area for experimentation and innovation (1). Designers and artisans from all areas of the decorative arts, and with every design orientation from traditionalism to Modernism, were drawn to the challenging new field of lighting design.

Edgar Brandt produced wrought-iron and glass lamps from early in his career. The critic Jean Locquin, writing in 1921, described

FOUQUET, *Jean*
1899-?
Jeweler
Born in France, joined his father at La Maison Fouquet in 1919, where he exploited to the full current taste for abstract composition in jewelry and *objets d'art*. He made his international début at the 1925 Paris Exposition, and from 1945 until his semi-retirement for health reasons in 1961, Fouquet continued to design jewelry.

FOXTON, *William*
d. 1945
Textile manufacturer
Director of William Foxton & Co. of London, and was responsible for the firm's production of interesting and innovative textiles in the 1920s in direct contrast to the rest of the British textile industry. Noted figures such as Charles Rennie Mackintosh designed for the firm.

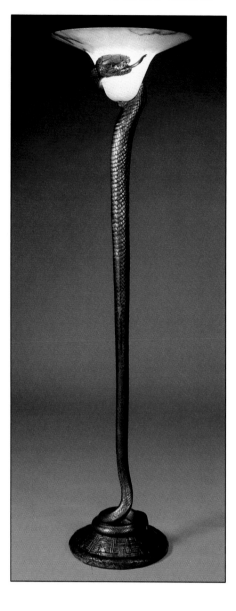

Left Edgar Brandt and Daum frères: "La Tentation" floor lamp, gilt-bronze and glass, early 1920s. Immensely popular at its introduction, the model was produced also in an intermediate and table model size, both with glass and alabaster shades. **Below** Edgar Brandt: "Les Crosses," wrought iron and alabaster, early 1920s.

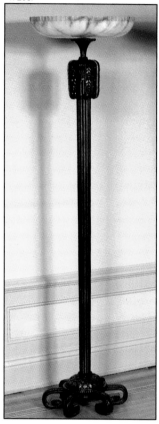

what he had seen on a visit to Brandt's gallery: "The floor lamps are basically simple in design, many in the form of an elongated mushroom, but with this rather banal idea, what a variety of types and diversity of decoration his fertile imagination has created. The light fixtures, extremely diverse in size and structure, are all distinguished by the logic of their construction, the sobriety of their decor, and the sureness of their taste."

Brandt worked with a number of glass-makers, but it was Daum whose work suited him best. The earlier shades that Daum created for him were smooth and silky in finish, and swirled with strong color. These gave way to the heavy, acid-etched glass with stylized floral or purely geometric motifs that Daum favored for his own production. The colors now were pale, with frosted white, yellow and orange predominating, often containing the metallic flecks found in his glass vases. The strong, linear design and heavy texturing of Daum's glass was well suited to the assertiveness of the iron, and the resulting floor lamps, ceiling fixtures and sconces were superbly stylish and refined. Brandt used shades carved from alabaster with equal success.

One of Brandt's most original and dramatic designs was the lamp entitled "La Tentation", variously known as the "Serpent" or "Cobra". It rears up on its tail, its neck coiled around a conical shade of glass or alabaster, and dares you, with its jaw open and ready to bite, to touch its curved fangs or feel the perfectly chased scales of its body. It was produced in table, intermediate, and floor models. It is of such universal appeal that reproductions are being done today, and are available in contemporary lighting shops.

Daum Nancy, in addition to producing glass shades for the various wrought-iron houses, did some wonderful lighting of their own. The forms were simple. Glass shades, shaped like mushroom

GATE, *Simon*
1883-1945
Glass designer, painter, illustrator
Born in Sweden, studied at the applied arts school of the Stockholm Academy from 1905-09. Traveled widely from 1909-16, and was mainly active as a portrait painter, but in 1912 he designed some book illustrations for the publisher B. Wahlstrom. From 1916 designed glass at the Orrefors factory, where he collaborated with Edvard Hald and the glassblower Knut Bergquist. Gate designed simple, geometric forms, Neo-classical figures and abstract patterns for engraving, and free-form glass. He won a Grand Prix at the 1925 Paris Exposition.

GENET ET MICHON
Founded in 1911 by Philippe Genet and Lucien Michon, both graduates of l'Ecole Boulle. It was intended as a design studio for furniture, seating and lighting design, but lighting became their primary interest. They devoted much effort to producing a superior thick pressed glass for lighting, usually with floral motifs, and became specialists in this field.

caps or coolie hats, or with an elongated phallic form, rested on spherical or cylindrical bases by means of a "spider", or round metal collar fitted with arms to hold the shade. The lamps were most successful in white and frosted, but were produced also in yellow, peach, pale green, blues and roses, usually etched with the firm's distinctive pattern of alternating smooth and rough stripes, sometimes intersected by a simple geometric or floral motif. Some of the larger and most striking table lamps had an all-over design of intricate geometrical elements. The best examples of Daum's table lamps are pure form suffused with light, and have a strong sculptural quality achieved by few other designers in glass.

Paul Kiss, Nics frères, Szabo, Bagues, Schenck and most of the wrought-iron houses produced sconces, *torchères*, ceiling fixtures and table lamps, most in traditional styles, but by the mid-1920s the growing infatuation with Cubism was making itself felt in all areas of the decorative arts, and advances in lighting design developed rapidly as lighting moved from the purely decorative plane into the disciplines of architecture and technology.

The influence of Jean Perzel

Jean Perzel's place in the history of lighting design is comparable to that of Pierre Legrain in bookbinding or Jean Puiforcat in silver. He was widely copied, but his originality, precision and technical mastery defied imitation. His interest in glass began when he was quite young. From his native Czechoslovakia he went to Paris in 1910 to perfect the techniques of glass window decoration that he had been experimenting with at home. In 1914, Perzel enlisted and was in the forces for the duration of the war. After demobilization he continued to work in glass, perfecting techniques and experimenting with new designs that reflected his concern with the quality of light and its logical distribution. They are a perfect balance of planes and volumes, using elegantly simple geometric forms executed in opaque glass made from completely colorless optical glass, sand-blasted to a matt finish, and then coated with a diffusing enamel.

The resulting light was calming, restful and flattering. This opacity, however, was insufficient to eliminate the points of light from the bulb, which he felt were disturbing to the eye. Several thicknesses of glass were required to achieve the desired effect, and by giving these layers of glass geometrical shapes, he achieved the dramatic interplay of superimposed disks, hemispheres, cylinders and semi-cylinders that is the heart and soul of his designs. In the late 1920s he began to use soft color in the enamels with which he sprayed his glass. Beige and rose were his preference: he felt that they gave "a happy color that makes women look pretty".

Although Perzel's light fixtures were calculated to provide both direct and indirect lighting, he did not favor the kind of indirect lighting that eliminated planes and shadows, feeling that this effaced the life of the room. To avoid this, he carefully balanced the light reflected from the ceiling with the direct light coming from below. Perzel succeeded in making lighting a plastic element. His genius was in his ability to distribute light so that it seemed to have an almost tangible volume.

Damon was another lighting designer who explored the combination of direct and indirect lighting in a single fixture, as well as using metal shades to reflect light. His work is testimony to his ingenuity in making full use of the latest advances in technology and in combining glass and metal to their best advantage. His strong, original and highly sculptural designs added more to a room than light; they became decorative statements.

GESMAR, *Charles*
1900-28
Poster artist, theater designer
His first poster dates from 1916, shortly before he became a constant companion of Mistinguett, aging Parisian music-hall sensation. He designed costumes, stage sets, program covers and posters for her performances at the Casino de Paris and Moulin Rouge.

Gesmar: Mistinguett, gouache and pencil, about 1925.

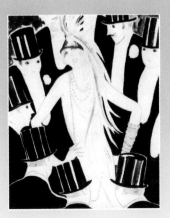

GIGOU, *Louis*
Locksmith, lighting designer
Primarily known as a locksmith, designed a number of door handles, keys, escutcheons and finger plates in chased bronze, wrought-iron, and steel with copper inlays, which were exhibited regularly at the SAD. He also designed desk lamps and a limited variety of other lighting.

Boris Lacroix was an extremely versatile and talented designer. He worked anonymously in the fields of decorating and furniture design before turning to lighting, in which he first attracted the public eye. When he initially exhibited his lamps, there were few designers seriously concerned with the problems of good lighting design, and fewer still who had come up with new solutions. His work was similar to that of Perzel in his use of frosted or polished white glass, held by a metal armature of geometric construction. Where Perzel sought to diffuse the light, however, Lacroix sought to give it solidity, and to create a block of radiance not limited or constricted by a metal framework **(2)**. His experience in designing everything from wallpapers to *couture* and furnishings gave his later work a strong unity of conception, and he was never at a loss for creative inspiration. He created many of his designs for women.

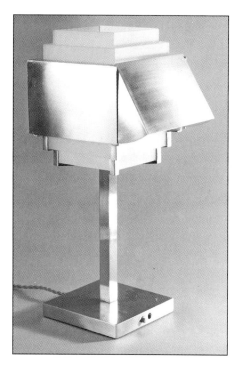

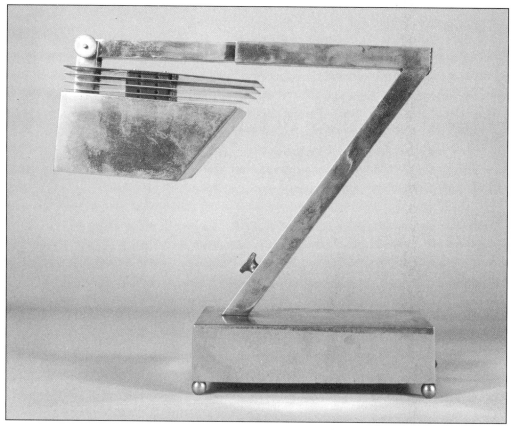

Above Jean Perzel: table lamp, brushed aluminum and glass, about 1928; and (**right**) Desny: table lamp, chromed metal, late 1920s.

GLASFABRIEK LEERDAM see
**N.V. VETREENIDGE
GLASFABRIEK LEERDAM**

GOULDEN, *Jean*
1878-1947
Enameler, silver designer
Born in Alsace into a wealthy farming family, studied medicine in Paris, and was a brilliant student. After World War I he learned enameling from Dunand, and became involved in the decorative arts movement in Paris, producing clocks, *coupés* and boxes in a distinctive Cubist style. He also designed for Dunand.

GOUPY, *Marcel*
b. 1886
Designer, all fields of the decorative arts
Born in Paris, studied architecture, sculpture and interior design at the Ecole des Arts Décoratifs. In 1909 met Georges Rouard, and joined La Maison Geo. Rouard as artistic director, a position he kept until 1954. He was a prolific designer of utilitarian glass, much of it enameled, as well as matching

Below Desny: table lamp, chromed metal and glass, late 1920s. **Right** Pierre Chareau, "La Religièuse" floor lamp, metal and alabaster, 1920s. After 1925 Chareau's earlier preoccupation with decorative mounts gave way to a stark linearism.

Architect-designers

Pierre Chareau was one of the most individual designers of the 1920s, applying the practical skills of an accomplished architect together with a wholesome love of clean, spare lines and beautifully polished surfaces to his lighting designs. He favored the effect of alabaster, cut in thin sections to transmit a maximum amount of light, or in chunky geometric forms. Held by simple – often invisible – wrought-iron armatures, Chareau's fixtures and sconces are Cubist images floating in space; his floor and table lamps are closer to illuminated sculptures than to lighting. One of his most famous designs, "La Religieuse", is an arrangement of alabaster slices surmounting a tapered, curved base of either wrought-iron or wood. The name is apt, as the lamp does, in fact, strongly resemble a nun in a black habit and white headdress.

Several other architects approached light as a tool to accentuate or soften surfaces and forms within a room, including Robert Mallet-Stevens, Louis Sognot, Charlotte Perriand and Djo-Bourgeois (a former student of Mallet-Stevens).

Despite its short period of existence, Maison Desny achieved acclaim for its strikingly simple and original designs. The firm was formed by two men, M. Maudy and a Mr Desnat – little is known about them except that they were connected with the circus, where they met and formed a personal, as well as business, relationship. Maison Desny was established at 122 Avenue des Champs Elysées around 1927, and remained in business until World War II. During this brief period, they created entire living environments for their clients (one of whom was the King of Belgium). Maison Desny's work was characterized by a rigorous geometry, and explored the juxtapositions of rightangles and flat surfaces. The influence of Cubism is strongly evident. They often

porcelain and ceramics, most of it made by Théodore Haviland at Limoges, and he also designed silver. At the 1925 Paris Exposition he displayed a wide range of his work in various pavilions and was the vice-president of the Glass Jury.

Goupy: enameled glass vase, about 1928.

GRANT, *Duncan*
1885-1978
Painter, decorative arts designer
British painter and co-director of the Omega Workshops with Vanessa Bell (1913-19). He contributed to the work of the Omega, and after its closure to a variety of special commissions, as well as carrying out schemes for Charleston, his joint residence with Vanessa Bell. Vivid color, an elaborately calligraphic style and a remarkable freshness and

originality characterize his decorative work.

used thick slabs of glass in geometric shapes, creating what they called *bibelots lumineux*: miniature marvels of lighting design.

Jacques Adnet and his brother Jean, who frequently worked together, were important figures in the Art Deco movement. Their designs for La Maîtrise and Saddier et fils were exhibited in the annual salons, and in 1928, Jacques was made director of La Compagnie des Arts Français, where he produced his own designs. He was in complete agreement with the philosophies of Le Corbusier, and this orientation is clearly present in his lighting, which contains the simplest possible elements. Where others sought to hide the light source and create a diffusion, the Adnet brothers were bolder, and used the bare bulbs as their major design element, making their lighting among the most inventive and controversial of the period.

The firm of Décoration Interieure Moderne – better known by its acronym, DIM – established itself as one of the major lighting studios in Paris, and sought out designers who were in sympathy with its design principles of clean, spare lines. DIM also undertook interior design, and it is ironic that René Joubert and Pierre Petit, the heads of the firm, eventually eliminated all but concealed lighting in their interiors. A number of notable designers worked for DIM. Among them were the firm of Venini in Murano, Jean Prouvé, Gabriel Guévrékian and Le Chevallier.

Le Chevallier's work is often compared to that of Maison Desny. He too used flat planes of metal, with no ornamentation to spoil the drama of form on form, but his pieces are less "polished" than Desny's, and their almost unfinished quality gives them the directness of seeming to be cut from the metal in a single burst of creative energy.

Albert Cheuret is difficult to place in the continuum of Art Deco design. His distinctive style, true to life or strongly stylized, was neither traditionalist nor Modernist, but instead took its influences from nature and antiquity. His fixtures and sconces, done in richly patinated bronze, used sheets of alabaster, cut very thin, to diffuse the light. The results were sumptuous and exotic.

Lighting design was in as much ferment in the United States as in France. A preoccupation with the "science" of lighting, combined with the renewed American interest in the decorative arts, produced designs that were bold, original and eminently practical. As in France, every designer of note produced excellently designed lighting. Donald Deskey, Walter Dorwin Teague, Kurt Versen, Gilbert Rohde, Eugene Schoen, Ilonka Karasz and many others put their best efforts into taming the darkness.

Walter Kantack was one of the pioneers in lighting architecture and decoration. He approached the problem of lighting much as an architect approached the problem of designing a house. There were practical considerations to be met, such as the purpose of each room, the design scheme, the sources of natural light and the activities of the occupants. Lighting had to serve its purpose above all else. Despite this functional orientation he incorporated period influences readily into his designs.

In terms of Modernism, however, Walter von Nessen was the most important designer working in the United States. German-born and trained, von Nessen, some years after his emigration to the United States, established the Nessen Studio at 151 East 38th Street, New York. Most of von Nessen's work was done for architects and decorators, and his designs were ingenious in their versatility and stark in their design. He favored strongly contrasting colors and finishes of metal, and made use of bakelite, rubber and formica as decorative accents.

GRAY, *Eileen*
1878-1976
Furniture and textile designer
Irish born, with a wealthy and artistic background. She studied at the Slade School in London, and soon developed an interest in Japanese lacquer. In 1902 she went to Paris, where she retained a flat for the rest of her life. She apprenticed under lacquerworker Sugawara, and in 1913 her exhibit at the SAD salon came to the attention of Jacques Doucet, who subsequently commissioned three important pieces, the celebrated "Le Destin" screen and two tables. In 1922 she opened the Jean Désert gallery, displaying unique pieces, and from 1925 she began to introduce chromed tubular steel and aluminum into her furniture.

Gray: table in lacquered wood inset with gold particles, about 1922.

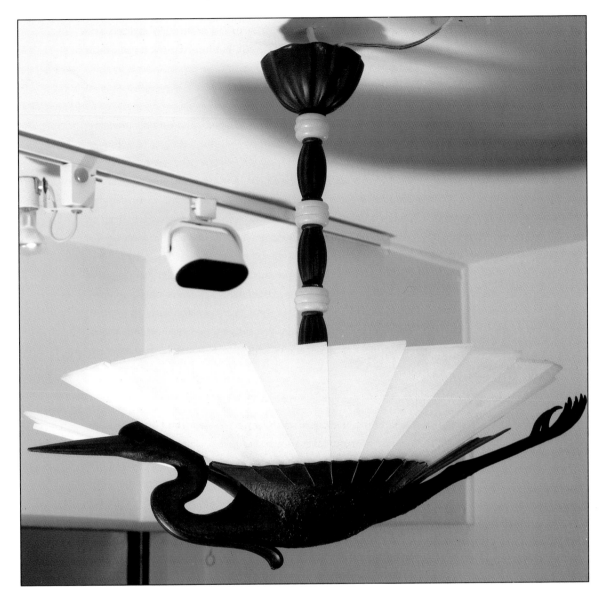

Left Albert Cheuret: chandelier, bronze, alabaster and ivory, probably 1920s. Cheuret continued to use a similar style well into the 1950s, creating difficulties in determining when a particular model was created. **Below** Georges Le Chevallier: table lamp in brushed aluminum, late 1920s. Like Chareau, Le Chevallier stressed the industrial, machine-made aspect of his fixtures by leaving their screws clearly visible.

GREGORY, *Waylande DeSantis*
1905-1971
Ceramist, sculptor
Studied at the Art Institute of Kansas City and then at the Art Institute of Chicago, starting as a sculptor in bronze and gradually turning to ceramic work. He worked at the Cowan Pottery from 1929-32. He then moved from Ohio to the Cranbrook Academy of Art, where he became an artist-in-residence with his own studio and kiln. In this decade he was given two important commissions for the 1939 New York World's Fair: "The Fountain of the Atom" and "American Imports and Exports," the latter for General Motors.

Gregory: terracotta group of a horse and dragon, about 1932.

PAINTINGS, GRAPHICS AND BOOKBINDING

PAINTINGS

The paintings and graphics of the inter-war years are difficult to place in an Art Deco context. Many artists whose work falls beyond the scope of this book, such as Léger, Matisse, Vlaminck and van Dongen, at times incorporated motifs in Art Deco style in their works on canvas and paper. Others, such as Rouault, Dérain, Marcoussis and Braque, utilized a similar range of indentifiable Art Deco motifs when venturing into the field of the applied arts to design textiles and rugs.

The boundaries between those who qualify as Art Deco exponents and those who do not are therefore far from finite. Most artists used a range of avant-garde mannerisms to solve traditional

problems of design and composition. Some of these – for example, abstraction by means of Cubism and elongation, or the Fauves' preoccupation with bright colors – were used by almost every Modernist artist, Art Deco or not. A study of the painters who are considered today to fall within the Art Deco movement reveals certain common denominators by which an individual artist can be judged. First, most Art Deco graphic artists were not innovative – they drew their inspiration from themes introduced by other Modernist artists, or schools of artists, often in the early years of this century, which they developed for their own purposes. Another criterion is that Art Deco graphics are decorative, designed to fit into the furniture ensembles of the era. Jean Dupas, for example, created paintings in a style which conformed to that of the furnishings in the room in which they would hang. To this end, many of his canvases were displayed at the decorative arts salons – the Salon d'Automne and the salon of La Société des Artistes Décorateurs – rather than those for paintings alone, They were, in the final analysis, decorative rather than artistic compositions. The same interpretation can be applied to the book illustrations and posters of the period, many of which contained images found on contemporary ceramics, glassware and sculpture.

To most devotees, Tamara de Lempicka represents the pinnacle of the Art Deco style in painting. Born Tamara Gorska to a prosperous Polish family near Warsaw, she married a Russian, Thadeus Lempitzski (Lempicki), while in her teens. The couple

GROPIUS, *Walter*
1883-1969
Architect and designer
Born in Berlin, studied architecture in Munich and Berlin from 1903-7. He started an independent architectural practice in 1910, and designed buildings for the 1914 Deutscher Werkbund exhibition in Cologne. After World War I he was appointed director of the Weimar school of art, which he reorganized as the Bauhaus. In

1928 he resigned to set up office in Berlin. In 1934 he moved to England, where he entered into partnership with E. Maxwell Frey. He became controller of design for the Isokon Furniture Company in 1936. In 1937 he went to America where he taught architecture until 1952. From 1938-41 he was in partnership with Marcel Breuer.

GROTELL, *Maija*
1899-1973
Ceramist
Born in Helsinki studied at the school of Industrial Art and later under William Alfred Finch. In 1927 moved to the United States and joined the faculty of Rutgers University in 1936. Two years later she joined the Cranbrook Academy of Art where she headed the ceramic department until 1966. She received many awards for her ceramic work.

GROULT, *André*
1884-1967
Furniture designer, decorator
Born in Paris and made his debut at the salons around 1910 as a decorator. His furniture designs were executed by a small group of craftsmen at his *atelier* in Paris, and were notable for their sumptuous materials, especially shagreen and horn. Groult was prominent at the Paris 1925 Exposition, for which he designed the ladies' bedroom in

Opposite page Tamara de Lempicka: *Portrait of Arlette Boucard* 1928, 28×31½in. **Left** Jean Dupas: gouache and ink drawing, 1928; and (**above**) *Woman in Furs with Borzoi*, oil on panel, 1920s, 25×19in. As in the Art Nouveau era, Woman emerged as a primary image in Art Deco Graphics.

the Ambassade Francaise. He also designed textiles and wallpapers.

Groult: ladies' desk, shagreen and amazonite, about 1927.

GUIRAUD-RIVIERE, *Maurice* 1881-?
Sculptor
One of the more prolific sculptors of the period, known for sophisticated, mainly female, nudes. He contributed models for the Sèvres and Robj porcelain companies as well as designing bronze and bronze and ivory sculptures.

Guiraud-Rivière: "Enigma," a white marble figure of a nymph, 1925.

arrived in Paris toward the end of World War. I

Deserted by her husband in the 1920s, de Lempicka decided to support herself and her daughter Kisette by painting. She enrolled at the Académie Ransom, where she studied with Maurice Denis, a disciple of Cézannes' and André Lhote, the theoretician of Cubism. She developed a highly personal, sometimes icy and enigmatic, style in which contrasting angular images and bright colors predominate. She painted roughly a hundred portraits, many nude, between the mid-1920s and World War II, several against a compact background of American skyscrapers. The Cubist influence is obvious, as is her use of chiaroscuro – light and shadow – to dramatize the impact. Sexuality, often highly charged, is at the core of her finest works.

The city of Bordeaux contributed several distinguished artists to the Art Deco movement, including Jean Dupas, Robert-Eugène Pougheon, René Buthaud, Jean-Gabriel Domergue, and Raphael Delorme, who together generated a wealth of works on paper and canvas. Dupas, in particular, developed a highly distinctive and abstract style which captured precisely in its elongations and dehumanizing expressions the mood of the period. Listed at the salons from 1909, he was awarded the Prix de Rome. He later explained his style, "I do not aim at a systematic deformation ... but one must realize that a painted decoration is part of an architectural scheme, and hence it demands scale and strong vertical lines ... For me, elongation is not even a stylization, but rather a means of expression."

Pougheon studied at the Ecole des Beaux-Arts in both Bordeaux and that in Paris, where he developed an abstract style in which the subject's anatomy was given a pronounced angular muscularity, often of heroic proportions. Some of his works are quintessentially Art Deco in their extreme stylization, while others portray

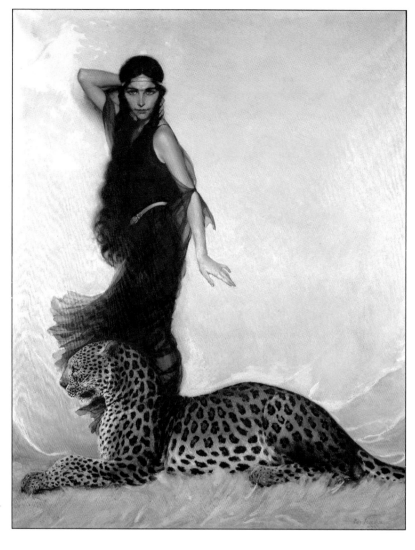

Opposite Erica Giovanna Klein: *Tango*, casein on canvas 59×399½in, 1925; and (**above**)Aldo Severi: untitled, oil on canvas, 57×72in.

HALD, *Edvard*
1883-1980

Painter, glassmaker, ceramist

Born in Stockholm, studied painting in Dresden and then in Paris under Matisse. His simplified, Modernist designs show a fresh and innovative style. He made his debut as an artist in Stockholm in 1909, and in 1917 began to pursue an evolving interest in glass and ceramics, which led to employment the same year at the Orrefors glass factory. In 1919 he designed ceramic tablewares for the Rörstrand porcelain factory and executed further ceramic designs for the Karlskrona factory. He served as artistic director at Orrefors from 1924-33, and for nearly 30 years had a close artistic and personal association with Simon Gate.

Hald for Orrefors: engraved glass vase, about 1925.

allegorical figures in naturalistic settings (1).

Domergue, another student of the Bordeaux Ecole des Beaux-Arts and Prix de Rome recipient, painted portraits of Parisian socialites, theater celebrities and nudes, in an engaging style in which certain facial features were exaggerated. Delorme, perhaps the only independently wealthy artist of the era (his cousin, Mme Metalier, housed him in her castle in Valesnes), later claimed that he sold only one painting in his entire career, to the Maharajah of Kapurthala. Mixing Neo-classical and Modernist images in a strange but appealing two-dimensional style, Delorme composed many of his paintings in architectural settings. Buthaud, like Dupas, switched media with great facility. His paintings, often rendered initially as cartoons for his stained-glass windows or *verre églomisé* panels, incorporate all the softness and sensuality of his designs for ceramics.

The abstract Modernist sculptors, Jean Lambert-Rucki, Josef Csaky and Gustav Miklos, generated characteristic studies in oil and gouache as sketches for their sculpture. Many of these have survived to highlight the parallels between two- and three-dimensional art.

Marie Laurencin was one of the painters whose portraits and floral compositions bordered on the Art Deco style (and on others). Using a distinctively feminine pastel palette, Laurencin worked closely with her brother-in-law André Groult, supplying paintings for his ensembles at the annual salons (2). The paintings of Robert and Sonia Delaunay also complemented the 1920s avant-garde interior. Robert, despite his adoption of some Cubist mannerisms, painted in a figurative style that explored the effects of space, light and color to achieve sharply contrasting imagery. His wife Sonia, renowned initially for her textile and fashion designs,

HAVINDEN, *Ashley (Eldrid)*
1903-73
Painter, graphic artist and textile designer
British-born, studied in London and with Henry Moore. He accepted marketing commissions until 1933 when he began to design rugs and other textiles for Duncan Miller's showroom; he also executed designs for Edinburgh Weavers and the Wilton Royal factory.

HEAL, *Sir Ambrose*
1872-1959
Furniture designer
The son of Ambrose Heal of the British bedding and furniture manufacturers and retailers. He designed furniture for the family firm from 1896, became a partner in 1898, managing director in 1907 and chairman in 1913. He was a member of the Art Workers' Guild and a founding member of the Design and Industries Association.

HENRI, *Hélène*
b. 1891
Textile designer
Born in France, began her work with textiles in 1918, establishing her own *atelier* in Paris. She worked with many of the major Modernists including Pierre Chareau and Robert Mallet-Stevens, and adhered to the stylistic principle of "truth to material" rather than printed decoration.

later concentrated her significant talents on painting. Equally difficult to place in an Art Deco context, were the paintings of Raoul Dufy, which followed his career as a textile designer, and Moise Kisling, a Polish émigré who settled in Paris, where he painted somewhat saccharine and melancholy portraits of young women.

A self-taught painter and printmaker, Louis Icart is today one of the better-known Art Deco artists. He joined a postcard company in Paris in 1907 and the following year established his own *atelier*. In the 1920s Icart generated a huge volume of lithographs and etchings, most depicting fashionable young women, often in languid repose attended by borzois or poodles, in a highly sentimental style that sometimes slipped into frivolity and high commercialism. Icart painted a considerable quantity of oils and gouaches on the same theme, in addition to a small number of erotica. **(3).**

As in sculpture, some French artists in the 1920s adopted a Modernist style in their portrayal of animals. The premier *animalier* painters were Paul Jouve, Jacques Nam, and André Margat. Unlike their nineteenth-century predecessors Delacroix and Géricault and, toward 1900, Barye and Rosa Bonheur, who depicted animals in their natural habitat, the 1920s artist chose to treat his subject in isolation, often silhouetted against a white ground. Felines — leopards and panthers, in particular — and snakes and elephants, were popular, all painted in slightly abrupt or faceted brush strokes to reveal the beast or reptile's innate power and rhythm. Jouve was the most diverse, generating an important body of *animalier* etchings, drawings, watercolors, woodcuts and oils. He frequently worked with artists in other fields, such as Jean Dunand for the murals on the ocean liner *L'Atlantique,* and with the bookbinder Georges Cretté, to design plaques for his book covers. **(4).**

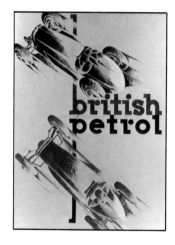

Above François-Louis Schmied: menu, oil and ink, 1926. Schmied showed his versatility over a wide range of graphics including bookcovers and illustrations. This menu was designed for his friend and colleague Jean Dunand. **Left** Poster for British petrol, designer unknown. **Right** Jean Dunand and Jean Dupas: "Dawn," 32-panel wall decoration for the Grand Salon of the ocean liner *Normandie,* gessoed wood, about 1933-34.

HERBST, *René*
1891-?
Furniture designer
Born in Paris, trained as an architect. He made his début as a furniture designer at the 1921 Salon d'Automne, displaying furnishings for a rest area in the Musée de Crillon. In 1926 he began to replace the earlier wood components in his furniture with metal, glass and mirror. He was co-founder of the UAM in 1929, and in the

1930s he won the commission to decorate the palace of the Maharajah of Indore in India.

Herbst: ladies' desk with detachable lamp, chromed metal and wood, about 1928.

HERNANDEZ, *Mateo*
1885-1949
Animalier sculptor
Born in Spain, began sculpting at age 12, later attending the School of Art and Industry in Bejar, where he worked primarily in stone. His first life-size model carved at the age of 17 won him a scholarship to Madrid, and he moved to France in 1913, settling in Meudon where he kept a studio and a private zoo. Although based on real animals,

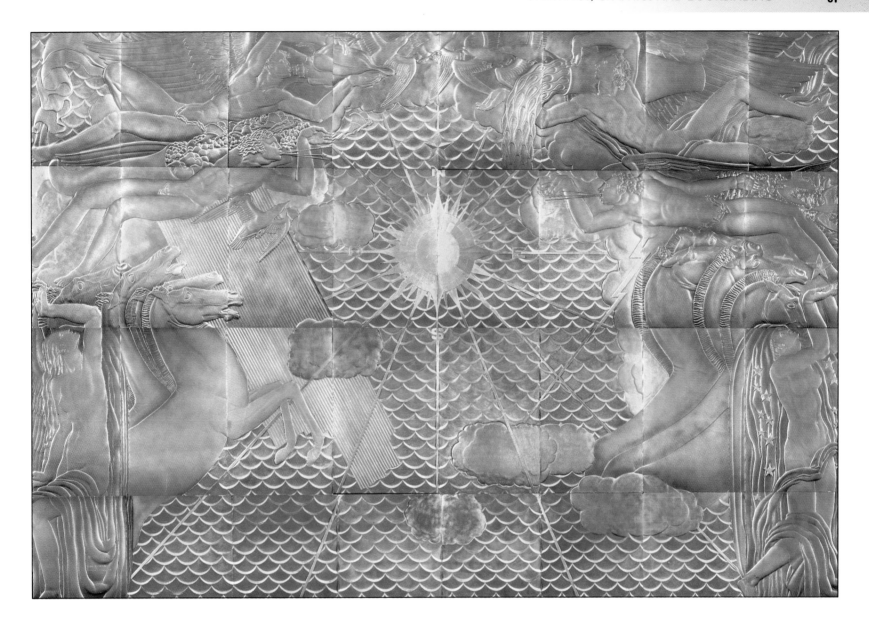

his sculptures, directly carved in stone or wood, are to some extent simplified and stylized. His life-size diorite figures of a black panther and a peacock were included in the 1925 Paris Exposition. Although primarily known for his animals he also modeled portraits, painted, and made frescoes and lithographs.

HEYMAN, *Oscar and Nathan*
Jewelers
Born in Russia, emigrated to New York in 1906 after a five-year apprenticeship in the jewelry business of their uncle in Kharkov. They had learned the skills of making platinum jewelry at a time when this metal was becoming fashionable, and in 1912 they were joined by their brother Harry, also a skilled jewelr, and formed Oscar Heyman & Bros. All six Heyman

brothers eventually worked there in partnership, and for 75 years superbly designed and crafted jewelry was produced by them. The emphasis of the designs was always on the stones, usually set in platinum but sometimes in gold, as a concession to fashion.

Oscar Heyman & Bros: drawing for necklace in diamonds, emeralds and onyx, set in platinum, about 1925.

POSTERS

The 1920s poster profession in France drew on the rich and enduring tradition of Toulouse-Lautrec, Steinlen, Mucha and Chéret at the turn of the century. Interpretation varied widely, from the transitional high-style renditions of Leonetto Cappiello prior to World War I, to the rigorously machined compositions of Cassandre a decade later. As their point of departure most posterists favoured the soft-edged, fanciful stylizations of Cappiello, who spanned the Art Nouveau and Art Deco epochs. Carlu, Loupot, Gesmar and Colin, for example, embraced a light and engaging graphic style which traced a clear progression from the *fin de siècle* poster of a quarter of a century earlier.

In the 1920s commercial art became a bona-fide profession which, in turn, gave birth to the graphic artist. Dynamic design was needed to manipulate the public's attention in the promotion of new products. The commercial poster, which reached the public at large on Paris's ubiquitous *colonnes d'affiche,* became a major advertising tool, one in direct competition with the radio. To reach the passer-by's subconscious, powerful symbols and advertising techniques were sought. Poster designs were simplified, their images reduced to the essentials of product and brand-name. Sharp linear compositions, floating on flat areas of background color, drew the eye quickly. Other gimmicks helped, such as aerial or diagonal perspectives. New sans-serif typefaces streamlined the message.

The Art Deco poster artist drew on many of the avant-garde movements from the early 1900s to strengthen his medium. Cubism and Futurism, in particular, provided powerful new advertising tools. Cubism added fragmentation, abstraction, and overlapping images and color. Futurism contributed the century's

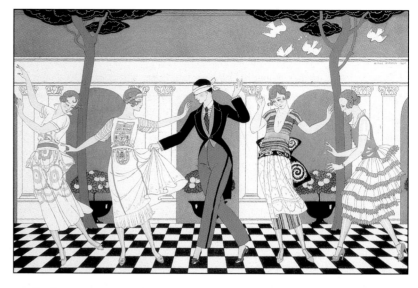

HOFFMANN, *Wolfgang*
b. 1900
Interior designer
The son of Josef Hoffmann, the leading spirit of the new decorative arts movement which emerged in Vienna at the turn of the century. Wolfgang studied architecture and the decorative arts and emigrated to the United States in 1925. He opened his own studio about 1927, designing a wide range of interiors — wood and metal furnishings, rugs, linens, etc., in collaboration with his Polish-born wife, Pola. Their marriage and business partnership were both dissolved in the 1930s. Hoffman was in the vanguard of the New York Modernist movement, and participated in all the New York exhibitions in the late '20s.

HOHLWEIN, *Ludwig*
1874-1949
Poster and graphic artist, painter
Studied architecture at the Munich Technical School, self-taught as an artist. From about 1905 concentrated on poster design. Known for his strong and unusual use of color and the virile images in his posters.

preoccupation with speed and power, translated most brilliantly by poster artists into images of the era's giant new ocean liners and express trains. The De Stijl and Constructivist movements added the further influences of pure line, form and color. Most of these avant-garde movements had been too esoteric and intellectual for the public at large when they were first introduced, and the poster artist helped, in borrowing certain of their concepts, to make them more comprehensible.

Art Deco posters can be divided broadly into two categories: theatrical and commercial (including travel and special events such as sports meetings, concerts, and art exhibitions). In Germany and Italy, the poster also became a dynamic Fascist propaganda tool.

In France, Jean Carlu studied architecture before turning, after World War I, to the graphic arts. His posters showed great diversity, ranging from a romantic impersonation of race-goers (such as "Têtes de Paris"), to Cubism ("Havana Larrañaga") and abstraction ("Théâtre Pigalle"). His posters for Air France and Mon Savon, both of which he served at some point as art director, remain among his most appealing. In the 1930s, Carlu settled in the United States, where he was commissioned to design a spectacular series of murals for the Eaton department store in Toronto.

Charles Loupot studied at the Ecole des Beaux-Arts, Lyon, with advanced instruction in lithography and poster art in Switzerland. On moving to Paris, he worked as an illustrator for the magazines *La Gazette du Bon Ton* and *Fémina*. In late 1920s he created posters for the automobile company Voison, before joining Cassandre and Moyrand's Alliance Graphique in 1930. He continued to design posters after World War II in a light and endearing style in which young women were portrayed with a rather Icart-like sentimentality.

Right Sané: "High Society," lithograph on paper, 35×24½in, 1928. Sané's poster captures precisely the image associated today with high-style 1920s living, one of cocktails, cabarets and chic evening wear. **Opposite page** George Barbier: "L'Amour est Aveugle," *pochoir* (transfer print) from *Le Bonheur ou les glaces à la mode*, 1920. **Far left** Julius V. Englehard: "Odeon Casino," lithograph on paper, 61½×43in, 1927. **Left** William Welsh: cover for *Woman's Home Companion*, February 1931.

A designer of theatrical posters, Charles Gesmar linked his young career inextricably to that of Mistinguett, the aging music-hall sensation who in the 1920s captivated Paris in the way that Loïe Fuller had 25 years earlier. Gesmar designed Mistinguett's plumed costumes, stage sets and program covers. His premature death in 1928, at the age of 28, deprived the French poster world of its most gifted young member, although his style was continued by Zig on a lesser, but thoroughly enjoyable, plane.

Paul Colin, born in the French provinces, settled in 1913 in the capital, where he became proficient in painting, posters, and set and costume design for the opera. His fame rests primarily on his long association with Josephine Baker, which began in 1925 with the

HOLLISTER, *Antoinette B.*
1873-0000
Sculptor
Born in Chicago, studied sculpture at the Art Institute of Chicago and then in Paris under Rodin and Injalbert. Was awarded an honorable mention for her entry at the Panama-Pacific Exposition in San Francisco in 1915 as well as the Shaffer Prize for sculpture at the Art Institute of Chicago four years later. Her attenuated Pan figures, decorated with stylized floral garlands, show many of the mannerisms of early French Art Deco.

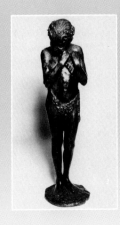

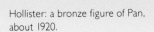
Hollister: a bronze figure of Pan, about 1920.

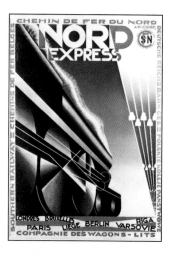

Left A.M. Cassandre: lithographic poster, about 1928. **Below left** Marrer: PKZ, lithograph in colors on paper, 49½×34¾in, 1923. PKZ, a fashionable men's clothing store chain, provided Marfurt and Marrer with a constant flow of work. **Below** René Magritte: "Le Tango des Aveux," sheet-music cover, about 1925. **Right** "L'Atlantique," lithographic poster for the Alliance Graphique, 39×24⅞in. The ocean liner *Atlantique* caught fire 16 months after it was launched and burned and sank off the coast of France.

HOOD, *Raymond*
1881-1934
Architect

Born in Pawtucket, Rhode Island, Hood attended Brown University before transferring to the Massachusetts Institute of Technology to prepare for a career in architecture. After graduating in 1903 he joined the New York architectural firm, Bertram Goodhue, working as a draftsman for six months before studying at the Ecole des Beaux-Arts in Paris. In 1922, he won the Chicago Tribune Competition with John Mead Howells with a Gothic-inspired design for the Chicago Tribune Tower. Major commissions in New York included the American Radiator Building (1924), the Daily News Building (1930) and the McGraw-Hill Building (1932), all of which bore distinct Modernist ornamentation.

publication of his "La Revue Nègre" poster that announced Baker's première performance at the music-hall des Champs Elysées. Colin's entertainment posters were invariably designed in a spirited, angular style that after 1926 traced the emerging influence of the machine.

Cassandre emerged as the era's foremost posterist. Born Adolphe Mouron in the Ukraine, Cassandre studied at the Académie Julian in Paris before launching his career across a broad spectrum of the graphic arts as a painter, theatre designer and typographer **(5)**. It was in poster design, however, that he made his most dramatic impact.

Cassandre comprehended fully the central property of a poster – that by the elimination of all superfluous details, its message could be exaggerated. Simplification, translated into a vigorous interplay of geometrical and machine elements, became the vehicle by which he transformed poster art into a dominant twentieth-century advertising phenomenon. Major works followed one after the other in the wake of his 1925 poster design for the Parisian newspaper *L'Intransigéant,* in which Marianne, the symbol of the voice of France, was depicted as a defiant young woman imparting the truth. His designs for the national railways, Nord Express (1927), Etoile du Nord (1927) and Chemin du Fer du Nord (1929), and those for the ocean liners *Statendam* (1928), *L'Atlantique* (1931) and, the most celebrated, *Normandie* (1935), quickly entered the realm of poster classics.

In 1930, Cassandre founded Alliance Graphique with Maurice Moyrand, a printer's representative. In September 1934 Moyrand was killed. Without his administrative leadership, the firm closed the following year. From 1936 Cassandre made several trips to the United States where, among other commissions, he designed many covers for *Harper's Bazaar.*

Another notable poster designer, René Vincent, forsook his architectural studies at the École des Beaux-Arts, Paris, for a career in the graphic arts and, to a lesser degree, ceramics. An illustrator for *La Vie Parisienne, The Saturday Evening Post* and *L'Illustration,* Vincent also designed posters for the giant Parisian department store Au Bon Marché. His compositions often featured fashionable demoiselles playing golf or bearing parasols done in a crisp, illustrative style heightened with contrasting blocked colors.

Many other French graphic artists provided the world of poster art with intermittent works. Jean Dupas, for example, turned his hand to a series of delightful advertisements for Saks Fifth Avenue, Arnold Constable and others, with a facility that showed his great versatility. Also from Bordeaux, René Buthaud transposed the lithe maidens on his stoneware vessels on to paper, some to herald the annual Paris *salons.* The identity of the prolific artist Orsi, whose name appears on more than a thousand posters, including images of Josephine Baker at the Théâtre de l'Etoile, remains an enigma. From the world of fashion, Georges Lepape and Natalia Goncharova created posters in a predictably colorful and theatrical style which depicted Paris as the pleasure capital of the world.

In the rest of Europe, poster artists adopted the Art Deco style to varying degrees. In Belgium, the Swiss-born Léo Marfurt formed a 50-year association with the tobacco company van der Elst, for which he designed advertising, packaging and posters. In 1927 he formed his own studio, Les Créations Publicitaires, where he produced two masterpieces of travel poster art: "Flying Scotsman" (1928) and "Ostende-Douvres" (around 1928) **(8).** The former consisted of overlapping parallel images in sharply contrasting blocks of color that impart a sense of bustle, and has emerged as one of the most

recognizable and popular images of the inter-war years. René Magritte, a magazine and advertising illustrator before he turned to Surrealism, also created some vibrant Art Deco poster images in the mid-1920s.

Two other Low Country artists, Willem Frederik ten Broek and Kees van der Laan, produced posters for Dutch shipping lines in a Cassandre-like Modernist style.

In Switzerland, Otto Baumberger, Herbert Matter and Otto Morach designed for the fashionable men's clothing store PKZ, as did the German Ludwig Hohlwein **(7)**. Baumberger, trained as a lithographer and posterist in Munich, London and Paris, worked principally in Zurich, where he helped to establish the Swiss School of Graphic Design. Matter is known principally for his pioneership of the photo-montage technique in travel posters such as "Winterferein" (1934) and "All Roads Lead to Switzerland" (1935). These appear today as overly romantic and sugary in comparison with his more forceful blocked Art Deco creations of the 1920s.

Ludwig Hohlwein was Germany's most popular and prolific poster artist. His preference for virile masculine images to advertise coffee, cigarettes and beer later won him many commissions for Nazi propaganda posters. Hohlwein's real gift lay in his use of color, which he employed in unexpected combinations to achieve dramatic effects.

Austrian-born Lucien Bernhard studied at the Munich Academy, from which he emerged as a versatile artist-architect, designing buildings, furnishings, and graphic works. In 1923 he emigrated to the United States, where in 1929 he co-founded the Contempora Group in New York. His poster style appears labored and undirected, but he was invariably treated with respect by contemporary critics. Other German posterists, such as Walter Schnackenberg and Josef Fennecker, embraced a softer French-inspired style in their designs for theater and ballet performances.

Right René Buthaud: poster for the Société des Artistes Décorateurs, gouache and ink, 39×29in, 1931. Here Buthaud has transferred one of the languid, lightly sensual nudes with which he adorned his ceramic wares onto the announcement for the annual Paris salon. **Below** A.M. Cassandre: lithographic poster for the Alliance Graphique, 10¼×14⅞in, 1935. One of a series of posters by Cassandre for Dubonnet in which the artist imparts an uncharacteristic light sense of humor. Most of his work was more abstract and dynamic.

ICART, *Louis*
1880-1950
Printmaker, painter, book illustrator
Self-taught as a printmaker, arrived in Paris in 1907 and worked for a lithographic postcard company. The following year he opened his own studio, printing magazines and fashion brochures. In World War I he contributed cartoons to the satirical reviews *Le Rire, Fantasia* and *La Baïonette*. From 1918 he concentrated on etchings,

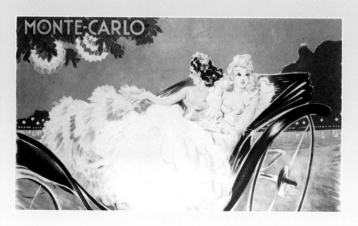

The Hungarian Marcel Vertès established himself immediately after World War I as a leading poster artist in Vienna. He moved in 1925 to Paris where, apart from the publication of two volumes of lithographs, *Maisons* and *Dancing*, and occasional work for Elsa Schiaparelli, he lapsed into obscurity, which probably contributed to his decision to move in the 1930s to the United States. His Viennese posters, however, were colorful and distinctly Parisian in their light mood.

Brilliant interpretations of the Art Deco poster were produced in other countries, but with less frequency. Marcello Dudovich and Marcello Nizzoli, in Italy; Maciej Nowichi and Stanislawa Sandecka, in Poland; and Edward McKnight-Kauffer, Alexander Alexeieff, J. S. Anderson, and Greiwirth, in Britain. In the US, commercial artists such as Joseph Binder and Vladimir V. Bobritsky, both immigrants, likewise captured the inter-war mood of Paris.

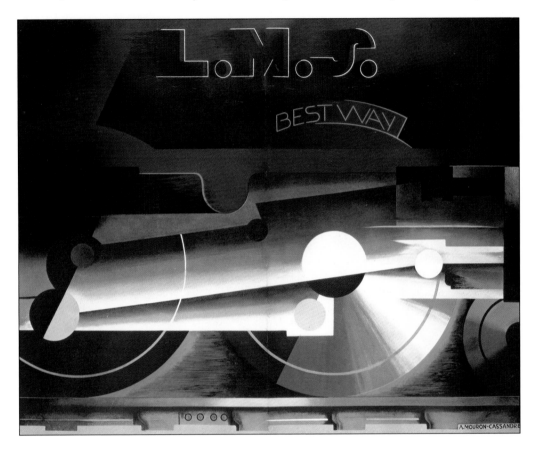

A.M. Cassandre: lithographic poster for McCorquodale & Co., London. To convey the message of speed and efficiency required by his client, a British railway company, the artist has created a powerful abstract image of a train's source of motion, its wheels. The careful selection of block colors adds to the sense of co-ordinated energy.

creating a large number of lithographs in a romantic and sensual style.

Icart: lithographic poster, about 1925.

IRIBE, *Paul*
1883-1935
Designer, all branches of applied arts
Born Paul Iribarnegaray, in Angoulême, trained as a commercial artist and became famous as a caricaturist for a range of Parisian journals including *L'Assiette au Beurre* and *Le Rire*. His creativity was confined largely to four years, from 1910-14. In the early 1900s he developed a skill as interior

decorator, probably encouraged by Paul Poiret, for whom he designed a range of jewelry, fabrics, wallpapers and furniture. In 1912 Jacques Doucet commissioned him to furnish his new Paris apartment, which sealed Iribe's fame as a furniture designer. With his young assistant Pierre Legrain, Iribe designed a range of modern furniture, three pieces of which were donated to the Musée des Arts Décoratifs in Paris.

Iribe: *bergère gondole*, mahogany, about 1925.

BOOKBINDINGS

The craft of bookbinding underwent a long-overdue renaissance after World War I, although most observers were unaware that it had in earlier times attained a high degree of artisanship. Book collecting was the preserve mainly of a select group of connoisseurs, with whom binders had worked in relative secrecy due to the confidential nature of the relationship between the two.

By long tradition, books in France had been published with flimsy paper covers, making them unacceptable to the serious collectors, who employed bookbinders to design and create covers for favorite volumes. This system prevailed right up to the early years of this century. The binding's function was to preserve the text, and it was not considered as a means of artistic expression until the emergence of the Art Deco movement.

Credit goes to Pierre Legrain for revolutionizing the art. In 1912, when Jacques Doucet disposed of his renowned collection of antique furniture at auction, he presented his correspondingly important library of eighteenth-century books to the city of Paris, retaining only his collection of works by contemporary authors. The young Legrain, who had been more or less unemployed since his former employer Paul Iribe set sail for the United States in 1914, was retained to design the bindings in a modern style **(9)**. Without prior experience, and largely self-taught, Legrain undertook the task in the *atelier* of the binder René Kieffer. Doucet was immediately impressed, and commissioned more bindings, and by the early 1920s Legrain's abilities had drawn the attention of other collectors, such as Baron Robert de Rothschild, Henri de Monbrison and Baron Gourgaud, all of whom became clients. Legrain introduced an unusual and endearing selling ploy, donating to the patron the tools used on each binding.

Left, top to bottom Georges Armand Masson: *Tableau de la Mode*: Editions de la Nouvelle Revue Française, 1926, binder Charles Benoit, illustrator Marcel Vertès. J. Valmy-Baysse: *Tableau des Grands Magasins*: Editions de la Nouvelle Revue Francaise, 1924, binder, Charles Benoit, illustrator J.E. Labourer. Francis Carco: *Tableau de L'Amour Venal*: Editions de la Nouvelle Revue Francaise, 1924, binder Charles Benoit, illustrator Luc Albert Moreau. **Above** Paul Morand: *Ouvert La Nuit*, 1924, binder Pierre Legrain. **Opposite page** Rudyard Kipling: *La Chasse de Kaa*, book-cover plate in lacquer and *coquille d'oeuf* by Jean Dunand, illustrations by Jouve, 1930.

JALLOT, *Léon-Albert and Maurice-Raymond*
1874-1967 and b.1900
Furniture designers
Léon-Albert was born in Nantes and trained at the Ecole des Beaux-Arts in Paris, which gave him the basic technical skills of artist, wood sculptor and engraver. His furniture was traditional in design, and he relied for decoration on veneers, especially jacaranda and wild cherry. In 1921 his son Maurice-Raymond joined his studio, and at the 1925 Exposition father and son exhibited for the Hôtel du Collectioneur, Ambassade Française, La Société Noel, La Maison de Bretagne and Gouffe Jeune. In 1926 they introduced a distinctive range of modern furniture: stainless steel card tables with reversible tops, mirrored cabinets and tea-tables.

Legrain's ignorance of traditional binding techniques served him well, for it allowed him to make free use of his creativity and to introduce materials not used before. From the start, his designs were avant-garde, in keeping with the revolution in design taking place throughout the decorative arts in Paris. In place of the lightly ornamented floral bindings of the pre-war years, he introduced forceful geometrical patterns in the same precious materials employed at the time by Modernist *ébénistes* such as Émile-Jacques Ruhlmann, Clément Rousseau and Adolphe Chanaux.

Bookbinding became, in many ways, an extension of the Art Deco cabinet-making craft, as exotic veneers and skins were borrowed in search of a means to modernize the age-old craft. Hides such as snakeskin, *galuchat* (sharkskin) and vellum were interchanged with binding's traditional Moroccan leather. Decorative accents were provided in innumerable ways. For instance the binding could be inlaid with a mosaic of colored leather sections, or with gold, silver, platinum or palladium fillets, or it could be gilt-tooled, blind-stamped or painted. Further embellishment was provided by the application of decorative plaques in sculptured or veneered wood, lacquered silver or gold, enameled porcelain, bas-relief bronze, or carved ivory. The encrustation of mother-of-pearl, tortoiseshell or semiprecious stones provided further aesthetic possibilities. More exotic works were covered with Japanese prints or silk-mounted on cardboard. A matching slipcase completed the package for unique, or limited-edition, works.

Beyond Legrain, Paris was home to a host of premier binders who worked in the Modernist idiom. Foremost among these was another Doucet protégée, Rose Adler, with Georges Crette (the successor to Marius Michel), René Kieffer, Paul Bonet, François-Louis Schmied, Lucien Creuzevault, Georges Canape and Robert

JENNEWEIN, *Carl Paul*
1890-978

Architectural sculptor, mural painter
Born in Stuttgart, but settled in the US, and was apprenticed to Buhler and Lauter, a firm of architectural sculptors and modelers used by McKim, Mead and White. He remained with the firm from 1907-09, and carried out the Pompeiian decorations for the home of John D. Rockefeler Jr. at Fifth Avenue and 55th Street. A series of murals for the dome of the Church of the Holy Spirit in Kingston, N.Y., followed, as well as commissions for the Dudley Memorial Gateway and Harvard University, and four murals for the lobby of the Woolworth Building. His career spans almost the whole twentieth century, and his earlier work has a strong Art Deco sensibility.

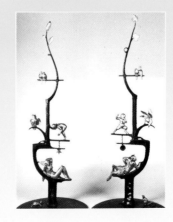

Jennewein: "Fantasy," a pair of parcel gilt-bronze groups, about 1942.

Bonfils. Less known were the works of Paul Gruel, André Bruel, Jean Lambert, Alfred Latour, Jeanne Langrand, Yseux, Louise Germain and Germaine Schroeder, whose creations in many instances matched those of their more celebrated colleagues **10.**

The new enthusiasm for bookbinding also drew in graphic artists, for example, Maurice Denis, George Barbier, Georges Lepape and Raphael Drouart. The artist-turned-decoractor André Mare incorporated a pair of love birds, in engraved and tinted parchment, for his cover design for *Amour*, commissioned by Baron Robert de Rothschild.

Many of these binders collaborated on commissions with artist-designers, and even with other binders. Schmied, in particular, was extremely versatile, participating on commissions as a binder, artist or artisan, with Cretté and Canape. Jean Dunand was likewise very active, creating lacquered and *coquille d'oeuf* plaques, and even wooden ones inlaid with detailed marquetry designs, for these and other binders. The *animalier* artist Paul Jouve, and the sculptor

Guino contributed designs for ivory and bronze panels **(11).**

The 1920s binder drew mostly on the same repertoire of motifs used in other media. Combinations of lines, dots, overlapping circles and centripetal or radiating bands, were used to create symmetrical or asymmetrical compositions. The influence of the machine and new technology became increasingly felt toward 1930, particularly by Paul Bonet, who emerged as Legrain's successor. The preferred motifs of the Paris salon in the early 1920s – the stylized floral bouquet or gazelle, for example – quickly yielded to a fiercely geometric vocabulary found especially in works such as Creuzevaults's *La Seine de Bercy au Point-du-Jour,* Legrain's *Les Chansons de Bilitis,* Kieffer's *Trois Eglises,* and Bonet's *Les Poilus.*

Beyond France, bookbinding remained conservative, and very few examples were produced in the Art Deco style in other countries. In the United States, John Vassos created a few starkly modern bindings, enameled in bright colors rather than inlaid with other materials. **(12).**

Far left and left *La Creation*: 1928, binders François-Louis Schmied and Conin et Cie, illustrations by F.-L. Schmied; Maurice de Noisay: *Tableau des Courses,* 1921, binder Charles Benoit, illustrations by J.L. Boussingault; and (**right**) J.C. Mardrus: *Ruth et Booz*: 1930, binder and illustrator François-Louis Schmied, maroon Levant Morroco with lacquered panel by Jean Dunand designed by Schmied.

JENSEN, Georg
1866-1935
Silversmith, jeweler
Born in Raadvad, Denmark, into a working-class family. His father was a grinder in a steel plant manufacturing knife-blades, and Jensen began his apprenticeship in a brazier's workshop. When he was 14 the family moved to Copenhagen, and he was apprenticed to a goldsmith, achieving journeyman status after only four years. He wanted to be

a sculptor, and worked as a goldsmith while studying drawing, engraving and modeling, but he did not meet with great success in this field. In 1904 he opened his first small shop in Copenhagen. This soon became highly successful, and branches were subsequently opened in several major cities.

JOEL, Betty
b. 1896
Furniture and textile designer
Born in China, the daughter of an English adminstrator there. She started a furniture workshop on Hayling Island in 1921 with her husband David, after which a factory was opened in Portsmouth and a shop in London. Joel's early furniture was primarily in the Arts and Crafts idiom, but in the 1930s she developed a more Modernist

approach. She also designed carpets, which were made in China, and fabrics, woven in France.

Top and above Pierre Benoit:
Mademoiselle de la Ferté, 1926,
binder Pierre Legrain, illustrations by
Yves Alix; François Coppée: *Le
Passant*, binder Georges Adenis,
illustrations by Louis Edouard
Fournier, brown Levant Morocco
and mother-of-pearl; and Anatole
France *l'Ile des Pingouins*, 1926,
binder H. Creuzevault, illustrations
by Louis Jou.

JOURDAIN, *François*
1876-1958
Furniture designer, ceramist
Born in France, the son of an
architect, studied painting and
sculpture. His exhibit at the
Salon d'Automne in 1902
included several very plain and
geometric pieces of furniture. By
1919 he had opened a showroom
in the Seine-et-Marne, with the
furnishings manufactured in a
nearby workshop. His preferred
woods in the early years were
walnut, oak, zingana and maple,
but he later introduced steel,
aluminum, lacquer and wrought-
iron. A co-founder of UAM, he
continued to work until World
War II.

Jourdain: pottery-covered vase, 1920.

JOUVE, *Paul*
1889-1973
*Animalier sculptor, painter,
illustrator, ceramist*
Exhibited a painting of lions at
the age of 15, and at 18 designed
the ceramic frieze of animals for
the Binet gate at the 1900 Paris
Exposition. He illustrated Kipling's
The Jungle Book, and provided
designs of animals for Jean
Dunand's lacquer screens. His
sculptural work was generally in
bronze.

GRAPHICS

The book and fashion magazine illustrators of the 1910–14 period anticipated the later Art Deco graphic style. Inspired primarily by the 1909 arrival in Paris of the Ballets Russes and Léon Bakst's vivid stage and costume designs, French commercial artists followed suit, introducing the same orgy of colors and medley of Persian, Oriental and Russian influences into their designs for book illustrations, fashion plates and theater sets. Couturiers such as Paul Poiret provided additional opportunities in the same style for employees such as Erté and Paul Iribe, by publishing volumes of their newest fashions. By the outbreak of World War I, Bakst-inspired *pochoirs* and aquatints dominated the pages of Paris's foremost fashion magazines: *La Gazette du Bon Ton, L'Illustration* and *La Vie Parisienne.* The first-mentioned in particular drew on the talents of a host of artists, including George Barbier, Edouard Garcia Benito, Georges Lepape, Robert Bonfils, Umberto Brunelleschi, Charles Martin, André Marty, Bernard Boutet de Monvel and Pierre Brissaud. These artists mixed eighteenth-century pierrots, columbines, powdered wigs and crinolines with women clad in the latest *haute-monde* creations. From 1920, the lightly sensual young woman of these transitional years was transformed into a chic *garçonne*, a willful coquette who indulged in sport and cigarettes.

Of the illustrators listed, Erté deserves special mention, not only for his minutely detailed fashion plates from 1913 until after World War II, but also for his perseverance through his long career **(14).** When the Art Deco revival began in the late 1960s, Erté was discovered at his drawing board in his studio near the Bois de Boulogne, still hard at work as he had been since his arrival in Paris nearly 50 years earlier, and today, at age 94, he continues to generate a substantial body of graphics in basically the same style .

His contemporaries Barbier and Lepape produced a similar range of intricate and colorful illustrations for many years.

Elsewhere in Europe, response to the French Art Deco style was sporadic and mixed. In Germany, the fashion revue *Die Dame* followed the lead of its French counterparts, as did the German-born illustrator Baron Hans Henning Voigt, who worked under the pseudonym Alastair, creating haunting images inspired by Edgar Allan Poe. Alastair spent most of his career in England, before moving to the United States.

KAGE, *Wilhelm*
1889-1960
Painter, poster designer
Trained initially as a painter at the Valand art school in Gothenburg, Sweden, went on to design posters, and was employed at Gustavsberg porcelain factory in 1917. His designs were successfully shown at all the major exhibitions, and he was awarded a Grand Prix at the Paris 1925 Exposition. He became art director at

Gustavsberg until 1949 and remained there until his death in 1960.

KAHN, *Ely Jacques*
1884-1972
Architect
Son of an Austrian-born importer of glass and mirrors, Kahn established himself in the late 1920s both as a brilliant architect and as America's leading exponent of Modernist architectural design. He attended Columbia University and the Ecole des Beaux-Arts in Paris before joining a New York architectural firm, previously

Left Georges Lepape: poster for the Théâtre des Champs-Elysées; and (**right**) Edouard Halouze: *pochoir* for a magazine illustration, 1920. Halouze's style is today almost indistinguishable from those of other graphic artists of the day, such as Lepape, Barbier, Brunelleschi and Martin.

Buchman & Fox, in 1915. Within 10 years he had become a partner and was designing commercial buildings throughout the city, over 30 of which were erected from 1925-31. These included the Film Center, the Squibb Building, the Holland-Plaza Building and the Lefcourt Clothing Center.

E.J. Kahn: mailbox, Holland-Plaza Building, New York, about 1928.

KANTACK, *Walter*
1889-1953
Metalware manufacturer
One of the foremost manufacturers in the US, associated with the decorating firm of French & Co., and worked with such prominent architects as Gmelin & Walker, Buchman, and Kahn & Voorhees, with whom he decorated the Irving Trust Company offices in New York. He exhibited at the 1929 Exhibition of Industrial Art at the Metropolitan Museum of Art, for which he collaborated with the sculptor Edmond R. Amateis and the architect Ely Jacques Kahn on a monumental urn.

Vanity Fair

October·1926 © The Condé Nast Publications Inc. 35 cts · 3.50 a year

Left Vladimir Brobritsky: cover for *Vanity Fair*, October 1926. A fashionable young woman, accompanied by a borzoi or greyhound, became one of the most popular images of the Art Deco era. Chiparus in sculpture and Dupas in paintings provided particularly vigorous interpretations. **Below** Lucien Bernhard: poster, 1929. Here Bernhard imbues his design with an uncharacteristically German Expressionist feeling.

REKLAME SCHAU

KARASZ, *Ilonka*
1896-1981
Textile, ceramics and silver designer
Hungarian-born, emigrated to the US in 1913 with her sister Mariska. Produced hand-dyed and embroidered textiles showing a successful integration of folk motifs in a modern context, as well as ceramics, silver and other crafts. Her work was carried by a large number of textile mills and retailers, including Rockledge,

Schwartenbach & Huber, and Ginzkey & Maffersdorf Inc. The textiles were usually executed by Mariska to Ilonka's designs.

KELETY, *Alexandre*
Sculptor
Born in Hungary, studied in Toulouse and Paris. Modeled small-scale figures of dancers, ladies of fashion, mythological characters and animals, generally mounted on marble bases. Some were utilitarian objects such as *luminaires*, some were bronze and ivory statuettes, and some were decorated in damascene and niello with flowers and geometric patterns. All were

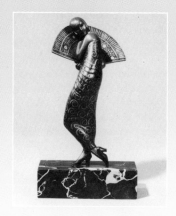

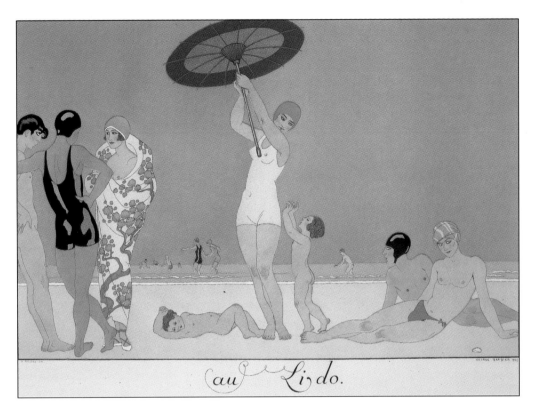

George Barbier: "Au Lido," book illustration, 1924. Period drawings such as this example by Barbier and those by Lepape capture perfectly the romance and buoyancy with which the 1920s are perceived today. They also, in their precise renderings of costumes, provide today's viewer with a vital chronicle of contemporary fashion. The style of the central woman bather's swimsuit, and the use of bathing caps by the men, date this scene to the mid-1920s.

The French Art Deco graphic style reached the United States in the late 1920s, where it quickly evolved into a Modernist idiom in which the machine's influence was increasingly felt. Fashion magazines such as *Vogue* and *Vanity Fair* (both owned by Condé Nast), *Harper's Bazaar* and *Woman's Home Companion* included French-inspired stylizations in their advertisements. To impress their readers, editors invited European illustrators such as Erté, Benito and Lepape to contribute cover designs. Other periodicals, such as *The New Yorker* and *Fortune,* tended toward a more geometric and industrial style, especially for their covers. Noted Modernist designers in the 1920s and 1930s included Joseph Binder and Vladimir V. Bobritsky, both European expatriates, and the native-born William Welsh, John Held, Jr and George Bolin. In the 1920s, Rockwell Kent pursued a light Art Deco graphic style in his woodcuts for book illustrations. John Vassos, the country's premier Modernist in book design, imparted a powerful linearism to his covers and illustrations.

elegant, sophisticated and out of the ordinary.

Kéléty: a bronze and ivory figure of a girl with a fan.

KIEFFER, *René*
1876-?
Bookbinder
Educated at the Ecole Robert-Estienne before spending 10 years in the *atelier* of the binder Chambolle. First exhibited at the Salon des Artistes Français in 1903. Co-founder of the SAD in 1910. Between 1917-23 executed most of Legrain's bookbinding designs for Doucet, adjusting successfully to the Art Deco style.

KISS (KIS), *Paul*
Wrought-iron designer
Born in Rumania, but became a naturalized Frenchman. He collaborated with Edgar Brandt, and then opened his own *atelier*, where he designed and executed a full range of wrought-iron furnishings and lighting as well as larger items of furniture. He had his own stand at the 1925 Paris Exposition. He worked for Paul Poiret, and also designed and executed a monumental grill for the palace of the king of Siam (Thailand).

GLASS

It is not easy to define or delineate "Art Deco" glass because there were very many new styles and techniques developed during the years prior to and following World War I. During this period distinction was increasingly made between glass as a medium of artistic expression, and glass as an everyday functional household item. With the onset of Modernism, new and varied uses for glass were found both within the home and in architecture. With steel and reinforced concrete, glass became one of the fundamental components of a new design aesthetic which rejected traditional modes of architectural ornamentation to focus on functionalism.

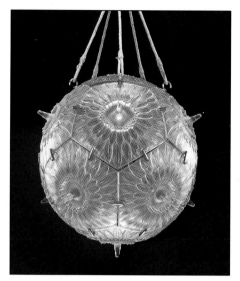

Above Maurice Marinot: bottle with mask decoration, 1920s. The deeply carved surface decoration complements the primitive facial design on the interior.

FRANCE

As in other media, French designers in this era produced the widest variety of forms and decoration in glass behind the leadership of two masters, Maurice Marinot and René Lalique, who jointly succeeded Emile Gallé as the leading *maître-verriers* in France. The work of Marinot is now considered one of the major design sources for glass after World War II, inspiring such prestigious designers in Scandinavia as Gunnel Nyman and Arttu Brummer. Marinot began his artistic training as a painter with the artist Fernand-Anne Piestre (also known as Cormon) at the Ecole des Beaux-Arts in Paris from 1901 to 1905. His early painting style was similar to that of the Fauves, Henri Matisse, André Derain and Kees van Dongen, whose canvases were exhibited alongside his at the 1905 Salon d'Automne. The exhibition jury perceived a common violence of

treatment and harshness of color in the works of these artists.

Marinot exhibited his works at the Salon d'Automne and Salon des Indépendants annually until 1913, by which time he had shifted to glass as his medium of artistic expression. His visit in 1911 to the glassworks of his friends Eugène and Gabriel Viard at Bar-sur-Seine changed the course of his career. His early experimentation included models for vases and bottles executed by the Viard brothers under his direction. Using the surface of the glass as a canvas, he applied bold stylized flowers and figures in bright blue, red, yellow and flesh-tinted enamels. Some of his earliest works

KLINT, *Kaare*
1888-1954
Furniture designer, architect
Born in Denmark, studied architecture under his father and then with Carl Petersen. In 1914 he collaborated with Petersen on the design of Neo-classical furniture for the art gallery at Faalborg. In 1924 Klint became a lecturer in furniture design at the Copenhagen Academy, and became a professor of architecture at the Academy in

1944. He was given many official commissions, including furniture for the Thorwaldsen Museum (1922-25), and his designs were shown at many exhibitions. Unlike many designers of the period, his style was influenced by English eighteenth-century furniture. His desk chair (1933) and his X-framed folding chair are considered among his best work.

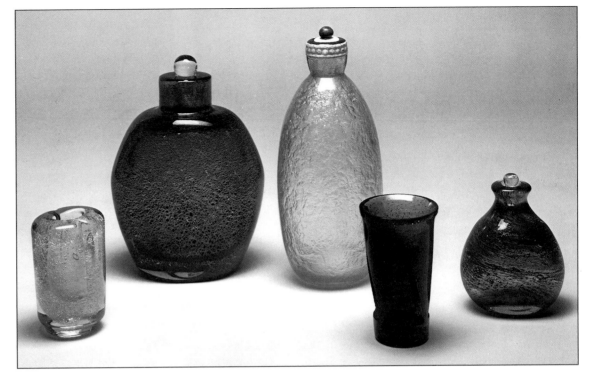

Left René Lalique: "Sunflower" chandelier in brown-stained and frosted glass, 19½in diameter, late 1920. Lalique applied a muted range of enamel tints to some of his glassware to provide subtle highlights. The brown used here was replaced elsewhere by pale blues, greens, grays and sienna.
Right selection of 1920s glassware: Henri Navarre, vase, 4½in high; Maurice Marinot, decanter, 9¼in high; an enameled and etched decanter, 10½in high; an etched vase 5in high; and a scent bottle, 5¼in high. In these examples, Navarre and Marinot have depended on simple forms and light internal decoration for a Modernist effect.

were included in the Cubist House exhibit conceived by his friend, André Mare, for the 1912 Salon d'Automne. These models achieved a quick popularity. By 1913 Adrien Hébrard, the noted Paris art dealer and bronze-founder, became Marinot's exclusive agent, exhibiting examples of his glass at his Rue Royale gallery. The Luxembourg Museum in Paris, Baron Robert de Rothschild, and Mme Louis Bartho, wife of the French Foreign Minister, were among his first patrons.

Marinot acquired the technical skills of glass-making quickly, which allowed him to execute his own designs. He worked virtually uninterrupted from 1914 to 1919, experimenting with transluscent enamels as an alternative to the opaque varieties. This led to a transitional period in which he continued to employ enameled figural decoration to the outside surface of the glass while experimenting with ways to apply the decoration internally. By 1923, he had rejected all types of extraneous decoration, including the use of enamels, in order to explore both hot and cold glass-making techniques. This allowed him to work with the glass mass itself. The glass objects of his mature years were extremely sculptural, while retaining the brute force of his early Fauvist

KOSTA GLASSBRUK AB
Founded in 1742, the oldest Swedish glassworks still in production. Its early makers created a variety of objects including a 'Kosta' chandelier with 12 arms dating from about 1760, now hanging in a church at Herrakra. From the turn of the twentieth century the firm began an association with well-known designers including Lindberg, Morales-Schildt and Wärff. The Kosta factory now includes the sister factories of Boda and Afors.

KREBS, *Nathalie*
b. 1895
Ceramist
Originally trained as a civil engineer, and was employed by Bing & Grøndahl from 1919-29. With Gunnar Nylund she opened a stoneware *atelier* which she renamed Saxbo in 1930; she was joined by Eva Staehr-Nielson.

paintings. An acid-etched vase in clear glass, dated 1934, now at the Corning Museum of Glass, provides a fine example of this union.

In the 1920s and 1930s, Marinot's work divided roughly into four categories (1). First, the vessels he designed after his initial attempts at enameling are characterized by heavy, thick walls which incorporate deeply etched or internal decoration, the latter comprising air bubbles, smoky tints, streaks of muted color, or a "sandwich" effect in which a layer of speckled or spiraling color was inserted between the inner and outer layers of clear glass. The second category consists of etched pieces that were very deeply acid-cut with powerful, almost brutal, abstract geometric motifs in which the acid-treated textured areas contrast with the polished and smoothed raised areas to maximize the refractive effects of the light. The third category includes glassware worked at the furnace, in which heavy applications of molten glass emphasize form; Marinot modeled some of these into formalized masks. The fourth category comprises Marinot's bottles, either molded or shaped at the kiln, which incorporate the artist's characteristic spherical or hemispherical stoppers and internal decoration.

Marinot's work, which was published extensively, received wide recognition and critical acclaim. At the 1925 Exposition, he exhibited "Hors Concours" at various pavilions, including the Ambassade Française, Musée d'Art Contemporaine, and the Hébrard shop on the Alexandre III bridge (2). Acclaim for his glass soon became worldwide, influencing not only his French contemporaries, but also glass-makers outside France. Articles about him in contemporary reviews, and traveling exhibitions of his works, further promoted his reputation.

With the closure of the Viard glassworks in 1937, Marinot abandoned glass-making altogether. His declining health, exacerba-

ted by years of intensive work at the furnace, contributed to his decision to retire. After a major exhibition of his glass at the 1937 Paris Exposition, he returned to painting, which he pursued until shortly before his death in 1960.

Marinot's influence was pervasive, particularly in France, where he had many followers. Of these, Henri Navarre is probably the best known (3). Navarre began to experiment with glass in 1924 after an earlier career as a sculptor. Most of his work is furnace-worked glass with heavy walls and internal decoration in the form of swirls and whorls of color, internal granulations and *intercalaire* (interlayed) textures. These effects were achieved by the use of powdered metal oxides patterned on the marver (glass-maker's slab) on to which a paraison (layer) of viscous clear glass was then rolled. The application of a second layer of clear glass encased the decoration. Navarre's palette is more somber than Marinot's, and his surfaces are more heavily adorned with applications pressed on to, or wrapped around, the body. He also designed leaded-glass windows and panels – for example, for the town hall of the XXième *arrondissement*, Paris, in 1930 – in addition to sculptures shaped with hydrofluoric acid, such as a mask of Mme H. N. in 1930. One of his most important commissions was the execution of a large figure of Christ in molded glass and a gilded bas-relief reredos representing Martha and Mary for the chapel of the *Ile-de-France* ocean liner in 1927.

Like Navarre, André Thuret began to experiment in glass in the 1920s after working as a glass technician for the Bagneux Glassworks. His work incorporated the same thick walls employed by Marinot, in clear glass enhanced with internal air bubbles. His style, however, was more adventurous in its range of shapes and colors; the semi-molten glass was either pinched into undulating

L

LACHAISE, *Gaston*
1882-1935
Sculptor
French by birth, emigrated to the US in 1906 after training in Paris. In 1917 he married his former mistress and model Isabel Dutaud Nagle, who was the inspiration for the voluptuous but geometrical female forms that became his trademark. He was commissioned to design reliefs for the RCA and International buildings at Rockefeler Center in 1929. He is now considered to have been one of the major figures in the development of a modern idiom in American art, although it was only towards the end of his career that he began to receive critical recognition.

Lachaise: a polychrome bronze figure of a pengouin, about 1925.

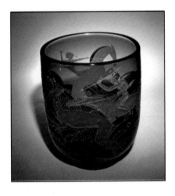

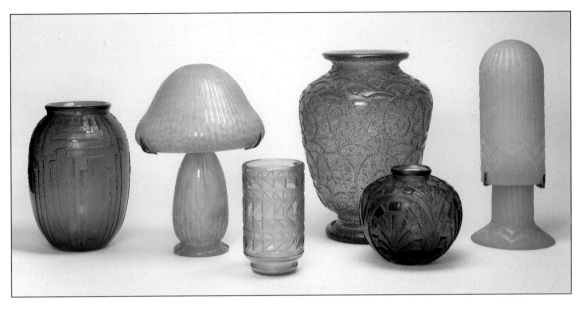

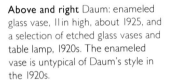
Above and right Daum: enameled glass vase, 11 in high, about 1925, and a selection of etched glass vases and table lamp, 1920s. The enameled vase is untypical of Daum's style in the 1920s.

shapes or rolled on to metallic oxides on the marver to produce multicolored swirls and patterns.

Georges Dumoulin was a noted painter and ceramist who received many awards before venturing into glass-making **(4)**. He made a series of waisted vessels with internal color and bubble effects reminiscent of Marinot's works in which trailing serpentine swirls were applied in spirals around the outside of the glass.

Under the guidance of Paul Daum, grandson of Jean Daum, the firm's founder, Daum frères of Nancy reopened in 1919, growing in prestige as the town's other glass *ateliers*, including the Gallé workshops, went into decline. Daum produced a line of thick-walled, large vases in transparent and opaque colored glass. Included among their most prominent works was a series of bowls, vases and lamp shades with deeply etched bold, geometric motifs, some of

which were blown into a bronze or wrought-iron armature. The backgrounds on these pieces were roughly finished to contrast with the polished relief sections, a technique borrowed from Marinot. After 1930, the walls on Daum's glass became thinner and the etching shallower. The firm also produced cameo vases in crystal or single colors etched with stylized designs of animals, repeating floral patterns, sunbursts or swirls, invariably against a roughly etched background.

Not far from the Daum works, Aristide Colotte joined the rival Cristallerie de Nancy in the mid-1920s as a modeler. Early designs included molded radiator mascots and statuettes. Experimentation soon led to enameled and painted glassware enhanced with etched detailing. By 1928 Colotte's style had become distinctly unconventional, more suited to wood or metal in its choice of

LACLOCHE, *Fernand and Leopold*
Jewelers
Joint founders of the firm LaCloche in Madrid, a prominent exponent of Art Deco jewelry and *objets d'art* in the 1920s. The brothers took over Fabergé's London shop in 1920 and were selected to contribute jewelry designs to the 1925 Paris Exposition.

LACROIX, *Boris Jean*
1902-?
Designer, all fields of the decorative arts
Lacroix first worked anonymously in decorating and furniture design, often doing complete installations including the architecture of the room. He designed wallpaper, and worked for a number of fashion houses, designing clothing and accessories and costume jewelry. He also designed lighting,

preferring simple, geometric forms, and working with polished and matte-finished nickel surfaces. Much of his lighting design was done for Damon.

Lacroix: tea service, silvered metal, ebony and mirrored glass, 1920s.

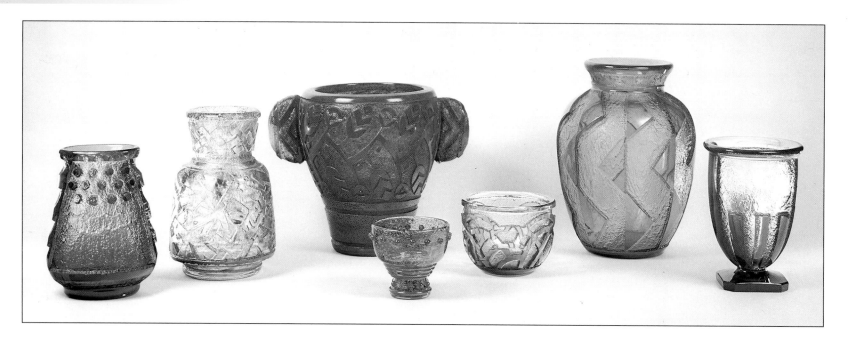

sculptural forms and techniques. He used a curious selection of tools, including chisels and files, to forge his designs from solid blocks of crystal. Contemporary photographs show him carving his pieces underwater! Favorite themes included animals and birds – for example, rams, owls and swallows – and a considerable body of religious subjects, to which he often applied powerful geometric motifs such as bolts of lightning or spiraling bands engraved deeply into the free-form mass of crystal. The sharp contrast between the polished cut detailing and the rough background generated vividly contrasted lighting effects.

Ernest and Charles Schneider established their glassworks at Epinay-sur-Seine in 1913. They created large, colorful lamps and vases decorated with internal bubbles and mottled or marbled color effects. Some pieces were decorated with boldly colored glass trailings fashioned into stylized flowers. Others were decorated with engraved geometrical whorls, stylized flora and portrait medallions, or applied in a combination of techniques with realistic scenes from nature, such as painted goldfish on a translucent bubbled ground which simulated an aquarium. Schneider glass was also sold under the names Charder and Le Verre Français.

Other glass artists, such as Marcel Goupy, followed the enameling style of Marinot's early work. A painter, silversmith and jeweler, Goupy was persuaded to pursue a career in glass by a meeting with Georges Rouard. Joining La Maison Geo. Rouard in 1909, Goupy designed a range of vessels in colorless or transparent colored glass on which the decoration was rendered in bright

LALIQUE, *René*
1860-1945
Jewelry and glass designer
One of the foremost exponents of the Art Nouveau style in his early years, Lalique's greatest triumph as a jeweler was at the Paris Exposition of 1900, which made him world-famous. Around 1905 he began to produce mirrors, textiles, paper-knives and other small items, using engraved glass, and from 1906 he was commissioned to produce

glass perfume bottles for François Coty. After this, glass became his main interest, and at the 1925 Paris Exposition he not only had his own pavilion but also designed and manufactured a glass table, wineglasses and candlesticks for the Sèvres porcelain pavilion. In 1932 he supplied glass panels and chandeliers for the liner *Normandie*.

Lalique: "5-Chevaux," a clear glass car mascot.

LALIQUE, *Suzanne*
b. 1899
Painter, textile designer and ceramist
Daughter of the famous jeweler and glass designer, trained as a painter and studied briefly under Eugène Morand. She produced delicate designs for textiles, as well as porcelain for the Sèvres Manufactory, and Haviland & Co., Limoges.

enamels painted on both the inside and outside surfaces of the glass. His decorative motifs ranged from stylized birds, flowers and animals to landscapes, mythological figures and female nudes. He also designed a number of vessels in smoky or colored glass that achieved new effects in their layering.

Auguste-Claude Heiligenstein started his career in glass at the age of 11 as a *garçon* at Legras et Cie. in Saint-Denis, after which he became an apprentice glass decorator from 1904 to 1906. In 1906 he moved to Paris, where he worked briefly at the Atelier Prestat before moving to the Cristalleries de Baccarat, where he remained until 1910. After a number of stints with other firms, he went to work for Goupy, under whom he became proficient in enameling. Four years later he began work as a freelancer for various workshops. His elaborately detailed and brilliantly colored vessels reflected the 1920s revival of Neo-classical themes delineated in the Art Deco style.

Jean Luce, the son of a porcelain and glass tableware dealer, became involved in glass while assisting in his father's shop, which he left in 1923 to concentrate on glass-working. In 1931 he opened his own studio, where he designed matched sets of glass and porcelain tableware, and glassware decorated with enameled stylized floral designs. Shortly afterward, he abandoned enameling altogether, preferring to decorate his glassware with geometric abstract patterns engraved or sandblasted in contrasting matte and polished finishes. Other models in this later period were thick-walled with mirrored or gilded surfaces engraved or sandblasted with geometric patterns. Primarily a designer, Luce left the execution of most of his designs to other glass artisans.

Unlike Marinot, René Lalique focused his attention on commercial glass-making. He attempted to bring good design to a

Opposite page Daum frères: selection of etched glass vases, 1920-30s; and (**below**) etched glass table lamps, also Daum frères, about 1930. Here Daum has used a thick glass to conceal the light bulb and to reflect the light downward rather than absorb it. **Right** Aristide Colotte: glass vase with wheelcarved and chiseled decoration, late 1920s. Colotte's forceful style incorporates elements of sculptural composition in its use of deeply carved or chiseled surface decoration.

LAMBERT-RUCKI, *Jean*
1888-1967
Sculptor, painter
Born in Poland, moved to Paris in 1911 after attending the Cracow School of Fine Arts. Exhibited at the Salon des Indépendants (from 1920), with the Section d'Or (1922-24), at the Léonce Rosenberg gallery (1924), and the Salon des Tuileries (from 1933). He was given a retrospective at the Claude Robert Gallery in Paris in

1971. He was influenced by Cubist principles and by African art, and used a wide variety of materials in his work, such as painted plaster, metal, wood and mosaic, used both singly and in combination.

Lambert-Rucki: *Le Commentaire*, tempera on board, 1928.

LARCHER, *Dorothy see*
BARON, *Phyllis*

wider, although still affluent, market by combining manual and mechanized production. He began his career as a graphic designer and then as a designer of Art Nouveau jewelry for celebrities such as the actress Sarah Bernhardt and the great collector and *bon vivant*, Calouste Gulbenkian.

Lalique's involvement with glass came in the course of his career as a jewelry designer. In his search for new and less expensive materials, he experimented with vitreous enamels and glass cast by the *cire perdue* (lost wax) method, and it was in the latter technique that Lalique produced perhaps his first all-glass object, a tear-shaped vial with stopper, in around 1893–97. After this initial success, he produced a limited number of glass items which he displayed alongside his jewelry at his new shop in the Place Vendôme.

Left Jean Luce: selection of vases with sandblasted and mirrored finishes, 1920s. Like Colotte, Luce applied powerful imagery to his designs by the use of deep and angular motifs. **Right** René Lalique: "Le Jour et La Nuit," clear and frosted blue clock, 14⅜in high, about 1932. **Far right** René Lalique: "L'Oiseau du Feu," *luminaire* in clear and frosted glass with bronze base, 17in high, about 1930. By placing the bulb inside the base, Lalique allowed the soft light to filter up through the foot of the glass to provide the etched decoration on the panel with gentle nuances. *Luminaires* were often used most effectively as nightlights.

LAURENCIN, *Marie*
1883-1956
Painter, illustrator, theater and textile designer
Attended Académie Humbert, Paris, before entering her painting career. She participated in the "Maison Cubiste" at the 1912 Salon d'Automne and exhibited regularly at Léonce Rosenberg's gallery between 1913-40. In 1924 she designed the costumes and sets for the ballet *Les Biches*. Her paintings were often included in the ensembles of her brother-in-law André Groult at the annual salons and the 1925 Exposition, and she was one of several French artists who on occasion designed carpets or textiles.

LAURENT, *Robert*
1890-1970
Sculptor
Born in Brittany, but went to New York in 1901 at the invitation of Hamilton Easter Field, an American painter, editor and teacher who was to become his mentor. Decided to abandon painting for sculpture and studied in Rome and London. His first interest was animals, but during the 1930s he turned his attention to people. One of America's first truly "modern" sculptors, his work cannot be seen entirely in the context of Art Deco, but it exemplifies the taste of the period.

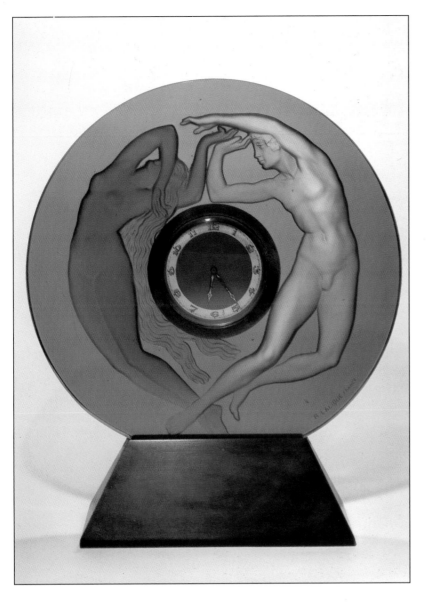

Lalique and his influence

It was in this shop in 1906 that Lalique's glass vessels first caught the attention of François Coty who, aware of Lalique's abilities as a graphic designer, is said to have asked Lalique to design labels for his various perfume lines. Perhaps eager to launch his career in glass-making, Lalique feigned lack of interest, agreeing to accept the commission only if he were asked to design the *flacons* as well. Coty agreed, and a partnership was born. Lacking facilities for large-scale

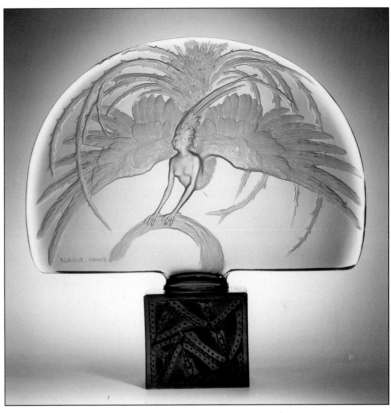

LEACH, *Bernard*
1887-1979
Ceramist
England's most prolific and prominent studio potter, who integrated Japanese philosophies of art and craft into his work, and influenced several generations of potters. He established the St Ives pottery in Cornwall in 1920, and another studio in Devon in 1936, and continued working until 1972.

Leach: pottery vase, 1940s.

LE CHEVALLIER, *Jacques*
1896-?
Lighting, stained glass and tapestry designer, painter, woodcarver
Born and studied in Paris, then entered into a partnership with Louis Barillet that lasted until 1945. He was a member of the SAD, and a founding member of the UAM His lighting designs, especially those done in collaboration with Raymond Koechlin, were strong and idiosyncratically original. After

1945 he devoted himself to work in stained glass, and opened an *atelier* at Fontenay-aux-Roses.

production, Lalique's first designs for Coty were produced at Legras et Cie, in crystal and mostly unsigned. In 1908, Lalique rented the Combs-la-Ville glassworks, where he began to execute his own designs, and these premises were purchased in 1909, allowing him to go into serial production. Glass produced in Lalique's own factories was all in *demi-cristal*, a malleable and relatively inexpensive material suitable for molding and mass-production. By the outbreak of World War I Lalique had almost ceased his jewelry production. In 1918 his emphasis on glass was consolidated with the purchase of a larger factory at Wingen-sur-Moder.

Lalique's vessels, which incorporated exceptionally high relief and finely detailed decoration, were made in three ways: by blowing glass into molds by mouth, mechanically by an *aspirée soufflé* or *pressé soufflé* process, or by casting with a stamping press. The base material used was always *demi-cristal* – glass with a 50% lead content that was either left clear or colored with metallic oxides, sulphides and chlorides, to produce an array of exquisite, jewel-like colors ranging from emerald green to ruby red. Opalescent effects were achieved by sandwiching a layer of opaque white glass between two layers of colored glass. Other forms of decoration were achieved by painting or staining with enamels, frosting with acids, "antiquing" or simulating the effects of aging, exposing the glass to metallic oxide fumes under a muffle, or by polishing with rouge or high-speed buffers.

Lalique's repertoire of decorative motifs was equally varied: naturalistic or stylized animals, flowers, human and mythical forms, and abstract geometric patterns. Relief patterns were heightened by the application of colored enamel stains. A wide variety of items was offered: vases, tableware, *garnitures de toilette, flacons, brûle-*

parfums, jewelry, clock cases, sculpture, mirrors, desk sets, light fixtures, furniture, architectural fittings, fountains and even such novelty items as car mascots.

Lalique was enormously successful throughout the 1920s, gaining wide acclaim at the 1925 Paris Exposition, where he had his own pavilion **(5)**. He also designed a dining room in glass for Sèvres and a large fountain in the Cours des Métiers. In addition, his *flacons* dominated the spectacular *fontaine des parfums* in the perfumery section, while other examples of his work were included in the exhibits of various *ensembliers*. Important commissions followed, including glass elements for transatlantic cruise liners such as the *Paris* (1920), the *Ile de France* (1927), and the *Normandie* (around 1935), for which he designed decorative panels, light fixtures, illuminated ceilings and other accessories **(6)**. He provided similar fixtures for luxury *wagons-lits* (sleeper-cars in the French railway system), restaurants, theaters, hotels and churches, and designed a series of public glass fountains at the Rond-Point on the Champs-Elysées. In anticipation of World War II, Lalique closed his Wingen-sur-Moder glassworks in 1939. He died shortly before it reopened in 1945 under the artistic direction of his son Marc.

LE FAGUAYS, *Pierre*
1892-?
Sculptor
One of the most diverse and prolific of the Art Deco sculptors in France. His subjects were mythological characters, ideal figures, allegorical representations, etc., modeled in bronze, silvered bronze, bronze and ivory, and with a damascened pattern similar to that used by Kéléty and Bouraine. His style developed

over the course of his career from the fairly realistic to the hyper-stylized.

LEGRAIN, *Pierre*
1887-1929
Bookbinder, furniture designer, interior decorator
Educated at the College Sainte-Croix in Neuilly and the Ecole des Arts Appliqués Germain Pilon. In 1908 drew cartoons for Iribe's *Le Témoin, L'Assiette au Beurre* and *La Baïonette*. With Iribe, he decorated Doucet's apartment at 46 Avenue du Bois, Paris. In 1917 he designed the first of nearly 400 bindings for

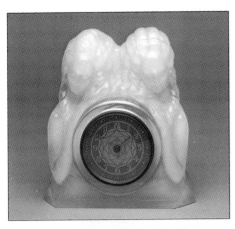

Opposite page René Lalique: cardboard containers and bottle for the *parfumeur*, Roger et Gallet, Paris, 1920s. Lalique was first drawn to glass through his invitation to design perfume containers for Coty. **Left** Ernest-Marius Sabino: opalescent glass table clock, 7½in high, about 1928. **Below** Ernest-Marius Sabino: glass and chrome clock/*luminaire*, 19in long, about 1928.

Lalique's success prompted several other designers to create a similar line of glassware. Included were Marius-Ernest Sabino, who exhibited at the 1925 Paris Exposition and subsequently at the Salon d'Automne and La Société des Artistes Décorateurs. Sabino's blue-tinted opalescent glass vases and decorative accessories were not as finely conceived and executed as Lalique's, but some were more colorful. His works included architectural elements, *electroliers*, floor and table lamps, chandeliers, tables, vases, wall *appliques*, fountains, and statuettes in human and animal form. The elaborate bronze, brass, and wrought-iron mounts for his lamps and decorative objects were made in his own workshops. Sabino's

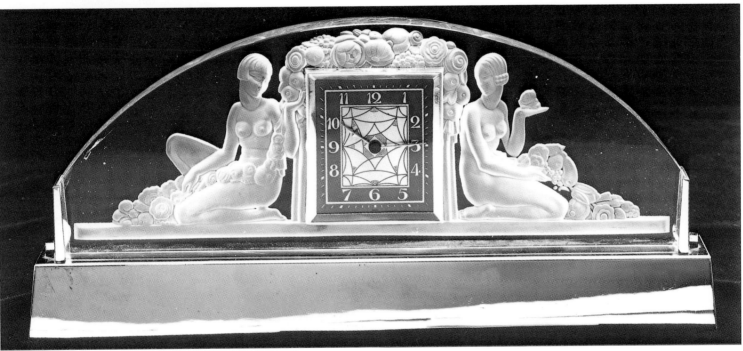

Doucet, which revolutionized the medium. In 1923 he established his own bindery and furniture studio. Clients included Doucet, Tachard, Meyer, Viscount de Noailles, Suzanne Talbot.

Legrain: chair, burr maple and shagreen, 1923.

LELEU, *Jules*
1883–1961
Furniture designer, interior decorator
Born in Boulogne and succeeded his father in the family painting firm in 1909. He was joined by his brother Marcel, and they entered the decorating field. After World War I Jules decided to specialize in furniture making and in 1924 opened a gallery in Paris. Warm woods became his hallmark — walnut, Macassar ebony, amboyna and pilisander

— the furniture's richness being derived from the material itself. In 1936 he furnished the Grand Salon des Ambassadeurs at La Société des Nations, Geneva. The room, still in existence, is known as the "Salon Leleu."

Leleu: table, Macassar ebony and ivory, about 1925.

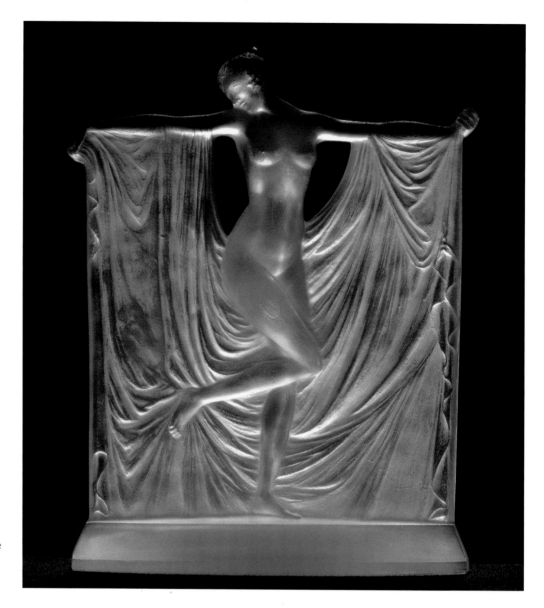

Right René Lalique: 'Suzanne (au bain)', opalescent molded glass figurine, 15.25cm high, about 1932. The molded glass details on the bather's towel enhance the sculptural qualities by capturing the passing light. **Opposite page** René Bauthaud: *verre églomisé* panel, about 1925.

DE LEMPICKA, *Tamara*
1900-80
Painter
Born Tamara Gorska outside Warsaw. In her teens married Thadeus Lempitzski, a Russian. She arrived in Paris c1918, and when her husband abandoned her in the 1920s, enrolled at the Académie Ranson. Her highly distinctive style can be seen in roughly 100 portraits done between 1925 and 1939. She and her second husband moved to the US in the late 1930s and eventually settled in Texas.

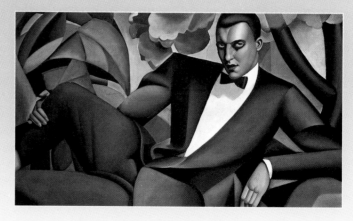

Tamara de Lempicka: Portrait of the Marquis d'Afflitto, 1925

reputation rests primarily on his inventive designs for lighting fixtures. The Sabino glassworks closed at the outbreak of World War II. It opened again in the late 1960s, producing an extensive range of small opalescent glass animals and nudes.

Edmond Etling et Cie produced a similar range of Lalique-inspired objects, including figurines of female nudes, animals and ships in opalescent glass with a blueish tint. The firm also made small chromed-metal and crystal lamps, examples of which were displayed at the second Salon of Light in 1934 and at the 1937 International Exposition. Etling designers included Dunaime, Georges Beal, Jean-Théodore Delabasse, Geneviève Granger, Lucille Sévin, Géza Thiez, Bonnet, Laplanche and Guillard. Like Etling, the firm of Verlys in Andelys, near Rouen, produced a range of opaline glass *bibelots* and vases.

Genet & Michon was established by two engineers, P. Genet and L. Michon, to manufacture light fixtures, lighting schemes, and custom-made illuminated panels inspired by Lalique. Their glass was slightly opaque, achieved by the application of hydrofluoric acid to its surface. This semi-opacity refracted and diffused the light in eye-catching patterns which the firm incorporated into architectural lighting commissions such as the Hotel Splendide at Dax. Genet & Michon also produced a remarkable selection of small light fixtures, such as a globe lamp in pressed glass with a map of the world engraved on its surface.

Albert Simonet, the head of Simonet frères, became another Lalique disciple. Inspired by the latter's success, Simonet changed the direction of the firm, an established bronze manufacturer since the nineteenth century, by introducing pressed glass panels into his light fixtures. Bronze was relegated to a secondary role, that of supporting the glass. One of the firm's more remarkable works is an

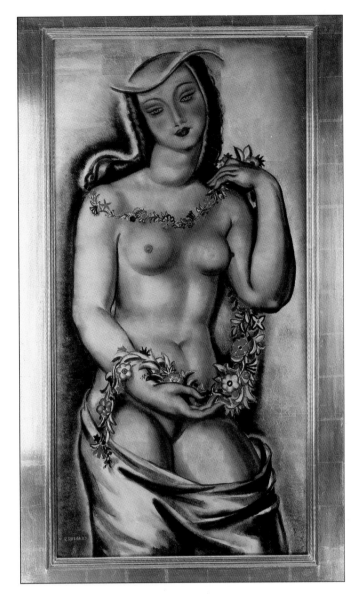

LENOBLE, *Emile*
1875-1940
Ceramist
Worked after 1930 for the prominent ceramist Ernest Chaplet his grandfather by marriage. Known for his concentration on exquisitely refined glazes and his mastery of the technique of engraving his surfaces, he was influenced by oriental pottery.

LENOIR, *Pierre-Charles*
b. 1879
Sculptor
Born in Paris, son and pupil of Charles-Joseph Lenoir. Also studied with Chaplain and Mercie. Exhibited at the salon of the SAF, winning second-class medals in 1905 and 1907 and a traveling scholarship in 1911. Lenoir designed many monuments and memorials, and his small-scale work retains a monumental quality.

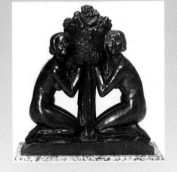

Lenoir: "Abundance," a bronze allegorical group, about 1925.

urn-shaped *torchère* in opalescent glass molded in relief with stylized floral patterns. The shade rests on a bronze *gueridon*-type base cast with a Neo-classical frieze of satyr masks above a band of goat's hooves. This remarkable piece was one of several shown by Albert Simonet and Henri Dieupart at the 1925 Paris Exposition. The firm's most characteristic designs for light fixtures were globular, the individual sections of pressed glass mounted in a metal armature. The glass itself was molded with a variety of naturalistic and abstract motifs.

Paul d'Avesn, a student of Décorchemont, worked for Lalique between 1915 and 1926 before establishing himself at the Cristalleries de Saint-Rémy, where he produced molded glass

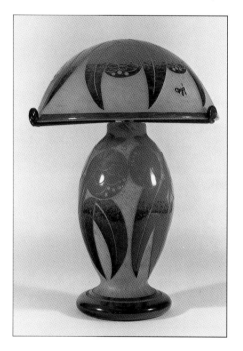

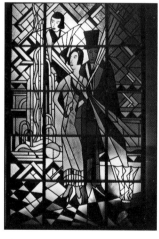

Left Degue: cameo glass table lamp, 27in high, about 1928; and (below) Gerda Wegener: stained-glass window, about 1925.

vessels in a variety of finishes. One of his best-known works is a vase with a frieze of alternating lions and lionesses stalking their way in an endless line around the squat, bulbous vase. André Hunebelle also designed molded vases *à la* Lalique which were more geometrical and stylized in shape and decoration than those of d'Avesn. Hunebelle, credited with the invention of the port decanter, became a noted film director after World War II (7).

Pâte-de-verre

Although the revival of *pâte-de-verre* in France was initiated by Henri Cros in 1884, its peak did not come until the 1920s and 1930s. The material is made of finely crushed pieces of glass ground into a powder mixed with a fluxing medium that facilitates melting. Coloring is achieved by using colored glass or by adding metallic oxides after the ground glass has been melted into a paste. In paste form, *pâte-de-verre* is as malleable as clay, and is modeled by being packed into a mold where it is fused by firing. It can likewise be molded in several layers or refined by carving after firing. Cros produced a number of polychrome *pâte-de-verre* medallions, plaques and frames, most with mythological or allegorical subjects molded in relief. Surviving pieces are rare and often damaged. Albert-Louis Dammouse was another turn-of-the-century pioneer in *pâte-de-verre*, experimenting with *pâte-d'émail* and related *cloisonné* techniques.

Alméric Walter, a former ceramist who had trained at the Ecole Nationale de la Manufacture Sèvres, first encountered *pâte-de-verre* as a student, experimenting with the medium under the direction of his teacher, Gabriel Levy. In 1908, he moved to Nancy, where he found employment as a glass-maker at the Daum works, producing an array of *pâte-de-verre* vases, ashtrays, bowls and

LEPAPE, *Georges*
1887-1971
Painter, poster and fashion artist, illustrator
Studied at the Ecole des Arts Décoratifs, Paris, and the *ateliers* of Humbert and Cormon. In 1911 illustrated *Les Choses de Paul Poiret* and the following year programs for the Ballets Russe. Innumerable magazine covers and fashion plates for *La Gazette du Bon Ton* and *Vogue*.

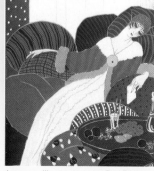

Lepape: Illustrations to *The Fashions of the Day*, about 1914

LEVEILLE, *André*
1880-1962
Fabric designer, jeweler
Born in Lille, became interested in fabric design while he operated a textile factory from 1905-25. He learned to paint by copying museum paintings, and by 1911 was exhibiting regularly at the Paris salons. He contributed outstanding jewelry designs showing a strong Cubist influence during his association with Georges Fouquet in the

1920s, and won a Grand Prix at the 1925 Paris Exposition.

statuettes. His style was influenced by that of the firm's designer, Henri Bergé, and other well-known local artists, such as Victor Prouvé and Jean-Bernard Descomps. Most of his works are highly sculptural, decorated with frogs, lizards, goldfish and beetles rendered naturalistically. Walter also designed *pâte-de-verre* medallions which could be used either as jewelry pendants or as decorative accents for furniture and lamps. Of merit also are his *pâte-de-verre* wall sconces and decorative panels, often in a dramatic palette of greens and reds. All items made prior to 1914 are marked DAUM NANCY with the Cross of Lorraine. Those after 1919 are signed A. WALTER NANCY, usually with the designer's signature added.

François-Emile Décorchemont brought the greatest recognition to *pâte-de-verre*. A ceramist by training, he was inspired in 1902, on seeing Dammouse's *pâte-d'émail* works, to experiment with *pâte-de-verre*. His first wares were typically Art Nouveau in style, with floral or symbolic motifs. Gradually, however, his style and technique changed. After returning from a traveling scholarship he won in 1908, he began to work in the *cire perdue* method of casting, producing thin-walled vessels with decorative details cut into the surface. By 1910 he was working with *pâte-de-cristal*, having rejected the thin walls and ethereal decoration that characterized his earlier models.

In the 1920s Décorchemont's style became increasingly bolder, progressing from the naturalistic floral motifs of his earlier works to the stylized asps and grotesque masks of the early to mid-1920s and, finally, the highly geometrical images of his mature style. Of restrained elegance, his works in this later period are characterized by rigid, often cubic forms, with relief geometrical decoration. Décorchemont developed a spectrum of jewel-like colors, using a variety of metallic oxides that rivaled Lalique's in their brilliance and sumptuousness. Jade green, turquoise and sapphire blue were streaked with black or purple to simulate semiprecious stones. In the 1930s Décorchemont became increasingly involved in the production of decorative window panels. From 1935 to 1939, for example, he worked almost exclusively on a window commission for the Sainte-Odile Church in Paris. In place of the traditional use of painted and leaded glass, Décorchemont used *pâte-de-verre* to create a rich and intimate effect.

Joseph-Gabriel Rousseau received his early training in ceramics, enrolling at the Ecole Nationale de Céramique de Sèvres in 1902. After his graduation in 1906, he became the manager of a small ceramics research laboratory and shortly afterward opened his own workshop where he experimented with *pâte-de-verre*. He married Marie Argyriades in 1913, at which time he added the first part of his wife's family name, Argy, to his own. In 1921 Argy-Rousseau formed a limited partnership with Gustave-Gaston Moser-Millot, the owner of a large decorative arts gallery at 30 Boulevard des Italiens in Paris. The firm was named Les Pâtes-de-verre d'Argy Rousseau, with Moser-Millot as chairman and principal shareholder, and Argy-Rousseau as managing director. A workshop was opened at 9 Rue de Simplon, where several dozen workers and decorators were employed to execute Argy-Rousseau's designs in *pâte-de-verre* for sale at the gallery on the Blvd des Italiens. The partnership was beneficial for Argy-Rousseau in that it gave him the financial freedom to concentrate on designing. He manufactured a wide range of decorative objects, including vases, bowls, lamps, jars and panels in colorful, opaque *pâte-de-verre* of very light weight and a high grade of clarity. These were decorated with a variety of stylized flowers and animals in combination with geometrical

LIKARZ-STRAUSS, *Maria*
b. 1893
Graphic artist, ceramic and textile designer
Employed with the Wiener Werkstätte from 1912-14 and 1920-31. She was a prolific designer of graphics, ceramics and textiles, and was particularly noted for a range of wallpapers using both stenciled and freehand decoration.

LINDSTRAND, *Vicke*
1904-83
Glassmaker
Born in Gothenburg, Sweden. Began as a newspaper editor and cartoonist, only becoming interested in glass at the age of 24, in 1928. He then started as a designer with Orrefors and in the following years exhibited his work in many national and international exhibitions. In 1940 he left Orrefors to work with the Uppsala-Ekeby ceramic firm, and in 1950 he joined Kosta as a designer and Director of Design. His designs for this firm are spontaneous and filled with movement. He also created glass sculptures for the towns of Norrkoping and Stuttgart, made of 3,000 pieces of plate glass held together with special adhesives.

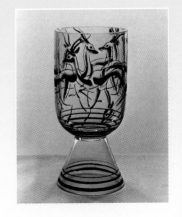

Lindstrand for Orrefors: cut glass vase, 1937.

Selection of *pâte-de-verre* by Alméric Walter, all from the 1920s, some modeled for him by the sculptor Henri Bergé. Chameleon dish, 10⅞in long; frog paperweight, 2⅞in high; moth tray, 13½in long; fish *vide-poche*, diameter 6in, and rhinoceros dish, 11in long. *Pâte-de-verre* was virtually the only area of 1920s glass in which emphasis on color was maintained after the Art Nouveau era. Most glassware, such as for light fixtures and vases, was limited to one, or possibly, two, colors, in keeping with the rather monochromatic interiors of the interwar period.

motifs. His more notable works, executed in *pâte-de-cristal,* had Neo-classical relief decoration, in keeping with the vogue for Egyptian revivalism spurred at the time by the discovery of Tutankhamen's tomb. Other models were rigidly geometric in form. A waning public interest in *pâte-de-verre* from 1929 led to a gradual decline in production and, with the onset of the Depression, Les Pâtes-de-verre d'Argy Rousseau was dissolved. Unable to launch his own firm, Argy-Rousseau turned to small-scale production, working on plaques and sharply angular vessels in jeweled colors streaked with black or deep burgundy.

SCANDINAVIA

With the exception of Scandinavia, glass produced in the rest of Europe was derivative of the styles and techniques developed in France at the time of World War I. In Scandinavia, specifically at

Orrefors in Sweden, glass designers emerged with a new creativity that established them as world leaders in the medium. During World War I, Svenska Slöjdföreningen (the Swedish Society of Industrial Design), inspired by the ideas of the German socialist critic and theorist Hermann Muthesius, launched a campaign to introduce high standards of design into mass-production. Every branch of the applied arts benefitted from the new union with industry, particularly glass.

The Swedish glass industry, comprising mostly small "bruks" (industrial communities) in the heart of the Smaland forests near Kalmar, was the first to capitalize on the new movement. At Orrefors, the owner, Johan Ekman, sought to expand the firm's first existing production of domestic wares – ink and milk bottles, and window panes – with a line of artistic glass **(8)**. In 1915 he applied to Svenska Slöjdföreningen for a glass designer, and was informed

LINOSSIER, *Claudius*
1893-1955
Dinandier
Born in Lyons to a working-class family and at the age of 13 apprenticed to a metalworker in a workshop manufacturing religious articles. After mastering all the metalwork techniques, he went to Paris, and shortly after World War I he returned to Lyons and opened a small *atelier.* He took the art of metal incrustation to new heights,

developing his own alloys, as he wanted to provide a richer range of tones and colors than those of silver and copper.

LONGMAN, *Evelyn Beatrice*
1874-1954
Sculptor
Born in England, but settled in the US. Studied under Loredo Taft at the Art Institute of Chicago, and became assistant to the sculptor Daniel Chester French. She modeled portrait busts similar in style to works by Herbert Adams, and memorial sculpture in the tradition of Saint-Gaudens. Her model for "Electricity" won the

about the promising young book illustrator and graphic artist, Simon Gate. Without prior experience in glass, Gate arrived at Orrefors in 1916, where he was joined the next year by Edward Hald, another artist new to the medium. The two formed a formidable team, collaborating closely with the firm's glassblower, Knut Berkqvist, and engraver, Gustav Abels. A fresh and innovative style evolved, particularly in the firm's Graal technique, an adaptation of the intarsia process that Frederick Carder had begun to develop in 1916–17 at the Steuben Glass Works in Corning, New York. Graal was a modification of the French Art Nouveau cameo technique popularized by Emile Gallé, in which superimposed layers of colored glass were etched or carved with relief decoration. To eliminate the hard and unsightly edges which formed in the cameo process, the Orrefors designers returned the glass "stock" to the furnace to soften and diffuse the images. The stock was then encased in an outer layer of clear crystal and blown into its final, enlarged form.

Until 1920 the firm's engraved glassware remained primarily Neo-classical, largely due to Gate's influence. It was left to Hald to introduce a series of Modernist designs, which he did in models such as "Ball-Playing Girls" (1922), a delightful image which showed the influence of Henri Matisse, under whom he had studied briefly in Paris. Gate and Hald were joined in 1927 by Vicke Lindstrand, a gifted and vigorous disciple of the Modernist idiom, whose initial experiments included a series of vessels painted in enamels with Parisian high style figures and animals. In the 1930s, when glassware became heavier and more massive following the move to functionalism introduced at the 1930 Nordiska Kompaniet (NK) exhibition in Stockholm, Lindstrand engraved thick, undulating vessels with themes such as "The Shark Killer" and "Pearl Fisher"

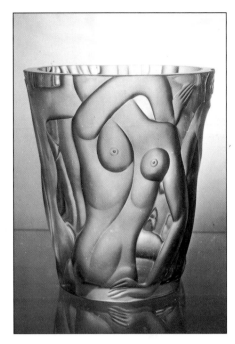

Above Edvin Ohrström for Orrefors: engraved glass vase, late 1930s; and (**right**) Vicke Lindstrand for Orrefors: engraved glass vase, 1937. Lindstrand, who joined Orrefors in the late 1920s, introduced a powerful brand of Modernism

(both around 1937). The detailing in these evoked the Paris Art Deco style of the mid-1920s. At the same time, Edvin Ohrström, who had trained as a sculptor, joined Orrefors. He quickly developed the Ariel technique, a variation on Graal in which air bubbles are entrapped in deeply etched grooves or holes beneath the outer layer of crystal. Ohrström and Lindstrand developed a dynamic range of Graal and Ariel models decorated with Modernist images, often of tribal figures or abstract geometrical patterns, which accentuated the refractive qualities of the embedded air bubbles. Before his death in 1945, Gate applied a quaint, somewhat exotic, Modernist style to models such as "King Solomon and the Queen of Sheba "and a series of etched window panels.

competition for a monumental figure to be installed on top of the American Telephone and Telegraph building, New York.

Longman: a bronze and painted-wood wall fountain, 1927.

LOUPOT, *Charles*
1892-1962
Poster and graphic artist
Studied at the Ecole des Beaux-Arts, Lyons and then in Switzerland. Moved to Paris and worked for *La Gazette du Bon Ton* and *Fémina*, designing advertisements. Designed one of the three official posters for the 1925 Exposition Internationale. In 1930 joined Cassandre's Alliance Graphique, exhibiting at Salle Pleyel. He designed

numerous magazine covers and posters before and after World War II.

Elsewhere in Scandinavian art glass, the Parisian Art Deco style was virtually absent. At the Kosta "bruk," near Orrefors, elegant lines of hand-blown wares were developed in the 1920s and 1930s by Elis Bergh, Ewald Dahlskog and Edvin Ollers. Edvard Strömberg, also initially at Kosta, established a glassworks (later taken over by Orrefors for its Sandvik operation) in Hovmanstorp, and, later, in Eda and Strömbergshyttan, where he and his wife developed a range of elegant Modernist colorless or lightly tinted glass.

In Copenhagen, functionalism was introduced into Danish glass in the appointment of the architect-designer, Jacob E. Bang, as designer for the Holmegaard Glasværk, in 1925. Bang created glass tableware and vases for the firm in his simple engraved or etched "Calligaglia" pattern until 1942.

In Norway, as in its neighbors, the production of Modernist glass in the 1920s was concentrated primarily in one factory, Hadelands Glassverk. In 1928 the firm employed the textile, glass and book designer, Sverre Pettersen, to design tableware with simple engraved patterns. Heavier, more functional models were introduced when Stale Kyllingstad joined the firm in 1937.

The production of Modernist art glass in Finland began in 1928 with the appointment of Henri Ericsson as artistic adviser to the Riihimäki factory. In the 1930s he was joined by Arttu Brummer, who developed a series of molded square and rectangular glass vessels entitled "Bubuki." Of greater interest was the line of Savoy vases in clear colored glass designed by Alvar Aalto in around 1936–37, at Karhula-Iittala. The model's undulating vertical walls and asymmetrical form, reminiscent of the architect's bentwood furniture, created a sensation in its bold modernity and anticipation of the biomorphic curvilinear shapes which became fashionable in the late 1930s and early 1940s. The design is still in production.

OTHER EUROPEAN COUNTRIES

In Belgium, the Val St-Lambert glassworks near Liège reopened after World War I. During the early 1920s the firm introduced a series of vases decorated by Léon Ledru and engraved by Joseph Simon with high style motifs, entitled "Arts Décoratifs de Paris," in which the crystal body was overlaid in transparent colored layers cut with repeating geometrical patterns. Other noted Val St-Lambert designers included Modeste Denoel, Charles Graffart, Félix Matagne, René Delvenne and Lucien Petignot.

In 1912, under the direction of P. M. Cochius, Modernist glassware began to be produced at the Royal Dutch Glass Works in Leerdam, Holland. The architects Hendrik Berlage and K. P. C. de Bazel were commissioned to create tableware items, bottles and ornamental stemware for mass-production. Berlage resigned in around 1925 to establish the Union Studio, and was replaced by Andries Dirk Copier, whose household glassware included the "Unica" series of ornamental glassware.

Elsewhere in Europe, the modern movement found its primary impetus in the work of the Bauhaus instructors and students. Mies van der Rohe, a student of Gropius, designed a model for a glass skyscraper in around 1920–21, conceived as a building flooded with natural light diffused through curving glass walls supported by concealed internal structural steel elements. Wilhelm Wagenfeld, the former Bauhaus pupil, designed a predictable range of functional heat-resistant glass cooking utensils for Schott & Sohn and the Jenaer Glaswerke. Wagenfeld produced a similar line of mass-production tableware for the Vereinigte Lausitze Glaswerke.

In central Europe – specifically Austria and Czechoslovakia – glass remained tradition-bound in the inter-war years, despite occasional excursions into Modernist design by the Wiener

LOVET-LORSKI, *Boris*
1894-1973
Sculptor
Russian-born, trained as architect, painter and sculptor. Emigrated to Paris as a result of World War I and then New York in 1920, becoming a US citizen in 1925. His early work was in plaster, but in the '20s he was introduced to marble. His work, which is truly unique, can be divided primarily into two categories — portrait sculpture and the female figure, and his style combines the geometric precision of Cubism with the strength of realistic classical sculpture.

Lovet-Lorski: white marble torso of a woman, about 1930.

Czechoslovakian (designer unknown): table lamp in etched and enameled glass, 15in high, 1920s. Except for the design schools of Bor Haida, Steinschonau and Zwiesel, there was little attempt by Bavarian glasshouses to emulate the Parisian high style. This model provides a rare glimpse of what might have been achieved in the modern idiom.

LUCE, *Jean*
1895-1964
Glass and ceramic designer
Born in Paris, worked first in his father's ceramic *atelier*, and in 1923 established his own. His early glass used clear enamel for decoration, but in 1924 he turned to sandblasting for his designs, which consisted of abstract patterns and stylized flowers. He designed porcelain and glass for the ocean-liner *Normandie*.

Luce: porcelain dinner service, about 1925.

LURÇAT, *Jean*
1892-1966
Painter, tapestry designer, ceramist
Studied under Victor Prouve, an exponent of the Art Nouveau style, and was a painter from 1919-36. He was largely responsible for the revival of tapestry in the modern style in the late 1930s. After World War II he worked in pottery.

Kunstgewerbeschule, J. & L. Lobmeyr, and the technical schools of Steinschonau, Bor Haida and Zwiesel. Restraint remained the catchword in commercial glass production. In Italy, Vetri Soffiati Muranesi Cappellin-Venini & C and Barovier & Toso, in Murano, mixed sixteenth-century techniques (millefioro and latticino) with modern ones (internal air bubbles and rough surface textures) **(9)**. In Britain, glass design was similarly lacklustre. Except for Keith

Murray, a New Zealand architect who turned his hand to glass in the late 1930s, little original work was forthcoming.

THE UNITED STATES

The glass industry in the United States, as in England, suffered a decline after the Art Nouveau flourishes of Louis Comfort Tiffany, who died in 1933. Two companies, the Steuben and Libbey Glass,

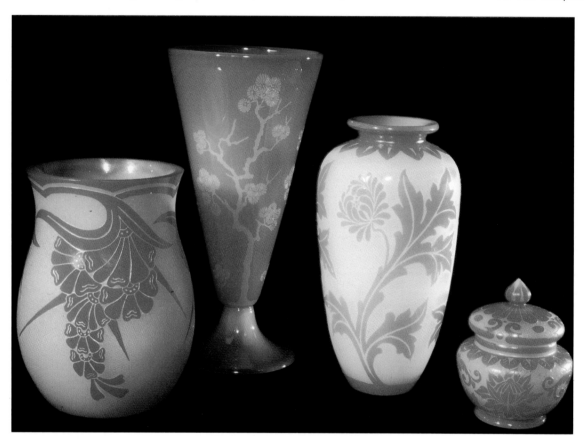

Opposite page ATO: molded glass clock for the ocean liner *Normandie*, 6in high, about 1934. The French government underwrote the series of ocean liners launched at Le Havre in the interwar years. Each in turn was faster and more luxurious than its predecessor, part of a proud tradition in which the nation's foremost designers were invited to furnish various rooms. This clock is one of a host of mementos from the *Normandie* that have been rediscovered recently in the nostalgia surrounding the ship's memory.

Left The Steuben Glass Company: a selection of cased rose and alabaster glassware, 1920s. The firm's chief designer, Frederick Carder, has here borrowed the dominant motifs seen at the Paris salons in the early 1920s: stylized foliage and flowers, which he reproduced in a wide range of similar wares in two contrasting colors, such as black on white or jade green on pink.

MAGNUSSEN, *Eric*
1884-1961
Silversmith, jewelry designer
Born in Denmark, apprenticed at his uncle's art gallery, Winkel & Magnussen, from 1898-1901, when he began to study sculpture with Stephan Sindig. He also studied chasing with the silversmith Viggo Hansen. From 1907-9 he was employed as a chaser by Otto Rohloff in Berlin, but left in 1909 to open his own workshop in Denmark. His work

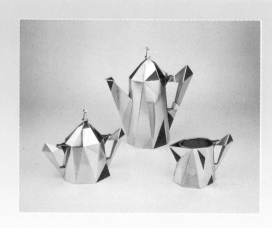

did, however, manage to survive the Depression, and both produced some successful designs based on the French Art Deco style.

The Steuben Glass Company produced expensive, limited editions of art glass that included images and patterns derived from the 1925 Paris Exposition. Founded in 1903 by the Englishman Frederick Carder, the firm was named after a famous Revolutionary War hero, Baron von Steuben. The company was originally organized to produce crystal blanks for the Corning Glass cutters, of which it became a division in 1918. An able craftsman, Carder created a line of colored art glass that remained in production until 1933. His work of the 1920s and early 1930s was based on the French Art Deco style. This is readily seen in his hunting pattern vase of around 1925. Made of acid-cut translucent glass decorated with leaping gazelles, this incorporates stylized foliage and curved and zigzag motifs drawn from French decorative objects.

In 1933 Carder was replaced as the head of Steuben in an attempt to revive the company, which faced financial difficulties brought on by the Depression. The company was reorganized, and radical policy changes were implemented under the presidency of Arthur Amory Houghton, Jr, who hired a new director of design, John Monteith Gates, and a principal designer, the sculptor Sidney Waugh. The colored glass line developed by Carder was completely eliminated, and only items in clear transparent crystal were made. This was a distinct departure for Steuben.

Waugh's style was drawn from the engraved designs of Simon Gate and Edward Hald a decade earlier. His elongated, highly stylized figures were crisply engraved to give the impression of bas-relief sculpture. His first exhibition piece was the now famous "Gazelle" vase of 1935. The frieze of 12 stylized leaping gazelles was

a re-statement of a popular motif of the 1920s seen not only in French design, but also in the sculpture of Paul Manship, and the ceramics and sculpture of W. Hunt Diederich.

In 1937 Steuben commissioned 27 world-famous painters and sculptors, including Henri Matisse, Jean Cocteau, Georgia O'Keeffe,

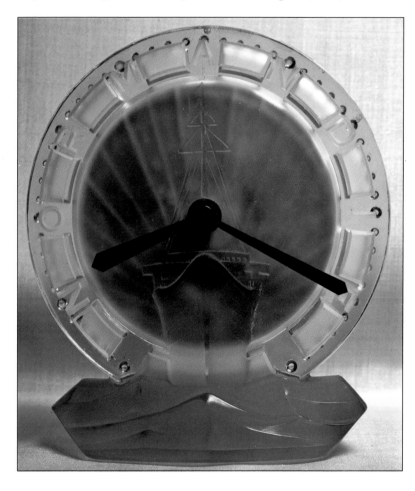

was exhibited frequently from 1901 onwards. He went to the US in the '20s, where he worked as a designer for Gorham until 1929. In 1932 he opened his own workshop in Chicago, and from 1932-38 he also worked in Los Angeles. He returned to Denmark in 1939.

Magnussen for the Gorham Company: "Lights and Shadows of Manhattan" coffee service, 1927.

MAIRET, *Ethel*
1872-1952
Weaver
First became aware of Arts and Crafts ideals through the work of her brother Philip, who had been associated with C.R. Ashbee's Guild of Handicraft. She left England with her half-Ceylonese husband in 1902 and studied the local arts of India; in 1907 they returned to England and renewed their contacts with the Guild. In 1913 she married

again and later established a weaving workshop known as Gospels, in Ditchling, Sussex.

Marie Laurencin, Pavel Tchelitchev, Salvador Dali, Thomas Hart Benton and Eric Gill, to create designs for execution in crystal. In the same year, Steuben received a gold medal at the Paris Exposition. The firm participated also in the 1939 San Francisco and New York World's Fairs.

The Libbey Glass Company was in the vanguard of 1930s American commercial glass design **(10)**. A novelty cocktail glass, "Syncopation" was introduced in around 1933 **(11)**; this had an angular stem which derived its inspiration from Cubist elements. The "Embassy" pattern, designed by Walter Dorwin Teague and Edwin W. Fuerst in 1939, was similarly Modernist, with slender fluted columnar stems that took their imagery from skyscrapers.

THE INFLUENCE OF MODERNISM

An alternative style began to develop in France prior to 1925. Modernism had long-term ramifications for the 1920s decorative high style, which it eventually eclipsed. In Paris, its arrival was heralded by L'Esprit Nouveau, a group of progressive designers and architects led by Amédée Ozenfant and Le Corbusier, whose radical pavilion shocked the world at the 1925 Exposition **(12)**. At the same exposition, where Lalique triumphed with his elaborately conceived, and traditionally inspired, glass creations, the architect Robert Mallet-Stevens made revolutionary statements in his use of glass as a design medium in his Pavillon du Tourisme, a building of rigidly austere geometric construction with a flat glass ceiling and geometric leaded-glass friezes by Louis Barillet that allowed an ample amount of natural light to permeate the interior **(13)**. Barillet also designed a wide selection of highly stylized leaded windows in the 1920s, as did Jacques Gruber and Paula and Max Ingrand in a contrasting black and opalescent white palette **(14)**.

One of the most extensive architectural applications of glass was that of the Maison de Verre, which Pierre Chareau designed for Dr and Mme Jean Dalsace as both a clinic and private residence **(15)**. Wired glass was used for internal partitioning and slim square glass Nevada bricks were used in the elevations to separate the interior spaces and to diffuse the daylight. Auguste Perret also employed glass extensively in his building designs, most notably for his own house on the Rue Franklin in Paris.

The formation of the Union des Artistes Modernes in 1930 helped to promote and unify the Modernist movement **(16)**. Oriented toward industrial production, the group found glass to be an exciting and extremely versatile medium. Notable works in glass designed by UAM members ranged from the bent chromed metal and glass furniture designed by Robert Mallet-Stevens to the luxurious glass bed and furniture designed by Louis Sognot and Charlotte Alix for the Palace of the Maharajah of Indore **(17)**.

Glass was also used extensively in Modernist British architecture. Eric Mendelsohn and Serge Chermayeff's De la Warr pavilion at Bexhill-on-Sea (1935–36), Wells Coates's Embassy Court flats in Brighton (1935), and Ellis & Clarke's Daily Express building in London (1929–32), exemplified the gradual incorporation of glass into progressive British architecture. British designers also used glass in interiors, primarily in hotels and other public areas, such as Oliver Bernard's back-lit glass paneling for the entrance to the Strand Palace Hotel (1929–30), Oliver Milne's use of mirrored-glass paneling in the remodeled Claridge's Hotel (1930) and Basil Ionides' all-glass Savoy Theatre foyer, which included spectacular illuminated glass columns.

The influence of the German Bauhaus was strongly felt in the United States, due primarily to the fact that many prominent

MALDARELLI, *Oronzio*
1892-1963
Sculptor
Born in Italy, the son of a goldsmith, emigrated to the US, and was awarded a Guggenheim Fellowship to study in Paris from 1931-33 and 1943. He worked on the ceiling of the Center Theater at Rockefeler Center and designed the figure of an airmail postman for the Federal Post Office Building in Washington D.C. Two monumental figures

were exhibited at the 1939 New York World's Fair, and he was given many public commissions, including reliefs for the Hartford Public Library, the New York State Insurance Fund building in New York City and the Martin Bird Bath at New York's Central Park Zoo.

MALINOWSKI, *Arno*
1899-1976
Ceramist, jewelry designer
Studied at the Royal Danish Academy and designed for both the Royal Copenhagen Manufactory and Georg Jensen. His crisp linear style was elegantly suited to the design of jewelry and the exotic porcelain figures for which he is known.

Malinowski for Royal Copenhagen: "David and Goliath," ceramic group, about 1932.

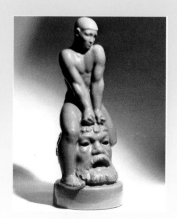

German designers and architects emigrated to America in the inter-war years. Mies van der Rohe, Walter Gropius, Marcel Breuer, Josef Albers and Laszlo Moholy-Nagy, among others, fled the increasing repression of a Fascist regime for the freedom and democracy of the new world. Under their influence, glass became a symbol of modernity for US designers. Mirrored and glass cocktail cabinets, frosted-glass paneling and glass-paneled chairs became fashionable among Modernist designers.

The Consolidated Lamp and Glass Company in Coraopolis, Pennsylvania, designed a Cubist line of glassware called "Ruba Rombic." The line, offered in pale hues such as gray, topaz and amber, was advertised in *Garden and Home Builder* **(18)** as "something entirely new in modern table glass…so ultra-smart that it is as modern as tomorrow's newspaper."

Donald Deskey employed glass in a variety of ways: in architecture, he used glass bricks to create indirect lighting, and in furniture he employed glass tops and shelves to achieve transparency and planarity. His clock of 1926–27 provides a fine example of how he combined several European influences to produce a unified whole **(19)**. Its use of textured glass panels recalls the work of Louis Barillet which Deskey saw at the 1925 Paris Exposition. The diagonal, geometric design evokes also the painting of the Dutch De Stijl artist Theo van Doesburg.

Many other designers in the United States incorporated similar principles. Among them were Gilbert Rohde (1894–1944) and Kem Weber, who used glass in their furniture designs. An end table by Weber, for example, utilizes three circular panels of glass separated horizontally by vertical silvered-bronze supports to create multiple transparent spaces that can be compared to the Constructivist work of Naum Gabo and Antoine Pevsner **(20)**.

Above Edwin W. Fuerst & Walter Dorwin Teague for the Libbey Glass Company: "Embassy" stemware, about 1938. The United States government chose this pattern, engraved with the Federal eagle and insignia, for its formal dining room at the 1939 World's Fair in New York.

MALLET-STEVENS, *Robert*
1886-1945
Architect, interior designer
Born in Paris, took the surnames of his father, Maurice Mallet, and his Belgian maternal grandfather, Arthur Stevens. He attended the Ecole Speciale d'Architecture, to which he returned in 1924 as a professor. In the 1925 Paris Exposition he had a resounding success, participating in five different projects, which included a studio for La Société des Auteurs de Film and a hall in the Ambassade Française. In 1930 he was appointed president of the newly formed UAM.

Mallet-Stevens: upholstered armchairs, fabric by Hélène Henri, about 1927.

CERAMICS

The artistic diversity of the Art Deco period was nowhere more pronounced than in the field of ceramics. The wide range of wares made between World War I and World War II stands in marked contrast to the artistic sterility of the late nineteenth century and the technological conformity of the first two decades of this century. To understand the richness of the period, however, a survey of the evolution of the art in the late nineteenth century must first be made.

The emphasis by late Victorian reformers such as John Ruskin

Left André Metthey: pottery charger, diameter 8½in, about 1928.
Above Vally Wieselthier for the Wiener Werkstätte: pottery-covered box, diameter 6⅞in, 1920s.

and William Morris on the virtue of handicraft was in part a reaction to the abysmal quality, both artistic and technological, of ceramics at the time. The production of vast quantities of cheap wares had been encouraged by the emergence of a large and prosperous bourgeoisie. In reaction to this development, artistic reformers assigned a higher moral and artistic significance to handmade wares, elevating the status of the craftsman to that of artist and thereby ennobling his creations. "Art pottery" became a distinguished art form. The craftsman was seen as virtuous; the machine and its product as the root of evil. This orderly transformation of the potter's art coincided with the public's short-lived infatuation with Art Nouveau.

The disruption caused by World War I played a major role in arresting progress in the ceramics industry. Equally important was the gradual yet cumulative awareness within Europe of orientalism. The beginnings of this cross-fertilization with the Far East was apparent in the "Japanesque" wares introduced by the Worcester Royal Porcelain Company (1) in the 1880s, and in the early twentieth century's fascination with oriental glaze techniques in the work of Ernst Seger in Berlin, Auguste Delaherche and Ernest Chaplet in Paris, and the Rookwood Pottery in Cincinnati.

It would be simplistic in an examination of the ceramics of the Art Deco period to discuss only the high style which dominated the annual Paris salons and the 1925 Exposition (2). Characterized by the mannered female form, accompanied by the slender silhouettes

MANSHIP, *Paul Howard*
1885-1966
Sculptor
Born in the American Midwest, moved to New York in 1905. From 1909-12 he lived in Rome and traveled throughout the Mediterranean, and Greek and Greco-Roman antiquities considerably influenced his style. Through the architects Charles Platt and Welles Bosworth he was given several commissions for garden sculpture, and at the same time he was working on small-scale bronze models based on classical subjects. In 1915-16 he held two successful exhibitions which gave rise to a series of commissions.

Manship: "Cycle of Life," bronze armillary sphere, 1918.

of animals against a background of conventionalized flowers, volutes or geometric motifs, this element of inter-war decorative taste was certainly important, but it represented only one facet of the wealth of artistic talent found in Modernist ceramics.

To comprehend better the full range of Art Deco ceramics, it is possible to divide the ceramics of the 1918–1940 period into three more or less distinct categories. First, and most important, was the school of the artist-potter, direct heir to the reform movements of the late nineteenth and early twentieth centuries. Second, there were the wares of the more traditional manufactories, some of which had been in continuous production since the introduction of porcelain into Europe in the eighteenth century. Third, and perhaps the era's most important contribution to the development of a distinct twentieth-century aesthetic, came the birth of the industrial ceramist, an artist whose wares, designed expressly for serial production, became the fortuitous offspring of a marriage between art and industry unknown in 1900.

ARTIST POTTERS

The artistic hiatus afforded by World War I redoubled the efforts of the individual studio potter. The "war to end all wars" revitalized the market for hand-crafted wares as the public sought to replenish its inventory of household goods in the face of widespread devastation. The potter was effectively involved in all phases of production – design, modeling and glazing – in a manner often hard to distinguish from that of his immediate forebears of the Arts and Crafts Movement. At no time were greater levels of technical virtuosity achieved than in French ceramics of the late 1910s and 1920s. The mastery of glaze became paramount. This preoccupation with technical perfection, however, came at the expense of artistic

innovation, and it was left to the British and Viennese-inspired Americans to breathe new life into this aspect of the medium.

The work of the French potter André Metthey (3) provided an important link between the reformers and the early modern period. Although the great body of his work was executed prior to World War I, his wares incorporated many of the conventional Near-Eastern motifs which became a standard vocabulary for Art Deco artisans. Working initially in stoneware and then in faience until his death in 1921, Metthey invited prominent artists of the School of Paris – Pierre Bonnard, André Derain, Henri Matisse, Odilon Redon, Maurice Denis, Auguste Renoir and Edouard Vuillard, among others – to decorate his wares (4).

More significant, from a technical standpoint, was the work of Emile Decoeur (5). His stoneware and porcelains were noted for a pronounced unity of form and decoration. Working at first in exquisite *flambé* glazes with incised decoration carved into rich layers of colored slip, his style evolved gradually in the 1920s toward monochromatic glazes which by their brilliance obviated the need for any further type of ornamentation.

The work of Emile Lenoble (6) was strongly reminiscent of Korean and Sung (*cizhou yao*) wares. Mixing kaolin to produce stonewares of exceptional lightness, Lenoble created geometric and conventionalized floral motifs suited to simple forms. Such decoration, incised into the vessel or its slip, was often used in conjunction with a refined celadon glaze. Lenoble's son Jacques likewise became an accomplished potter.

The work of George Serré was profoundly influenced by a sojourn in the Orient. On his return from Saigon in 1922, he established a studio where he produced massive vessels incised with simple geometric motifs and glazed to resemble cut stone.

MARE, *André*
1887-1932
Painter, furniture and textile designer
Born in Argentan, France, studied painting in Paris. By 1910 his interest in the decorative arts had increased, and he began designing bookbindings, furniture and ensembles. From 1911-13, he collaborated with several leading artists, exhibiting his controverial "Maison Cubiste" in 1912. He formed his association with Louis

Süe immediately before the war, though it was not formalized until the establishment of La Compagnie des Arts Français in 1919. During the war his wife Charlotte executed his furniture, carpet and fabric designs. Süe et Mare furniture designs were very distinctive and profoundly French.

Süe et Mare for Fontaine et Cie: copper door fitting, about 1925.

In 1932, they were commissioned to design a dinner service for Kenneth Clark, wittily decorated with the bust-portraits of female noteworthies ranging from Elizabeth I to Greta Garbo.

THE WIENER WERKSTÄTTE INFLUENCE

The influence of early twentieth-century Vienna was felt profoundly in American studio pottery of the 1920s and 1930s. Whereas Germany took the abstractions of the 1905 years in the Austrian capital as an early manifestation of the Art Deco vocabulary, it was the more expressionist ceramics of Vienna's potters that had the most pronounced effect on American ceramists.

The Wiener Werkstätte (9), founded in 1903, provided a forum for artisans in a variety of different fields. With the hope of providing a commercially viable enterprise true to the ideals of reformers everywhere – the union of artists with craftsmen and the elevation of the decorative arts – the Wiener Werkstätte's early style was severe and uncompromising. Perhaps in reaction to the deprivations of World War I, a spontaneous style evolved in the Werkstätte's ceramic workshop. Throughout the 1920s, Susi Singer Gudrun Baudisch-Wittke and Valerie (Vally) Wieselthier, among others, worked in a highly idiosyncratic style characterized by coarse modeling and bright discordant drip-glaze effects. At the 1925 Exposition, Wieselthier exhibited both independently and through the Wiener Werkstätte. Also at the Exposition, Michael Powolny and Josef Hoffmann showed modern ceramics through the Wiener Keramik workshops. In 1928 the Wiener Werkstätte potters participated in the International Exhibition of Ceramic Art (10) which toured seven American cities, a seminal event which contributed to the later decision by Singer and Wieselthier to emigrate to the United States. Singer established herself on the

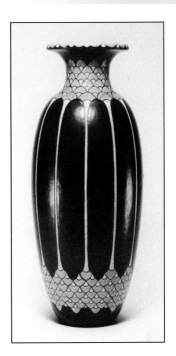

Right Raoul Lachenal: pottery vase, 1920s. Exquisite in detail while impressive in size, this vessel incorporates a host of complicated techniques ranging from the lustrous cartouches of thick brown glaze and the remarkable control of vestigial *craquelure* to the manipulation of lappet motifs to reproduce *cloisonné* enamel. **Below** Vally Wieselthier, Susi Singer, Kitty Rix and Ena Kopriva for the Wiener Werkstätte: pottery cactus holders and candelabrum and companion pair of cactus holders, late 1920s. A studied carelessness marks the ceramic figures and decorative vessels that were produced for sale in quantity by the Werkstätte. Cactus holders are seen in many representations of German interiors of the late 1920s and early 1930s.

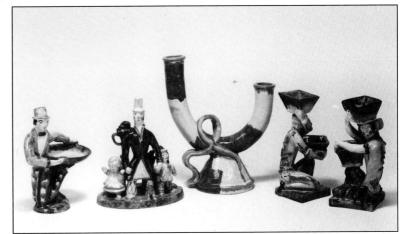

Marinot: glass vases, late 1920s.

MARTEL, *Jan and Joel*
both 1896-1966
Sculptors, designers
Twin brothers who turned their hand to a variety of media in order to realize their designs. They embody the spirt of French Art Deco both in terms of their novel use of these media, the sophistication and cleanness of their design and their constant implementation of new ideas. The 1925 Exposition included a variety of contributions from the

Martel brothers, and Sèvres produced terracotta and porcelain figures designed by them. These figures were sometimes also produced in bronze.

Jan and Joel Martel: plaster figure, about 1925.

Above Katharine Pleydell-Bouverie: pottery vases, 1930s. These understated pots, devoid of decoration, but with slight surface modulation, express the artist's interest in the delicate pastel monochromes of wood-ash glaze. Her decorative vocabulary, like that of most studio potters, changed relatively little over the decades.
Right Josef Hoffmann for the Wiener Werkstätte: pottery vase, 1920s. Hoffmann's characteristic geometry is triumphant, whether in the design of buildings, textiles or ceramics. Here a fluted column glazed in canary yellow is manipulated into a vessel, expressing both Modernism and the serene proportions of classicism which lend it a timeless appeal.

West Coast after her husband's death in the 1930s, while Wieselthier, whose reputation grew rapidly in importance after she moved to America, was retained both by Contempora in New York and the Sebring Pottery in Ohio.

The impact of the Austrian school was also felt through the teachings of Julius Mihalik, who emigrated to Cleveland. A number of his students found employment at the Cowan Pottery in Rocky River, Ohio, west of Cleveland. Viktor Schreckengost, Waylande DeSantis Gregory, and Thelma Frazier Winter survived the economic reversals and demise of the Cowan Pottery in 1931 to pursue independent careers as studio potters.

Among Cowan's stock items were sleek Art Deco figurines designed by the artist Waylande Gregory after his return from Europe in 1928. After Cowan's closure, Gregory's sculptural style began to mature. Sensual forms, in biscuit or washed in a monochrome glaze, became characteristic of his monumental works in the late 1930s, such as his "Fountain of the Atoms" at the 1939 New York World's Fair. A touch of humor – another Viennese legacy – was evident in the lithe and sprightly figures which he designed throughout the decade. Characteristic Viennese levity was also evident in the work of Cleveland artist Thelma Frazier Winter, whose figures and groups expressed her search for a sculptural ceramic style expressive of metal or stone.

Viktor Schreckengost's (11) exposure to Viennese ceramics was direct: he studied under Michael Powolny at the Wiener Keramik in 1929. A part-time jazz musician, his figures displayed a typically Austrian "feel" for the material. He is best known for his "Jazz" series punchbowls, the first executed in *sgraffito* for Eleanor Roosevelt, who was so elated by his design that she commissioned a second example for the Roosevelts' impending move from the New

MARTIAL, *Armand*
1884-?
Sculptor
Worked in a variety of styles in the 1920s and '30s, from the semi-erotic to the classical. He provided several works for the 1925 Paris Exposition including a bronze nude, and at the French section devoted to the arts of the garden his fountain, also in bronze, took center stage. This consisted of a monumental vase decorated with a figural frieze

mounted on a pedestal in the center of a pool.

Martial: "Leda and the Swan," bronze, 1930s.

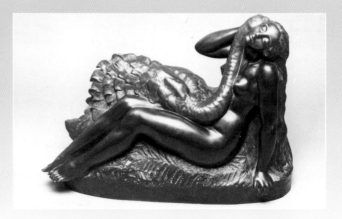

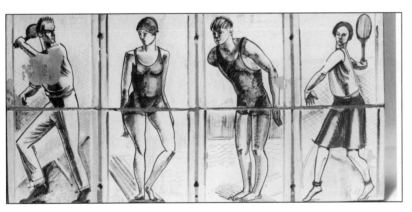

Left Wilhelm Hunt Diederich: pottery charger, diameter 10½ in, 1925. Diederich, who came from an artistic lineage, worked in a variety of media, most often representing animals locked in combat (perhaps as a play on his middle name). Here these simple silhouettes and brilliant colors bring to mind the traditions of ancient Mediterranean potters. Below left Carl Walters: pottery figure of a pig, 1930, one of the classics of American studio pottery of the 1930s. Its originality lies in its masterful assimilation of such widely variant techniques as sponge-decoration, based on American folk pottery, and the strong modeling of the Austrian school. Below Henry Varnum Poor: pottery tile mural, about 1930. Poor's style defies categorization, but his figural work, seen here in this panel for Edgar Levy's residence Littlefarm, is allied to the American Realist school both in the literal treatment and the choice of subject.

York Governor's mansion to the White House. The studied vitality of the bowl's decorative motifs – champagne bubbles, gas lights, musical notes, neon signs, etc. – recalls the spirit of such artists as Charles Sheeler and Walter Demuth.

Trained as a painter with Robert Henri at the Chase School in New York, Carl Walters turned late to ceramics (in 1919), producing models with glazes derived from sources as diverse as American folk art and Egyptian faience. His clever animal figures, produced in limited editions, relied on strong modeling techniques.

Wilhelm Hunt Diederich, better known for his elegant metalwork, also executed pottery. Characteristic were animal forms in silhouette, reminiscent both in style and technique of the transparent washes found in early Mediterranean earthenwares.

Henry Varnum Poor, better known as a painter, turned to pottery in part from economic necessity. Inspired by primitive ceramics, Poor at first produced simple tableware. Although his emphasis gradually shifted toward more profitable architectural commissions, his style remained basically unchanged, relying on the decorative value of slip and sgraffito decoration.

The inter-war period in America witnessed the growth and maturity of the Cranbrook Academy (12), founded in 1932 in Bloomfield Hills, Michigan. The Academy is best known as a catalyst of the post-World War II Studio Movement. Remarkable are a cool and elegant dinner service by Eliel Saarinen for Lenox, and the serene and austere creations of Majlis "Maija" Grotell, both distinctive contributions to Cranbrook's reputation for progressive design. Grotell's ceramics of this period exhibited a tactile quality and careful glaze manipulation which showed her mastery of Oriental kiln techniques.

MARYE, *Simone*
One of the few female sculptors in the Art Deco period, this French artist exhibited her superb *animalier* works at the Salon des Indépendants, the Salon d'Automne and the Salon des Tuileries from 1926 on. Her style recalls that of Pompon.

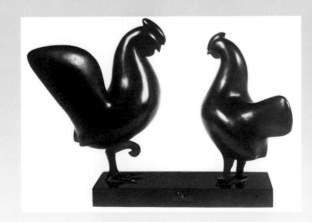

Marye: bronze group of a rooster and hen, mid-1920s.

The Manufactories

The state manufactories of France and Germany experienced general artistic stagnation in the 1920s and 1930s. Throughout the nineteenth century such manufactories had become bastions of conservatism, creating wares for those who could afford to indulge their taste in expensive ornaments, rather than trying to promote a Modernist idiom. On the whole, the national manufactories never recovered the vitality they lost in reproducing a seemingly endless repertoire of popular eighteenth-century forms. It was left in part to the Scandinavians, whose boundaries between art and craft were less rigid, to integrate the aesthetics of the potter's wheel with the grammar of Modernist ornament.

Other potteries, with widely varying capabilities, turned their attention to the possibilities of the modern style. These ranged from the French-inspired interpretations of Belgian firms, to the dichotomous efforts of the British, who produced both modern wares and period reproductions, and to various other European and American firms whose products showed a thinly veiled attempt to capitalize on the 1925 style. Ironically, it was the last-mentioned which served most to popularize the Art Deco style and, through such vulgarization, to precipitate its decline.

The 1920s and 1930s are generally conceded to have been artistically dry years for Sèvres despite the continuing efforts of the manufactory towards modernization. Under the direction of Georges Le Chevallier-Chevignard from 1920, the factory participated in the 1925 Exposition, with items commissioned from artist-designers and architects whose principal expertise lay outside the field of ceramics: for example, Emile-Jacques Ruhlmann, Jean Dupas, Robert Bonfils, Félix Aubert, Jan and Joël Martel, Eric Bagge and Louis Jaulmes. The firm's pavilion and gardens at the Exposition

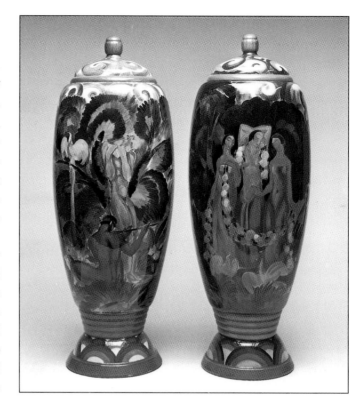

were embellished with ceramic statuary and friezes by Henri Patout, Max Blondat, Le Bourgeois, Charles Hairon and Simon Lissim, the last-mentioned a stage designer and book illustrator who provided a sharply angular and Cubist imagery. Henry Rapin, in collaboration with Maurice Gensoli, the director of the newly formed faience department at Sèvres, designed a range of translucent porcelain light fixtures and lightly decorated tablewares for the pavilion's interior.

Rather more successful, in a Modernist context, were the stylish

MARX, *Enid*
b. 1902
Textile designer
British designer, who assisted Phyllis Barron and Dorothy Larcher in 1925, and in 1927 established her own studio. Her talents stemmed in part from her emphasis on pattern acquired during her studies at the Royal College of Art; during World War II she was selected to design fabrics for Great Britain's Utility scheme. She also designed graphics and related materials for London Transport.

MATHSSON, *Bruno*
b. 1907
Architect, furniture designer
Born in Sweden, trained in his father's cabinet-making workshop in Varnamo, where he worked from 1923-31. He is best known for his Eva chair (1934) with a curvilinear, laminated wood frame and webbing in the upholstery. It was produced from 1935 with and without arms. From 1945-57 he was primarily working as an architect, but then returned to furniture design with Piet Hein.

tablewares produced by Théodore Haviland et Cie, of Limoges. Commissioned from such artists as Suzanne Lalique, the *maître-verrier's* daughter, and Jean Dufy, brother of Raoul, there was an obvious attempt to adapt a contemporary decorative vocabulary to traditional forms. Marcel Goupy, a successful glass designer, created dining ensembles in porcelain and glass which were retailed by Georges Rouard **(13)**. These displayed a fairly conservative mixture of floral decorations. Jean Luce, another artist whose designs in glass overshadowed his achievements in ceramics, designed tablewares for Haviland in a light Modernist style. A delightful selection of small *animalier* porcelain figurines in glazed porcelain and biscuit by Edouard M. Sandoz was similarly issued by the firm.

In the 1920s, the large Paris department stores generated a wide range of household ceramics designed by their own studios. At Pomone, Charlotte Chaucet-Guilleré, the director of the store's Primavera studio, Madeleine Sougez, Marcel Renard and Claude Lévy, created lightly-decorated tablewares and accessories to complement their furnishings. At the Galeries Lafayette, Maurice Dufrêne, the director of the store's La Maîtrise studio, Jacques and Jean Adnet, Bonifas, and Mlle Maisonée, offered a similar line of household pieces executed for the store by André Fau & Guillard, and Keramis, in Belgium.

Louis Süe and André Mare's firm, La Compagnie des Arts Français, rivaled in prestige the department-store pavilions at the 1925 Exposition. The pair designed heavily scrolled and floral tablewares such as tureens and vegetable dishes which evoked Louis-Philippe opulence, for their dining room ensembles. At the Exposition, Paul Véra and José Martin were retained to enhance the firm's pavilion with a series of ceramic friezes of recumbent nudes in bas-relief.

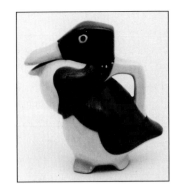

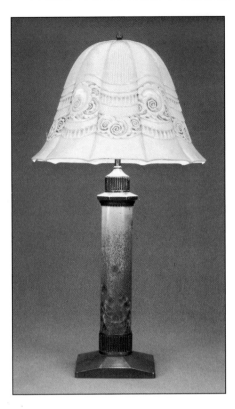

Opposite page Sèvres: pair of porcelain vases, 1920s. The decorative appeal of the French colonies was often a theme in ceramic decoration. Here languid figures are depicted in a vivid tropical palette. **Above** Edouard Marcel Sandoz for Haviland Limoges: porcelain teapot, 1920s. This clever bird-form vessel is typical of the compact structural style which Sandoz applied to functional objects. **Right** Henri Rapin for Sèvres: porcelain table lamp, 1920s.

The firm of Longwy, a *faiencerie* established in the eighteenth century, was known for brightly enameled wares in the Near-Eastern taste which reached their peak of popularity in the closing years of the nineteenth century. The firm's vivid palette, outlined in black in a style derived from North African tiles, was successfully integrated with images such as leaping gazelles and conventionalized flora. A limited range of similar designs was produced by Sarreguemines in Lorraine.

The potteries of Robert Lallemant, dating from the 1920s and

MATTER, Herbert
1907-1984
Poster and graphic artist, photographer
Born in Switzerland, studied in Geneva and Paris. In the late 1920s he designed posters for PKZ and worked on occasions with Cassandre. In the 1930s he introduced photography into his graphic designs, especially the photomontage techniques. In 1936 he moved to the US, where he did freelance photography for

House Beautiful and *Vogue* and worked less and less in graphics.

MAYODON, Jean
1883-1967
Ceramist
Originally trained as a painter and carried his interest in figural schemes into his art pottery, producing tablewares as well as architectural fittings. He was artistic director of the Sèvres factory from 1941-2.

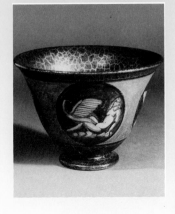

Mayodon: pottery bowl with decorative cartouche of Leda and the swan, 1930.

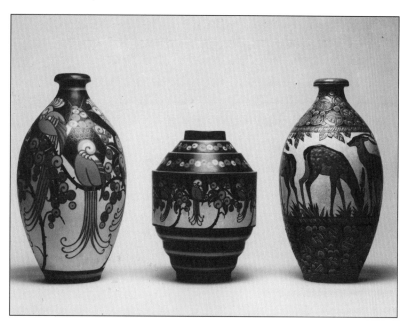

early 1930s, reflected the vogue at the time for angular forms. Generally these were decorated with sporting scenes, stylized eighteenth-century vignettes, or quotations from popular verse. In 1929 Lallemant introduced a line of sporting figures. The large number of his wares fashioned as lamp-bases attest to his purely decorative intent. A similar series of crisply angular forms and bird figures designed at the time by Jacques and Jean Adnet was produced by La Faiencerie de Montereau.

The Parisian retailer Robj sold figural decanters and other ornaments by a variety of designers. Vaguely Cubist and often quite charming, these ceramic figurines were intended to be collected in series. The purported seriousness of Robj's designs was evident in a competition held in 1927, judged by a notable group of contemporary sculptors, including François Pompon and Georges Saupique. The winning entry, a clock surround by Henri Martin (14), drew a comment from the jury that all similar decorative editions should be considered as "art" rather than mere decoration.

With the closure of the famed Vienna manufactory in the nineteenth century, only the Augarten firm founded in 1922 by Franz von Zülow, and the firm of Friedrich Goldscheider, remained to play a significant role in Austria's production of modern-style porcelain wares. The age of Viennese porcelain had passed its prime. Augarten produced a limited selection of decorative wares designed by Professor Josef Hoffmann and Ena Rotenberg. The Goldscheider factory, founded in 1885 by Friedrich Goldscheider, had developed a reputation for stylish ornamental wares in its production of Eastern-inspired ceramics and its association with students of the Vienna Kunstgewerbeschule. In the 1920s the firm's range of ballerinas and pierrettes, some from models by Lorenzl, achieved a certain gaiety and popularity. At the 1925 Exposition,

Above Charles Catteau (**left**) and Jan Windt for Boch *freres*: group of pottery vases, about 1925. Boch's decorators seem to have had pattern books, from which the most successful patterns were adapted to fit a variety of shapes: note the similar decoration on the two right-hand vases. The stylized animals worked into highly conventionalized floral grounds are typical of the Belgian taste. **Left** Longwy: pottery charger, about 1925. The brilliant enamel decorations of Longwy, although said to be derivative of North African ceramics, sometimes resemble the linear quality of *cloisonné* enamel.

MERE, *Clement*
b. 1870
Painter, furniture designer
Born in France, studied painting under Gérôme in Paris. Around 1900 he joined Meier-Graefe's La Maison Moderne, working closely with Franz Waldorff, a designer of bookcovers and embroidered silks. He introduced furniture into his repertoire about 1910. His preferred woods were Macassar ebony, maple and rosewood, and

the emphasis was on the object's materials rather than its shape. Around 1924, he received two important commissions: a cabinet for Lord Rothermere and a desk, now in the Musée des Arts Décoratifs, Paris, for Robert de Rothschild.

Mère: ladies' desk, Macassar ebony, lacquered leather and ivory, about 1923.

Above Gio Ponti for Richard Ginori: "Donatella," pottery charger, about 1930. The dreamy, surreal quality of much of Ponti's figural work is nowhere more brilliantly captured than in this mannered figure from his series entitled "My Women." **Right** Gio Ponti for Richard Ginori: "Classical Conservation," porcelain vase, about 1930, aptly titled to reflect the dialogue among allegorical creative artists.

the firm's Paris branch displayed a more stimulating range of ceramic dinnerwares, statuettes and lamp-bases designed by Eric Bagge, Henri Cazaux and Sybille May.

In Czechoslovakia, the firm of Royal Dux, whose languorous nymphs of the Art Nouveau epoch had been extremely popular, generated a limited selection of new designs after World War I.

In Belgium, the modern style was vigorously adopted by the firm of Keramis, owned by Boch frères, in La Louvière. Charles Catteau **(15)**, born in Douai, designed a wide selection of Parisian high style ceramic wares in which leaping gazelles and flowers predominated. His choice of brilliant turquoise glazes on crackled ivory grounds evoked Lachenal's earlier palette. The firm shared its success in this line of bright commercial wares with the Primavera department store in Paris.

In Germany, the Meissen State Porcelain Manufactory was under the direction of Max Adolf Pfeiffer from 1926 to 1936. Little of any artistic innovation was produced, but the modeler Paul Scheurich, who also worked for Nymphenberg in Berlin, was commissioned to produce 102 figures, much in the tradition of Johann-Joachim Kandler and Franz Anton Bustelli of the eighteenth century, but with a rather cloying sweetness. It was left to the Berlin manufactory to espouse an interest in twentieth-century design. A survivor of the Jugendstil era, Max Läuger, created a small selection of Modernist stoneware and ceramic models.

The decorative genius of the architect Gio Ponti reversed the fortunes of the declining Società Ceramica Richard-Ginori factory in Doccia, Italy **(16)**. His work, in its attempt to link the decorative vocabulary of ancient Rome with the modern period, displayed a penchant for Neo-classicism in both form and decoration. The titles given to certain of his series – "Classical Conversations," "Love and

METTHEY, André
1871-1921
Ceramist
Began his career with an entry in a local sculpture competition, and established his own stoneware studio in 1901 at Asnières. After 1907 he turned to native-inspired faiences of Middle Eastern inspiration, often decorated by members of the Ecole de Paris.

MIES VAN DE ROHE, Ludwig
1886-1969
Architect, furniture designer
Born in Aachen, worked as a draftsman of stucco ornaments before moving to Berlin in 1905 to study under Bruno Paul. From 1908-11 he worked in the office of Peter Behrens; in 1926 he became vice-president of the Deutscher Werkbund, and in 1927 he organized the Stuttgart Exhibition. For the Barcelona 1929 Exhibition he designed a

German pavilion furnished with X-framed chairs constructed of chrome-plated steel strips. The 'Barcelona' chairs have been produced by Knoll since 1947. In 1930 he became the last director of the Bauhaus, which he moved from Dessau to Berlin. In 1938 he went to the US to teach at the Illinois Institute of Technology.

Antiquity", and "Archaeological Voyages" – emphasize this traditionalism. His wares included a prodigious range of crisp, delicate ceramic forms with highly mannered decoration. Ponti also produced wares of strictly modern decoration – sporting scenes, grotesques, geometrical forms, etc. – with an easy affinity. In Turin, Eugenio Colmo, the founder of the review *Numero*, created ceramics as a hobby under the name of Golia. He purchased white porcelain blanks to which he applied a forceful range of Art Deco images in vibrant colors.

The English firm of Josiah Wedgwood & Sons **(17)** was among the first in the nineteenth century to commission graphic artists to decorate their wares, a technique which the firm again pursued from 1935 under the artistic directorship of Victor Skellern. The well-known engraver and painter Eric Ravilious **(18)** was retained to decorate blank ceramic vessels designed by the architect Keith Murray through the transfer-printing process. Ravilious, who felt that only his least adventurous designs were chosen, complained that the management "think my beautiful designs [are] above the heads of their public and that something should be done that is safer and more understandable . . ." Nevertheless, his unique calligraphic style was shown to advantage in a coronation mug, a "Boat Race" bowl, and various tablewares, such as "Harvest Moon," some of which were put into production only after his death during World War II.

Relatively few British artists took the trouble to transpose the modern decorative idiom into manufactured wares. Among the foremost were Eric Slater, responsible for design and decoration of tablewares for Shelley potteries, and Susie Cooper, who produced her own simply decorated services. Initially a decorator of blanks at the firm of A. E. Gray & Co. Ltd. in Hanley, Cooper accepted an

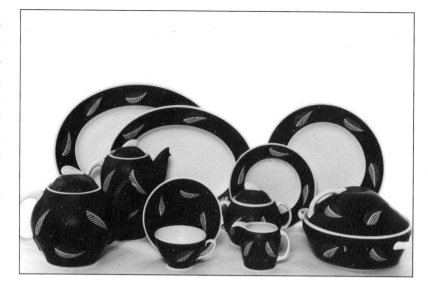

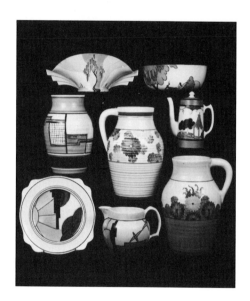

Above Susie Cooper: "Kestrel" porcelain dinner service, 1930s. A subdued modernity is characteristic of Susie Cooper's designs. Simple in form and decorations, her designs were economical to produce, and widely popular with the somewhat conservative British households of the 1930s. **Right** Clarice Cliff for Newport and Wilkinson Potteries: selection of pottery pitchers and vases, about 1930. These vessels are representative of the wide range of stylishly quirky wares created by Clarice Cliff. On the whole, such pieces were brilliantly decorated, but their unassuming shapes rather detract from their overall quality.

MIKLOS, *Gustav*
1888-1967
Sculptor, designer
Born in Hungary, and originally trained as a painter. After World War I he began working in *champlevé* enamels, then repoussé metal reliefs, finally abandoning painting altogether. He worked in a variety of media including copper, stone and plaster, and combined early Christian traditions with the Cubist aesthetic.

MILLES, *Carl*
1875-1955
Sculptor
Born in Sweden, but claimed by America, as he lived and worked in the US for many years, and was Professor of sculpture at the Cranbrook Academy from 1931-51. Many of his pieces, however, were done in his native country. He trained under Rodin in Paris from 1897-1904, and drew on Scandinavian myth and folk tales for many of his subjects, as well

as on classical Greek myths. Many of his commissions were for monuments or fountain groups, his Triton Fountain (1916), Europa Fountain and Folkunga Fountain (both 1924) being the best known. His monumental figure of "The Astronomer" was exhibited at the 1939 New York World's Fair.

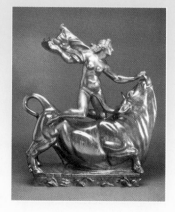

Milles: "Europa and the Bull," bronze, about 1926.

offer in 1931 from Wood & Son's Crown Works to execute shapes of her own design. She produced dozens of tableware designs, decorated with subdued abstract or geometric "jazz style" patterns in muted tones. Her perception of the British consumer's innate conservatism and her stringent attention to detail in both design and marketing rendered her wares a great success.

At the other end of the spectrum, Clarice Cliff's "Bizarre" tablewares **(19)**, produced by the Newport Pottery from 1928, have come to symbolize the decorative exuberances and excesses of the Art Deco style. Her use of color, geometry and eccentric shapes turned her wares into novelty items. Clever marketing schemes – including editions with fanciful names such as "Delicia," "Biarritz" and "Fantasque" – and moderate prices helped to popularize her wares. Her employment of decorative artists such as Vanessa Bell and Duncan Grant, who were already engaged in pottery decoration, and others such as Sir Frank Brangwyn, Graham Sutherland and Laura Knight, was less successful. These artists were commissioned to design ceramics for A. J. Wilkinson & Company, the Newport Pottery's parent company, but their wares were not well received. Critics likened the idea to "eating off pictures" and the project was quickly abandoned.

A number of potters established workshops in London's Chelsea district for serial production of figures. These included Phoebe and Harold Stabler **(20)** whose wares were manufactured by Carter, Stabler & Adams in Poole, Gwendolyn Parnell, and Charles and Nell Vyse. The last-mentioned also produced wares inspired by Chinese *jun song* and celadon wares.

The Royal Copenhagen & Bing Grøndahl porcelain manufactories continued after 1900 to apply a range of traditional Danish decoration to their commercial wares, perhaps in response to the

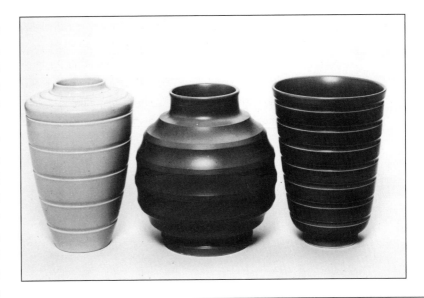

Above Keith Murray for Wedgwood: pottery vases, 1930s. These simple forms show Murray's ingenious application of industrial-inspired lathe-like turnings to traditional ceramic bodies. **Right** Clarice Cliff: pottery vase, about 1925. Cliff's simple forms are often painted with decorative motifs of great charm, but their form was remarkably Modernist.

MOORE, *Bruce E.*
1905-80
Sculptor
Born in rural Kansas, moved to Wichita in 1917, and then went East to study at the Pennsylvania Academy of the Fine Arts. In 1926-29, Moore returned to Wichita and produced some of his finest animal sculptures. From 1929-31 he lived in Paris, still working in the Art Deco style but becoming less dependent on its stylized vocabulary. He then moved to Connecticut, where he worked as an assistant to James Earle Fraser as well as working on his own projects.

Moore: "Black Panther," bronze, 1929.

Right Laura Knight for Wilkinson
Pottery: pottery mug, 6¼in high,
about 1930. The graceful simplicity
of Knight's brushwork saves this
vessel from the overdecorated
appearance which plagued more
ambitious designs. Below Designed
by Wilhem Kåge for Gustavsberg:
"Argenta" silver-inlaid pottery vase,
6in high, late 1920s. The motifs on
Kåge's "Argenta" wares range from
Near-Eastern inspired creatures
such as this fish to simple,
conventionalized floral designs.

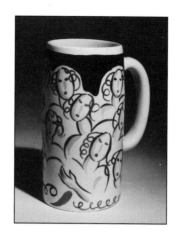

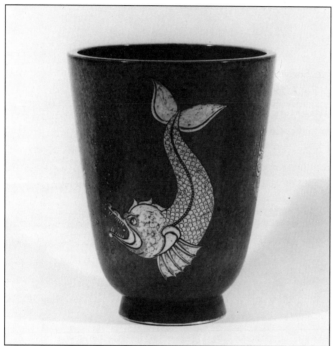

enthusiasm at the time in England and France for similar iconography. In 1912 the Royal Copenhagen factory introduced a series of stonewares under the direction of Patrick Nordstrøm **(21)**. Later, a variety of Neo-classical and Modernist themes were developed concurrently by designers such as Christian Joachim, Arno Malinowski, Knud Kyhn, Jais Nielsen, Axel Saltø and Gerhard Henning. At Bing & Grøndahl, the porcelain figures of Kai Nielsen and the powerfully modeled groups of Jean Gauguin, son of Paul Gauguin, were the most noteworthy. Gunner Nyland and Nathalie Krebs established their own studio in 1929 **(22)**. Under Krebs, the name was changed to Saxbo. The artist Eva Stähr-Nielsen helped to develop a serene style comprising monochromatic semi-matte glazes and simple unadorned forms **(23)**.

In Sweden, Wilhelm Kåge was artistic director at the Gustavsberg porcelain works. His "Liljeblå" earthenware table-wares of around 1917, with restrained underglaze floral decoration in cobalt blue on a white ground, were based on traditional Swedish crockery designed to make good quality wares affordable to the working class. His "Praktika" tableware of 1933 showed the beginnings of the functionalist aesthetic while retaining elements of traditional design. Kåge's well-known "Argenta" stoneware is more decorative, with chased silver images applied to green-glazed grounds that resemble verdigris bronze. At the 1925 Exposition, Gustavsberg was joined in the Swedish pavilion by the Rörstrand Porcelain Manufactory, which displayed a line of understated floral designs. In Norway, the geometry of Nora Gulbrandsen's designs for Porsgrunds Porselensfabrik reflected very clearly the Modernist aesthetic.

In the United States, the foremost conservative mid-West potteries were reluctant to embrace the new idiom. Rookwood

MORTON, *Alastair F.*
1910-63
Textile manufacturer, painter
Director of the British firm Morton Sundour Fabrics and its creative design division, Edinburgh Weavers. His sponsorship of Barbara Hepworth and Ben Nicholson's "Constructivist Fabrics" received wide acclaim.

MULLER-MUNK, *Peter*
1904-67
Silversmith
Born in Germany, studied in Berlin. He exhibited at the 1925 Paris Exposition, and went to the US a year later, working for Tiffany and Co. before opening his own studio in 1927. His work is characterized by simple lines and refined, Neo-classical designs. He stressed the importance of handwork. In the mid-1930s he became an

Associate Professor at the Carnegie Institute in Pittsburgh, Pa., and he also founded an industrial design firm which still bears his name.

(24) encouraged individual decorators, such as Jens Jensen, Edward T. Hurley, William Hentschel, Elizabeth Barrett and Harriet E. Wilcox, to familiarize themselves with Paris's newest fashions through contemporary art reviews, but its continuing financial vicissitudes from the mid-1920s prevented it from full commitment to anything new and risky. The same reticence applied to the Fulper, Newcomb, van Briggle and Grueby potteries, all in various stages of decline since their celebrated 1900 years. Only Roseville had the temerity to produce a spirited line of new designs called "Futura," inspired by the terraced contours of New York's skyscrapers.

INDUSTRIAL DESIGN

Perhaps most significant to the development of a twentieth-century aesthetic was the birth of the professional industrial designer in the inter-war period. The profession is seen today as the inter-relationship between art and industry, the result of attempts in numerous fields — not the least of which is ceramic design — to prove that good design should be economical to produce and easy to sell, as well as functional. The true industrial ceramics of the 1930s, non-derivative in form and generally devoid of decoration, lost none of their character through mass-production. Throughout the decade, there occurred a gradual acceptance of functional forms coupled with modern industrial techniques. In this the machine, seen decades earlier as the antithesis of good design, now became the vehicle for its production.

The turning point in this evolution can be traced to the establishment of the Bauhaus in Weimar in 1919. Although today nearly everything of functional form — from tea cups to seat furniture — is said to be "Bauhaus", the school was not founded to create a style but to develop a new approach to the applied arts. While no body of ceramic works evolved in the Bauhaus ceramic workshops to equal, for example, the metalware designs of Marianne Brandt or the furniture of Mies van der Rohe, the Bauhaus ceramists are noteworthy for their wholehearted rejection of tradition, and for their artistic creativity amid the chaos of the Weimar Republic after the defeat of World War I. The initial lack of adequate facilities for pottery in Weimar was turned to an advantage when the workshop was established at nearby Dornburg, in 1921, under the technical supervision of Max Brehan. As the workshop received commissions from the local town, and as the need for pottery melded with the Bauhaus' artistic ideals, it is clear that the Dornburg workshop (25) came closest to achieving the union of art and craft stated in Walter Gropius's original manifesto.

The only German manufactory to show a significant interest in functionalism was the Staatliche-Porzellanfabrik in Berlin. Its most direct link to industrial design occurred in the employment of ex-Bauhaus pupil Margarete Friedländer-Wildenhain, who designed the simple, classic shapes of the "Halle" service of 1930, in which plain banding was the only form of decoration. Trude Petri's "Urbino" service of 1930 was more remarkable. In production for some 40 years, the service was among the first to rely neither on color nor ornament for commercial success.

Also in the functionalist mode was Dr Hermann Gretch's "Arzberg 1382" for the Arzberg Porcelain Works. This form, again devoid of ornamentation, showed rather softer, more rounded, silhouettes than contemporary Berlin wares. First shown at the 1930 Deutscher Werkbund Exhibition, it won a gold medal at the 1936 Triennale in Milan and the Paris Exposition of 1937. These designs signified a growing interest in unornamented form as a

MURRAY, *Keith Day Pierce*
1892-1981
Architect, ceramic and glass designer
New Zealand-born, but moved with his family to Britain in 1906. Having trained as an architect, he began experimenting in glass at the Whitefriars glassworks and in 1932 he designed glass for Stevens & Williams before accepting employment with Josiah Wedgwood & Sons in 1933. He also provided designs for the silversmiths Mappin & Webb in 1934. After World War II he returned to architectural practice.

Murray: "Cactus" decanter, late 1920s

characteristic of good design, without neglecting porcelain as a costly and formal material.

Eva Stricker Zeisel **(26)** is one of the most noted twentieth-century industrial designers, and although her most mature work generally belongs to the post-World War II period, her designs for the Schramberger Majolika Fabrik in the 1920s incorporated several geometrical motifs associated with Modernism. Throughout the 1930s her work in Berlin for Christian Carsten, in the Soviet Union for the Lomonosov Porcelain Factory and Dulevo Ceramics Factory, and in the United States for Bay Ridge Specialty and Riverside China, reflected a somewhat softening geometry.

In Britain, Keith Murray's designs for Wedgwood were very avant-garde. Trained as an architect and experienced in Modernist glass design at Stevens & Williams, in Brierley Hill, Staffordshire, Murray joined Wedgwood in 1933. He designed large numbers of non-derivative shapes in which ornament consisted exclusively of turned or fluted motifs. Glazes provided textural interest. His wares were executed in black basalt, celadon, silken "Moonstone" (1933) and matte green or straw (1935).

It was left primarily to the Americans to explore the phenomenal sales potential of mass-production. The most accomplished, and one of the best-selling tablewares, was Frederick H. Rhead's "Fiesta", designed for the Homer Laughlin Company, of which Rhead had become artistic director in 1927. Rhead, a Staffordshire potter who had emigrated to America in 1902, aimed at a mass-produced line of high-quality pottery free from derivative ornament, which would appeal to America's prosperous middle class. Introduced in 1936, "Fiesta's" simple geometrical shapes were offered in five bright colors. In production for more than 30 years, the line was an overwhelming success, helping to precipitate a revolution in industrial design. The ceramics industry was served notice that the American consumer was ready to embrace Modernism.

Russel Wright **(27)** was another American whose ideas had a profound effect on the public perception of "good design." His "American Modern" dinner service, designed in 1937, introduced by Steubenville Pottery in 1939, and marketed by Baymor until around 1959, presaged in its biomorphic forms and subdued colors the work of post-World War II organic designers. It was a logical extension of the "good design" theory by which Wright's "American Modern" became part of a larger scheme of decorative items entitled "American Way". Although the latter succumbed to the rigors of wartime restriction, more than 80 million pieces of Wright's crockery were created during the 20 years that it was produced.

NASH, Paul
1889-1946
Painter, designer
Trained as a painter and designer at the Slade School of Art in London. He was a war artist during World War I and again in World War II. He designed ceramic tableware and textiles in the 1930s, and was one of the founders of Unit One, an avant-garde group of architects and artists.

NAVARRE, Henri
1885-1970
Sculptor, glassmaker
Born in Paris, studied architecture and then woodcarving. He apprenticed with a gold- and silversmith, studied at the Ecole des Beaux-Arts, and in addition took a stained-glass course. Influenced by Marinot, he started working in glass from 1924 and exhibited regularly from 1927. His work was often massive and stained with colored pigments and powdered metal oxides. He designed large glass sculpture including a Christ for the chapel on the liner *Ile-de-France* in 1927. Among his works of sculpture was a large gate for the 1925 Paris Exposition.

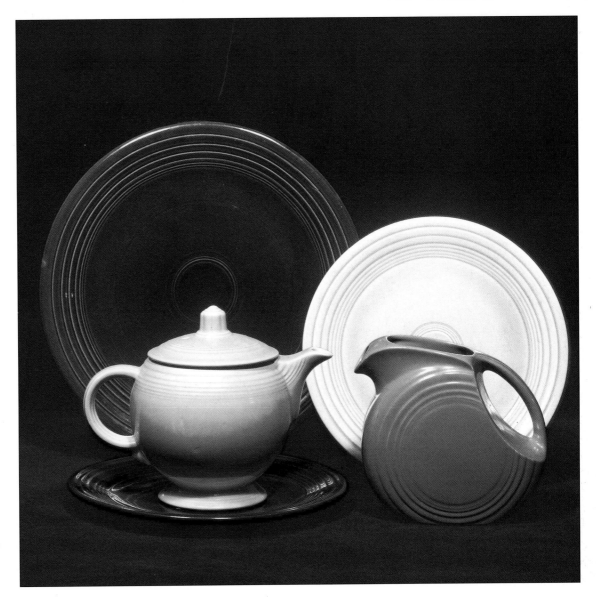

Right Frederic Hurten Rhead for Homer Laughlin: "Fiesta Ware" pottery tablewares, about 1936. The meticulously crafted glazes of this tableware range originally came in these five colors. A clever marketing strategy was developed whereby the consumer was encouraged to purchase the pieces in open stock and mix colors at the table.

Left Russel Wright for Steubenville Pottery: selection of "American Modern" pottery tableware, 1939. The subdued colors of coral, chartreuse, curry, cedar green and granite were particularly suited to the gentle organic forms of this range of ceramics. Such shapes seem to presage the postwar reaction to the strident geometry often associated with the interwar period.

NICS FRERES

Hungarian brothers, Jules and Michel, who settled in Paris. In the 1920s, they went into partnership and produced the usual range of decorative wrought-iron furniture and lighting. Their work is characterized by a pronounced *martelé* effect. They designed and executed wrought-iron work for a hairdressing salon designed by Ruhlmann.

N.V. VEREENIGDE GLASFABRIEK LEERDAM

Established in 1765 in Leerdam, Holland, the firm received no great recognition until its association with members of the Dutch De Stijl group about 1915, when the architects H.P. Berlage and K.P.C. de Bazel were commissioned to design glass for mass-production. Under the design leadership of Andries Dirk Copier the company started its unique series of free-formed glass called 'Unica'. Glasfabriek Leerdam merged with N.V. Vereenigde (the United Glassworks) in 1937.

METALWORK

It has often been said, and with reason, that the style of an era is best expressed not by its paintings and sculptures but by its furniture and accessories, the diverse objects that are part of our daily lives. In the hierarchy of the arts, it is most convenient to classify such "objects" as "minor" arts or *objets d'art,* and they differ from the 'fine arts' in that their creators work in a collective ethos rather than expressing a personal, often solitary, vision. This is not to say that the designers do not work with originality and vision, indeed many interior designers of the 1920s were so concerned with the appearance of decorative objects that they designed them themselves. Süe et Mare, for instance, designed clocks, mirrors, ashtrays and porcelain dinnerware with the 'bursting with ripeness' appeal that characterized their other work, while Ruhlmann's accessories reveal the same restrained elegance as his furniture. Many designers remained traditionalist in their inspiration, while others reflected the more radical style, as seen in the designs of the Maison Desny in Paris. Still others designed in an intensely personal style that is less easily identified with any design movement.

FRENCH SILVER AND SILVERPLATE

Since time immemorial, rare and precious materials have symbolized luxury, gold and silver taking pride of place among them. Gold, because of its expense and weight, was impractical for making any but the smallest useful objects, such as snuff-boxes; silver-gilt, also known as *vermeil,* was far more practical, and gave a

Right Süe et Mare for Gallia (Christofle): creamer, silver-plated metal, 1920s. Brightly plated metals made increasing inroads into silver's traditional domain of hollow- and flatware in the late 1920s as the economy worsened, since they provided the semblance of posterity at a margin of silver's cost. **Below** Desny: *coupe* and vase, silver-plated metal, about 1928.

OMEGA WORKSHOPS see **GRANT**, *Duncan* and **BELL**, *Vanessa*

ONU, *Aurore*
Sculptor
A sculptor of decorative objects such as figural *luminaires* designed along the lines of works by Fayral and Max Le Verrier. She signed her works with her full name. Her signature is often accompanied by a small number similar to those used by the LN & JL foundry, although one cannot positively attribute her production to this workshop.

similar look to gold. Silver shares many of gold's desirable qualities, being soft and easily worked and capable of being cut and hammered or cast into an infinite variety of shapes (1).

There is a great variety of ways of working silver – the most painstaking, but also for many the most satisfactory, is hand-raising which is too time-consuming and cost-intensive to be practical for commercial production. Successful alternatives include spinning, stamping and casting, all of which had been greatly improved upon by early twentieth-century technology, and worked well with the spare, uncluttered lines of Art Deco silver design. Puiforcat and other fine silver houses made use of these techniques, although considerable hand work was still required to produce a finished piece of uncompromised quality.

Because of its color, silver is sometimes described as a "dry" material, and to give it life without the use of surface ornament the silversmith had to rely on an interplay of light, shadow and reflection created by contrasting planes and curves. Another way of relieving the soberness of form and color was to incorporate semi-precious stones, rare woods, ivory and horn, and toward the 1930s gilded sections and thin plates of gold soldered to or inlaid into the surface were added to the repertoire. These materials, when used with restraint so that they did not overwhelm the balance and purity of the design, added warmth, richness and textural contrast.

Items of luxury created solely to be admired need only concern themselves with aesthetics, but articles intended for use must respond to practical considerations as well. Silversmiths who sought to modernize silver design quickly realized the difficulties presented by drastic modifications of traditional forms which served their purpose well – styles change, but human bodies do not, and we must still grasp by handles, pour from spouts and cut with knives.

Above Jean Puiforcat: tray, silver and ivory, early 1920s; and (**right**) water jug, silver and rosewood, about 1925. Puiforcat's early style, shown first at the 1921 salons, showed traces of the prewar preoccupation with curvilinear forms. By 1925 this had yielded to a more severe and angular style inspired by machine-made forms.

The Art Deco silversmith, who disdained influence from the past and relied only on creative inspiration, had to approach these technical problems in a new way. When designing a teapot he had to forget everything he knew about teapots and think instead about how to contain the greatest quantity of liquid in the smallest volume, how to facilitate pouring out at any angle, and how to unify the design so that it combined practicality with elegance (2).

There were many unsuccessful efforts, but the great innovators,

ORLOFF, *Chana*
1888-1969
Sculptor
Russian by birth, emigrated to Palestine with her family in 1905, and in 1911 moved to Paris to study. Her very personal style was a mixture of Cubism and realism: busts formed of flat planes yet recognizable as portraits, and wonderful stylized animals reminiscent of work by the Martel brothers and Pompon. From 1942-45 she lived in Switzerland, where she created 50 sculptures. From 1950-60 she modeled several memorial commissions from the State. She worked in a variety of media. Her early works are carved wood, but later she modeled in bronze and marble or stone.

such as Jean Puiforcat and Tétard frères, produced some stunning results **(3)** – indeed Puiforcat produced some of the most beautiful silverwork of the twentieth century. He grew up in a family which had been in the trade since 1820. He studied sculpture with Louis Lejeune while learning silversmithing in his father's *atelier*, and after this lengthy double apprenticeship he began to show regularly at the Salon d'Automne and the salon of the Société des Artistes Decorateurs.

Gifted with a powerful originality, Puiforcat concerned himself with rejuvenating silver design, which had long been over-ornamented in response to the clients' love of ostentation and the silversmiths' desire to display their technical virtuosity. His elegant

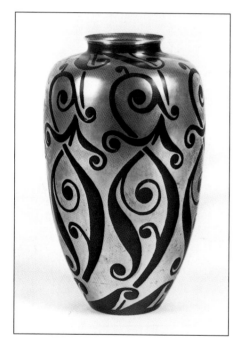

Left Christofle: vase, silvered and patinated metal, 1920s; and (**below**) Marcel Wolfers: tea service, silver and ivory, 1920s.

and simple designs proved that figures, flowers, chasing, repoussé and all the traditional embellishments could be eliminated without sacrificing either beauty or luxury.

Gabriel Henriot, writing in the January 1927 issue of *Art et Décoration*, said: "The work of Jean Puiforcat seems to evolve more and more in the direction of Cubism." Puiforcat himself, however, was uncomfortable with the term Cubism, feeling that ignorance and misinterpretation had given it a bad reputation, as he said himself, in the same article: "For me, all that I have made is not definitively modern. They are only the products of my search, and are far from satisfying me. If there is one desire I have for my work, it is not to be at the mercy of a formula, but to arrive at that which I feel and can freely express."

It is human nature to look for visual analogies in an artist's work, and because some of Jean Tétard's forms resembled the prow of a boat or the sleek lines of an automobile, it was concluded – wrongly – that he was inspired by boats and cars. In fact, Tétard tried to keep his mind free of pre-conceived ideas, and let the design flow

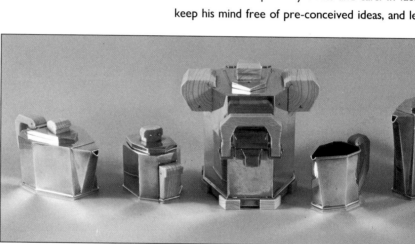

PATOU, *Jean*
1880-1936
Couturier, parfumeur
Born in Normandy and joined his uncle's fur company in 1907. By 1912 he had opened Maison Parry in Paris, offering tailoring, dressmaking and furs in the same establishment. In 1919, after World War I, he opened his *couturier* house, and by 1921 was designing sportswear for the tennis star Suzanne Lenglen. He is also known for the fragrance

"Joy," which he introduced in 1926.

according to his logic. A base, for instance, would enlarge to become the foot; the top, projecting at a sharp angle, would become the spout; and the rear would narrow and rise up on itself to become the handle. Tétard's teapots were not just vases with handles and spouts, they were the very essence of teapots **(4)**.

Tétard was a latecomer to the field of silver, but the pieces he presented at the Salon d'Automne were audacious in their originality and of superb workmanship. He had abandoned simple geometric shapes and was fascinated by the challenge of more complex flattened forms made of two identical sections joined by a flat piece at the front. These designs required a high degree of technical skill but freed him from the restrictions of more conventional forms: Brief experimentation with surface decoration led him to abandon the idea immediately: his only concessions to ornament were lovely sculptured handles of rare woods that seemed to grow out of the silver. He handled curves with virtuosity, going from concave to convex to create spiral movements that were both dramatic and elegant. The execution of these pieces was so difficult that only a few artisans with great experience could produce them **(5)**.

We have little information about Jean Tétard or the Paris firm, Tétard frères, but it is known that two other designers worked with them, M. L. Tardy and M. Valéry Bézouard, and that they were located at 4 Rue Béranger. They produced all manner of silversmith work: table services, flatware, cigarette boxes, planters and mirrors, all in the intensely personal style that became the firm's trademark.

There was a ready market in France for fine silverware, and many smaller houses also flourished, among them Cardeilhac, Keller, Fouquet-Lapar, Chapuis, Linzler and Ravinet-d'Enfert, all of

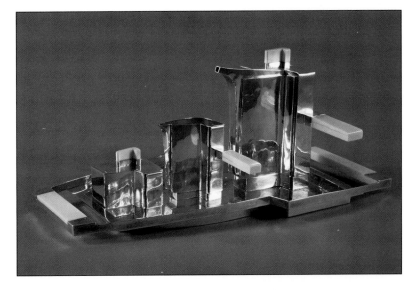

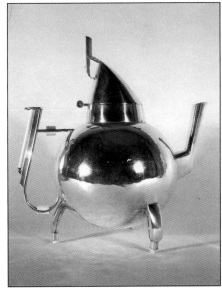

Above Theodore Wende: tea service, silver and ivory, 1920s; and (**right**), teapot, silver and ivory, about 1925. Two distinct styles are evident in these two works by Wende: the teapot shows a functionalism characteristic of his training at the Bauhaus; the tea service shows his appreciation of the stylizations of Puiforcat and Tétard in Paris at the time.

PECHE, *Dagobert*
1887-1923
Designer in all fields of the decorative arts
Born near Salzburg, studied architecture at the Vienna Polytechnic from 1906-8 and at the Vienna Academy until 1911. One of the most brilliant decorative artists of the early twentieth century, in spite of a tragically short life. Entering the Wiener Werkstätte in 1915, he produced almost 3,000 designs,

developing his own decorative vocabulary full of fantasy and based on the earlier Austrian Baroque and Rococo styles. He designed furniture, silver, ceramics, glass, bookbindings, textiles and papers.

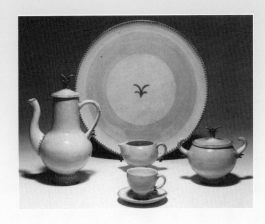

Pêche for the Wiener Werkstätte: pottery tea service, 1920s.

which produced quality articles. Boin-Taburet created elegant objects that, while traditional in style, showed a strong oriental influence, often incorporating jade carvings and wood sections inlaid with semi-precious materials in the Japanese manner.

The name Christofle is almost synonymous with silverplate in France. The firm was founded in 1839 by Charles Christofle, who invested his entire personal fortune plus money borrowed from friends to buy up the existing French patents for electroplating. By 1859 the firm employed 1,500 people. Christofle made a fortune and was awarded the Cross of the Légion d'Honneur. He also won high awards at the Paris exhibitions in 1839, 1844, 1849 and 1868, and received commissions from Napoleon III, the Empress Eugènie

and the city of Paris. His nephew, Henri Bouilhet, was aggressive in marketing abroad, and the firm's work was shown in London, Vienna and Philadelphia. They were so proud of the quality of their production that they stamped their goods with the weight of silver used. Christofle produced every conceivable article of both utilitarian and decorative silverplate, and many of their pieces in the 1920s were designed by such notable artists as Gio Ponti, Maurice Daurat, Luc Lanel and Christian Fjerdingstad, among others. The company still flourishes today, and their flatware pattern "Baguette," first produced in 1861, has remained one of the best-selling designs in Europe.

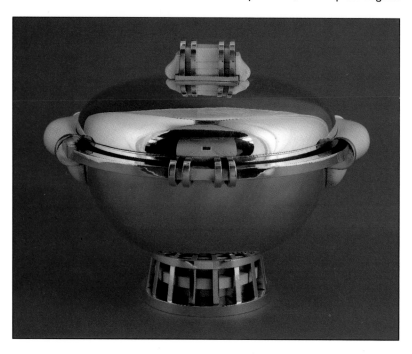

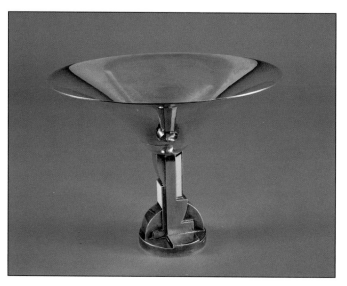

Left Cardeilhac: centerpiece, silver and ivory, 1920s.

Above Jean Goulden: *coupe*, silver and enamel, late 1920s.

PERRIAND, *Charlotte*
b. 1903
Furniture designer, decorator
Born in France, studied interior design and made her debut as a decorator at the SAM in 1926. The following year she joined Le Corbusier's practice, where she remained until the end of the 1930s. They exhibited mainly as collaborators so it is difficult to credit furniture designs individually. In 1930 she was a founder-member of the UAM.

Perriand: card table, chromed metal and mirror, 1926.

SILVER IN THE USA

American silver was less influenced by European styles than other areas of the decorative arts, although Puiforcat and other major designers exhibited their work at The Metropolitan Museum of Art, New York, in 1926 and 1928. Their designs were admired, but the conservative attitude toward silver design remained – silver, being something passed down from generation to generation, hinted at inherited wealth, and most silver design was intended as "instant heirlooms." Tiffany & Co., one of the largest and most prestigious showcases for fine silver, executed few pieces that incorporated contemporary design trends, but even these did not make an appearance until the 1930s, and in the main they continued to produce fine, traditional silver for a wealthy and conservative clientele. Several of their attractive Art Deco designs, principally the work of A. L. Barney, were exhibited at the 1939 World's Fair, but in the early 1920s Tiffany & Co. was more interested in the designs of eighteenth-century masters such as Paul Revere than those of Jean Puiforcat.

Gorham Manufacturing Co. in Providence, Rhode Island, another important name in American silver, was under duress both financially and stylistically in the period following World War I; indeed 1920 was the worst year in their history. The situation improved in 1923, when Edward Mayo came to head the firm. Gorham's chief designer, William Codman, rejected all aspects of "modern" silver design, and Mayo may have attempted to inspire Gorham by hiring the Danish silversmith, Eric Magnussen, who worked for the firm from 1925 until 1929. Codman continued to design silver in various academic and revival forms, but Magnussen produced contemporary designs that took their inspiration from Constructivism, Cubism and the skyscraper. His Cubic coffee set "The Lights and Shadows of Manhattan," with its contrasting triangles of silver, gilt and brown patina, was highly original both in form and in the use of color (8). Among his other audacious – possibly rather extreme – designs for Gorham were the serving pieces, similarly architectonic in inspiration, which caused considerable controversy. They were also much imitated, most notably by two "Skyscraper" tea services in nickel-plate produced by Bernard Rice's Sons, Inc. for Apollo and skyscraper-inspired tea-services by the Middletown Silver Company and the Wilcox Silver Plate Company, both in Connecticut. Norman Bel Geddes designed a "Skyscraper" cocktail set and a "Manhattan" serving tray, but these were in a restrained, linear design that was almost Scandinavian in feeling; in fact Scandinavian design was more successful than French in the United States, and Magnussen's subsequent work was considerably more conservative.

Unlike many American silver companies whose success was based on traditional designs, International Silver of Meriden, Connecticut, hired outside designers such as Gilbert Rohde, Eliel Saarinen and Gene Theobald to design a wide range of hollow- and flatware in silver, silverplate and pewter that reflected new trends in the decorative arts.

One of the most noteworthy silversmiths working independently in the United States during the 1930s and 1940s was the German-born Peter Müller-Munk. After coming to New York in 1926, he worked briefly for Tiffany before setting up his own studio in 1927. His designs were modern without being extreme, and reflected a European sophistication that attracted many private clients.

PERZEL, Jean
1892-?
Glassmaker, lighting designer
Born in Czechoslovakia, and studied glassmaking, the family profession, before moving to Paris with his family. After World War I he resumed his glassmaking career, working with Jacques Gruber. Becoming interested in lighting, he experimented extensively to find the best glass for diffusing light. He advocated purity of form for lighting fixtures, and was extremely successful, working with Jallot, Tétard frères and Roux-Spitz and designing for Henry Ford, the Savoy Hotel in London, and the King of Siam (Thailand).

Perzel: wall sconce, chromed metal and textured glass, about 1930.

OBJETS D'ART AND CLOCKS

Jewelry and *objets d'art* are two closely linked fields, and several jewelers saw artistic possibilities in larger objects. Jean Despres, for instance, made silver-plated or pewter bowls, boxes, tureens and flatware, starkly simple, almost brutal, in design, with heavily hammered surfaces and boldly hewn bolts and rivets. Gérard Sandoz produced a small number of distinctive objects often incorporating lizard skin, *galuchat* and ivory, and the American designer William Spratling designed small objects characterized by a primitive elegance. Cartier, Van Cleef & Arpels, Marchak, Mellerio, Tiffany and, in fact, all of the major jewelry houses produced an amazing variety of *objets d'art,* some of which are really more jewelry than object, with elements carved in semi-precious stones set in silver and gold, often elaborately lacquered. Cartier's famous mystery clocks are perhaps the most extreme examples.

Clocks deserve a special mention in this chapter, partly because timepieces are such an important part of our daily lives, and partly because the twentieth century saw many innovations in the field of clock-making which freed designers from previous restrictions. With the new smaller movements clocks could now be made of a suitable size to sit comfortably on a table, and with an electric clock that required no winding, wall placement was not a problem either.

Nearly all French designers after World War I abandoned the round clock, as strongly vertical and horizontal shapes were more in keeping with current decorative tastes, and there was much radical experimentation with clock design. Some designers modified or even abolished the traditional needle-shaped hands, replacing them with balls on moving metal plates, or stationary points on a rotating dial of numbers. Great attention was paid to the design of the numbers themselves; the traditional Roman numerals no longer sufficed, even though they were more inherently geometric than the curved Arabic ones.

There were several noteworthy designers working in this field. Jean Trenchant experimented with radical designs in polished glass and metal directly influenced by Modernism. UTI, under the direction of George Meyer, produced clocks of varying degrees of distinction, the best deriving their interest from the interplay of black, triangular needles against the black circles that served for numbers. Gascoin designed some interesting models in curved wood and metal, elegant in their extreme simplicity, with the numbers always given an interesting treatment. Melik Minassiantz, among the most original designers, replaced the needles with balls which, attached to metal plates, moved along circular grooves, suggesting the solar system and giving an intriguingly mysterious air. Puiforcat also designed some extraordinary clocks, usually of silver-plated metal with glass, rock crystal or other semi-precious stones in dramatic geometric forms, and Jean and Jacques Adnet and Boris Lacroix were responsible for some clocks of very original, rather stark design, primarily in metal.

In America, clock design was less extreme. Paul Frankl, Gilbert Rohde, Kem Weber and others produced designs in the streamlined, machine-age style that characterized the Art Deco movement in America. The sumptuousness of the materials – contrasting metals with brushed or polished surfaces, tinted glass, and new varieties of celluloid and other synthetics – substituted for the more innovative designs coming out of France.

France was on the whole less dominant in the area of *objets d'art* than in other arts during the Art Deco period; some extraordinary work was being done throughout Europe in this field. In Brussels, Marcel Wolfers, son of the Art Nouveau jeweler and silversmith

PFLUEGER, *Timothy L.*
1892-1946
Architect
Affiliated with the San Francisco architectural firm of J.R. Miller & Timothy Pflueger. He designed several important commissions including the Medical & Dental Building (1930) and the Luncheon Club in the San Francisco Stock Exchange, but his most celebrated architectural achievement was the theater he designed for the Paramount-Publix chain, in Oakland, California (1931).

POERTZEL, *Otto*
b. 1876
Sculptor
Known as "Professor Poertzel," one of the most prominent German sculptors at the turn of the century. Best known for his chryselephantine statuettes of theatrical subjects, cabaret and burlesque performers and circus stars as well as for more sedate figures of women and dogs.

Philippe Wolfers, became as famous as his father. Like Puiforcat, he studied sculpture while working in his father's *atelier*, and also mastered the techniques of enameling and stone carving. He was fascinated by Chinese decorative techniques and used them extensively in his work. In England, Charles Boyton produced many interesting articles, elegantly geometric in design. But some of the most exciting designs were produced in Germany by Bauhaus designers – Marianne Brandt, Christian Dell, Wilhelm Wagenfeld, Wolfgang Tümpel and Otto Rittweger – and by Bauhaus-influenced designers, such as Theodore Wendte and Emmy Roth.

Denmark's Georg Jensen was a major figure in twentieth-century silver. He was not a great innovator, nor did he create a new style; his major accomplishment was to make a successful commercial enterprise of hand-crafted modern silver **(6)** , taking it far beyond the realms either of idiosyncratic personal expression or the elitism of objects made for the wealthy few. Jensen opened his first shop in Copenhagen in 1904, and prospered under the astute financial backing of the Hostrup-Pedersen family. Within 25 years, they had opened branches in Berlin, Paris, London, New York and Stockholm. Through the efforts of Jensen and his colleague, the painter Johan Rohde, Scandinavian modern silver came to be a practical realization of the ideals of William Morris and the British Arts and Crafts Movement **(7).**

Jensen and Rohde did much of the firm's designing, but they also hired a number of distinguished artists to design for them. One of the most important was Harald Nielsen, who joined the firm in 1909 and brought with him a functional style derived from the Bauhaus. Two decades later, in the 1930s, their most influential designer was Sigvard Bernadotte, son of the King of Sweden, whose hard-edged pieces were often characterized by incised parallel lines.

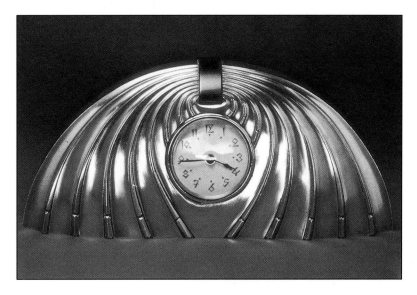

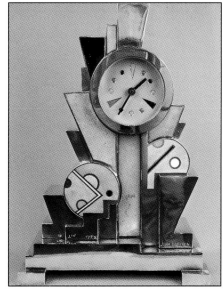

Above Albert Cheuret: mantel clock, silvered bronze and onyx, probaby 1920s. Here Cheuret has drawn on the enthusiasm for "Egyptiana," which followed Carter's discovery of Tutankhamen's tomb in 1922. **Right** Jean Goulden: clock, silver and enamel, 1929. A member of Dunand's artistic circle, Goulden was in the vanguard of the design movement which introduced Cubism into three-dimensional work.

POILLERAT, *Gilbert*
b. 1902
Metalworker, jewelry designer
Trained as an engraver and chiseler at the Ecole Boulle, then worked for Edgar Brandt for seven years. In 1927 he joined Baudet, Donon et Roussel, a firm specializing in construction frameworks, as head of their newly formed decorative ironwork division, producing grills, tables, screens, andirons and lighting. His style evolved from calligraphic to rectilinear, often incorporating figurative elements. In 1934 he began designing jewelery for the *couturier* Jacques Heim, and in 1935 he executed the doors of patinated bronze for the pool of the *Normandie*.

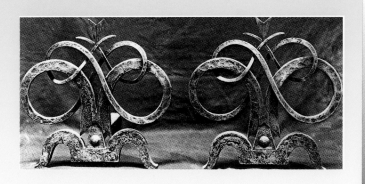

Poillerat: andirons, wrought iron, about 1925.

DINANDERIE

America in the 1930s saw ever-increasing quantities of accessories in inexpensive silverplate, chrome and nickel. A worsening economy made these wares especially appealing, and if they lacked quality, they certainly had style. The most successful manufacturer of mass-produced chrome and nickel accessories was the Chase Brass and Copper Co., in Waterbury, Connecticut. Chase hired many prominent designers, among them Walter von Nessen, Gilbert Rohde, Russel Wright, and Rockwell Kent to design Modernist-inspired articles, particularly cocktail and smoking accessories for the mass market.

Luxury and beauty are not necessarily dependent on precious materials: fine techniques of metalwork, with inlays and lacquer techniques, often embellished with eggshell or mother-of-pearl, have given us objects of elegance and opulence that often even surpass those in the most precious materials. Work in non-precious metals is called *dinanderie*, a term which derives from the Flemish town of Dinant, where quantities of brassware were made during the Middle Ages. Many of the techniques of metal incrustation were of ancient origin, and by returning to old traditions and applying them in a new way, twentieth-century artists were able to produce works of a singular vitality.

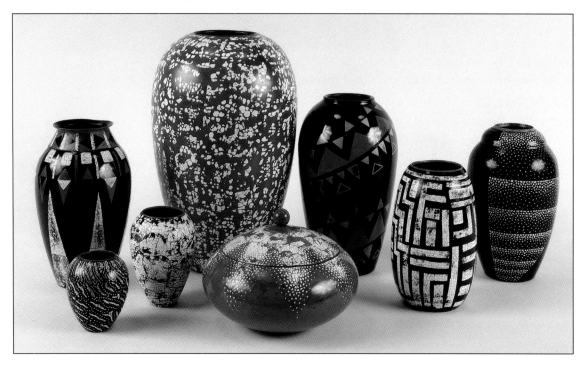

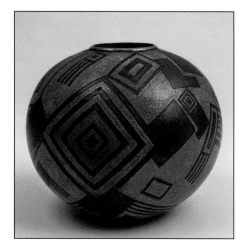

Left Jean Dunand: group of lacquered objects, all but one with *coquille d'oeuf* applications, 1920s; and (**below**) vase, copper with green patination, 1920s.

POIRET, *Paul*
1879-1944
Couturier, painter, ensemblier
Born in Paris, the son of a draper. From an early age he showed a strong aptitude for drawing and designing clothing and costumes, and at age 19 was invited by Jacques Doucet to join his establishment. Designed clothes for Rejane and Sarah Bernhardt, and in 1903, after a brief association with Gaston Worth, decided to set up his

own business and opened La Maison Poiret. In 1912 he established Atelier Martine, largely to market the designs of his pupils at the Ecole Martine, a school of interior decoration for young women. The students specialized in "naive" colorful fabrics, wallpapers and murals, and furniture with veneers and brightly painted wood. They decorated Poiret's three houseboats at the 1925 Paris Exposition.

POMPON, *Francois*
1855-1933
Animalier sculptor
The son of a French cabinetmaker, learned the basics of carving at an early age, and apprenticed to a marble cutter in Dijon before studying architecture, etching and sculpture. In 1875, he moved to Paris, and worked as an assistant to Mercie and later Falguière, Saint-Marceaux and finally Rodin. Encouraged by Rodin, he began

to model his own figures — some portraits but mostly animals. These animals had an impressionistic quality similar to that of Rembrandt Bugatti's bronzes, but later he developed the smooth, sleek style which is regarded as the quintessential Art Deco *animalier* style. Ironically, it was not until 1922, when he was 67, that Pompon's work gained recognition, owing to the exhibition that year of his striding polar bear, which was

The interest in Japanese art that began in the late nineteenth century had much to do with the resurgence of interest in *dinanderie* and lacquer. Jean Dunand, who was to become the most important artist to work in these techniques, was introduced to the medium by the Japanese lacquerer, Sougawara, who approached him with a metalwork problem. Dunand agreed to help if Sougawara would in return teach him the techniques of lacquer work, and this was to have a profound effect on his life and career. He quickly mastered the technique, and his skills brought him so many important commissions that he had to extend his *atelier* and was soon employing as many as a hundred people. Dunand developed yellows, greens and corals that had always eluded the Japanese artisans, and was able to produce top-quality lacquer at lower cost, experimenting endlessly with the extremely demanding and often dangerous lacquer techniques. In order to achieve white (unobtainable with vegetable dyes) he expanded the applications of an existing technique called *coquille d'oeuf,* a laborious process which involved inlaying crushed eggshell into the last layers of the lacquer, either in sections, often covering the entire surface, or in minute, precisely placed pieces. The tone and texture of the finish could be varied by using the inside or outside of the shell, and additional subtleties were achieved by thin applications of lacquer over the egg shell. Dunand's fascination with these techniques produced some of the most extraordinary objects of his or any other time.

Obviously the lacquer had to be applied to a surface, and Dunand began with vases, all made by hand in the *dinanderie* technique. His earliest vases derived their shape from gourds and other vegetal forms, and he often worked the surfaces with repoussé, chiseling, patinas of browns and greens, and inlays of other metals either to highlight the naturalistic form or to produce organically inspired motifs such as scales and peacock feathers. His forms gradually became simpler and his designs more geometric, relying on surface ornamentation and applied metal for effect; some of his later vases were little more than spheres or cones of color.

Both figurative and abstract tendencies appeared in Dunand's work throughout his career. He often depicted animals and plants in his work, sometimes quite naturalistically, but sometimes in exciting and inventive stylizations. Good examples are the pieces he made in collaboration with the painter and sculptor Jean Lambert-Rucki, whose bizarre and whimsical animals cavort on vases, screens, panels and furniture surfaces. Dunand was on close terms with most of the major artists and designers of the Art Deco movement, and worked with many of them. He exhibited at the Georges Petit Gallery with Paul Jouve, François-Louis Schmied and Jean Goulden, all of whose designs he executed, and they continued showing together for a number of years.

Jean Goulden was something of a dilettante, for he was a doctor by profession, specializing in cardiology. The son of wealthy farmers, he had come to Paris to study medicine, and became fascinated by the artist's life, frequenting the "artists quarter" of Montmartre, where he met Dunand and his circle. Goulden was stationed in Macedonia during World War I, after which he spent several months as a guest of the monks at Mount Athos. Here he saw the Byzantine enamels that inspired him to learn the technique of *champlevé* enameling from Dunand on his return to Paris. Once he had mastered this technique he used it with great originality. His highly sophisticated objects are simple in shape, with strong, Cubist volumes and flat planes of strongly contrasting enamels in abstract, or occasionally representational, designs. His preferred metals were

again exhibited at the 1925 Paris Exposition. When he died, over 300 examples of his work were left to the French state and a museum was set up in his name.

Pompon: "Polar Bear," white stone, about 1922.

gilt-copper, gilt-bronze, silvered bronze and sterling silver.

Claudius Linossier was a master of the art of *dinanderie* whose inspiration flowed from a different source. As Yvanhoë Rambosson wrote in *Mobilier et Décoration* in 1933: "Claudius Linossier appears to me as a patient Byzantine artist reincarnated amongst us. His works offer the abundant magnificence of the decor of the Hagia Sophia in Istanbul or St Mark's in Venice. Their surfaces seem to

shimmer with fire, with the ferment of metal in fusion." There were other metalworkers using similar methods, but Linossier took his work far beyond that of his competitors. He was an apprentice metalworker in his native Lyons when only 13 years of age, and mastered embossing, engraving, enamelling, metal incrustation, repoussé and all the other metalwork techniques. He was attracted to sculpture, and worked on medals, which had an important

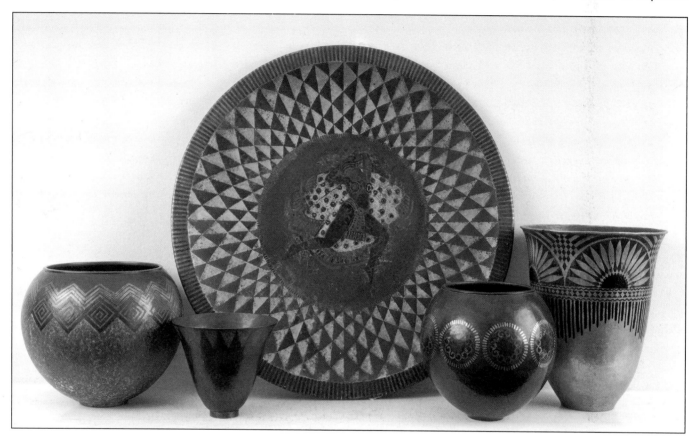

PONTI, *Gio*
1892-1979
Architect, designer
Italy's most prominent figure in the decorative arts, designing ceramics, furniture and lighting fixtures. He trained as an architect, and established the review *Domus* in 1928, which he edited until his death. From 1936 he taught at the Milan Polytechnic, and in 1957 he published *Amate l'Architettura*.

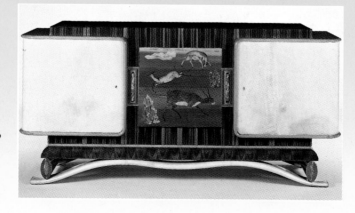

Ponti: commode, Macassar ebony, vellum and marquetry, with marble topl, about 1928.

influence on his later compositions, leading him to an extensive exploration of the interplay of forms and planes; the perfectly proportioned volumes of his vases are a direct result of this experience. He also studied alloys, and his understanding of these enabled him to achieve the various tonalities of silver that gave his pieces their understated richness. He subsequently abandoned silver because it was too costly, and devoted himself exclusively to *dinanderie*.

The outstanding element of Linossier's work is his use of metal incrustation. He was a great admirer of Etruscan pottery, and this served as a departure-point for his designs, painstakingly executed in the techniques of metal incrustation. He loved the subtle play of

one tone against another, and as silver and copper provided only a limited palette he began to develop his own alloys, using ingots he cast himself, and fashioning thin plaquettes that he graded by tone. Once the design was decided, he fitted these one by one into the *champlevé* sections and subjected them to heat. This was delicate and painstaking work, and full of risks. Each metal has its own melting point and coefficient of expansion, and he had to take constant precautions to avoid accidents. The next step was the oxidation of the inlays to create the subtle tones that gave each finished piece its richness. He refused to use acids because they did not produce permanent colors; instead, he used the flame, causing the inlays to expand and flow very slightly into one another, producing shaded tones of faded rose, silvery white, grays, pinks, yellows, mauves and deep, rich black.

Maurice Daurat was an artist who chose to work in pewter. This humble metal had long been disdained for because of its centuries of service in the kitchen, although it enjoyed some popularity during the Art Nouveau period – as attested to by numerous bonbon dishes depicting Ophelia drowning amid hovering dragonflies. Some more artistic work was done in England by Liberty & Co, and J. P. Kayser Söhne of Germany, who designed a range of pewter called Kayser Zinn whose sensuous lines were reminiscent of Hector Guimard, but these pieces were all industrially produced and aimed at a middle-class market. Daurat, one of the few who took pewter really seriously and tried to explore its aesthetic potential, had begun his studies as a painter. He was fascinated by examples of cast and hammered metal that he saw in museums, and began by chasing jewelry and large coupes in bronze with reliefs inspired by Art Nouveau and Renaissance designs before he became more aware of current design trends.

Left Claudius Linossier: group of inlaid and patinated *dinanderie* objects, about 1925.

Above Jean Goulden: cigarette box, vermeil and enamel, late 1920s.

POOR, Henry Varnum
1888-1971
Painter, ceramist
Studied at Stanford University, then in London and Paris, returning to the US in 1912 to teach in San Francisco. He concentrated on ceramics from 1923-33. His work was deeply rooted in French Modernist painting, many subjects showing a Fauvist influence, and his ceramic and painting styles did not vary greatly, although he did

introduce some abstract motifs into his pottery. Poor accepted several commissions including a mural entitled "Sports" for the Hotel Shelton in New York City and an eight-paneled tile mural, "Tennis Players and Bathers," for the financier Edgar A. Levy.

POUGHEON, *Robert-Eugène*
1886-1955
Painter
Born in Paris, studied under Charles Lameire and Jean-Paul Laurens. Worked also in Bordeaux. His early Neo-classical style evolved into a Modernist one in which the human figure was sharply elongated. Today considered one of the most successful Art Deco artists.

Pougheon: study for *les Captives*, gouache and pencil, 1920s.

Pewter is a soft metal, ductile and extremely supple, and Daurat exploited its almost flesh-like surface and its potential for somber shadows and irregular reflections of light from hammer marks, finding that these imparted a warmth more appealing than the cold gleam of silver. His designs became increasingly refined, until they were almost a series of exercises in form and simplicity. His minimal concessions to ornament were a ring of beads at the base or an interestingly designed handle. He intended his pieces to be admired rather than used, and in fact their very weight often rendered them impractical. This was not as arrogant as it might seem: compared with the price of fine silver or porcelain Daurat's pieces were an affordable extravagance. Nor was it perverse to try to elevate this low substance to the status of a precious metal; in Daurat's hands

pewter achieved the status of a new-found material and could stand next to the finest silver without shame.

Another silversmith who on occasion worked in base metals, often with silver inlays, was Jean Serrière. His objects, mainly trays and bowls, are massive in feeling and of extremely simple design, enlivened by traces of the hand work that formed them. Paul-Louis Mergier, an aeronautical engineer who painted, designed and made furniture, also found time for *dinanderie* work. His vases are simple in form, and his preferred subjects were stylized figures and animals defined by various patinas, inlaid silver and lacquer often executed by the well-known Japanese artist Hamanaka. The latter also produced a number of interesting articles of his own, among them trays and small tables with a strongly oriental flavor.

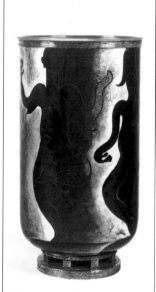

Far left Claudius Linossier: vase, patinated and inlaid metal, 1920s; (**left**) Sarlandie for Limoges: vase, enamel on copper, late 1920s; and (**right**) Württembergische Metallwarenfabric(WMF): covered jar, silver-plated and patinated metal and ivory, about 1930. Known primarily for its small Jugendstil objects in metal and pewter before World War I, WMF adopted the emerging Parisian high style with relative success in the 1920s.

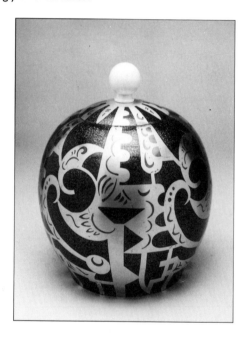

POWOLNY, *Michael*
1871-1954
Ceramist
A seminal figure in the development of twentieth-century ceramics. He founded the Wiener Keramik in 1906, which merged with the Gmündener Keramik in 1913. Powolny's long tenure at the Kunstgewerbeschule in Vienna (1909-36) permitted him to influence a generation of European and American ceramic artists studying abroad.

Powolny: pottery figure of a horse, 1920s.

PREISS, *Johann Philippe Ferdinand*
1882-1943
Sculptor
Leading sculptor whose company Preiss-Kassler (PK) controlled the production of bronze and ivory sculpture in Germany. He began his career in Milan, then moved to Berlin in 1906 and opened the workshop with his friend Arthur Kassler. In 1910 they were joined by two ivory carvers, and the production of

WROUGHT IRON

During the eighteenth century, French ironwork, both in technique and design, was arguably the best in the world, but by the mid-nineteenth century, it found itself in mortal combat with foundry work, which was far cheaper and easier to produce. Grills, balustrades and gates were readily made by casting elements previously done in wrought iron, and no one seemed to mind that they were relatively feeble imitations. There were, fortunately, still artisans who could adapt to the changes in taste and lifestyle brought about by new developments in science and technology. It was their dedication, working against an industry hypnotized by the past, that allowed ironwork to emerge with new dignity; its techniques enriched by recent scientific discoveries in metallurgy that allowed the full exploitation of the virtues and potentials of this versatile material. Oxyacetylene soldering and the development of various patinas made possible technical *tours de force* bound only by the imagination, skill and daring of the designer **(9)**.

A contemporary wrote: 'The inter-war years were, in fact, a golden age for wrought iron. The spare, clean lines of a new, emerging taste in architecture lent themselves particularly well to decorative metalwork.' Sconces, *torchères* and chandeliers could be, and often were, made of other materials. Few of these, however, could match the versatility of wrought iron, which could be crude or refined, massive or lace-like, according to the needs of the client, the taste of the designer and the requirements of the setting.

New developments in technology made wrought iron indispensable where scientific innovation introduced into the home or building required decorative camouflage. Radiators begged to be covered, and wrought iron was ideal for this purpose because it neither obstructed the flow of heated air nor was adversely affected by it. Elevator cages became decorative focuses in building lobbies, coordinated in design with railings and entrance doors to create an overall unity that was modern, practical and often stunning in its impact. The combination of wrought iron with other metals such as copper, silver, bronze, steel and aluminum expanded the opportunities for dramatic effects.

The role of wrought iron as architectural detail was of major significance. A well-designed door did much to modify and enhance the aspect of a building, and many architects thought it superior to the combination of stone and wood. Doors, by virtue of their sheer size and mass, allowed both designer and artisan ample opportunity to display their decorative abilities, sometimes with mixed results. Many were little more than amusing *tours de force* of workmanship resembling braided wickerwork, flowered bookbindings, or embroidered napkins. While superficially amusing, these designs deprived the metal of its solidity and permanence by reducing it to little more than a handwriting scrawl **(10)**. At the opposite extreme were doors designed for banks, which aggressively accentuated the concept of power. Here, iron and bronze were worked to draw out all of the intrinsic force and vigor of the metals.

The movement now known as Art Deco was broadly defined by two predominant styles. The first and most strongly "traditional" made extensive use of stylizations of nature: of birds, flowers and animals; natural phenomena such as clouds, waterfalls and sunbursts were subject to varying degrees of geometrification. An almost Mannerist elongation of proportions and an exaggeration of round volumes were also much in evidence, and there was a predilection for choosing animals and plants that naturally exhibited some of these qualities. Greyhounds, gazelles, pigeons and ripe fruit were

multi-media sculptures began in earnest. Preiss designed most of the models himself, and his very personal style became almost a national one. There was a strong international market for the figures, especially in England where, due to the anti-German feeling after World War I, Preiss was advertised as an Austrian sculptor.

PUIFORCAT, *Jean*
1897-1945
Silversmith
Born in Paris, studied silversmithing in his father's *atelier* and sculpture with Louis Lejeune. He first began exhibiting his designs in 1923, and was renowned for his pure forms in silver, often incorporating semi-precious materials and rare woods. He was chairman of both the 1925 and 1937 International Expositions, on the board of the Salon d'Automne, a founding member of the UAM, and a member of both the SAD and "Les Cinq."

Puiforcat: clock, silver-plated metal and quartz, about 1926.

among the motifs that came to be associated with the Art Deco style. After 1925, decorative wrought iron also began to reflect in its images the more simplified geometric lines of the "rationalists" and sleek lines of machinery, aeroplanes and steamships. The beauty of the straight line had become the new aesthetic.

Because most ironworkers were ironworkers first and furniture designers second, their emphasis was usually on creating beautifully worked and embellished pieces, the form often taking second place. For this reason, furniture was more often than not quite ornate, and too overpowering to be used for an entire room.

Screens, with fine all-over abstract, geometric or floral designs, were used to great advantage as room dividers. Consoles and tables of various sizes, topped with slabs of rare marble, were dramatic as well as useful, and mirror frames added striking points of interest. Andirons, fireplace tools and, particularly, firescreens, lent themselves readily to the decorative possibilities of the medium.

Edgar Brandt

Edgar Brandt's superiority in his field came not only from his perfect understanding of his materials, but also from his rigorous discipline. He and his associate Henri Favier oversaw the construction and decoration of a building down to the last detail. They worked in close communication with designers and artisans, co-ordinating their efforts with a precision that allowed for the rapid transformation of ideas to finished projects (11).

Brandt had a deep respect for the aesthetic and moral heritage of French art, and he saw it as his duty to keep France in the forefront of contemporary decorative design. He felt that industrial processes could be well used to serve this end, and he sought constantly to ally art with industry.

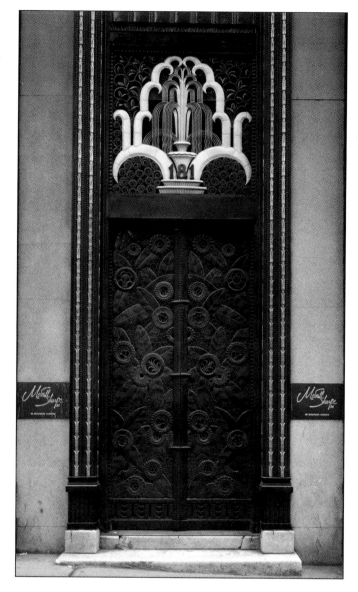

RATEAU, *Armand-Albert*
1882-1938
Furniture designer, decorator
Born in Paris, studied drawing and woodcarving in Paris. In 1905 he took over the directorship of the Ateliers de Décoration de la Maison Alavoine, where he oversaw the commission to furnish the New York town house of George and Florence Blumenthal. In 1919 he became an independent decorator, opening the Atelier

Many artists, on the other hand, feared that the introduction of industrial techniques would lead to mass-production, which they felt would debase their art. Brandt found this fear groundless. It was his conviction that artists could only benefit from an understanding of the mysteries and difficulties of production and of the processes and techniques of the machines **(12)**. He had himself served a long apprenticeship not only in wrought-iron work, but in silversmithing and jewelry, in which he had won prizes at the salons of the

Société des Artistes Français. He was also on the juries of the Salon d'Automne and the Société des Artistes Décorateurs. A man of phenomenal drive and energy, he executed both his own designs and those of others. Blessed with a strong affinity for architecture, some of his finest work was done in collaboration with architects such as André Ventre and Henri Favier, the latter a close friend with whom he worked for many years.

Although already well known prior to 1925, it was Brandt's

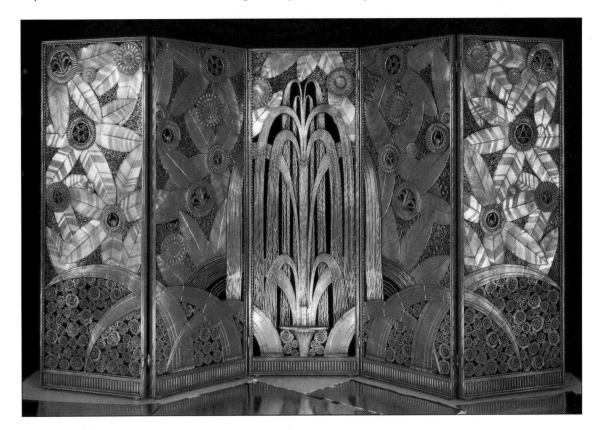

Left Edgar Brandt: pair of entrance doors for Cheney Bros, on the corner of Madison Avenue and 34th Street, New York, wrought-iron with gilt-bronze applications, about 1925. **Right** "Oasis" five-panel screen, exhibited at the 1925 Exposition, wrought iron with brass applications. The screen was the most photographed object at the Exposition, generating a host of copies, both by Brandt himself and his imitators. For the Cheney entranceway, Brandt used the same basic design, pushing the central fountain up to form the lintel.

Levallois in Neuilly. In the 1920s he was commissioned to decorate Jeanne Lanvin's apartment. His style was distinctive, its inspiration the Orient and antiquity, and he usually limited his furniture production to editions of three.

Rateau: chaise longue, giltwood, 1920s.

RAVILIOUS, *Eric*
1903-42
Painter, engraver, ceramics designer
One of the most prominent artists of the inter-war period. He studied at the Royal College of Art in London and later worked in mural, watercolor, wood engraving, and lithograph techniques. He was commissioned to produce pottery for Wedgwood as well as furniture for the Dunbar Hay Gallery.

Ravilious for Wedgwood: "Boat Race Day," pottery vase, about 1938.

varied and extensive work at the 1925 Exposition that catapulted him to the forefront of his field. He was commissioned, with Ventre and Favier, to design the Porte d'Honneur for the Exposition, which they designed in collaboration with René Lalique and Henri Navarre.

The Porte d'Honneur was made of "staff," an inexpensive alloy, for the cost of iron in a project of this size and impermanence was prohibitive. Part of the challenge was to make the "staff" look as fine as the material which it imitated. They were a great success, as were the other commissions he did for the exhibition. In particular he was responsible for the acclaimed metal furniture and furnishings for the Ruhlmann Pavilion. Another vital exhibit for Brandt at the Exposition was his own pavilion, for which he designed an ensemble

Left Edgar Brandt: detail of the "Oasis" five-panel screen (see previous page). The brass chevron panels, applied paper-thin by electrolysis, have mellowed with age to their present golden hue. Right Edgar Brandt: firescreen, wrought iron, early 1920s. Brandt generated a wide range of similar household accessories, including radiator covers, railings, light fixtures and fireplace furniture in wrought-iron for sale through his Paris and New York showrooms.

REEVES, *Ruth*
1892-1966
Textile designer
Studied at the Pratt Institute, New York, and with Léger during her years in Paris (1920-27). In the late 1920s printed textiles were her specialty, in a style distinctly influenced by Cubism. Her one-person textile show at the New York department store W. & J. Sloane showed her enthusiasm for experimentation. She had the ability to bring a colorful blend of Modernism to any subject, whether classical, primitive, figural or abstract.

RHEAD, *Frederick Hurten*
1880-1942
Ceramist
Born in Staffordshire, England, and followed family tradition in becoming art director of the Wardle Art Pottery in Hanley. He emigrated to the US in 1902, worked at Weler and Roseville potteries and in 1927 became artistic director of the Homer Laughlin Company, for which he designed a best-selling line of tableware, "Fiesta."

ROHDE, *Gilbert*
1894-1944
Furniture designer
Born in New York to Prussian-immigrant parents, and showed an early interest in woodworking and mechanics. He was employed by Abraham and Strauss as a furniture illustrator, and became aware of the Modernist movement while in Europe in 1927. By the 1930s he was doing less custom work and more design intended for mass-

that included the spectacular and monumental five-panel screen "L'Oasis", a highly refined fantasy of stylized flowers, foliage and fountains executed in brass and iron.

The Brandt *ensemble* led to his first major commission in the United States, for what is variously known as the Madison-Belmont Building or the Cheney Building, on the corner of Madison Avenue and 34th Street in Manhattan where the exterior metalwork is still in situ. Cheney Brothers, a fabric house that occupied several floors in the building, also invited him to design their showrooms. This gave him the impetus to open Ferrobrandt Inc. in New York. He expanded his operations in Paris at the same time, taking full advantage of all the publicity that evolved from his work at the Exposition.

Brandt's work was successful because he understood the delicate balance between the monumental and the decorative. His talent for balancing these two elements added great style to modern decoration. He was sometimes criticized for his use of industrial techniques, but his work was always redeemed by the beauty of the material, his meticulous attention to detail, and especially for the fine, finished appearance of his pieces. This finish was achieved by one of the industrial techniques that he perfected – oxyacetylene welding, which is all but invisible. In joining decorative elements, Brandt used hidden screws and bolts so that the eye was never distracted by details of construction. Another reason for the great success of Brandt's designs was his understanding of the relationship of each piece within an ensemble – such as a grill, staircase or chandelier – to the whole. Other objects – trays, paper-knives, pendants, brooches and small items of jewelry – are testimony to the same inventiveness and sureness of hand as his more monumental works.

Right Edgar Brandt: vase, wrought iron, early 1920s; and (**below**), pair of andirons, wrought-iron, early 1920s. The serpent was a popular motif in the early 1920s, made fashionable by the *fin-de-siècle* jewelry of Lalique, Fouquet and Vever, and the glassware of Gallé and Daum. Dunand also incorporated the snake into several metalware objects, such as vases and light fixtures.

production. He designed for the Heywood-Wakefield Company, Koehler Manufacturing Co. and the Herman Miller Furniture Co. He exhibited at the 'Design for Living' house at the 1933 Century of Progress fair in Chicago, and played a major role in the design for the Administration Center at the 1936 Texas Centennial Exhibition.

RIEMERSCHMID, *Richard*
1868-1957
Furniture designer
Born in Munich, studied painting at the Munich Academy before his interest turned to furniture design. In 1898 he designed furniture for the Munich Vereinigte Werkstätten. From 1902-05 he taught at the Nuremberg School of Art, in 1907 he became a founding member of the Deutscher Werkbund and taught at the

Berlin Kunstgewerbemuseum, and from 1912-24 he directed the School of Applied Arts in Munich.

Raymond Subes

Raymond Subes was second only to Brandt in the scope and quality of his work. In 1919, at a relatively young age, he was appointed successor to Emile Robert as the director of the firm of Borderel et Robert. It was a perilous position, being both director and creative force, but Subes proved himself equal to the task. It was his good fortune that Emile Robert, himself instrumental in the nineteenth-century revival of wrought-iron work, recognized Subes' intelligence and love of his craft, and took the time to train him. Their collaboration began in 1910, but was interrupted when Subes was mobilized at the outbreak of World War I, during which he suffered serious injury. He was discharged in 1916, and returned to the workshop in Enghien where he continued to receive the best possible training.

Subes endeavored to create an impression of richness and elegance in his work, but with great simplicity of technique. This aim was completely in accord with the economic and social conditions of the time, for (as now) the public demanded the maximum effect for the lowest price. Subes' solution was similar to that arrived at by Edgar Brandt: the marriage of artistic design with industrial technique. He found through his research that industrial techniques could be used with very satisfactory results both in furniture and more massive architectural works. This philosophy journeyed a long way from that of his mentor, Emile Robert, who had stubbornly scorned the use of anything but handtools.

Subes devoted a great deal of time to the technical problems of his trade: how to produce the finest work, keep costs within reason, and yet maintain artistic integrity. In particular he oriented much of his research to the uses of sheet steel, which could be formed by machine into any desired shape. Subes was also ingenious at using flat iron pieces to create works in series.

The intelligent use of machines allowed Subes to produce pieces as cheaply as by casting. Instead of the traditional mortise-chisel, he made use of the countersink and planing machine, which could cut and notch more than a dozen bars of metal simultaneously. He used polishing machines to replace the tedious and expensive process of hand-polishing. At the same time he understood that unique pieces must still be produced by hand, and he himself often took up the hammer to create powerful bas-reliefs for a door. A new metalwork had been born which allowed for production in series, and also made possible works too monumental in scope to be executed at the forge.

It is hard to comprehend that the man who pioneered so many industrial techniques, and who became best known later in his career for his monumental doors and other architectural ironwork distinguished by simple lines, strongly marked divisions and contrasts of robust masses, was the same man who, in 1920, had created lacy interior grills in iron and copper, with arabesques so

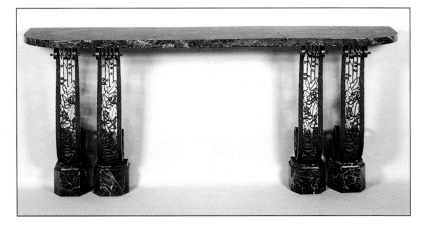

RIETVELD, *Gerrit*
1888-1964
Architect, furniture designer
Born in Utrecht, started his own cabinet making business in 1911, continually experimenting with designs. He produced his famous red-blue chair about 1918. In 1919 he joined the De Stijl group and remained a member until 1931. In 1927 he began to experiment with chairs of molded fiber and later with plywood. After World War II his architectural career

flourished, but he maintained an interest in furniture design.

RUHLMANN, *Emile-Jacques*
1879-1933
Furniture designer
Born in Paris, the best known of all the French Art Deco furniture designers. After World War I he organized a large furniture workshop, Etablissements Ruhlmann et Laurent, as well as designing silks, carpets, textiles and lighting. By 1920 his reputation was established, and at the Paris 1925 Exposition his Hôtel du Collectionneur was the

Ruhlmann: coffee table, pilisander and ivory, about 1924.

light and airy that they resembled embroidery. The pieces which Subes exhibited at the 1925 Exposition were different in character from both his earlier and later work, representing clearly the middle point in his evolving style.

Other wrought-iron masters

The 1925 Paris Exposition was the proving ground for contemporary metalware designers and decorators. In this great international contest, each found his place according to the level of his work. Some languished, others flourished.

Jules and Michel Nics were Hungarian-born brothers who worked in Paris under the name of Nics frères, producing a complete range of decorative ironwork from furniture to architectural decoration. Their work was characterized by a highly conspicuous *martelé* (hand-hammered) decorative finish and a rather excessive use of naturalistic forms even after these had gone out of fashion. They rejected as heresy die-stamping and file work, and affirmed themselves as masters of the hammer, proud of their ability to make any piece by hand in a technique comparable to the finest artisans of the past **(13)**.

Pierre-Paul Montagnac was a painter who designed tapestries and furniture in addition to wrought iron. His partner, Gaston-Etienne le Bourgeois, was a well-known sculptor strongly influenced by Cubism. Together they successfully allied modernity and tradition in their elegant designs for wrought iron.

Schwartz-Hautmont exhibited in the metal section at the Paris Exposition. Jean Schwartz, director of Schwartz-Hautmont, created many works of quality, among them the grill designed by the architect M. Thomes for the Grand Palais des Beaux-Arts, the marquee for the façade of the Grand Magazin de la Samaritaine, the

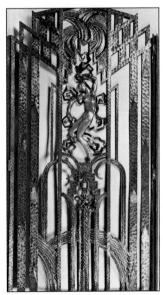

Above Nics frères: console table, wrought iron and marble, 1920s. The distinctive *martelé* finish on the grillwork provides the easiest identification for the work of Nics frères, which was frequently unsigned. **Opposite page** Raymond Subes: console table, wrought iron and marble, about 1925. **Right** Paul Kiss: wrought-iron gate with gilt-bronze applications, about 1926.

center of attention. This incorporated the work of the best designers of the period including Puiforcat, Brandt, Legrain and Dunand. In the late 1920s and early 1930s his luxury furniture, made of the rarest material, was based on French Neo-classical styles but later, changing tastes and the influence of the UAM forced him to use slightly more modern materials and forms.

RUSSELL, *Sir Gordon*
1892-1980
Born in England, began to design furniture in 1910. After World War I he established contact with the Design and Industries Association, and his furniture was exhibited at the 1924 Wembley British Empire Exhibition and at the Paris 1925 Exposition. In 1926 he became a member of the Art Workers' Guild and in the same year his company, Gordon Russell Ltd,

was formed. In 1930 he began to work in a modern style, and in 1931 he was commissioned by Murphy Radios to produce a series of modern radio cabinets which were designed by his brother, R.D. Russell. From 1942 he was a member of the Board of Trade Committee which initiated the production of "Utility" furniture.

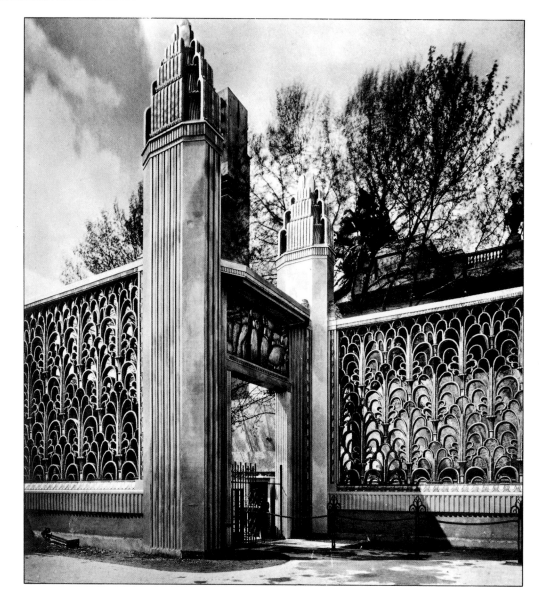

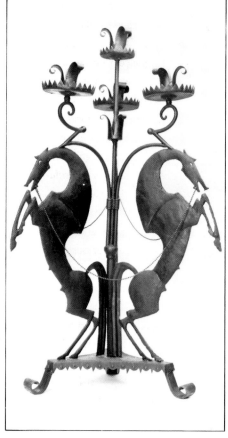

Left Edgar Brandt in collaboration with Henri Favier and André Ventre: Porte d'Honneur, 1925 Exposition, imitation wrought iron. **Above** William Hunt Diederich: candelabrum, wrought iron, 1920s. Diederich applied the same sharp silhouetted imagery to his work in other media, especially ceramics.

SAARINEN, *Eero*
1910-62
Architect, furniture designer

Born near Helsinki, son of Eliel Saarinen. Moved to New York in 1923, and then to Cranbrook, Michigan. He trained as an architect at Yale, after which he worked on furniture design with Norman Bel Geddes. Returning to Cranbrook in 1936, he worked with Charles Eames on furniture design, winning in 1941 the two first prizes in the Organic Design Competition sponsored in 1940 by the Museum of Modern Art. He later designed for Knoll Associates.

grille for the Hotel Scribe. His company, Schwartz-Hautmont, worked in collaboration with many prominent architects and design firms. One of their most important commissions was the magnificent entrance door for La Bibliothèque du Musée de Reims, which was dedicated to the cause of world peace by the Carnegie Foundation in the United States (14).

The metalworker Richard Desvallières produced some extraordinary pieces in the 1920s. He combined the massive presence of Art Deco design with the sinuous lines of Art Nouveau, keeping both elements in careful balance.

Amoit-d'Orbigny had an *atelier* on the Boulevard Exelmans, Paris, exhibiting at the salon of the Société des Artistes Décorateurs and the Société des Artistes Français. He took his work very seriously, and was one of the first in his field to realize that electric lighting required a new approach to design. He decried his contemporaries' preoccupation with naturalistic forms, which he felt were facile and over-used, and his work is characterized by the simple lines that he felt were more expressive of the dignity and strength of metal (15).

Paul Kiss (sometimes spelled Kis) was born in Rumania and went to Paris to study, where he eventually became a naturalized Frenchman. His work explored the lyrical and expressive qualities that he saw in wrought iron, but was quite different in character from that of Edgar Brandt, with whom he collaborated early in his career. He exhibited a comprehensive range of wrought-iron furniture and lighting at the salons of La Société des Artistes Décorateurs and La Société des Artistes Français.

There were many other serious and dedicated artisans in the field of wrought-iron work who, if they lacked the artistic sensibilities of the more major exponents, nonetheless produced a range of attractive and serviceable pieces. Noteworthy were Edouard and Marcel Schenck, Adelbert Szabo, Louis Gigou, Charles Piguet, Fred Perret, Gilbert Poillerat, Edouard Delion, Robert Merceris and Paul Laffillée.

Almost all Parisian decorating firms worked with Fontaine et Cie, who by the 1930s had been producing decorative hardware for over a hundred years. They were the only company willing to take the financial risks involved in producing decorative hardware of good design in editions large enough to permit reasonable prices. One of the reasons for Fontaine's success was its enlistment of prominent sculptors and decorators, who were given wide latitude to produce designs each in their own distinctive style.

Süe et Mare designed some exuberant wrought-iron furniture and innumerable decorative objects for Fontaine. Included were mirror-frames, fire screens, clocks, chandeliers, floor and table lamps, and a complete line of hardware, all with the firm's characteristically beautiful stylizations of natural forms, and *trompe l'oeil* depictions of pleated 'fabric' executed in gilded, silvered or bronzed copper and, later, polished aluminum. The sculptor Paul Véra was closely associated with their work.

The furniture designer René Prou also worked with Fontaine. His style, more Modernist than that of Süe et Mare, was characterized by geometric motifs worked in variously finished metals that provided the surfaces with an interesting play of light.

In the 1920s, scientific advances rapidly introduced new alloys into the market, and new ways were developed of incorporating them into daily life. Metals of incredible lightness and strength allowed buildings to be constructed of armatures covered with cement. This altered forever the look of architecture, and provided the perfect means for the expression of Bauhaus ideals (16).

SAARINEN, Louise 'Loja'
Gesellius
1879-1968
Textile designer
Studied in her native Helsinki and at the Académie Colarossi in Paris. In 1904 she married Eliel Saarinen and emigrated to Michigan in 1923, establishing the studio, Loja Saarinen, at the Cranbrook Academy in 1928. She was responsible for all textile designs for the complex itself and for dozens of commercial commissions, and participated in numerous museum and international exhibitions.

SALTØ, Axel
1889-1961
Ceramist
Trained as a painter at the Copenhagen Academy of Art and later as a draftsman and ceramist. His initial work was for Bing & Grøndahl, then for Nathalie Krebs, and subsequently for the Royal Copenhagen porcelain manufactory.

Although the United States lagged behind France in its adoption of metalwork for interiors, the influence of the 1925 Paris Exposition and the opening of Edgar Brandt's New York office stimulated a taste for this highly versatile area of the decorative arts. By the late 1920s it had become immensely popular, and there were a number of American designers and craftspeople who produced a great variety of both interior and exterior ironwork.

Oscar Bach was perhaps the only craftsman in this field who could match the technical mastery of the great French ironworkers. Born in Germany, he enjoyed a successful career there before coming to the United States in 1914. He opened a studio in New York, where he was soon flooded with private and commercial commissions. Proficient in many metals and styles of metalwork, he used copper, aluminum, bronze, chrome, and nickel silver to provide color and textural contrast in the decorative elements he designed. His contribution to many of New York's most outstanding buildings was immeasurable. He is best known for the interior metalwork for the Chrysler and Empire State buildings, as well as the Radio City Music Hall.

William Hunt Diederich emigrated to the United States from Hungary when he was 15, and took up residence in Boston with his grandfather, William Morris Hunt, who was an artist. Diederich was a successful designer in several areas, but was particularly attracted to metalwork. His simple two-dimensional figures and animals seem snipped out of the iron. With their sharp, jagged edges and minimal surface decoration, they have a lively vitality that reflects their creator's personality and love of animal subjects.

Jules Bouy was another craftsman who came to the United States from Europe. Born in France, he emigrated in 1913, and later became the manager of Ferrobrandt, where he was no doubt strongly influenced by the work of Edgar Brandt. He was also inspired by the skyscraper, and columnar elements reflecting this influence can be seen in many of his furniture designs.

By 1930 the car and the airplane had created a taste for smooth surfaces and simple, logical forms. It was only natural that these same tendencies were reflected in metal-furniture design. Here, one can also see the extensive influence of the Bauhaus' preoccupation with purity of line, utility and mass-production. Le Corbusier had rejected the use of wood in furniture as too traditional. The only logical replacement was metal (17).

Iron and other metals thus became an integral part of much of the furniture designed in the late 1920s. Chairs were designed with structures of iron piping or tubes; flat pieces of hammered metal formed the supports for tables and consoles. To be sure, these creations came as a shock to those enamored of the "traditionalist" style, and there were many decorators who, in their desire to be modern, used metal to excess – with results that were cold and hostile.

Many of the pieces proposed by industry were unsatisfactory – one could not sit comfortably in a steel chair for very long. Moderation is born of excess, however, and equilibrium found its way. Metal furniture became progressively more elegant and useful. In the hands of talented interior designers, metals were stretched, curved, bent, folded, riveted or soldered. Combined with slabs of glass or marble, they created an atmosphere in which transparency and clean lines were the essential characteristics. Elegance and modernity did not have to be cold or impersonal.

SANDOZ, *Edouard Marcel*
1881-1971
Animalier sculptor
Born in Switzerland, studied with Injalbert, then with Marius Jean Antonin Mercie and at the Ecole des Beaux-Arts in Paris. Classically trained, he modeled many memorials, public monuments and portraits, but is best remembered for his animal sculpture — large figures of birds of prey, groups of dancing frogs, foxes, monkeys, etc., produced in both bronze and porcelain.

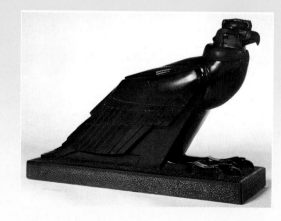

Sandoz: granite figure of a condor.

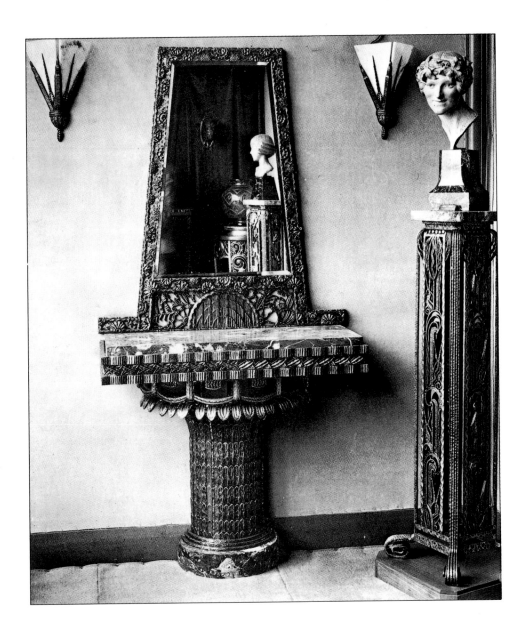

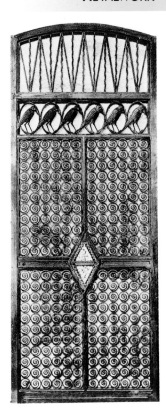

Above left Paul Kiss: hall stand, pedestal and wall sconces, wrought iron, about 1925; and (**above**) Adalbert Szabo: gate for a private residence in Angoulême, wrought iron, early 1920s. Both Szabo and his former student Kiss created a forceful selection of domestic metalware that on occasion matched that of the period's two masters, Brandt and Subes.

SANDOZ, *Gérard*
b. 1902
Jeweler
Born into a family of jewelers from the Jura, and exhibited an early aptitude for painting and design. At the age of 18, while in the family firm, he started designing jewelry characterized by rigorous geometric lines, and his pieces shown in the 1925 and 1937 Paris Expositions epitomized his belief in simple, clean design lines.

SANFORD, *Edward Field Jr*
1886-1951
Architectural sculptor
Born in New York, studied sculpture there and in Paris and Munich. He was deeply impressed with the adaptations of archaic Greek sculpture by Paul Manship, and adopted similar qualities of restraint, balance and symmetry in his own work. Throughout his career he worked on large-scale architectural projects and

devoted himself to the education of the next generation of sculptors. He re-organized the sculpture department of the Beaux Arts Institute of Design, of which he was director from 1923-25 and for which he inaugurated the Paris Prize.

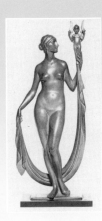

Sanford: "Inspiration," a parcel gilt-bronze allegorical group, 1929.

JEWELRY AND ACCESSORIES

Jewelry is one of the most exciting disciplines of the 1920–30 era. The Art Nouveau movement freed jewelry design from the antiquated influences of the nineteenth century. Art Deco took this evolution a step further, introducing geometrical forms and brilliant color schemes. All of the major jewelry houses, both in Europe and the United States, embraced the new style to some degree, but it was due primarily to Parisian artist-jewelers, such as Jean Fouquet and Raymond Templier, that jewelry design became an art form.

The style which later became known as Art Deco traces its origins to the period before World War I. In the first decade of the twentieth century many factors caused an abrupt change in fashion. The couturier Paul Poiret, for example, revolutionized dress design, freeing the female figure from constricting layers of clothing. Serge Diaghilev's performances of the Ballets Russes in Paris in 1909 and in the United States in 1916, provided another influence, both through its introduction of bright colors into the drab world of fashion, and its emphasis on the Orient. New art movements, such as Cubism, Futurism and Neo-plasticism, helped further to create a new vernacular for art, which in turn initiated new concepts of jewelry design that were taken up with renewed interest after World War I.

The abstract qualities of Art Deco jewelry can be traced to various avant-garde art movements in the first decade of the twentieth century. Picasso's *Demoiselles d'Avignon,* painted in 1907, launched the Cubist movement in its division of the human figure into flat, overlapping, geometric configurations. In 1909 the Italian poet Marinetti published the Futurist Manifesto, which heralded the machine, urban life and speed as the pictorial expression of a new reality. The Dutch De Stijl painter Piet Mondrian took Cubism a step further, into Neo-plasticism. Through abstraction, he freed forms from any suggestion of objective reality.

JEWELRY MOTIFS

As early as 1913, several of these new concepts were evident in jewelry design, particularly in France. In the United States, where Modernism in jewelry design was resisted fiercely for many years, a critic for *The Jewelers' Circular Weekly* (on 26 March 1913) asked, "Will the new movement in painting and sculpture be reflected in the forthcoming jewelry?" The article went on to conclude, concerning Cubism and Futurism, that "whether the exhibits appeal to us or not the vital impulse toward something new and simple is apparent on every hand ..."

The principal motifs in Art Deco jewelry design were simple geometric forms, such as the square, circle, rectangle and triangle. These shapes were often juxtaposed or overlapped to create complex linear configurations. Abstract patterns, derived from the architecture of ancient civilizations, such as Babylonian ziggurats and stepped Mayan and Aztec temples, likewise found their way into the contours of jewelry design.

Art Deco jewelry incorporated gold and silver, and precious and

SCHENCK, *Edouard*
Metalworker
Born in Toulouse, began producing decorative metalwork at the turn of the century, and was joined by his son Marcel in the early 1920s. They produced a full range of consoles, fire screens, radiatior covers and floor- and table-lights, the latter in both wrought-iron and copper. Father and son exhibited at the annual salons, and their designs always remained traditional. The firm remained active until after World War II.

Schenck: *torchère*, wrought iron and glass, 1920s.

semi-precious stones, in designs that emphasized their contrasting colorative effects. Strong, earthy and unrefined colors dominated. Semi-precious stones such as amber, jade, lapis lazuli, coral, turquoise, topaz, tourmaline, onyx, amethyst, aquamarine and rock crystal (some of which had been incorporated into Art Nouveau jewelry) gave jewelry settings vibrancy and interest, especially when placed next to precious stones such as diamonds and emeralds. Faceted and flat stones provided additional contrast in their different surface treatments.

By the end of the 1920s, jewelers refined gem cutting further by the introduction of several new shapes, such as the baguette, trapezium, table and square cut. Jewelers also engraved emeralds, jade, coral and lapis lazuli in imitation of Oriental jewelry (the stones were often carved in the Orient and shipped to the West for setting). Cartier; Black, Starr & Frost; J. E. Caldwell & Co. and Van Cleef & Arpels mixed engraved stones in figurative compositions, such as animals and baskets of fruit and flowers, that took their inspiration from Japanese and Egyptian prototypes.

Sir Flinders Petrie's archaeological excavations in the first decade of the century started an Egyptian craze. Howard Carter's discovery of Tutankhamen's tomb in 1922, and the press coverage which this generated for ten years, insured a continuing interest in Egyptian art. The clean lines in hieroglyphic calligraphy reiterated the linear concepts which had begun to emerge before the war. Van Cleef & Arpels, among others, introduced stylized pharaonic motifs into a series of bracelets, shoulder clips and brooches. Diamonds, rubies, emeralds and sapphires were interchanged with neutral stones such as onyx.

Top Jean Fouquet: bracelet, white gold, yellow gold and onyx, 1925.
Above Jean Despres: rings. all about 1925 in vermeil, lacquer and semi-precious stones.mounted in silver.
Left Raymond Templier: earrings in gold, ivory and enamel, about 1925; ring in yellow and white gold, coral, carnelian and onyx, about 1925.

SCHMIED, *François-Louis*
1873-1941
Graphic artist, engraver, printer, publisher, bookbinder
Swiss-born, educated at the Geneva School of Industrial Arts. In early 1900s moved to Paris, establishing himself as a wood engraver. Developed great versatility, working with Dunand, Jouve and other bookbinders on numerous projects. Notable works included illustrations for *Daphne* and Kipling's *Jungle Book*.

Became insolvent in the Depression, died in virtual poverty.

NEW TRENDS IN COSTUME JEWELRY

The French dress designer Coco Chanel, who championed the use of costume jewelry from the early 1920s, utilized carved beads in her designs for imitation jewelry. Costume jewelry is made out of base metals or silver set with marcasite, paste or imitation stones. In the 1920s, the introduction of synthetic substances such as Bakelite and galalite brought the price of artificial jewelry within the reach of the general population.

Settings

Until 1900, stones were set almost exclusively in gold and sterling silver, often to the visual detriment of a piece of jewelry. The discovery of platinum in the first decade of the twentieth century, and its perfection a few years later – it was used in the manufacture of explosives during World War I – allowed a stone to be set with very little supporting mounting. Because of platinum's great strength, less of it was needed (there were technical problems in working with the similar metal palladium). Art Deco jewelry therefore became both lighter in weight and more delicate in appearance. Van Cleef & Arpels developed the *serti invisible* (invisible setting), in which several rows of stones are placed next to each other with no apparent mounting. Although this technique was not perfected until 1935, a few pieces of the firm's jewelry from the early 1920s have survived to show its initial experiments.

The pearl became a dominant gem of the period. In the nineteenth century, Oriental pearls had been treasured because of

Left Lacritz: suite including necklace, earrings and ring, white gold and onyx, about 1933. **Below left** Jean Fouquet: Bracelet and ring, frosted rock crystal, amethysts and moonstones set in platinum, about 1930. **Right** Van Cleef & Arpels: mirror in agate, rubies, lacquer and gold, 1930.

SCHNIER, *Jacques*
b. 1898
Sculptor
Born in Rumania, a self-taught sculptor much influenced by the art of Polynesia and the Hawaiian Islands, where he worked for two years. Many of his pieces were carved in teak, and his figures are boldly blocked and fully carved. His major commissions include a gilt bas-relief for the Anne Bremer Memorial Library (1936), eight monumental figures and reliefs for the Golden Gate International Exposition on Treasure Island, San Francisco (1929-40) and decorative bas-reliefs for the Hawaiian Room and the Congressional Club in Washington, DC. (1949). Still active at 89, he has recently been modeling large-scale works in stainless steel.

Schnier: "The Kiss," teakwood, 1933.

their scarcity. George Gould, son of the railroad magnate Jay Gould, is reputed to have spent $500,000 on a string of pearls as a gift for his wife. After Mikimoto developed a technique of producing cultured pearls in Japan, however, pearls were available for a wider market. They could be set with other stones, worn in chokers around the neck, or in single strands, and became the accepted accessories for any occasion. A testimony to the popularity of pearls in the 1920s is evidenced by the following quote from an article in *Vogue* magazine: "Day after day, I used to see poor Regina frying in that Lido sun in torture getting her neck brown. She did it, of course, for her pearls."

JEWELRY AND FASHION

Fashion influenced the style, size and shape of Art Deco jewelry. The rise and fall of both the hem line and neck line precipitated a wider need for different types of jewelry. Color, which had been reduced to subdued shades in clothing, suddenly came alive with Diaghilev's Ballets Russes. The sets and costumes, designed by Léon Bakst, radiated with oranges, bright blues and greens, generating a sudden craze for anything Eastern. Oriental stones such as coral, jade, onyx and crystal became popular and remained so until after World War I. Paul Poiret brought this mania for the exotic into fashion, first by streamlining dresses and then by introducing the Empire waistline, which eliminated the need for tightly laced corsets.

World War I introduced women into the workforce, helping to liberate them further from constrictive clothing. For patriotic reasons it became acceptable for women to undertake certain types of work. This change in the traditional role of women brought sweeping changes in what they wore. Women had gained

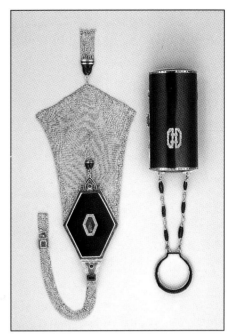

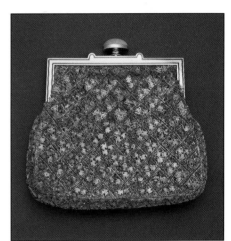

Above Georges Fouquet: pendant in jade, diamond, onyx and enamel set in platinum, 1924. **Above right** J. Chaumet: compact in diamonds, coral, gold and black lacquer, about 1925; and chain purse, diamonds and gold, green and black enamel, about 1925, designer unknown. **Right** Van Cleef & Arpels: evening bag in gold, enamel, platinum, diamonds and chrysoprase, with embroidered and sequined fabric, 1926.

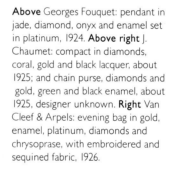

SCHRECKENGOST, *Viktor*
b. 1906
Ceramist
Born to a family of Ohio potters, studied at the Cleveland School of Art, where one of his instructors was Viennese designer Julius Mihalik. His appreciation of the Viennese school was enhanced by the traveling International Ceramic Exhibition which opened at the Cleveland Museum of Art in 1929. Shortly after, he left to study under Michael Powolny in Vienna, returning in 1930. He then taught at the Institute of Art and worked with the small group of artist-designers retained by the Cowan Potteries in their last-ditch stand against bankruptcy.

Schreckengost for the Cowan Pottery: punchbowl, about 1932.

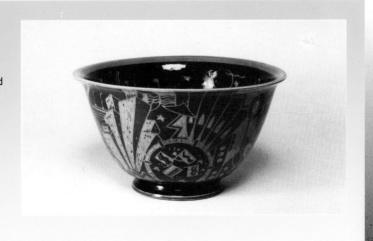

freedom in dress and were not about to give it up. In 1917, Mrs Vernon Castle arrived in Paris and changed forever the concept of the ideal woman. Her slim, lithe figure glided across the dance floor, charming Parisian society with the latest ballroom dances and providing a preview of the energetic woman who appeared after the war to challenge the staidness of her predecessor's role in society.

During World War I there was a need to conserve heavy fabrics for the troops. This hastened women's acceptance of a softer, slimmer silhouette. The introduction of rayon and muslin, materials too light to bear the weight of a heavy piece of jewelry, necessitated lighter pieces of jewelry, now made possible with platinum.

Poiret's slim, high-waisted dresses were replaced in 1917 with a line of low-waisted models. Hemlines fluctuated for the first five years of the 1920s, from ankle- to calf-length. Then, in 1925, skirt hems shot up to just below the knee (the length now generally associated with the 1920s), and dropped back to mid-calf-length in 1929. The silhouette of the body became long and flat, and suppressed all curves. The new look necessitated new jewelry with simple lines, minimum design and vivid colors.

Both the neckline and the back of the dress fluctuated, the latter plunging to almost obscene depths. To accentuate the vertical line of the tubular dress, jewelry designers introduced long, dangling necklaces influenced by the multi-strand models of the Indian maharajahs. Women wore *sautoirs* and strings of beads in materials such as ivory, wood and semi-precious stones, either in the traditional manner, or hanging down the back, over one shoulder, or even wrapped around one leg. Necklaces, suspended with pendants and tassels, hung as far as the stomach or, on occasion,

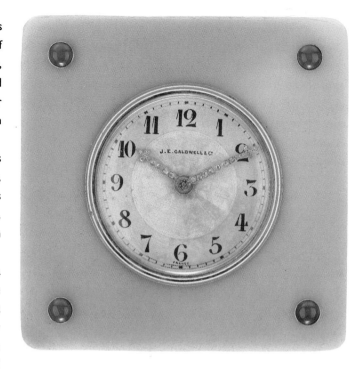

even to the knees. In the dance-crazy "Roaring Twenties," long necklaces complemented short tunic dresses, fast dances and swaying movement.

Brooches were worn attached to hats, shoulders, straps or belts. The brooch-buckle was composed of a ring of onyx, crystal or coral, either in a circle or an ellipse, with decorative motifs at either end using diamonds, pearls or sapphires. Black, Starr & Frost advertised a typical example in 1926 with oxblood coral, diamonds and onyx. The brooch-buckle and the hatpin, another piece of jewelry which became popular in this period, could be worn either

SCHWARTZ, *Jean*
Metalworker
The son of a master ironworker, and director of the firm of Schwartz-Hautmont, which exhibited in the 1925 Paris Exposition. The firm collaborated with architects, and their major commissions included grills for the Grand Palais des Beaux-Arts, Maxim's restaurant and the Hôtel Scribe. Their most important work was for the library doors of Rheims

museum, one of which, the Port de la Concorde, was donated by the Carnegie Foundation in America.

SCHWERDT, *Fritz*
Jeweler
Born in Pforzheim, Germany, and set up his jewelry workshop in partnership with Hubertus Forster, specializing in the manufacture of silverware. His innovative Art Deco jewelery creations incorporate elements from mechanical designs.

SERRE, *Georges*
1889-1956
Ceramist
Began as a colorist for Sèvres and traveled to Saigon where he became an art teacher in 1916. Returning in 1922, he opened his own studio and from 1940-50 directed the ceramic work of the Ecole des Arts Appliqués.

on a belt or attached to the cloche, the hat which became a symbol for the 1920s. Making its appearance in the winter of 1923, the cloche completely covered the head from the eyebrows to the nape of the neck. Long hair or hair pinned back in a bun distorted its shape, however, which prompted women to cut their hair in the new bobbed and shingled styles.

Such new cropped hair styles exposed the ear for the first time, and long, dangling earrings of diamond, jade, ivory, jet, onyx, crystal and amber became fashionable. By 1929 earrings were so long that they touched the shoulder, further emphasizing the verticality of fashion.

In response to the new slender fashions at the beginning of the century, the bandeau had replaced the tiara and diadem. Still desired as an ornament worn in the evening, women in the 1920s wore the bandeau on the hairline, or set back on the head, like a halo. In 1930 Chaumet designed an elegant diamond bandeau with three rosettes and stylized foliage (1). In the United States, Oscar Heyman & Bros., a jeweler's jeweler which still manufactures fine jewelry for other prestigious firms, designed a delicate diamond-studded example.

The typical Art Deco dress was sleeveless, which allowed the jewelry designer free rein to design creative jewelry to decorate the wrist and upper arm. There were several types of bracelets. The first were flat, flexible, narrow bands decorated with overall stylized designs of flowers, geometricized shapes and motifs from Egypt and Persia. Because these were narrow, four or five were worn together on the wrist. Toward the end of the 1920s they became wider. Big, square links of coral, rock crystal, onyx and pavé diamonds were accentuated with emeralds, rubies, sapphires and other cabochon gems.

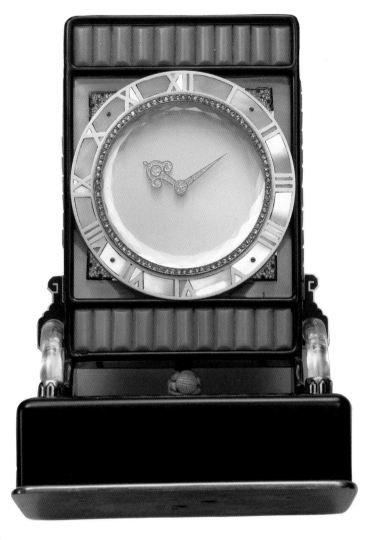

Opposite page J.E. Caldwell & Co: clock in diamonds, jade, chalcedony and silver, about 1925.

Above Cartier: clock in rock crystal, mother-of-pearl, diamonds, coral, black enamel and gold, 1926.

SHONNARD, *Eugènie Frederica*
b. 1886
Animalier sculptor
Born in New York, and lived in Paris from 1911-23, studying under Rodin and Bourdele. Her first works were portraits, but she soon turned to animals and in particular to birds. Her strong carvings of marabou and casts of herons are typical of her simplified forms, and her figure of a marabou bears a striking resemblance to much smaller models of the same animal by Bouraine. Her animal sculpture modeled during her Paris years under the influence of the Art Deco *animalier* sculptors has given her a well-deserved reputation as one of the earliest and best of the American sculptors working in that idiom.

Shonnard: bronze figure of a heron, 1922.

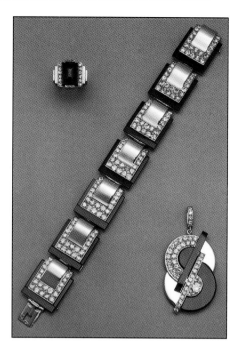

Left Desausoy: suite consisting of pendant, bracelet and ring in diamonds, onyx, white gold and platinum, about 1928; and (below) Jean Fouquet: vanity case, gold, 1930. The younger Fouquet was in the vanguard of the new Modernist movement in design which emerged in the wake of the 1925 Exposition. Rejecting the floral and sunburst imagery of the early 1920s, he introduced powerful machine-inspired motifs into his jewelry designs, many overlapped to provide an even more dynamic look. To help achieve this effect, concentrated settings of small stones were replaced by broad areas of a single color.

Other types, bangles or slave bracelets, were worn on the upper arm or just above the elbow. (In England they covered the wearer's vaccination mark.) They were made out of gold, silver and materials such as bamboo. Like flexible bracelets, several were worn at a time. Artist-jewelers such as Jean Fouquet, Raymond Templier, Jean Despres and Gérard Sandoz combined a variety of stones and metals. In Sweden, Wiwen Nilsson mixed silver with large pieces of crystal.

A third type, worn in the evening, consisted of loose strands of pearls, held together by a large pearl-studded medallion from which additional strings of pearls were suspended. Like the bangle, it was worn above the elbow.

With sleeveless dresses and the rage for sports, the watch bracelet became very popular in the 1920s. Jean Patou introduced the *garçonne*-type (the boyish woman) into fashion when he outfitted the tennis star Suzanne Lenglen, the ideal personification of the new woman. Every woman wanted to look the part of a sportswoman even if she did not participate. The wristwatch, worn during the day, was plain and strapped with leather or ribbon. The evening watch resembled a richly jeweled bracelet set with pearls and diamonds, either enameled or in different colors of gold. An example from the period by Tiffany & Co. was set with diamonds and onyx and mounted in platinum.

From 1925 to 1930 the pendant and châtelaine watch became popular. Suspended from a ribbon or silk cord, the face of the watch was upside down so that the wearer could glance downward to determine the time. An example by Van Cleef & Arpels shows the Eastern influence with jade, enameling and Oriental motifs. The pendant watch, suspended from a sautoir chain, was worn in the evening. The chain was studded with pearls, diamonds and colored

SINGER, Susi (Susi (Selma) Singer-Schinnerl)
1895-1949
Ceramist
Studied at the Kunstgewerbeschule in Vienna under Michael Powolny, was associated with the Wiener Werkstätte and established her own studio in Grunbach in 1925. She emigrated to the US in the late 1930s, settling in California.

Singer for the Wiener Werkstätte: pottery vase, 1920s.

SLATER, Eric
b. 1902
Ceramics designer
Originally intended to be an engineer. In 1928 he became director of Sheley Potteries, Stoke-on-Trent, and was responsible for much of their product design throughout the 1930s.

SOUDBININE, Séraphin
1870-1944
Ceramist
Born in Russia, but moved to Paris, where he became a protégé of Rodin. After seeing Near Eastern ceramics in New York, he began to produce sculptural ceramics in stoneware and porcelain.

Left Suzanne Belperron: bangle and clips in rock crystal and gold, about 1935; and (**below**) Jean Dunand: brooch and earrings in silver and lacquer and a handbag clasp converted to a brooch in metal and lacquer, all about 1925.

gems. Its case was embellished with diamonds.

After the war, rings grew larger and bolder, dominating the finger. Surfaces were smooth, polished or in satinized metals. Stones could be either precious or semi-precious, set with *pavé* diamonds or a combination of two lacquered metals. Toward the end of the 1920s, gloves went out of fashion; muffs were preferred for the new fur-trimmed coats. Women started to wear massive rings to adorn their now-gloveless hands. The popularity of the fan for evening wear gave them additional opportunites to show off the latest in ring fashions. Suzanne Belperron's large ring in carved chalcedony, set with a single Oriental pearl, captured the new mood. Other designers offered widely different solutions. Jean Despres combined crystal, gold and silver in abstract geometric patterns influenced by Cubism and African masks. Fritz Schwerdt, working in Germany, designed rings inspired by machines, one of which reproduced precisely the inner mechanism of a rotary engine in which an agate rod acted as the connecting pin (2).

The Art Deco style was also reflected in men's jewelry, although never with the same flare as women's. Geometric forms characterized the dials of pocket watches which were mounted in platinum set with onyx, diamonds, pearls, emeralds, rubies and topazes. Watch chains were made up of cylinder links enhanced with polished or faceted stones. Cuff links followed the same general shapes. Jean Fouquet designed a notable pair with enameled Cubist motifs (3). Black, Starr & Frost's selection included a pair in onyx with diamond borders (4).

ACCESSORIES AND ORNAMENTS

Van Cleef & Arpels and Cartier, among others, made beautiful accessories for the well-dressed lady of the period. Influenced by

STADLER-STOLZL, *Gunta*
Weaver
Studied at the Munich Kunstgewerbeschule, then went to the Bauhaus, where she began to experiment with weaving. Strongly influenced by painters such as Paul Klee, her work marked a turning point in the relating of textiles to interiors. The weaving workshop was a commercial success. She left the Bauhaus in 1931.

STAITE MURRAY, *William*
1881-1961
Ceramist
Influential English potter, who headed the ceramics department at the Royal College of Art in London, and set up his own studio in Berkshire. He regarded ceramics as an art form on a level with painting and sculpture, and his work shows a strong Chinese influence. In 1940 he settled in Rhodesia.

STAM, *Mart*
b. 1899
Furniture designer
Born in Holland, studied drawing in Amsterdam, and worked as an architectural draftsman in Rotterdam until 1922. He is best known for the cantilevered tubular-metal chair, constructed of gas pipes, which he designed in 1926. In 1926 he was invited by Mies van der Rohe to design three houses at the Deutscher Werkbund's Stuttgart Exhibition.

Chinese, Japanese, Persian and medieval art, these *objets d'art* combined colored gemstones, precious stones, marcasite, enamel and lacquer. The small cigarette cases designed by Gérard Sandoz introduced a further type of decoration in its use of crushed *coquille d'oeuf.* Whether a vanity case, cigarette case, compact, lighter, lipstick case, mirror or handbag, each item was intended as a miniature work of art.

The *nécessaire,* or vanity case, which held a mirror, compact, lipstick and comb, took its form from the Japanese *inrō* (a small case divided into several compartments). Although small in size, it accommodated all of the accoutrements that a lady might need. Vanities were mostly rectangular or oval, and hung from a silk cord. In 1930 the vanity case was enlarged into the *minaudière* by Alfred Van Cleef, who named it this after witnessing his wife simper (*minauder*) into the mirror. The *minaudière* replaced the evening bag and daytime dress bag.

The Art Deco handbag was made of luxurious fabrics or exotic skins with gold or platinum frames and clasps. Gemstones, accented with faceted or cabochon rubies, emeralds, sapphires and diamonds studded the frames. Semi-precious stones carved with Egyptian and Oriental motifs were used for the clasps. An evening bag designed by Van Cleef & Arpels was embroidered with sequins sewn onto the fabric. Mauboussin designed elaborate evening bags with diamond and emerald clasps that matched the brooches and bracelets worn on the bearer's evening gown.

Clocks and other small table items were similarly embellished with elegant *moderne* motifs. Cartier epitomized splendor in its "mystery clocks," which blended the world of myth and fantasy with stones, crystal and quartz carved with antique Chinese figurines. More progressive, Boucheron superimposed rectangles,

triangles and squares in a gold clock embellished with diamonds and enamel **(5).** In a sumptuous electric table lamp by Van Cleef & Arpels, light passes through slabs of rock crystal.

"HIGH" ART DECO

As in most disciplines of the decorative arts, French jewelry was well represented in the 1925 International Exposition in modes that celebrated the culmination of the high Art Deco style. Beyond France, the style had few adherents. In the Japanese display, for example, Mikimoto filled a showcase with loose strands of cultured pearls. Great Britain was represented by one jewelry firm, Wright & Hadgkiss, which exhibited items influenced by Gothic metalwork. Similarly, Italy and Spain sent exhibits that were more traditional than modern. On the whole, foreign entries did not reflect the current geometrical style which had prevailed in Paris since World War I.

Georges Fouquet of La Maison Fouquet was elected chairman of the selection committee for the *Parure* section. Under his leadership the committee decided that only works of new inspiration and originality would be accepted. Objects had to be submitted anonymously; the names of the designers and firms whose works were chosen were omitted from the showcases. Of the nearly 400 firms which submitted entries, only 30 were accepted. Eric Bagge was commissioned to design a display case which would not detract from the jewelry on view.

The principal exhibitors were Boucheron, Chaumet, Dusausoy, Fouquet, Lacloche, Linzeler, Mauboussin, Mellerio and Van Cleef & Arpels. Cartier chose to exhibit in the Pavilion de l'Elégance with the fashion designers. The house of Boucheron was represented with creations by M. Hirtz, M. Masse and M. Rubel. Their exhibition

STORRS, *John Henry Bradley*
1885-1956
Sculptor
Born in Chicago, but lived and worked in France. He worked in a variety of new materials and experimented with the Art Deco, Cubist and International Styles. He studied in Paris with Rodin and as the sculptor's favourite student was chosen to oversee the installation of Rodin's works at the Panama-Pacific Exposition in San

Francisco and, in 1917, to draw his death portrait. He returned to America frequently, exhibited in New York and received major architectural commissions in Chicago, including the aluminum figure of Ceres for the top of the Chicago Board of Trade Building (1930).

Storrs: "Bathers," bronze, 1916-19.

included two remarkable corsage ornaments which were characteristic of the Art Deco style. Scalloped lapis, jade and onyx were combined with matt coral and turquoise within diamond-studded borders in geometrical patterns that resembled miniature mosaics **(6)**.

The artist-jewelers Raymond Templier, Paul Brandt and Gérard Sandoz contributed outstanding examples in new and original materials. La Maison Fouquet was represented by the architect Eric Baggé, the graphic artist André Mouron (called Cassandre), the painter André Leveillé, Louis Fertey and Georges Fouquet's son Jean, who had joined the family firm in 1919. André Leveillé and Louis Fertey received Grand Prix awards, and Cassandre and Jean Fouquet received honorable mentions. Leveillé's designs recalled the overlapping images in Picasso and Braque collages, while Cassandre adopted the mandolin, a motif popularized on canvas by Picasso, into the design for a brooch. The Exposition was very well attended, which allowed the general public to become familiar with the new trends in French jewelry design.

By 1929 the abstract creations seen at the 1925 Exposition had evolved into mechanistic forms based on industrial design. The design principles inherent in automobile and airplane construction inspired a new decorative vocabulary for jewelry. A remote but real influence could now be traced to the Bauhaus.

Jewelry design had evolved from the thin, delicate creations of the early 1920s into bolder, larger designs with sharp outlines. The rainbow palette of bright colors gave way to muted tones. Stark contrast was achieved with black and white, epitomized with onyx and diamonds. Bracelets became wider and earrings longer. A bangle bracelet and matching ring that Jean Fouquet designed for his wife was made out of frosted rock crystal set with amethysts and

Above left designer unknown, pendant in ivory, amazonite and gold, about 1918; and E. David: pendant in aventurine, coral, onyx and gold, about 1925. **Above** Jean Despres: brooch and rings in silver, enamel and glass, about 1925.

moonstones. In place of the earlier uniformly narrow band bracelet, it expanded in thickness toward the center. Overlapping forms gave way to clean, simple lines.

1929 marks the year of another exposition in Paris, the Exposition des Arts de la Bijouterie, Joaillerie et Orfèvrerie which was held at the Musée Galliéra. Organized in the same spirit as the 1925 Exposition, the major houses sent representative works in the new updated style. Only one truly novel piece of jewelry was displayed – a large tie by Van Cleef & Arpels which is knotted around the neck and falls, like a ribbon, to the breastbone **(7)**.

The diamond reigned supreme, cut in the new baguette style and placed next to other stones for contrast. Boucheron exhibited a baguette-cut diamond bracelet edged with sapphires. Mauboussin incorporated diamonds onto the tassel of a large sapphire collar. There was also a return to the colored diamond, out of fashion since the late nineteenth century. Lacloche displayed a brooch and bracelet set with canary diamonds.

SUBES, *Raymond*
1893-1970
Wrought-iron designer
Born and studied in Paris, was made artistic director of Borderel et Robert in 1919, and became one of the most important wrought-iron designers and producers of his time. His early work was ornate and naturalistic, but later became geometric and linear. His most important work was in architecture, and his grills and doors can be seen all over Paris. Among his major commissions were a grill for the Permanent Colonial Museum (1931) and wrought-iron work for the liners *Normandie*, *Atlantique* and *Ile de France*.

THE DEPRESSION YEARS

From 1930, the effects of the Depression were felt in luxury items. After the Crash of 1929, multiple-use jewelry (jewelry comprising two or more components which could be dismantled and used separately) became popular. Pendants could double as brooches or be attached to lapels. The double barrette, formed from two linked parts, could be separated and worn in two places. Tiffany & Co. designed a necklace which came apart either to form a pendant and two bracelets or a choker.

As the economic effects of the Depression deepened, firms were hesitant to produce new items which might prove difficult to sell. In 1931, therefore, when entries were solicited for the Exposition Coloniale in the Bois de Vincennes outside Paris, only 23 firms participated. Whereas some exhibited jewelry embellished with colonial themes such as Negro masks, African motifs and jungle ornaments, most contributed objects from existing inventories. The exotic ivory was combined with the ever-popular diamond. Jean Fouquet exhibited pendants designed as African masks.

The United States

Art Deco was principally a French movement, although jewelry firms in the United States adopted a restrained version of the style, suitable for the American taste. Whereas the French jewelry designers were directly or indirectly inspired by the dominant European art movements of the first decade of the century, no such source existed within the United States. The 1913 exhibition of modern European and American art, held at the Armory in New York, generated a savage response from both the critics and public. One example, Duchamp's *Nude Descending a Staircase*, enjoyed a *succès de scandale*. It took another 30 years before this new art was

Above designer unknown: necklace, chrome and bakelite, about 1925; and (**opposite page**) Auguste Bonaz: galalite necklaces, 1923-4. Fine pieces such as these were often created in the 1920s by small family jewelers who preferred to sell their wares to retail outlets, such as large department stores, rather than market them themselves. For this reason, many pieces are unsigned and therefore difficult, if not impossible, to attribute to a specific designer.

SÜE, *Louis*
1875-1968
Architect and designer
Born in Bordeaux, moved to Paris in 1895 to train as a painter. In 1912 he organized his interior decorating business, the Atelier Français, designing textiles, furniture and ceramics. In 1919 he and André Mare founded the Compagnie des Arts Français. At the Paris 1925 Exposition the firm received acclaim for its designs, and in the same year they designed a Paris shop for Parfums d'Orsay. In 1928 the designer Jacques Adnet took over the direction of the company from Süe, who continued to be active as an architect and designer. At the 1937 Paris Exposition he designed much of the interior decoration of the pavilion of the SAD, becoming president in 1929.

Süe: dressing table and stool, burl ash and anodized aluminum, 1933.

absorbed into the US art scene.

With typical American conservatism fostered by the country's Puritan background, Art Deco was assimilated with reluctance into jewelry design. Tiffany's in New York, the leading American jewelry establishment in the nineteenth century, created traditional objects in the new style, but never with the clear geometrical elements found in pieces by Boucheron or Mauboussin. Other jewelry firms such as Black, Starr & Frost and Udall & Ballou in New York; J. E. Caldwell & Co. and Bailey, Banks & Biddle in Philadelphia; and C. D. Peacock and Spaulding-Gorham, Inc. in Chicago, produced jewelry in the new style, but again not with the panache of their counterparts in France.

Within these limitations, the progress of Art Deco jewelry in the United States followed a path similar to that taken in France. In the early part of the decade, the theme in jewelry design was lightness and economy. Toward the end of the decade, large, massive pieces, worn in quantity, became popular. In 1924, the major French houses of Boucheron, Cartier, Mauboussin, Sandoz and Van Cleef & Arpels displayed the most up-to-date creations at the French Exhibition at the Grand Central Palace in New York. Although American jewelry design did not directly derive models from this exhibition, it later became more geometric, and objects in the new style were termed "modernist."

One new stylistic development can be discerned in US jewelry at this time. The stepped outline made its debut on the contour of a few pieces of jewelry, coinciding with the emergence of skyscrapers, which were transforming the skylines in major cities across the country.

In summary, the 1925 Exposition was the high point in Art Deco jewelry. After this date, forms grew larger and more massive.

Color was toned down until black and white predominated. The spirit of the period gradually faded, and with the advent of the Depression the demand for luxury goods was severely reduced. The major jewelry houses cut back their staff or closed. In 1935, Art Deco's grand master Georges Fouquet ceased major production. In the United States, Tiffany's remained open but operated with no additional staff. By this time the influence of the Bauhaus had been felt in all phases of the decorative arts. Industrial design, based on machine production, was assimilated into a design paradigm for the masses. The spirit of Art Deco had waned.

SZABO, *Adalbert*
Metalworker
Born in Hungary, first exhibited in 1906 at the SAF, and continued in business for about 30 years. His earlier work was historically oriented, but he adapted to new trends in design. His most important commission was the doors for the first-class dining room of the liner *Normandie* in 1936.

TEXTILES

The textile arts had a tendency to follow the decorative trends of the 1920s and 1930s: in this way they were usually ancillary to the major movements in furniture and interior design of the period. The development of the *Gesamtkunstwerk* in Germany and Austria, and the growth in importance of the French *ensemblier* did, however, lend a new air of importance to the textile arts as the inter-war period progressed. Wallpapers and, later, fabrics and rugs, were often the only note of pure decoration in interiors that tended toward the doctrinaire.

Only a few of the Modernist textile designs of the 1920s and 1930s were designed by individual artists or small studios. The United States and Britain, and to a lesser degree Continental Europe, were home to a notoriously conservative buying public whose chief interest in home furnishings lay in antique furniture or period reproductions. Concern with textiles within the home was limited primarily to the need for occasional replacement.

The ephemeral nature of the textile and paper market encouraged manufacturers to adopt the latest fad or fashion, except in the carpet industry, which was loath to commit its power looms to the Modernist idiom until it was sure that the style was more than a passing fancy. The fragile nature of fabrics and carpets has resulted in the survival of few examples from the 1920–30 era **(1)**. Those that have survived have often suffered alterations in color which lead today's observer to very different conclusions about the decorating scheme and the use of color originally intended by the artist **(2)**. In addition, the lack of textile examples of sufficient quality to maintain a consistent market at auction has engendered a further neglect.

COLOR, TEXTURE AND PATTERN

The taste for color changed more rapidly in the field of textile design than in any other medium. The electric colors that dominated Parisian textile design in the early 1920s were the result, in part, of the deprivation experienced within the city during World War I. In 1920 the impulse to celebrate manifested itself partly in a search for flamboyance. Vivid, sometimes discordant, shades of lavender (Lanvin blue), orange-red (tango) and hot pink, were juxtaposed with lime greens and chrome yellows to generate a psychedelic palette rivaling that of the 1960s.

The spectacular success of Serge Diaghilev's Ballets Russes, conceived in 1909 and in production until the outbreak of World War I, gave additional impetus to the daring use of post-war color. The unity of his productions, in which brilliant painterly effects in costume and stage design echoed the music and choreography, served to promote a kaleidoscope of color. After the hostilities Organic Cubism, a movement that gave primacy to color over form and that was founded and dominated by Robert and Sonia Delaunay, quickly gathered momentum. Sonia Delaunay's "simultaneous" fabrics attracted both followers and imitators from the mid-1920s onward, launching a vogue for contrasting color schemes.

TEAGUE, *Walter Dorwin*
1883-1960
Industrial designer
Born in Decatur, Indiana, he moved to New York in 1903, attending night classes while working for an advertising agency. Opened his own office in 1911, specializing in book and advertising designs, and in the mid 1920s established himself as an industrial designer, after creating designs for packaging and piano cases. First major

In the late 1920s, however, the pendulum began to swing the other way. The gathering international neurosis over political and economic instability heralded a conservatism that, in interior design, ushered in more neutral schemes. Texture was re-emphasized at the expense of color. Center stage was captured in the Depression by the muted, albeit luxurious and costly, schemes of decorators such as Jean-Michel Frank in Paris, and Syrie Maugham in London. Color accents in the work of Frank's imitators were sought in tones of charcoal, bottle green, and a peculiarly dusty shade of brown which on the Continent was referred to as *tête de nègre* and, unabashedly in leading English art and decoration journals, as "nigger."

These interiors were popular throughout the early Depression years, and were well in keeping both with the increasing Neo-classicism of the Modernist decorative artists and the economic austerity of the moment. As the political situation again darkened toward the end of the 1930s, the decorative arts escaped into a cacophony of revival styles. The emphasis immediately preceding World War II was once more on color, whether in the overblown cabbage-roses-on-chintz of the Victorian revival, the innocuous stripes of the neo-Regency, or the crimson silk upholstery of the sofa which Salvador Dali modeled on Mae West's lips, now an icon of the Surrealist influence on design.

Perhaps the most significant contribution of the 1920s and 1930s to textile design was the growing belief in the doctrine of truth to material. Among the Modernists this took the form of a virtual abandonment of printed decoration, which was now seen as an attempt to imitate costlier woven fabrics. Interest centered on the innate qualities of the fiber. Good weaving, it was felt, would help to bring out the beauty of the fabric through its texture, in contrast

E.A. Seguy: *pochoir* (transfer-printed) maquette for wallpaper/textile production, early 1920s. These

rather fluid interpretations of natural forms would be executed in vivid hues.

client (1928) was Eastman Kodak, and his best-known designs include the Marmon car (1930), the plastic Baby Brownie camera (1933), the Scripto pen (1952), coaches for the New Haven Railroad, and Texaco gas stations. For the 1939 New York World's Fair he designed the Ford exhibition, including chairs of aluminum and Lucite.

Teague for the Steuben Glass Company: "St Tropez" glassware, about 1932.

TEMPLIER, *Raymond*
1891-1968
Jeweler
Born in Paris, one of a family of Parisian jewelers. In 1919 he joined the Maison Templier, founded by his grandfather 70 years earlier, and he collaborated for nearly 30 years with designer Michel Percheron in rigorously geometric jewelry designs, almost entirely without decoration. He was a founding member of the UAM.

Templier: aquamarine and diamond brooch; diamond and moonstone brooch, 1932-33.

to the deceptive manipulation of printed or other "applied" decoration. This attitude was fuelled in part by the principles of the Bauhaus weaving workshop, the full effects of which were felt only after the war in the mass-production of large-scale, woven fabrics.

A further catalyst of the 1930s interest in textures was the development of synthetic fibers, such as a form of rayon called artificial silk, and cellulose. Both of these were of textures which rivaled traditional linen weaves and wool. Also, the effective application of Cubism to the textile arts lent itself to an interest in the application of weaving techniques that emphasized pattern.

It was also logical that, in the absence of vibrant color-schemes, interest in the early 1930s would concentrate on texture: varied weaves, the use of such unusual materials as straw and gypsum, the qualities of hand-knotted, fringed area rugs and sculpted carpets such as those designed by Marion Dorn. In helping to emphasize the decorative qualities of extremely coarse or "natural" textiles, Modernism reversed the course of the industry, and the strident pastiches of the early 1920s yielded to an era of almost apologetic hues and patterns.

A predictable taste for Neo-classicism was evident in the years immediately preceding and after World War I in the work of many French textile designers, who saw themselves as heirs to the decorative traditions of the Louis XVI and Louis-Philippe styles. This was, in part, an understandable reaction against late Victorian clutter and the excessive whiplash curves of Art Nouveau. The 1925 Exposition served as a watershed of new ideas, as motifs from the Near East, the Orient, folk art, Cubism and Fauvism were applied with great vigor to decorative objects. Simultaneously, the role of the textile within an ensemble was analyzed: should it be designed without consideration toward the furnishings which it was

to complement, or should it act as a decorative accent which, by definition, would always play a secondary role?

The emphasis on flat graphic decoration was felt most strongly in Europe and in the US. In Britain, little change was evident until the 1930s, when the earlier rich splashes of color in the flowered fabrics sold through department stores gave way to a series of muted floral chintzes.

FRENCH FABRICS AND PAPERS

Paul Poiret couturier, painter and *ensemblier*, was one of the seminal figures in the promotion of the exotic and colorful Art Deco style. Both the representative of the Ministère des Beaux-Arts and the Commissaire-Général acknowledged their debt to Poiret and his workshop, the Atelier Martine, at the 1925 Exposition. Poiret founded the Martine workshop in 1911 as an adjunct to his couture business. Named after one of his daughters,

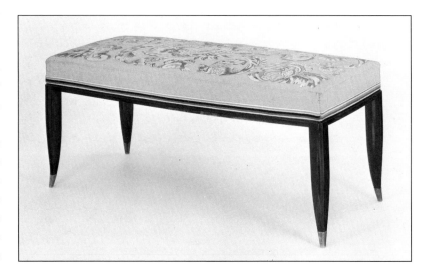

THURET, *André*
b. 1898
Glassmaker
One of the few artists who attempted to continue the important early twentieth-century traditions in French glass. He experimented with metallic oxides, introducing them into his individual examples of bubbled glass.

the workshop comprised mainly a group of young girls from the working-class suburbs of northern Paris. Poiret provided them with minimal academic training, encouraging them to paint and sketch subjects from nature spontaneously. The most successful of these were translated into fabrics by Paul Dumas and carpets by the firm of Fenaille. The Martine style was essentially colorful and frivolous, but combined with an exoticism that evoked the Ballets Russes. Poiret described other influences as Persia, the South Sea Islands and, to a limited extent, the more decorative elements of the Weiner Werkstätte, which he had visited in 1910.

For the 1925 Exposition, Poiret designed an exhibit comprising three barges entitled "Amours," "Delices" and "Orgues," which were moored on the Seine beneath the Alexandre III bridge. "Orgues" provided the setting for 14 steam-dried wall hangings executed by Raoul Dufy. But Poiret's heyday had passed, hastened by his financial inabilities, and his once-adoring public's rejection of the elaborate floral style which he had helped to popularize.

Raoul Dufy's fabric designs drew on the narrative and pictorial eighteenth-century style in which figures were portrayed in various outdoor pursuits surrounded by arabesques or floral ornament. Patterns included "La Danse," "Le Pêcheur à la Barque" and "La Moisson". Other designs show the facility with which Dufy interpreted decorative fruit and floral trelliswork of the kind associated with Indian calicoes ("Croisillons de pensées," "Fleurs et torsades") and, somewhat later, subdued geometrics ("Rectangles aux striés," "Motifs hindous," "Coquilles"). Dufy worked exclusively for the Atelier Martine until 1912, when, with Poiret's approval, he joined the giant textile mill Bianchini-Férier, for whom he worked until 1930. From 1930 until 1933 his commissions included printed silk designs for Onondaga in New York.

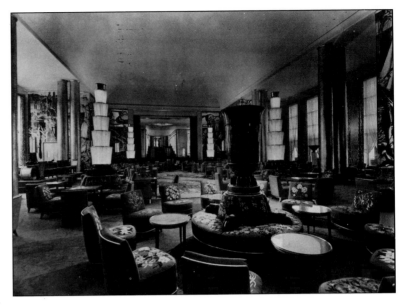

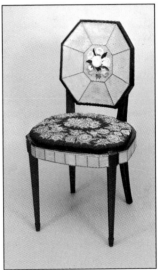

Left Emile-Jacques Ruhlmann: Macassar ebony chairs with tapestry upholstery, about 1925, tapestry woven by Beauvais after the cartoons by Gaudissart. Above Süe et Mare: gilt-wood salon suite with tapestry upholstery after cartoons by Charles Dufrêne, 1925. The understated colors of tobacco-brown and silver-gray are the exception, rather than the rule, to woven upholsteries of the 1920s and '30s. Right André Groult: side chair, painted wood with needlepoint upholstery by Marie Laurencin, about 1925.

TIFFANY & CO.
Began as a stationery and dry-goods store in New York (Tiffany & Young) which opened in 1937, and within ten years had added gold jewelry and silverware to its stock. In 1841 John L. Ellis joined the firm and for the next ten years the company was known as Tiffany, Young & Ellis. In 1853 Tiffany bought out his partners, and the store assumed its existing name. Tiffany's participated at all the international expositions during the nineteenth century and early part of the twentieth, receiving top prizes. Beginning in 1903, the company retailed items produced by Tiffany Studios, the firm established by Louis Comfort Tiffany, son of the founder.

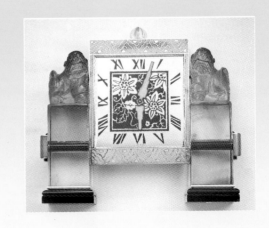

Tiffany & Co: clock in rock crystal, onyx, enamel and gold, made by Georges Verger, about 1929.

Sonia Delaunay rivaled Dufy as a textile designer, producing a diverse range of sharply Modernist and colorful fabric and rug patterns **(3)**, in addition to stage-set and costume designs. As a measure of the esteem in which she was held by her contemporaries, she was retained by the publisher Charles Moreau to author *Tapis et Tissus*, part of a series of volumes on 1920s decorative arts entitled *L'Art International d'Aujourd'hui*.

Many French artist-decorators designed printed papers and textiles – lace, silks, cretonnes, crêpes de chine, damasks and brocades, in addition to the standard selection of furniture fabrics – to complement their interiors. These included André Groult, sometimes in collaboration with Marie Laurencin, Francis Jourdain, Emile-Jacques Ruhlmann, René Gabriel, René Herbst, Pierre-Paul Montagnac, Fernand Nathan, Léon Jallot, Jacques and Jean Adnet, Tony Selmersheim and Stéphany. The catalogues of the annual Paris salons in the 1920s and 1930s list a large number of textiles designed by such *ensembliers*, in addition to liaisons between the *ensembliers* and textile designers.

Specialist textile designers and manufacturers in and around Paris issued a similar range of designs: Henri Gillet, Maurice Quénioux and Jules Coudyser for Cornille frères; La Société des Toiles de Rambouillet; Robert Bonfils for Bianchini-Férier; Edouard Bénédictus for Brunet; René Piot for Tassinari & Chatel, and Paul Rodier. Patterns were divided broadly into two categories: floral and geometric. The latter often comprised overlapping blocks of color or abstract linear motifs. The Parisian department stores provided a matching range of light Modernist designs to supplement their furnishings: Pomone (Paul Follot, Mlle Labaye and Mme Schils) and La Maîtrise (Maurice Dufrêne).

Right Benedictus: wool carpet, about 1925. The rug's vivid palette and dimensionless decorative motifs are unusually exotic for the mid-1920s in France. **Below** Expert & Boijean: Grand Salon, *S.S. Normandie*, 1934. Color representations of the *Normandie's* Grand Salon are virtually nonexistent, but one can gain an impression of the splendor of this vast space and the careful balance of the various surfaces. **Opposite page** Giltwood salon suite with tapestry upholstery, about 1925. The neo-Rococo lines of this suite are well suited to the floral upholstery.

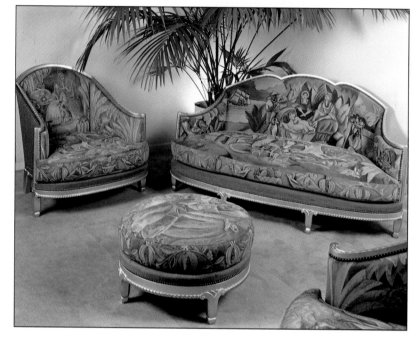

VAN ALEN, *William*
1883-1954
Architect
Although he designed several buildings in the modern idiom, van Alen is most remembered for the Chrysler building, which he designed in 1930 for Walter P. Chrysler, the purchaser of the building, whose goal was to build the world's greatest monument. The building provides a characteristic example of late 1920s commercial architecture, and with its Modernist ornamentation it has become a classic.

VAN CLEEF & ARPELS
French firm of jewelers begun by Julien, Louis and Charles Arpels and Alfred van Cleef in 1904. They took over a small shop in the Place Vendôme, Paris, and quickly earned the reputation of master jewelers. Branches opened in Cannes, Deauville and Monte Carlo. At the 1925 Paris Exposition they won a Grand Prix for jewelry designs, and a decade later they revolutionized the art of jewelry design by

TAPESTRIES

The French were considered masters in the art of tapestry. By tradition, these "portable textile walls" had been used to define interior space and to lend warmth to cold interiors. But the concept in the eighteenth and nineteenth centuries of the tapestry as a woven reproduction of a painting stifled artistic initiative until the appearance of Jean Lurçat, who designed for Aubusson in the 1930s. Lurçat conceived his panels as geometrical compositions which accentuated the interplay of colors. He also advocated the use of relatively coarse fibers which both reduced production costs and lent themselves to dramatic compositions.

Tapestries and rugs executed under the artistic direction of Marie Cuttoli for Aubusson were also popular, representing a continuation of the tradition of faithful *trompe l'oeil* reproductions of paintings by contemporary artists. Cuttoli retained artists such as 'Henri Matisse, Georges Rouault, Fernand Léger and Pablo Picasso, to submit cartoons for weaving (4). Most of the fabrics designed by these artists' exhibited through 1930, show a remarkable insensitivity to the nature of the material, but, were readily accepted by patrons with a taste for contemporary painting.

In the 1920s, seat furniture and screens upholstered in tapestry were widely offered by foremost interior decorating firms and department stores in Paris. Süe et Mare, in particular, offered tapestried furniture designed in both Neo-classical and Modernist styles by Paul Véra, Gustave-Louis Jaulmes, Marianne Clouzot, Marguérite Dubuisson and Maurice Taquoy. For the 1925 Exposition, Charles Dufrêne (13) depicted the story of Paul and Virginia in tapestry on the suite of gilt-wood furniture which Süe et Mare displayed in the Grand Salon of their pavilion, Le Musée d'Art Contemporaine. At La Maîtrise, the design studios of Les Galeries

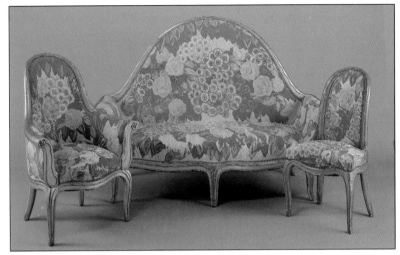

Lafayette, Maurice Dufrêne retained Jean Beaumont to design colourful screens and chairs upholstered in tapestry.

Upholstered furniture fabrics were commissioned from France's traditional tapestry and carpet manufacturers: La Manufacture Nationale de Tapis et Couvertures de Beauvais, La Manufacture Nationale des Gobelins, Aubusson, Braquenie et Cie, and Myrbor. All of these retained their own design staff. Beauvais, for example, used Jean Veber; Aubusson, the services of Edouard Bénédictus, P. Deltombe, Henri Rapin and P. Plumet, and Braquenie et Cie, those of Charmaison and Jane Lévy. In 1936, Beauvais and Gobelins were incorporated into the Mobilier Nationale.

The S.S. *Normandie*, launched in 1934, provided a most spectacular commission for French *tapissiers* to upholster all of the seat furniture in the ocean liner's Grand Salon. Against a background of theatrical splendor, including Dupas' silvered and gilt *verre églomisé* murals and Jean Beaumont's 20-foot lengths of curtain decorated with cerise wisteria on a cream ground, were

Van Cleef & Arpels: brooch, diamonds and brilliants set in platinum, 1931.

introducing the *serti mystérieux* (invisible setting).

VENINI, *Paolo*
1895-1959
Glass designer
Born in Italy, first studied law at Milan university, but turned to glassmaking, and in 1921 became a partner with Cappellin in Murano. Two years later he took over sole control. He is considered one of the finest glass designers of the twentieth century, in addition to employing the foremost designers of the period, including Tyra Lundgren,

Napoleone Martinuzzi and Gio Ponti.

VERA, *Susan see* **COOPER**, Susie

hundreds of abundantly stuffed chairs and canopies designed by F. Gaudissart and upholstered by Aubusson in tapestry woven with flowers from various French colonies. The lavish ivory and olive tones on vivid orange-red and gray grounds, set against the gold and silver leaf of the murals, gave an image of splendor unrivaled in the "floating palaces" of any other nation (6)

BRITISH FABRICS, WEAVING AND NEEDLEPOINT

In Great Britain in the 1920s there was little interest in modern textiles or in printed papers (7). The only noteworthy exceptions were the geometrically patterned fabrics produced by William Foxton & Co., of London, to the designs of Charles Rennie Mackintosh, Minnie McLeish, Gregory Brown and Claude Lovat Fraser.

Examples of Foxton's fabrics were exhibited at the 1925 Exposition, but it was not until the 1930s that the British textile industry warmed to designs in the modern idiom. At that time the firm owned by Allan Walton, a painter, designer and decorator, commissioned designs from Vanessa Bell and Duncan Grant, Frank Dobson, Cedric Morris, Margaret Simeon, T. Bradley and H. J. Bull.

Another group was that of the Edinburgh Weavers, a division of Morton Sundour Fabrics Ltd. Under the direction of Alastair Morton, the firm commissioned designs by such artists as Hans Tisdall, Ashley Havinden, Terence Prentiss, Mario Marini, William Scott, Jo Tilson and Keith Vaughan. One of the firm's more notable lines was the Constructivist fabric jointly designed by Barbara Hepworth and Ben Nicholson in 1937.

Other concerns which added Modernist designs to their repertoire were Sir Thomas Barlow's Helios, which sold furniture fabrics exclusively designed by Marianne Straub; Donald Bros, Ltd.

of Dundee, known for its Old Glamis line, and the Old Bleach Linen Co. Ltd., for which Marion Dorn was a principal designer of woven and printed fabrics.

The delicate artistic style of Vanessa Bell and Duncan Grant translated well into the printed fabrics that they designed for Allan Walton. Although their Omega Workshops, devoted to the promotion of household furnishings painted with post-impressionistic designs, had closed in 1919, Bell and Grant continued their artistic efforts in a style that came to depend less on post-impressionism than on purely decorative appeal. From 1931 until the outbreak of World War II they introduced more than a dozen designs which exuded the 'cozy' character of English nineteenth-century printed fabrics.

In the 1920s Bell and Grant also designed needlepoint canvases which were successfully worked by Ethel Grant, Duncan Grant's mother, and the painter Mary Hogarth. These were shown in the 1925 independent gallery exhibition entitled "Modern Needle-work" and again in 1932 at the Victoria and Albert Museum. Two examples of their decorative commissions stand out from the remainder of their work in the 1930s. One is the Music Room exhibited at the Lefevre Gallery, London, in 1932 (8). Grant's "Grapes" design, with its bold repeat, was effectively the focal point of the room, cascading down the full height of the wall, at the same time serving as a backdrop to the seating arrangement composed of two slipper chairs and a large settee. The other was the uncompleted 1935 commission to design the lounge of the Cunard Liner, R.M.S. Queen Mary, which a company official considered too sophisticated for the average transatlantic traveler to which Cunard catered. Halfway through the project Grant was dismissed, with compensation.

VERTES, Marcel
1895-1962
Painter, graphic and poster artist
Born in Hungary. Established himself in the early 1920s as a poster artist in Vienna. Moved to Paris in 1925, where he produced two albums of lithographs portraying Parisian night life. Moved to the US in the late 1930s. In 1952 won Academy Awards for the set and costume designs for the film *Moulin Rouge*.

VINCENT, René
1879-1936
Poster and graphic artist, painter, ceramist
French-born, studied at the Ecole des Beaux-Arts, Paris. Became an illustrator for *La Vie Parisienne*, *L'Illustration* and *The Saturday Evening Post*, and designed posters for Au Bon Marché. Concentrated in the 1920s on poster design, especially for automobiles and fashion. In 1924 opened a studio

in Sèvres where he designed ceramics.

VOROS, Bela
b. 1899
Sculptor
Born in Hungary, and began as an apprentice to a cabinet maker. In World War I he got a job as a delivery boy for a pharmacy, whose owner was a sculptor. Voros began to assist him in his studio and then enrolled in the Ecole des Arts Décoratifs in Budapest. After World War I he studied with the Hungarian sculptor Strol, and began

Above Vally Wieselthier for the Wiener Werkstätte: "Spieldose," ("music box") printed silk, 1920s. Left Maria Likarz-Strauss for the Wiener Werkstätte: "Panath," printed silk, 1920s. Below Maria Likarz-Strauss for the Wiener Werkstätte: "Kurzola," printed silk, 1920s.

The team of Phyllis Baron and Dorothy Larcher (9), whose workshop was first at Hampstead and then in Gloucestershire, was responsible for the revival of interest in printed textiles. Their patterns ranged from Larcher's naturalistic interpretation of flowers traditionally associated with English chintzes, to Baron's simple, but bold, geometrics. Discharge printing, in which an acid was used to bleach out a pattern on a dyed ground in the manner of Indian calicoes, was one of their specialties. They were joined in 1925 by Enid Marx (10), who two years later established her own workshop, gaining wide acclaim in 1937 for her upholstery designs for the London Passenger Transport Board, and for her work for the Utility Design Scheme during World War II.

Paul Nash, who had trained as a painter, executed a variety of inventive modern designs for both printed textiles and rugs. Fabrics such as "Cherry Orchard" of 1933 show his interest in the conventionalization of naturalistic motifs. His "Fugue" design of 1936 presented a graphic, although abstract, interpretation of non-visual subjects. Nash's output, however, was never large, due both to his declining health and perfectionist tendencies. His refusal to relinquish artistic control of his designs was a result of his hostile attitude toward industrial design.

Marion Dorn, although better known for her Modernist sculpted carpets, created textile designs markedly influenced by her association with the graphic artist, Edward McKnight Kauffer. Her designs of the late 1930s were relatively simple and therefore inexpensive. One, "Aircraft," manufactured by the Old Bleach Linen Co. in 1938, was particularly well received and used in the interiors of the first-class lounge of the liner Orion.

No account of British textile development in the 1930s would be complete without mention of Ethel Mairet. Her interest in the

exhibiting. In 1925 he arrived in Paris, where he exhibited at the salons. From 1932-38 he lived in Nice, working with an ivory carver and modeling figurines and decorative objects. After World War II, he retired to Sèvres, devoting himself almost exclusively to his work.

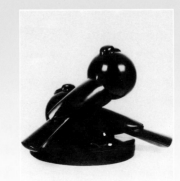

Voros: bronze group of two pigeons, 1926.

VYSE, *Charles*
1882-1971
Ceramist
Born in England to a family of Staffordshire potters, he and his wife Nell began making ceramic figures in 1919. He also experimented with oriental glazing techniques.

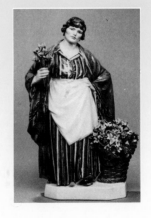

Vyse: "Daffodil Seller," pottery figure, 1920s.

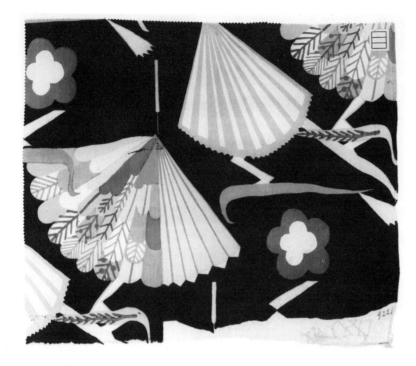

Above Mathilde Flögl for the Wiener Werkstätte: "Marchesa," printed silk, 1920s. Left Eduard Josef Wimmer for the Wiener Werkstätte: "Guinea," printed silk, 1920s. Opposite page Dagobert Pêche for the Wiener Werkstätte: bone lace panel, diameter 25in, about 1920. Relatively little lace work done by the Werkstätte exists today, but they did not ignore the centuries-old technique.

importance of the artisan, essentially a philosophy held over from the Arts and Crafts Movement, was developed in her Gospels weaving studios in rural Ditchling, Sussex, part of a larger community founded by the typographer Eric Gill. Her early weavings reflect her initial distrust of industrial procedures. Her encounters with other designers, in particular Gunta Stolzl, later convinced her that her idiosyncratic weaves would lose none of their character in the process of mass-production. The fabrics of the post-war era, beginning with the simple weaves of the Utility Design Panel, owed much to Mairet's dedication to weaving as both art and craft.

THE WIENER WERKSTÄTTE AND THE BAUHAUS

Elsewhere in Europe, the success of the textile division of the Wiener Werkstätte, established as a separate workshop in around 1910, led to the establishment of an independent retail outlet in 1917. Textiles and carpets were originally designed as part of an overall scheme for specific interiors only, the overriding principle of the Wiener Werkstätte's *Gesamtkunstwerk*, or creation of a total work of art.

Whereas early textiles and carpets designed by Josef Hoffmann and Koloman Moser, executed by Backhausen & Co., were rigidly geometric and almost invariably black and white, the Wiener Werkstätte textiles of the late 1910s and 1920s grew increasingly more colorful, employing whimsical decorative motifs characteristic of the workshops' later productions. In the United States, the Wiener Werkstätte of America, Inc., retailed textiles, including table linens, at their New York branch and through Marshall Field's in Chicago. Their fanciful lacework and embroideries combined traditional techniques with a brilliant use of color. Popular

W

WAGENFELD, Wilhelm
b. 1900
Glass and porcelain designer
Born in Bremen, Germany, and trained as a goldsmith. In about 1919 he entered the Bauhaus, where he concentrated on metalwork. From 1923-24 he designed lamps and tea services, and from 1926-30 the firm of Walter & Wagner produced a number of his designs for the Bauhaus. He started working with glass about 1927 and in

1930 began designing for the Jenaer Glaswerke and then the Vereinigte Lausitze Glaswerke. He also designed porcelain for the Fürstenberg (1934) and Rosenthal (1938) factories. In 1955 he resigned from the Deutscher Werkbund, of which he had been a member since 1925, believing that the organization designed only for the wealthy.

WALTER, Alméric
1859-1942
Ceramist and glassmaker
Born in France, worked for the Daum brothers in Nancy but established his own glass workshop in 1919. Some of his work in *pâte-de-verre* was done in collaboration with the painter and sculptor Henri Bergé.

decorative motifs included the whimsical patterns of Mathilde Flögl and the African-inspired geometry of Maria Likarz-Strauss, in addition to the eccentric "Spitzbarock" patterns of Dagobert Pêche, whose brilliant career was tragically cut short by his death in 1923.

Wallpapers were also produced for the Wiener Werkstätte by Salubra Werke and Flammersheim & Steinmann. Peche created a large selection of designs in 1919 and again, a year before his death, in 1922. One of these was selected as the catalogue cover to the Austrian design section of the 1925 Paris Exhibition. His colleague Maria Likarz-Strauss created a portfolio of wallpaper designs in 1925, and examples of Mathilde Flogl's work were included in the workshops' 1929 collection, three years before they were forced to close through bankruptcy.

The popularity of the Wiener Werkstätte's fanciful wallpaper patterns in this period was enormous. Literally thousands of patterns were produced by Josef Hoffmann, Dagobert Peche, Mathilde Flögl, Franz von Zülow, Ludwig Heinrich Jungnickel, Arnold Nechansky, and the Rix sisters, Kitty and Felicie. Hoffmann's designs in the mid-1920s simplified the enchanting herringbone and dash patterns of his pre-war style. Notwithstanding, the workshops' light-hearted designs in the 1920s reflected a digression from their original crusade for artistic reform. In their efforts to concede to what it conceived as popular taste, the Wiener Werkstätte compromised the very ideals for which they had originally stood.

In Germany, textiles were rescued from oblivion by the legacy of the Bauhaus. Weavers such as Gunta Stadler-Stolzl and Anni Albers, whose careers flourished in the post-World War II period, helped early to implement change in the field of textile design and production. In fact, much of the textile industry after the war owed

its success to the goal of the Bauhaus designers to develop prototypes for industry. Focusing on materials, the decorative effect of each fibre was judged both by its properties of colour and texture, and its ability to convey 'tactility'. Material was given preference over all other factors as the key to successful industrial production.

Gunta Stadler-Stolzl single-handedly directed the Bauhaus weaving workshop from 1926 to 1931, and it was through her talent and guidance that the mass-production of Bauhaus designs

WALTERS, *Carl*
1883-1955
Painter and ceramist
Trained and worked as a painter until nearly 40, then taught himself ceramics, building his own studio and kiln at his home in Woodstock, New York, and creating his own glazes whenever possible. He produced essentially decorative sculptures, especially colorful and humorous animals. His entries at the 1933-34 Century of Progress Exposition in Chicago — a bull and a warthog — brought wide acclaim for their "pleasing unity of basic form, surface modeling, and glaze texture."

Walters: pottery figure of a horse, about 1930.

WALTON, *Allan*
1891-1948
Textile manufacturer
British-born, trained in a London architect's office, became director of Allan Walton Textiles and helped promote modern design through his commissions of contemporary artists to design fabrics.

became a reality. The workshop's early designs demonstrated an affinity for color reminiscent of the work of Paul Klee, whose teachings helped to free the Bauhaus artists from their lingering pre-war notions concerning the application of conventional pattern and ornament. Klee espoused the belief that art should be not merely a superficial imitation of things found in nature, but an attempt to follow the actual process of their growth.

Beyond the Bauhaus, the Modernist idiom was pursued by many German textile designers, including Edith Eberhart, whose style is reminiscent of Stadler-Stolzl's; Marie Hannich, who designed powerful images of boats, cars and buildings rendered in rigid geometrical patterns; Richard Herre; Martha Erps, and Hedwig Keckemann.

BELGIUM AND SCANDINAVIA

Modernist Belgian fabric designers appear to have been inspired mostly by their German neighbors in their choice of a muted palette. Jaap Gidding and Paul Haesaerts, at the Studio de Saedeleer, produced linens and tapestries decorated with Peruvian Indian and tribal African motifs on geometrical grounds. At the Vanderborght frères mill, Sylvie Feron created dynamic geometrical patterns composed of overlapping triangles, zigzags and small squares. For the 1925 Exposition, Darcy designed roller-printed wallpaper with geometrical and fanciful floral patterns on a pale ground for the Société des Usines Peters-Lacroix.

Abstract Modernist art made inroads into the Scandinavian textile industry in the 1920s and 1930s. This was most prominently felt in the traditional form of weaving, the *ryijy*, or *rya* rug. In textiles, however, emphasis was on structure, an inspiration drawn from the work of the Bauhaus weavers. In Denmark, Marie Gudme-

Leth proved an exception to this rule. One of the few to establish a name for herself in printed textiles in the 1930s, she became dissatisfied with the labor involved in block printing, turning in 1934 to the less costly screen process. This enabled her to mass-produce her designs through the Dansk Kattunkrykkeri, which she founded in 1935. Leth's work included representational motifs printed in intense monochromes on a ground bleached to reveal its structure. Characteristic were folk patterns of buildings and animals which depicted the changing industrial landscape of Denmark against a stark white ground **(11)**.

At the 1925 Exposition, examples of modern Swedish fabric design were exhibited in the Grand Palais. Included were examples by Märta Måås-Fjetterström and Maja Andersson, weavers for the Föreningen För Svensk Itemslöjd. Plant and animal motifs were mixed with geometric patterns in a slightly primitive style **(12)**.

THE UNITED STATES

On the other side of the Atlantic, Americans, like the British, were slow to accept the modern French aesthetic, but once they had done so, proceeded with remarkable ability. While the acid colors of the early French designers were initially perceived as too bold for the conservative American public, the inclusion of French textiles at exhibitions at The Metropolitan Museum of Art, New York, in 1926, and the New York department stores from 1928, led to the gradual understanding that Modernism was more than a short-lived fancy, and that American manufacturers might soon be left behind if they did not offer at least a modest selection of designs in the idiom.

There was only a handful of specialist textile designers of note in the United States at the time: Henriette Reiss, Zoltan Hecht and, at

WARNECKE, *Heinz*
1895-1983
Animalier sculptor
Born in a farming district near Bremen, Germany, and was early drawn to animals as subjects. He trained in his native country, and during World War I was sent to Bucharest to serve on the commission for war memorials. After the war he was awarded a master studio in the Kunstgewerbemuseum where he developed a personal technique

for carving wood and brass, but he found it difficult to make a living in post-war Germany, and in 1923 emigrated to the US, where in the late '20s and '30s he produced the animal carvings of boar, monkeys, pelicans and bears for which he is best known. In 1942 he moved to Washington, DC, where he headed the sculpture department at the Corcoran School of Art.

WAUGH, *Sidney*
1904-63
Glass designer
Born in the US, studied at the Massachusetts Institute of Technology and at the Ecole des Beaux-Arts in Paris under Henri Bouchard. From 1928-29 he earned bronze and silver medals at the Salon du Printemps in Paris and was awarded the Prix de Rome. He became Chief Associate Designer for Steuben Glass from 1933 until his death,

Cranbrook where her husband was the director, Loja Saarinen. Small firms which added Modernist lines to their traditional repertoire included Nancy McClelland and M. H. Birge & Co.

Members of the three organizations staging exhibitions staged in New York in the late 1920s and early 1930s to promote the Modernist movement – the American Designers' Gallery, Contempora and the American Union of Artists and Craftsmen (AUDAC) – designed carpets for their up-to-the-minute interiors. Included were Herman Rosse, Pola and Wolfgang Hoffmann, Eugene Schoen, Joseph Urban, Henry Varnum Poor and Donald Deskey. For the execution of their fabrics, these designers resorted, in most part, to small rural weaving communities such as the New England Guild, the Connecticut Handicraft Industry, the New Age Workers, or the Contemporary American Artists' Handhooked Rugs Guild. The large textile mills, such as Orinoka Mills, Robert McBratney, Lester-Whitman & Co., Lehman Connor, Stead & Miller, and Dupont-Rayon, were reluctant to commit themselves to the execution of such unique or limited orders.

The Hungarian emigrant sisters, Ilonka and Mariska Karasz (13), successfully integrated traditional folk-art motifs with the exuberance of the new palette. Their needlework was executed in colors and patterns somewhat reminiscent of the Fauves, Ilonka, who also designed ceramics, silver and furniture, served as the designer, while Mariska executed the designs. Another folk-inspired American artist was Lydia Bush-Brown, who revived the batik technique in a blend of stylized Middle-Eastern and modern motifs. In tapestry wall-hangings, Lorentz Kleiser and Marguerite Zorach emerged as the USA's pioneer Modernist designers.

The work of Ruth Reeves reflected the continuing search in America for a native vernacular appropriate to modern decoration.

Above Evelyn Wyld: wool carpet, 3ft 10in×4ft 5in, 1930s. A rare carpet from the hand of this designer, whose richly textured and costly weaves were featured by Eileen Gray's Jean Désert Gallery before she formed a partnership with the Modernist Eyre de Lanux. **Right** Frank Brangwyn for James Templeton & Co: wool carpet, about 1930. The subdued motifs woven into this carpet reflect the more conservative tradition of the British textile industry around 1930.

and his glass for this company, characterized by superior engraving, has been included in almost every major museum.

Waugh for the Steuben Glass Company: "The Venus Vase," engraved glass, 1935.

WEBER, *"Kem" (Karl Emanuel Martin)*
1889-1963
Industrial designer
German-born, apprenticed to Eduard Schultz, Potsdam's Royal Cabinetmaker, and studied under Bruno Paul from 1908-10. Went to San Francisco in 1914 to assist in the architectural work on the German pavilion at the Panama-Pacific Exposition, and was trapped by the outbreak of war. He failed to earn a living as an

interior designer, and settled finally in Los Angeles, where he joined the design studio at Barker Bros. In 1927 he opened a studio in Hollywood, listing himself as an industrial designer, and within a year was fully

launched. His style was extremely distinctive, and he was the only designer on the West Coast to embrace Modernism.

Weber for Lawson Time Inc: digital clock, about 1932.

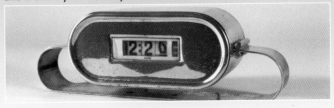

Her association with Fernand Léger in the 1920s in Paris left a firm imprint of Cubism on both her woven and printed designs. In 1930 the department store W. & J. Sloan exhibited 29 of her designs **(14)**, signifying the confidence that American firms were beginning to show in the economic viability of the new style. "Figures with Still Life," "Manhattan" and "Electric" show Reeves' interest in the vigorous inter-relationships of geometric forms. Among her most successful works was the repeating abstract design which she conceived for the carpets in Radio City Music Hall. Reeves translated her designs into roughly a dozen different types of fabric, including chintz, monk's cloth, voile, velvet and muslin.

Donald Deskey, America's foremost Modernist designer of the period, designed textiles which exhibit his fascination with asymmetrical geometric forms **(15)**. The photographer Edward Steichen produced a unique range of silks for the Stehli Silk Company in which everyday objects lit from various angles were reproduced photographically in black and white.

By 1930 the modern textile movement had settled into its stride in the United States, its tenet being simplicity of form and color. No finer example of this simplicity was provided than a printed linen fabric, in three complementary hues of yellow, by Jules Bouy.

RUGS AND CARPETS

In the 1920s, rugs provided a decorative accent to the lavish interiors of the Paris *ensembliers*. Maurice Dufrêne, Paul Follot, Süe et Mare, Emile-Jacques Ruhlmann, Jules Leleu, René Gabriel, Fernand Nathan, Francis Jourdain and André Groult, among others, designed carpets to complete their decorative schemes. Toward the end of the decade, rugs took on the added importance of providing the only element of warmth and ambience in the austere

metal-dominated interiors presented by Pierre Chareau, Djo-Bourgeois and René Herbst at the initial exhibitions of the Union des Artistes Modernes.

Modernist fabric designers and manufacturers turned their hand to rugs and carpets with equal facility, generating the same selection of floral, abstract and geometric patterns. Contemporary literature reveals a host of fresh designs by Aubusson (Edouard Bénédictus, Paul Véra, Henri Rapin, P. Deltombe and L. Valtat); Myrbor (Louis Marcoussis and Jean Lurçat); La Maîtrise (Maurice Dufrêne, Jacques Adnet, Suzanne Guiguichon and Mlle Marionnée); the Atelier Martine (Raoul Dufy); Pomone (Paul Follot); D I M (Dresa); Primavera (S. Olesiewicz); Süe et Mare (Paul Véra and André Mare), and Pierre Chareau (Jean Lurçat and Jean Burkhalter). Other designers of merit appear to have worked independently: Marcel Coupé, Jacques Klein, Mlle Max Vibert, Elise Djo-Bourgeois, Maurice Matet, Boderman, Raoul Harang, J. Bonnet and Mme S. Mazoyer.

As in fabric design, French artists occasionally applied their talents to carpets, mixing abstract and Cubist painterly styles. Noteworthy were Louis Marcoussis and Fernand Léger. Marie Laurencin likewise translated her lively floral compositions into carpet designs. The finest carpets were hand-knotted (*à la point noué*). As synthetic fibers made their entry into the medium, experimental pieces in cellulose and vegetable fibers, and new washable linen materials, were shown at the Paris salons.

The most successful rug and carpet designs in Paris were those of Ivan da Silva Bruhns, many manufactured by the famed Savonnerie works. Drawn to Berber and Moroccan textiles shown in Paris during and immediately after World War I, da Silva Bruhns' early works borrowed also at first from American Native motifs. From

WENDE, *Theodore*
1883-1968
Silversmith
Born in Berlin, apprenticed in gold- and silversmithing and then studied drawing in Hanau and at the Kunstgewerbeschule in Berlin. He began working for Ernst Ludwig von Hessen at the Darmstadt artists' colony in 1913, and in 1921 began work for the Arts and Crafts School in Pfotzheim, where he was made a professor. He was awarded the

"Ring of Honor" by the Goldsmith's Association. Much of his work was traditional in nature, but he also designed a number of pieces, especially tea and coffee services, with strikingly original shapes.

WIESELTHIER, *Valerie "Vally"*
1895-1945
Ceramist
Born in Vienna. Her colorful and carefree style, nurtured under Josef Hoffmann at the Viennese Kunstgewerbeschule and then at the Wiener Werkstätte, came to fruition at the 1925 Paris Exposition. She moved to the US in 1929, joined the Contempora group, and later designed for the Sebring Pottery in Ohio. She created a wide

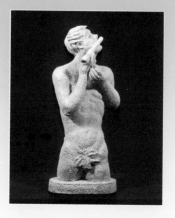

the mid-1920s, however, his style evolved into a powerful Cubist-inspired form of geometry. His preferred palette included beige, rust, ocher and gray tones. Cubism also played a role in the Modernist designs of Hélène Henri, who was retained by François Jourdain and the architects Robert Mallet-Stevens and Pierre Chareau.

Irish-born Modernist Eileen Gray (16) also used carpets to relieve the severity of her austere Modernist interiors. Her crisp angular designs, executed by a studio under the direction of Evelyn Wyld, were displayed at annual salons and through her gallery, Jean Désert. A notable example is Gray's "Blackboard" rug, which dates from around 1927, the year Wyld left her employ to work with another Modernist, Eyre de Lanux, with whom she collaborated in the design of interiors, a number of which were exhibited at the salons in the late 1920s and early 1930s, at which point the Depression forced the closure of the studio. Invariably creative, the Maison Desny introduced carpets similar in design to those of Gray to complement its metal furniture and light fixtures.

In Britain, rugs and carpets were retailed by a number of decorating firms which espoused a subdued and comfortable Modernism popular in the 1930s. The geometric rugs of graphics designer Edward McKnight Kauffer were manufactured by the Royal Wilton Carpet Factory and Edinburgh Weavers. These were retailed through Curtis Moffat's short-lived Fitzroy Square galleries, and used in interiors by David Pleydell-Bouverie and Raymond McGrath. Betty Joel, who initially used rugs designed by Ivan da Silva Bruhns, later designed her own models (17). These, an extension of her own understated furnishings, were woven in China and retailed by her own firm, Betty Joel Ltd. Similarly, Ronald Grierson had his fanciful designs woven in India and retailed at the

Above Ivan da Silva Bruhns: wool rug, 12ft 8in×9ft 6in, about 1928. Many of Bruhns' rugs comprised strong geometric forms punctuated with rows of dots or linear devices reminiscent of industrial components. The use of such decoration prevented such rugs from "disappearing" into the sometimes rather bland or over-upholstered interiors of the 1930s. **Right** Marion Dorn: wool carpet, 3ft 9½in×4ft 10½in, about 1930. Uncompromising non-representational motifs from the decorative vocabulary of Marion Dorn, nicknamed "the architect of floors." Her rugs show a masterful integration of scale and texture.

selection of ceramic figures, masks, tableware items, mannequins and busts, examples of which were shown by both Contempora and AUDAC as well as in national ceramic exhibitions.

Wieselthier: terracotta figure of Pan, 1940s.

WILDENHAIN, Marguerite Friedlander
b. 1896
Ceramist
Born in France and studied in Berlin at the School of Fine and Applied Arts. In 1919 she joined the Bauhaus in Weimar. Her most noteworthy designs were for the Berlin manufactory. She emigrated to the US in the late 1930s.

WRIGHT, Russel
1904-76
Ceramics, furniture and pewter designer
Born in the US, entered Princeton in 1923 but left the following year to pursue a growing interest in theater design. He began selling modeled caricatures to shops in 1930 and designed his first spun-pewter accessories in 1931. Best known for his design of "American Modern" crockery (1939), he

also designed furniture and decorative accessories for a short-lived program called "American Way," and developed an experimental program for national park activities in America called "Summer in the Parks."

Redfern Gallery. Ashley Havinden's delicate calligraphic carpets were sold through Duncan Miller. At the same time Francis Bacon designed carpets to complement his own interior schemes. In 1930, Sir Frank Brangwyn, who combined nineteenth-century and Modernist elements, designed carpets for James Templeton in a highly decorative style reminiscent of his panels symbolizing the riches of the British Empire in the House of Lords.

The expatriate American, Marion Dorn, whose carpets were sold through Fortnum & Mason, earned the nickname "architect of floors." Her lifelong association with Kauffer gave her career a boost. Beginning in the early 1920s with designs for batik fabrics, her first collaborative efforts with Kauffer were executed by Chelsea weaver Jean Osage. In 1929, their designs for Royal Wilton were exhibited at the galleries of Arthur Tooth & Son, Ltd. Dorn's skillful integration of varied piles added textural interest to Kauffer's brilliant geometric patterns. Her rugs echoed the decorative architectural features of the interiors that still grace Oswald Milner's Claridge Hotel (1935), and added a dramatic note to subdued interiors created by Brian O'Rorke for the R.M.S. *Orion*.

Most Scandinavian weavers created hangings and *ryijy*, or *rya*, rugs in small studios. Motifs were derived from native, particularly Finnish, folk motifs, some of which in the 1920s were Cubist-inspired. Texture continued to play an important part, especially as a heavy pile was required to provide warmth and comfort.

Among the most noteworthy Swedish tapestry and textile weavers was Marta Maas-Fjetterström, whose work typically combined the traditions of native handicraft and Middle-Eastern patterns to create flat-woven rugs of a distinctive character. The Finnish artists Marianne Strengell and Greta Shogster-Lehtur integrated *rya* motifs into native textiles. Hannah Ryggen was

Above Jules Leleu: wool carpet, 3ft 9in×2ft 5in, about 1930. This sculptural effect probably dates from the 1930s when such a scale would have harmonized well with the Modernist interiors. **Above right** Jules Leleu: wool carpet, 10×12ft, 1920s. **Right** Marion Dorn: tufted wool rug, 1930s. The clever *entrelac* motif reflects Dorn's geometric style, which was certainly influenced by her association with the graphic artist Edward McKnight Kauffer. **Opposite page** Ivan da Silva Bruhns: wool rug, 7ft 6in×12ft, about 1930. The intricate patterns of Bruhns' early work derive from a variety of ethnic traditions. Seen here is a ground of North African or American Indian inspiration within a modified Greek key border.

ZACH, *Bruno*

Sculptor

There is little information on the life of this Austrian sculptor, best remembered for his erotic figures of cabaret dancers and 'lounge lizards'. Most of his sculptures depict women with chiseled features wearing costumes emphasizing their bodies and sexuality, such as leather suits and high heels.

ZEISEL, *Eva Stricker*

b. 1906

Ceramist

Born in Hungary, apprenticed to potter Jakob Karapancsik in 1924, and began her own pottery at the age of 18, her first serial production designs being for Kispester Pottery (1926). She emigrated to the US in 1938. Her most prominent design was for the Museum Service for Castleton China (1942-45), in the then-popular organic style.

another notable figure in Scandinavian fabrics of the period. Born in Sweden and trained as a painter, she settled in Norway in 1924, devoting the rest of her career to weaving. Her "Tapestry: Fog Fishes" of 1938 incorporated her technique of interweaving flat tapestry into *ryijy* rugs enhanced with *rya* knots. Finnish-born Impi Sotavalta also worked in the *ryijy* technique, employing strong abstract geometric designs to short-piled rugs.

In the United States, three specialized exhibitions helped to stimulate modern carpet design: At the Art Center, New York (1928); the Newark Museum (1930), and The Metropolitan Museum of Art, New York (1931) European designers were seen by the American public for the first time. The quiet symmetry of the German designers (Bruno Paul, Ernest Boehm and Wilhelm Poetter) was contrasted with the more spontaneous and colorful works of Edward McKnight Kauffer and Marion Dorn.

The Cranbrook Academy, north of Detroit, played an important role in the dissemination of Scandinavian ideals to a generation of American weavers whose work came to prominence after World War II. Rugs and decorative hangings were seen as an extension of the *Gesamtkunstwerk* concept of the interior as a total environment. Loja Saarinen's weaving studio was established in October 1928 to complete special commissions, and in 1929 a weaving department was founded, staffed with Swedish expatriates, to execute commissions by architects and designers such as Frank Lloyd Wright. Loja Saarinen's style, and indeed Cranbrook's weaving style in general, was marked by a restrained palette and an absence of either sharp geometry or purely representational motifs. When US mills such as Stephen Sanford & Sons and Bigelow Hartford finally became convinced that the modern idiom was more than a fad, they commissioned designers such as Ralph Pearson, T.

Betor and Pola Hoffmann to work in a mode largely derivative of the European Modernists. There was also a market in America for rugs woven in China with subdued patterns.

ZORACH, *William*
1887-1966
Sculptor and painter
Russian by birth, but moved to the US in 1894. He began his art training at the age of nine, working as an errand boy and later as an apprentice lithographer while attending the Cleveland School of Art at night. In 1907 he moved to New York, and from 1910-11 he lived in France. He exhibited paintings in Paris, Cleveland and New York until 1916. In 1917 he carved the first sculptural work he had done since boyhood, and by 1922 he had given up painting altogether in favor of sculpture. He became one of the leaders in the revival in America of direct carving in both various woods and stone, and also cast his models in bronze.

Zorach: "Rhythm," aluminum figure in Radio City, New York.

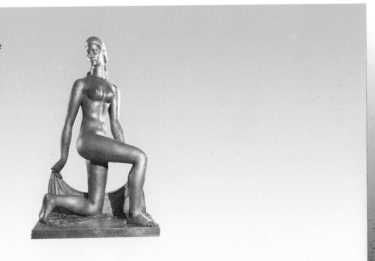

SELECT BIBLIOGRAPHY

Select bibliography

The books and magazines listed below contain illustrations of many of the Art Deco buildings and objects discussed in the book. The numbers given here correspond to those in the text.

ARCHITECTURE

1 G. Henriot, *Nouvelles Devantures et Agencements de Magasins*. Ch. Moreau (ed.) Paris: n.d.

2 *Art et Décoration*, no. 47, 1925; *Encyclopédie des Arts Décoratifs et Industriels Modernes au XXième Siècle* (12 vol. edition), Vol II, Office Central d'Editions et de Librairie, Paris: n.d.

3 *Encyclopédie des Arts Décoratifs et Industriels Modernes au XXième Siècle, op. cit.*, Vol II

4 Marcus Whiffen and Carla Breeze, *Pueblo Deco*, Albuquerque, 1983

5 Edgar Tafel, *Years with Frank Lloyd Wright, Apprentice to Genius*, New York 1979

6 *The American Architect*, September 1927, May 1931

7 *Architecture*, October 1934, September 1930

8 *The American Magazine of Art*, August 1932, no. 2

9 *The Studio*, May 1933; *Architectural Forum*, May 1931; *Design*, February 1934

10 *Architectural Forum*, July 1932

11 Laura Cerwinske, *Tropical Deco, The Architecture and Design of Old Miami Beach*, New York, 1981

12 Lynne M. Appleton and Bruce London, *Miami Beach's Art Deco Buildings: Resources for Recycling, Urban Resources*. Vol. 2, Miami

13 Anne Lee, The Chicago Daily News Building, *Architectural Form*, January 1930; *Architecture*, January 1930

14 *The Metal Arts*, Vol II, no. 3, April 1929

15 *Architectural Forum*, June 1933; *Fortune*, June 133; S. March, Cincinnati, n.d.

16 *Metalcraft*, February 1930; *The American Architecture*, May 1931

17 *Tulsa Art Deco*, The Junior League of Tulsa, Inc., Tulsa, 1980

18 *Metalcraft*, February 1930; *The American Architect*, May 1931

19 *Eastern-Columbia Building*, Cultural Heritage Board, Los Angeles

20 *Metalcraft*, November 1930; *Progressive Architecture*, November 1982

21 *Metalcraft*, August 1930

22 *Architecture*, October 1934

23 *American Architecture*, July 1932

24 *Architecture*, November, 1929

25 *The American Architect*, December 1929

26 *American Architecture*, April 1928

SCULPTURE

1 Victor Arwas, *Art Deco*, Harry N. Abrams Inc., New York, 1980

2 Katharine Morrison McClinton, *Art Deco: A Guide for Collectors*, Clarkson N. Potter, Inc., New York, 1972

3 Bryan Catley, *Art Deco and other Figures*, Chancery House Publishing Co. Ltd, London 1978; Victor Arwas, *Art Deco Sculpture: Chryselephantine Statuettes of the Twenties and Thirties*, St Martin's Press, New York, 1975

4 Bryan Catley, *op. cit.*

5 Victor Arwas, *Art Deco Sculpture... op. cit.*

6 Victor Arwas, *Art Deco*

7 *Catalogue Général Officiel: Exposition des Arts Décoratifs et Industriels Modernes*, Paris, April-October 1925, Pavillon 1-115

8 Donald Karshan, *Csaky*, Depot 15, Paris, 1973

9 *Encyclopédie des Arts Décoratifs et Industriels Modernes au XXìeme Siècle*. (The 12 volumes are filled with photographs of the 1925 Exposition)

10 Michele Bogart, "American Garden Sculpture: A New Perspective," The Parrish Art Museum; *Fauns and Fountains: American Garden Statuary, 1890-1930*, Southampton, New York, April 14-June 2, 1985

METALWORK

1 Graham Hughes, *Modern Silver*, Crown Publishers, New York, 1967

2 G. Brunon Guardia, *Art et Décoration*, 1934, pp 419-422

3 Henri Clouzot, *Mobilier et Décoration*, July-December 1931

4 G. Brunon Guardia, *op. cit.*

5 G. Brunon Guardia, *op. cit.*

6 Graham Hughes, *op. cit.*

8 Charles H. Carpenter Jr., *Gorham Silver 1831-1981*, Dodd, Mead & Co., New York

9 Jean Lort, *Mobilier et Décoration*, April/May 1923

10 Raymond Cogniac, "Les Portes et la Ferronerie," *Art et Décoration*, December, 1931

11 Jean Locquin, "Edgar Brandt et la Maison d'un Ferronnier," *Art et Décoration*, March 1921

12 Pierre Olmer, *Mobilier et Décoration*, 1921-22

13 Jean Lort, *Mobilier et Décoration*, April/May 1923

14 Georges Denainville, *Mobilier et Décoration*.

15 G le C, *Mobilier et Décoration*.

16 Fabien Sollar, *Les Echos d'Art*, 1932

17 Christopher Wilk, "Furnishing the Future: Bentwood and Metal Furniture 1925-1946," *Bentwood and Metal Furniture 1850-1946*, Derek Ostergard (ed.), The American Federation of the Arts, 1987

JEWELRY AND ACCESSORIES

1 Graham Hughes, *Modern Jewelry: An International Survey 1890-1960*, New York, 1968

2 Anne Ward, John Cherry, Charlotte Gere, and Barbara Cartlidge, *Rings Through the Ages*, New York, 1981

3 Marie-Noel de Gary, *Les Fouquet Bijoutiers & Joailliers à Paris 1860-1950*, Paris 1983

4 *Vogue*, December 1929

5 Mellissa Garbardi, *Les Bijoux de l'Art Deco aux années 40*, Paris, 1986.

6 Melissa Garbardi, *op. cit.*

7 Henri Clouzot, "Reflexions sur la Joaillerie 1929", *Le Figaro Supplément Artistique*, July 1929

FURNITURE AND INTERIOR DECORATION

1 Charles Saunier, "le 5ème Salon de la Société des Artistes Décorateurs," *Art et Décoration*, no. 27, 1910

2 M.P. Verneuil, "L'Art Décoratif aux Salons," *Art et Décoration*, July-December 1913

3 *Art et Décoration*, July-December 1912; *Art et Décoration*, July-December 1913

4 Florence Camard, *Ruhlmann*, Editions du Regard, Paris 1983

5 Léon Rosenthal, "Le Paquebot Paris," *Art et Décoration*, no. 40, 1921

6 *Vogue* (American edition), August 1929

7 Ruhlmann's work appeared in almost every issue of *Art et Décoration* from about 1915. Among the most important articles are: Jean Laran, "Notre enquête sur le mobilier moderne," no. 37, 1920; J.-E. Ruhlmann: Charles-Henri Besnard, "Quelques nouveaux meubles de Ruhlmann," no. 45, 1924; Gaston Varenne, "Un ensemble de Ruhlmann à la chambre Commerce de Paris," no. 53, 1928; and "Ruhlmann, Oeuvres dernières," no. 63, 1934

8 Wilhelm Lotz, "German Furniture of the Twentieth Century," *Good Furniture Magazine*, no. 31, November 1928

9 David R. McFadden, *Scandinavian Modern Design*, Harry N. Abrams, New York, 1982

10 John Gloag, *The English Tradition in Design*, Adam & Charles Black, 1959; Fiona MacCarthy, *A History of British Design 1830-1970*, George Allen & Unwin, 1979

11 Fiona MacCarthy, *British Design since 1880: a Visual History*, Lund Humphries, 1982

12 *British Art and Design 1900-1960*, Victoria & Albert Museum, 1983; R. Gordon Stark, "The Furnishing & Decoration of a Medium Office," *The Architectural Review*, July 1930

13 *British Art and Design 1900-1960*

14, 15 McFadden, *Scandinavian Modern Design 1880-1980*

16 *British Art and Design 1900-1960*

17 Fiona MacCarthy, *British Design since 1880*; Derek Ostergard, *Mackintosh to Mollino*, Barry Friedman Ltd., NY, 1984

18 Alastair Duncan, *American Art Deco*, Harry N. Abrams, Inc., New York, 1986

19 Karen Davies, *At Home in Manhattan: Modern Decorative Arts, 1925 to the Depression*, Yale University Art Gallery, New Haven 1983; Joseph Downs, "Buffet in the Contemporary Style," *Pennsylvania Museum Bulletin*, no. 24, March 1929

20 Alastair Duncan, *American Art Deco op.cit.*; Louise Bonney, "New Metal Furniture for Modern Schemes," *House and Garden*, no. 57, April 1930

21 David A. Hanks with Jennifer Toher, *Donald Deskey: Decorative Designs and Interiors*, E.P. Dutton, New York, 1987

22 Karen Davies, *At Home in Manhattan*, op. cit.

LIGHTING

1 Eugene Chute, "Modern Decorative Light Sources," *Architecture*, August, 1931
2 Raymond Cogniat, "Boris Jean Lacroix," *Art et Décoration*, 1933

TEXTILES

1 "Art Deco Fabrics," *Musée Historique des Tissus*, Lyon
2 Fabrics of the period were featured regularly in the journals *Art et Décoration* and *Mobilier et Décoration*
3 Luc Benoist, "Les Tissus de Sonia Delaunay," *Art et Décoration*, July-December 1926; Robert J. Buck, *Sonia Delaunay: A Retrospective*, Albright-Knox Art Gallery, Buffalo, 1979; Arthur Allen Cohen, *Sonia Delaunay*, Harry N. Abrams, Inc., New York, 1975
4 Raymond Cogniat, "Tapisseries pour notre temps," *Art et Décoration*, 1937
5 H.A. Martine, "Les Cartons de Charles Dufrène, Pour un Meuble en Tapisserie," *Art et Décoration*, July-December 1926
6 Bruno Foucart, *Normandie: Queen of the Seas*, Vendôme Press, New York, 1985
7 Donald King, *British Textile Design in the Victoria and Albert Museum; Victorian to Modern (1850-1940)*, Gakken Co., Ltd, Tokyo 1980
8 Anscombe, *Omega and After: Bloomsbury and the Decorative Arts*, Thames and Hudson, London, 1981
9 *Hand Block Printed Textiles by Phyllis Baron and Dorothy Larcher*, exhibition catalog, Crafts Study Centre, Bath, 1978
10 *Edith Marx, A Retrospective Exhibition*, Camden Arts Centre, London, 1979
11 David R. McFadden, *Scandinavian Modern Design, 1880-1980*, Harry N. Abrams, New York, 1982
12 Erik Wettergren, *The Modern Decorative Arts and Crafts of Sweden*, The Malmö Museum, Stockholm and the American Scandinavian Foundation, New York, 1926; Dr Nils G. Wollin, *Modern Swedish Arts and Crafts in Pictures*, Charles Scribner & Sons, New York, 1931
13 Louise Bonney, "Modern Fabrics," *Good Furniture & Decoration*, November, 1929; Louise Bonney, "Modern Fabrics and the American Manufacturer," *Good Furniture & Decoration*, February, 1930
14 "Exhibition of Contemporary Textiles," exhibition catalog, W. & J. Sloane, New York, December 1930; *The American Magazine of Art*, January 1931; "Cotton Printing, a Note of Progress," *Good Furniture & Decoration*, December 1930
15 David A. Hanks with Jennifer Toher, *Donald Deskey, Decorative Designs and Interiors*, E.P. Dutton, New York, 1987
16 J. Stewart Johnson, *Eileen Gray Designs, 1879-1976*, Debrett's Peerage for the Museum of Modern Art, New York, London, 1976
17 David Joel, *Furniture Design Set Free: The British Furniture Revolution from 1851 to the Present Day*, J.M. Dent & Sons Limited, London, 1969

PAINTINGS, GRAPHICS AND BOOKBINDING

1 Alain Lesieutre, *The Spirit and Splendour of Art Deco*, Paddington Press, London, 1974
2 Yvonne Brunhammer, *1925*, Les Presses de la Connaissance, Paris 1976
3 The contents of the Icart atelier, including a selection of etchings, oils, watercolors, drawings, sculpture and memorabilia, sold at auction at Christie's East, New York, on March 30, 1983 (auction catalog, no. 5301)
4 Ernest de Creuzat, *La Relieure Française de 1900 à 1925*, vol. 2, 1926
5 Henri Mouron, *A.M. Cassandre*, Rizzoli, New York, 1985; Robert K. Brown & Susan Reinhold, *The Poster Art of A.M. Cassandre*, E.P. Dutton, New York, 1979
6 Patricia Frantz Kery, *Art Deco Graphics*, Harry N. Abrams, Inc., New York, 1986, p. 72
7, 8 Patricia Frantz Kery, op. cit.
9 *Art et Décoration*, no. 43, 1923; Léon Deshairs, *Les Arts Décoratifs Modernes 1918-1925*, Paris 1925
10 Ernest de Creuzat, op. cit.
11 Ernest de Creuzat, op. cit.
12 Alastair Duncan, *American Art Deco*, Harry N. Abrams, Inc., New York, 1986
13 Charles Spencer, *Erté*, Clarkson N. Potter, Inc., New York, 1970; Erté, *Things I Remember* (autobiography), Quadrangle, New York, 1975

GLASS

1 Dan Klein, "Glass Between the Wars," *The History of Modern Glass*, Orbis Publishing Ltd., London, 1984
2 Guillaume Janneaur, "Introduction a l'exposition des arts décoratifs," "La section française: conclusion," *Art et Décoration*, nos. 47 and 48, 1925 and *Art et Décoration*, no. 48, 1925
3 "Le XVIIIe salon des artistes décorateurs,' *Art et Décoration*, 53, 1928; Jean Galotti, "Une artiste de verre: Henri Navarre," *Art et Décoration*, no. 61, 1932
4 Yvanhoë Rambosson, "George Dumoulin verrerier," *Art et Décoration*, no. 53, 1928
5 "La section française: conclusion," *Art et Décoration*, no. 48, 1925
6 Léon Rosenthal, "Le paquebot Paris," *Art et Décoration*, no. 40, 1921
7 Nino Frank, "André Hunebelle," *Art et Décoration*, no. 59, 1931
8 Léon Deshairs, "Les verreries d'Orrefors," *Art et Décoration*, no. 49, 1926
9 Robert Linzeler, "Les verreries de Cappellin et Venini," *Art et Décoration*, no. 43, 1923
10 Carl U. Fauster, *Libbey Glass Since 1918*, Len Beach Press, Toledo, Ohio, 1979
11 Alastair Duncan, *American Art Deco*, Thames & Hudson, London, 1986
12 Wily Boesiger (ed.), *Le Corbusier*, Praeger Publishers, New York, 1972
13 Gaston Varenne, "Le mobilier et l'art décoratif," *Art et Décoration*, no. 40, 1921
14 Gaston Varenne, "Quelques aspects nouveaux de l'art du vitrail," *Art et Décoration*, no. 49, 1926; Louis Cheronnet, "Le ive salon de l'union des artistes modernes," *Art et Décoration*, no. 62, 1933
15 Raymond Cogniat, "La maison de verre de Pierre Chareau," *Art et Décoration*, no. 63, 1934
16 "Le premier salon de l'union des artistes modernes," *Art et Décoration*, no. 58, 1930
17 Dan Klein, *The History of Modern Glass*, Orbis Publishing, London, 1984

18 *Garden and Home Builder*, no. 48, July, 1928
19 Karen Davies, *At Home in Manhattan: Modern Decorative Arts 1925 to the Depression*, Yale University Press, New Haven, 1983
20 Karen Davies, op. cit.

CERAMICS

1 Henry Sandon, *Royal Worcester Porcelain from 1862 to the Present Day*, Barrie & Jenkins, London, 1973
2 *Encyclopédie des Arts Décoratifs et Industriels Modernes au XXième Siècle*, Office Central d'Editions et de Librairie, Paris 1925
3 Henri Clouzot, *André Metthey, décorateur et céramiste*, Librairie des arts décoratifs, Paris
4 Tamara Preaud, *Ceramics of the Twentieth Century*, Rizzoli, New York, 1982
5 Guillaume Janneau, "L'Art décoratif moderne: Emile Decoeur," *La Connaissance*, 1923; Anne Lajoin, "La Ceramique en France de l'Exposition des Arts décoratifs aux années d'aprés-guerre, 1925-1947," (exhibition catalog), 1983
6 Léon Deshairs, "Emile Lenoble," *Art et Décoration*, October, 1924; Marcel Zahar, "Les Ceramiques de Jacques Lenoble, *Art et Industrie*, February, 1931
7 *Ceramique française contemporaine, sources et courants*, Musée des Arts Décoratifs, Paris 1981
8 Jacqueline du Pasquier, "Céramiques de René Buthaud," exhibition catalog, Musée des Arts décoratifs, Bordeaux, 1976; Pierre Lahalle, "Les oeuvres de céramique de René Buthaud," *Mobilier et Décoration*, October, 1928
9 Werner J. Schweiger, *Wiener Werkstätte, Design in Vienna, 1903-22*, Abbeville Press, New York, 1984; Waltraud Neuwirth, *Wiener Keramik*, Klinkhardt & Biermann, Braunschweig, 1974
10 "International Exhibition of Ceramic Art," exhibition catalog, The Metropolitan Museum of Art, New York, 1928
11 "Viktor Schreckengost, A Retrospective Exhibition," exhibition catalog, Cleveland Institute, 1976
12 Martin Eidelberg, "Ceramics," The Detroit Institute of Arts and The Metropolitan Museum of Art, 1983; *Design in America; The Cranbrook Vision, 1925-1950*, Harry N. Abrams, Inc., New York, 1983
13 René Chavance, *La céramique et la verrerie*, Riedeo, Paris, 1928; *Les Arts du Feu*, Paris, November, 1938
14 *Mobilier et Décoration*, 1927
15 *Encyclopédie des Arts Décoratifs...*, op. cit.; Katharine Morrison McClinton, *Art Deco, A Guide for Collectors*, Clarkson N. Potter, New York, 1986
16 L. Ginori Lusci, *la Porcellana di Dorcia*, Milan, 1963
17 Maureen Batkin, *Wedgwood Ceramics, 1846-1959: A New Appraisal*, Richard Dennis, London, 1982
18 "Eric Ravilious Memorial Exhibition," exhibition catalog, London: Arts Council, 1948; Helen Binyon, *Eric Ravilious*, Frederic C. Beil, New York, 1983
19 Peter Wentworth-Sheilds & Kay Johnson, *Clarice Cliff*, L'Odeon, London, 1976
20 A.W. Coysh, *British Art Pottery*, David & Charles, Newton Abbot, 1972
21 David A. Hanks, with Jennifer Toher, *Donald Deskey: Decorative Designs and Interiors* (New York: E.P. Dutton, 1987)
22 Davies, *At Home in Manhattan*

INDEX

Numbers in bold type refer to captions/illustrations.

ACKNOWLEDGMENTS

Gratitude is extended to the following for their assistance in the compilation of this book:

Alexander and Karen Jones Acevedo, and Sarah Steves of the Alexander Gallery, New York; Anthony de Lorenzo of the de Lorenzo Galleries, NY; William Doyle and George Roos of the William Doyle Galleries, NY; Barry Friedman of the Barry Friedman Gallery, NY; Richard P. Goodbody; Paul Greenhalgh of Christie's, London; David A. Hanks; Adam Heyman and Kathleen Healy of Oscar Heyman Bros., NY; Carolyn Holmes of Sotheby's, NY; John Jesse and Irina Laski of Jesse & Laski, Ltd., London; Randy Juster; Pat Kery of Pat Kery Fine Arts, Inc., NY; Dianne Lykes; Paul Mas; Lillian Nassau; Penny Proddow; Nicola Redway and Lucy Dexter of Sotheby's London; Aldred Rios; David Robinson; Caroline Stern; Maurice Tzwern of the Galerie Tzwern-Aisinder, Brussels, Robert Vallois and Cheryl Niedorf of the Galerie Vallois, Paris; Nina Wahl and Jesse Gamboa of Van Cleef & Arpels, NY; Gavin Young of Christie's NY; and Robert Zehil of the Robert Zehil Gallery, Beverly Hills.

Very special thanks to MaryBeth McCaffrey, who helped to co-ordinated, edit, and research the entire encyclopedia, and to Isidra Pastor, for her research on several chapters.

PHOTOGRAPHIC ACKNOWLEDGMENTS

The publishers would like to thank the following people and organizations for supplying photographs and/or allowing photography of works in their possession.

(Abbreviations used: b — bottom; l — left; m — middle; r — right).
R. Asselberghs 20b; John P Axelrod, 117t; Maria de Beyrie 54t, 50b; Geoffrey Bradfield 50b; Francesco Carraro 127t and m; Charles H. Carpenter Jr. 114b; Christie's, Geneva 15b, 25b, 82t and mr, 88, 90r, 91 l and r, 95, 161tr, 163t, 164b, 172b; Christie's, London 19bl, 103b, 121m, 122t, 128m, 149b; Christie's, New York 12, 20, 26, 27tr and tl, 28t, 29t, 30, 31t and br, 32tr and tl, 33, 34tr and tl, 35t, 36t, 37t, 38 l and r, 39t and m, 40, 41, 42, 43, 44, 47, 48r, 49b, 53m and b, 54m, 57, 59mr, 62m, 70 l, 71, 73b, 75b, 77b, 78t, 82ml, 83t and b, 89b, 94b, 96r, 97, 98, 99tr, 100t and b, 101m, 105t and m, 108tl, 110, 112b, 113b, 115, 117b, 118b, 121br and bl, 122b, 123b, 124, 125b, 126t, 128b, 129b, 138 l, 141t, 143, 144b, 145m, 146 l, 147, 152, 153, 154r, 156, 157b, 160b, 161tl, 162, 163b, 166, 173t, 174m, 177bl, 183t; Corning Museum of Glass 170; Warren Cresswell and George Matheson Gerst 51 l; Wiliam Doyle Galleries 118, 132, 133; Martin Eidelberg 123t, Fifty-50 Gallery 62t; French & Co 39b, 48 l, 51tr, 55mr, 73r, 74; Audrey Friedman and Haim Manishevitz 66t and m, 70r, 73ml; Barry Friedman Inc. 17br, 36b, 55b, 76, 77tl and tr, 79, 84 l and r, 86m, 87t, 106b, 135m, 137m, 141m, 145b; Galérie les Arts Plastiques Modernes 108tr; Steven Greenberg 53tr; Hedrich-Blessing 18r; Oscar Heyman Bros. 81b; Historical Design Collection Inc. 61 l Scott Hyde 15t; Jesse and Laski Gallery 35b; Randy Juster 11, 14, 17t and m, 18 l, 19t, 21tl and tr, 23tl and tr, 23tl and tr, 25m, 148t; Muriel Karaski 107b; Pat Kery Fine Arts Inc. 65b, 94 l and r; Eric Leyton 120; Miles J. Lourie 31bl, 72r, 101t, 102, 134t and m, 136m, 137t, 138r, 139, 142r, 181b; de Lorenzo Gallery 52 l, 55ml, 75 l, 144t; Félix Marcilhac 105, 126b; Terry McGuiness 103 l; Michael Meek 182; Randall Michelson 24; Jacques Mostini 53tl; Lillian Nassau 160tl and bl; National Museum of American Art, Smithsonian Institution, Washington D.C. (Bequest of Harold Callender) 32b; Newel Art Gallery Inc. 65m, 81t; Orrefors Archive 78b, 109, 111; Primavera Gallery 19br, 23b, 28b, 37b, 52r, 58, 67, 68, 69 l, 75r, 135t, 146m, 157t and m, 159 l, r and m, 164t, 165t and m, 168, 169, 171b; Rockwell Museum 114t; William Rothschild 13m; Sotheby's, London 29b, 34b, 91r, 122m, 125tr and tl, 128t, 129t and m, 171t, 172m, 174t, 179t; Sotheby's, New York 17bl, 21b, 89t, 118tr, 121t, 123m, 126m, 137b, 146b, 161b, 173m, 175t, 178t and m, 184tl, tr and m, 185t; Matthew Stirling 96 l; Van Cleef & Arpels Collection 160r, 161m, 175b; Virginia Museum of Fine Arts 72 l; Weinstein Collection 103r, 104m, 106t; Mitchell Wolfson Jr., Miami-Dade Community College 61r; Wurts Bros. 9 l; Robert Zehil 69r, 86t, 149t, 150 l.